GREEK SCULPTURE

Nigel Spivey

CAMBRIDGE
UNIVERSITY PRESS

CAMBRIDGE UNIVERSITY PRESS
Cambridge, New York, Melbourne, Madrid, Cape Town,
Singapore, São Paulo, Delhi, Mexico City

Cambridge University Press
The Edinburgh Building, Cambridge CB2 8RU, UK

Published in the United States of America by
Cambridge University Press, New York

www.cambridge.org
Information on this title: www.cambridge.org/9780521760317

First published 2013

Printed and bound in the United Kingdom by the MPG Books Group

A catalogue record for this publication is available from the British Library

Library of Congress Cataloguing in Publication data

Spivey, Nigel Jonathan.
 Greek sculpture / Nigel Spivey.
 pages cm.
 ISBN 978-0-521-76031-7 (Hardback) – ISBN 978-0-521-75698-3 (Paperback)
1. Sculpture, Greek. I. Title.
 NB90.S65 2013
 733′.3–dc23
 2012021706

ISBN 978-0-521-76031-7 Hardback
ISBN 978-0-521-75698-3 Paperback

Je voudrais que le lecteur ne crût rien sur parole et sans l'avoir vérifié, et qu'il se méfiât de tout, même de cet itinéraire. Croire sur parole est souvent commode en politique ou en morale, mais dans les arts c'est le grand chemin de l'ennui.

STENDHAL, *Promenades dans Rome, 25 Janvier 1828*

CONTENTS

LIST OF FIGURES x

PREFACE xix

NOTE xxii

1 INTRODUCTION: THE STUDY OF GREEK SCULPTURE 1

Ancient writing about Greek sculpture 4

The modern tradition 6

The periods and styles of Greek sculpture: a glossary 7

Sources and further reading 13

2 THE GREEK REVOLUTION 17

Defining the Greek Revolution 20

Style and democracy 24

Narrative, truth and consequences 27

The cult of beauty 33

The logic of anthropomorphism 42

Conclusion: 'Pygmalion's power' 50

Sources and further reading 51

3 DAEDALUS AND THE WINGS OF *TECHNÊ* 55

Daedalus: the invention of the arch-inventor 57

Technê: limestone and marble 64

Technê: bronze and terracotta 74

'The colours of white' 81

Sources and further reading 83

4 *ANATHÊMATA*: GIFTS FOR THE GODS 87

The economics of idolatry and the archaeology of cult 89

Votive occasions and votive sculpture 95

Conclusion: *Eusebeia* and 'Greekness' 116

Sources and further reading 119

5 HEROES APPARENT 123

Of the great and the good 124

'Say not that the good die' 127

'Heroic nudity' 133

The Tyrannicides 136

Heroes beyond the grave 139

Sources and further reading 148

6 TEMPLE STORIES 151

The Corfu pediment 153

Temples on the Archaic Akropolis 156

Metopes of the temple of Zeus at Olympia 160

The Parthenon frieze 165

The Bassae frieze 170

Sources and further reading 172

7 IN SEARCH OF PHEIDIAS 175

Pheidias: the legend 177

Rationalizing genius 182

Athena Parthenos and Olympic Zeus 188

Sources and further reading 192

8 REVEALING APHRODITE 195

Aphrodite's genesis and Aphrodite's cult 197

Knidos: the shock of the nude? 202

Aphrodite at large 209

Sources and further reading 213

9 ROYAL PATRONAGE 217

The Nereid monument 220

The Mausoleum at Halicarnassos 222

Ruler-cult and 'propaganda' 226

After Alexander 230

Pergamon: the Athens of the East 235

From Pergamon to Rome — 243
Sources and further reading — 245

10 PORTRAITS AND PERSONIFICATIONS — 249
'The mask of Socrates' — 250
Putting names to faces — 254
Seven Athenian worthies — 255
The physiognomic factor — 257
Alexander – 'the Great' — 258
After Alexander — 262
Personifications: a selective survey — 265
Sources and further reading — 271

11 GRAECIA CAPTA — 277
The Verrine controversy — 281
'Captive Greece made captive her wild conqueror' — 284
Sculptures in the *horti* — 286
The Sperlonga sculptures — 292
Hadrian's Antinous — 295
Coda: mutilated statues — 296
Sources and further reading — 297

12 AFTERLIFE — 301
Byzantium and the Middle Ages — 303
The Renaissance — 306
Enlightenment and Romanticism — 313
The rise of archaeology — 317
Sources and further reading — 321

INDEX — 324
COLOUR PLATES FOUND BETWEEN PAGES 168 AND 169

FIGURES

My thanks to colleagues who have assisted with pictures: Lucilla Burn, David Gill, Ian Jenkins, Bert Smith, Cornelia Weber-Lehmann. I am also obliged to John Donaldson at the Museum of Classical Archaeology, Cambridge. Museum references (especially those of Berlin, currently under reorganization) are provisional: here, the following abbreviations have been used: BM – British Museum; NM – Athens, National Archaeological Museum.

Frontispiece: Laocoon – a sketch attributed to Michelangelo, in the underground room of the New Sacristy of San Lorenzo, Florence.

COLOUR PLATES

I Portrait of J.J. Winckelmann, by Anton von Maron, 1768. Weimar, Schlossmuseum.

II (a) Detail of Riace Figure 'B'. Reggio Calabria, Archaeological Museum (Nick Murphy).
(b) Detail of Riace Figure 'A'. Reggio Calabria, Archaeological Museum (Nick Murphy).

III Detail of painted drapery on Athens Akropolis *korê* no. 594, as recorded at time of excavation. After H. Schrader, *Auswahl archaischer Marmor-Skulpturen im Akropolis-Museum* (Vienna 1913), pl. V.

IV Part of a fragmentary Attic funerary *stêlê*, *c.* 540 BC: girl with flower. Berlin, Staatliche Museen. (Further parts of the same monument are in the New York Metropolitan Museum.)

V Reconstruction of the Triton pediment: after T. Wiegand, *Die archaische Poros-Architektur der Akropolis zu Athen* (Cassell 1904), pl. iv. (Original fragments in Athens, Akropolis Museum.)

VI Reconstruction of the chryselephantine Zeus at Olympia. Artwork by Sian Frances.

VII Detail of the 'Terme Boxer'. Rome, Palazzo Massimo.

VIII Figure 'N' – usually identified as Iris – from the Parthenon west pediment. London, BM.

FIGURES IN TEXT

1.1 Portrait of J.J. Winckelmann, by Anton von Maron. Weimar,
Schlossmuseum. 4

1.2 'Daedalic' relief from Mycenae. Athens, NM. 7

1.3 'Apollo of Tenea'. Munich, Glyptothek. 8

1.4 'Blond Boy'. Athens, Akropolis Museum (D. Gill). 9

1.5 View of the Athenian Akropolis, *c.* 1950 (from archive of
R.M. Cook). 10

1.6 'Nike adjusting her sandal'. Athens, Akropolis Museum. 11

2.1 Horse-head from the Parthenon east pediment. London,
BM. Photo by courtesy of the Trustees. 18

2.2 Drawing of the same. 19

2.3 Geometric bronze horse figurine. Cambridge, Museum
of Classical Archaeology. 20

2.4 Black-figure amphora by Exekias. Vatican Museums (Beazley Archive). 21

2.5 Detail of the Parthenon frieze. London, BM. 22

2.6 'Kritian Boy'. Athens, Akropolis Museum. 23

2.7 Detail of relief from the Apadana, Persepolis. 27

2.8 Ensemble from the west pediment of the temple of Zeus
at Olympia. Olympia Museum. 29

2.9 Central figures from the east pediment of the temple of Zeus
at Olympia. Olympia Museum. 31

2.10 Figure of 'The Seer' from the east pediment of the temple
of Zeus at Olympia. Olympia Museum. 32

2.11 Bronze torso from Vani. Vani, Georgian National Museum. 33

2.12 Detail of red-figure kylix by Oltos. Berlin, Antikensammlungen. 34

2.13 Terracotta group of Zeus and Ganymede. Olympia Museum. 35

2.14 'Polykleitan' torso, perhaps of Herakles. Copenhagen,
Ny Carlsberg Glyptotek. 37

2.15 Doryphoros. Naples, Archaeological Museum. 40

2.16 'Metrological relief'. Oxford, Ashmolean Museum. 41

2.17 Detail of an Apulian vase: Apollo within a temple. Amsterdam, Allard Pierson Museum. 46

2.18 'Piraeus Apollo'. Athens, Piraeus Museum. 47

2.19 Detail of an Apulian vase: Cassandra seeking refuge. London, BM. By courtesy of the Trustees. 49

3.1 Palaikastro *kouros*. Crete, Sitia Museum. 62

3.2 'Auxerre Goddess'. Paris, Louvre. 63

3.3 Nikandre's *korê*. Athens, NM. 64

3.4 Detail of metope from Selinus temple E. Palermo, Archaeological Museum. 65

3.5 Abandoned quarry-piece at Apollonas on Naxos (F.H. Stubbings). 67

3.6 Figures in the court of Ramesses II at Luxor. 68

3.7 *Kouros* from the approach to the Samos Heraion. Samos, Archaeological Museum. 70

3.8 Unfinished figure in Pentelic marble. London, BM. By courtesy of the Trustees. 71

3.9 Abandoned *kouros* at Melanes on Naxos. 72

3.10/3.11 Metopes from the Foce del Sele sanctuary. Paestum, National Archaeological Museum. 73

3.12 Diagram showing the structure of a *korê*. 74

3.13 Winged deity done in *sphyrelaton* technique. Olympia Museum (R.M. Cook). 76

3.14 Bronze statuette from Samos. Berlin, Antikensammlungen. 77

3.15 Detail of Athenian red-figure kylix (the 'Foundry Cup'). Berlin, Antikensammlungen. 78

3.16 Remnants of a clay mould for a bronze figure. Athens, Agora Museum (R.M. Cook). 79

3.17 Terracotta sarcophagus-lid figure from Cerveteri. Cerveteri Museum. 80

3.18 'Dancing girls' terracotta relief from Rhegion. Reggio Calabria, Archaeological Museum. 80

4.1 Detail of the Parthenon frieze. London, BM. 88

4.2a/4.2b 'Artemis of Ephesus' figure, with detail. Selçuk Museum. 90

4.3 Part of a caryatid from Eleusis. Cambridge, Fitzwilliam Museum. 92

4.4 Votive assemblage from Ayia Irini, Cyprus. As displayed in the A.G. Leventis Gallery, Stockholm, Medelhavsmuseet. 94

4.5 Demeter, Persephone and Triptolemos on a relief from Eleusis. Athens, NM. 96

4.6 Detail of the frieze on the Siphnian Treasury. Delphi Museum. 98

4.7 Imaginary view of the interior of the temple of Apollo at Bassae: after C.R. Cockerell, *The Temples of Jupiter Panhellenicus at Aegina, and of Apollo Epicurius at Bassae near Phigaleia in Arcadia* (London 1860), 59. 99

4.8 Nike of Paionios. Olympia Museum. 100

4.9 'Delphi Charioteer'. Delphi Museum. 102

4.10 'Motya *kouros*'. Motya, Whitaker Museum. 102

4.11 'Lancelotti Discobolus'. Rome, Palazzo Massimo. 103

4.12 Inscribed base of a statue by Polykleitos: after W. Dittenberger and K. Purgold, *Die Inschriften von Olympia* (Berlin 1896), no. 164. Olympia Museum. 104

4.13 'Westmacott Ephebe' type. Rome, Baracco Museum. 105

4.14 Votive relief dedicated by Lysimachides. Athens, NM. 106

4.15 Votive relief from the Piraeus Asklepieion. Athens, Piraeus Museum. 107

4.16 Fragment of relief from Anavysos. Athens, NM. 108

4.17 'Hermes of Praxiteles'. Olympia Museum. 110

4.18 *Korê* of Euthydikos. Athens, Akropolis Museum. 111

4.19 *Korê* no. 674. Athens, Akropolis Museum. 112

4.20 Statue of the priestess Nikeso, from Priene. Berlin, Staatliche Museen. 113

4.21 Drawing of the *Moschophoros*. Athens, Akropolis Museum. 114

4.22 Part of a terracotta plaque from Gela. Oxford, Ashmolean Museum. 115

4.23 Bronze deity from Cape Artemision. Athens, NM. 116

4.24 Gypsum statuette from Naukratis. London, BM. By courtesy of the Trustees. 118

4.25 *Kouros*-figure from Naukratis. London, BM. By courtesy of the Trustees. 118

4.26 Alabaster *kouros*-figure from Naukratis. London, BM. By courtesy of the Trustees. 119

5.1 *Stêlê* of Pollis. Getty Museum, Malibu. 126

5.2 Sketch of figures from the west pediment of the temple of Aphaia on Aegina: from the notebook of C.R. Cockerell. London, BM. By courtesy of the Trustees. 127

5.3 Dying figure identified as Laomedon, from the east pediment of the temple of Aphaia on Aegina. Munich, Glyptothek. 128

5.4 'Kleobis and Biton'. Delphi Museum. 130

5.5 *Kouros* from Cape Sounion. Athens, NM. 131

5.6 'Hockey-players' on a late Archaic statue-base. Athens, NM. 133

5.7 Archaic *kouros*-torso. Cleveland Museum of Art. 134

5.8 Part of an over-lifesize statue from Miletos. Paris, Louvre. 134

5.9 'Tyrannicides' Group. Naples, Archaeological Museum. 137

5.10 *Stêlê* of Dermys and Kittylos. Athens, NM. 140

5.11 Archaic *stêlê* of a *hoplitodromos*-figure (?). Athens, NM. 141

5.12 Lower part of an Archaic *stêlê*. Rome, Baracco Museum. 142

5.13 *Stêlê* of Dexileos. Athens, Kerameikos Museum. 143

5.14 Dexileos monument *in situ* in the 'Street of the Tombs'. 143

5.15 'Ilissos *stêlê*'. Athens, NM. 144

5.16 Fragment of a fourth-century BC Athenian funerary relief. Oxford, Ashmolean Museum. 145

5.17 Lakonian funerary *stêlê*. Berlin, Antikensammlungen. 145

5.18 Part of a statue of Penelope, from Persepolis. Teheran Museum (R.M. Cook). 146

5.19 *Stêlê* of Mnesarete. Munich, Glyptothek. 146

5.20 Detail of funerary *lekythos* of Theophante. Athens, NM. 147

6.1 The west pediment of the Corfu Artemision (after Rodenwaldt). 153

6.2 Central figure of the Corfu west pediment (after Rodenwaldt). 154

6.3 'Triton' pedimental group from the Akropolis. Athens, Akropolis Museum. 158

6.4 'Bluebeard' pedimental group from the Akropolis. Athens, Akropolis
 Museum. 159

6.5 'Introduction of Herakles' pediment from the Akropolis. Athens,
 Akropolis Museum (D. Gill). 160

6.6 Herakles cleansing the Augean Stables, on a metope from the temple
 of Zeus at Olympia. Olympia Museum. 161

6.7 Herakles supports the heavens while Atlas fetches the Apples of the
 Hesperides, on a metope from the temple of Zeus at Olympia.
 Olympia Museum. 163

6.8 Detail of same. 164

6.9 Suicide of Ajax: sketch of a relief from the Foce del Sele sanctuary.
 Paestum, Archaeological Museum. 166

6.10 Detail of the Parthenon frieze (the 'peplos scene'). London, BM. 167

6.11 Fragment of the Parthenon frieze (north side), Vienna,
 Kunsthistorisches Museum. 168

6.12 View of Bassae (before protective tent). 170

6.13 Detail of the frieze from Bassae: Lapith women seek sanctuary.
 London, BM. 171

6.14 Detail of the frieze from Bassae: Apollo and Artemis. London, BM. 172

7.1 *Pheidias showing the Frieze of the Parthenon to his Friends*, by Lawrence
 Alma-Tadema (1868). Oil on wood. Birmingham City Museum
 and Art Gallery. 176

7.2 Putative head of Pheidias. Copenhagen, Ny Carlsberg Glyptotek. 180

7.3 Riace Bronzes. Reggio Calabria, Archaeological Museum. 188

7.4 Model reconstruction of the Athena Parthenos. Toronto, Royal
 Ontario Museum. 189

8.1 Detail of *The Birth of Venus* by Botticelli. Florence, Uffizi Galleries. 197

8.2 'Ludovisi Throne'. Rome, Palazzo Altemps. 198

8.3 Interior of Athenian red-figure cup by Onesimos. Brussels, Royal
 Museums. 201

8.4 'Capitoline Venus'. Rome, Capitoline Museums. 203

8.5 Terracotta relief-figurine of Astarte (?), from Tharros. London, BM.
 By courtesy of the Trustees. 204

8.6 Demeter of Knidos. London, BM. 206

8.7 View of the 'Round Temple' at Knidos. 207

8.8 'Knidian Temple' at Hadrian's Villa, Tivoli. 208

8.9 Torso-fragment of Knidia type from Tralles. Berlin, Staatliche Museen. 209

8.10 'Crouching Aphrodite', from Sainte-Colombe. Paris, Louvre. 210

8.11 Statuette of 'Crouching Aphrodite'. Agrigento, Museo Archeologico. 211

8.12 'Aphrodite Kallipygos' (cast). Dresden, Skulpturensammlung. 212

8.13 'Venus de Milo'. Paris, Louvre. 213

8.14 Roman matron *qua* Capitoline Venus. Naples, Archaeological Museum. 213

9.1 Imaginary engraving (nineteenth century) of the Colossus of Rhodes. After G. Zervos, *Rhodes* (Paris 1920), Figure 387. 219

9.2 'Nereid monument'. London, BM. 221

9.3 Detail of Nereid figure. London, BM. 222

9.4 Lion figure from the Mausoleum. London, BM. 224

9.5 Detail of the Amazon frieze from the Mausoleum. London, BM. 225

9.6 'Mausolus' figure from the Mausoleum. London, BM. 226

9.7 Miniature ivory head, presumed of Philip II. Vergina Museum. 227

9.8 Miniature ivory head, presumed of Alexander. Vergina Museum. 228

9.9 Figure of Agias the pankratiast, from the Daochus Group. Delphi Museum. After P. de la Coste-Messalière, *Delphes* (Paris 1957), pl. 185. 229

9.10 Detail of the 'Alexander Sarcophagus'. Istanbul, Archaeological Museum. 230

9.11 'Drunken Old Hag'. Munich, Glyptothek. 232

9.12 Winged Victory of Samothrace. Paris, Louvre. 234

9.13 'Old Fisherman'. Paris, Louvre. 235

9.14 Presumed portrait head of Attalos I. Berlin, Antikensammlungen. 236

9.15 Detail of Suicidal Gaul Group. Rome, Palazzo Altemps. 237

9.16 'Dying Gaul'. Rome, Capitoline Museums. 238

9.17 Detail of Pergamene Great Altar Gigantomachy: Artemis. Berlin, Pergamon Museum. 240

9.18 Detail of Pergamene Great Altar Gigantomachy: marine deities. Berlin, Pergamon Museum. 241

9.19 Detail of Pergamene Great Altar, Telephos frieze: Herakles and infant Telephos. Berlin, Pergamon Museum. 242

9.20 Laocoon Group. Vatican Museums. 244

10.1 Portrait of Socrates: engraving in the *Illustrium Imagines* of F. Ursinus (Fulvio Orsini) (1598), 51, Figure 1. 250

10.2 Head of Socrates ('Type B'). Rome, Palazzo Massimo. 251

10.3 Cast of statuette of Socrates. Cambridge, Museum of Classical Archaeology. 252

10.4 Herm of Themistokles, from Ostia. Ostia Museum. 255

10.5 Herm of Perikles, from Tivoli. London, BM. 255

10.6 Head of an Athenian general, perhaps Konon. Rome, Palazzo Massimo. 255

10.7 Head of a senior priestess ('Lysimache'). London, BM. By courtesy of the Trustees. 256

10.8 Head of Plato. Cambridge, Fitzwilliam Museum. 256

10.9 Full-length portrait of Demosthenes. Copenhagen, Ny Carlsberg Glyptotek. 256

10.10 Head of Menander. Copenhagen, Ny Carlsberg Glyptotek. 256

10.11 Youthful Alexander, from the Akropolis. Cast in the Nederlands Institute, Athens. 260

10.12 Head of Alexander, from Yannitsa. Pella Museum (Tim Cragg). 261

10.13 Head of a priest, from the Agora. Athens, Agora Museum. 263

10.14 Head of 'the melancholic Roman', from Delphi. Delphi Museum. After P. de la Coste-Messalière, *Delphes* (Paris 1957), pl. 195. 264

10.15 Statue of Themis, from Rhamnous. Athens, NM. 267

10.16 Figure of Pothos. Paris, Louvre. 268

10.17 Marble relief of Kairos. Trogir, Archaeological Museum. 269

10.18 Tyche-figure of Antioch. Vatican Museums. 271

11.1 Terracotta pedimental figure from a mid Republican temple (Via di S. Gregorio). Rome, Capitoline Museums. 280

11.2 Head of volcanic stone figure from a mid Republican shrine or tomb on the Via Tiburtina. Rome, Capitoline Museums. 281

11.3 Detail of Hanging Marsyas figure from the Horti Maecenatiani. Rome, Palazzo Massimo. 287

11.4 Punishment of Marsyas: detail of a late antique sarcophagus, in the cloister of the Basilica di S. Paolo, Rome. 288

11.5 Dying Niobid, from the Horti Sallustiani. Rome, Palazzo Massimo. 289

11.6 Head of a Polykleitan athlete, from the Forum area. Rome, Capitoline Museums. 290

11.7 'Terme Boxer'. Rome, Palazzo Massimo. 290

11.8 Farnese Bull Group. Naples, Archaeological Museum. 291

11.9 'Apoxyomenos', after Lysippos. Vatican Museums. 291

11.10 Fragments of the Palladium Group from Sperlonga. Sperlonga Museums. 292

11.11 Polyphemus Group from Sperlonga, as reconstructed with casts. Bochum, Ruhruniversität. 293

11.12 Head of Odysseus from the Polyphemus Group. Sperlonga Museum. 294

11.13 Detail of a figure of Antinous. Naples, Archaeological Museum. 295

11.14 Trial pieces from sculpture workshop by the council-house, Aphrodisias. Aphrodisias Museum. 296

11.15 Mutilated Three Graces Group from Perge. Antalya Museum. 297

12.1 'Dancing Maenad' relief. Rome, Palazzo Massimo. 303

12.2 'Horses of San Marco'. Venice, Museum of St Mark's. 305

12.3 'Apollo Belvedere'. Vatican Museums. 308

12.4 'Spinario'. Rome, Capitoline Museums. 308

12.5 *Andrea Odoni*, by Lorenzo Lotto, 1527. London, Royal Collection. 309

12.6 'Belvedere Torso', as drawn by P.P. Rubens. New York, Metropolitan Museum. 310

12.7 Farnese Hercules, as engraved by Hendrik Goltzius, *c.* 1592. 310

12.8 'Barberini Faun'. Munich, Glyptothek. 311

12.9 Detail of same. 312

12.10 Group of female deities from the Parthenon east pediment. London, BM. 316

12.11 Drawing of a Discobolus-cast, by Vincent van Gogh. Amsterdam, Van Gogh Museum. 320

PREFACE

This book is the offspring of another. Entitled *Understanding Greek Sculpture*, it was published in 1996 and went out of print several years ago. As any author would, I wished for a reissue – or rather, a second edition, correcting and updating where necessary. This wish developed into the more ambitious project of entire renovation. Motives were mixed: since I could not trace the 'floppy disk' where the words of the original text were stored, the book would have to be rewritten – but in any case I was glad of the opportunity to implement numerous *pentimenti* of style and substance, while adding several further chapters and extra material throughout.

The basic structure remains – along with the intention to provide an 'understanding' of Greek sculpture. In a fresh introductory section I have outlined the historic and aesthetic justification for studying this body of ancient art; here it may be worth adding a reminder that the 'power of art' is rarely self-sufficient. If artists of today require (as they seem to) critics and commentators to 'explain' their work, how much greater the need for glossaries on work produced 2,000 or more years ago? And naturally we create our own academic priorities for this as for any other field of study. Since 1996, there have been two distinct trends in research and writing about Classical art in general, and Greek sculpture in particular. The first has been to investigate 'the viewer's share' – to focus not so much on how images were produced as on how they were received. It remains rare to have any insight about the *contemporary* response to sculptures of the fifth century BC and earlier. Yet the exploration of later texts related to images and attention to the literary genre of *ekphrasis* – the descriptive 'speaking-out' of writers alluding to works of art, from Homer onwards – has become more sensitive and sophisticated; and there is even some fresh evidence (notably from papyrus remains of the third-century BC poet Posidippus). An evolutionary and collective account of ancient response is still difficult to compose. This study, nonetheless, tries to maintain alertness to the religious power of images in their original function: a 'theology of viewing' wherever sculpture was once situated.

The second major shift of scholarly opinion in recent years concerns the activity of Greek sculptors working within what may broadly be termed 'the Roman world' – that is, not only Rome and Italy, but all those areas (specially in the eastern Mediterranean and Asia Minor) that came under Roman administration. It has long been accepted that Greek sculptors flourished beyond the surrender of

independence by Greek city-states to Rome. But there has also been a long tradition of scorning the work done by Greek sculptors throughout this period. From my own student days I well remember the overt distaste expressed towards 'Roman copies' by our teachers – with one of them (Martin Robertson) maintaining that the rot had set in during Hellenistic times.

A gallery of yellowing 'restored' marbles from the Antonine epoch can still cause the willing spirit to falter. But it is no longer conventional to pronounce Greek sculpture from the second century onwards as the tired replication of masterpieces from an earlier age. A modern 'preference for the primitive' may linger on; objectively, however, one could make the case that Athenodorus, Polydorus and Hagesander – the three sculptors from Rhodes accredited with the Laocoon Group, who left their names on equally powerful work installed in a cave at Sperlonga – were absolutely matchless exponents of the art of transforming blocks of marble into epic drama; and they probably worked in the early decades of the century beginning *Anno Domini*. Readers must not be surprised, then, to find many works with Roman provenance included here as 'Greek sculpture' – and the category of 'Roman copy' virtually taboo throughout the book.

Certain masterpieces of Greek sculpture may be characterized as 'time lords'; albeit eroded, fractured or otherwise incomplete, they have not only survived for around two and a half thousand years, but have also been visible over several or more centuries. So, while this book is essentially a quest for original meanings, I have tried to give some sense of that enduring presence and resilience throughout the text. Beyond a dedicated last chapter on the post-Roman reception of Greek sculpture, I have also chosen some illustrations 'of a certain age' – and indicated, especially in captions, circumstances of discovery for individual pieces.

We suppose Classical relics to form a fixed body of knowledge: yet this is a considerably weightier tome than its predecessor – not only for the sake of verbiage or *corrigenda*. Added substance reflects further information; though there are certain monuments for which a deeper knowledge seems only to bring less comprehension, one could point to many sites and monuments where excavation and research over the last two decades have made a marked difference to 'understanding Greek sculpture'. Nonetheless, this remains an essentially speculative, dare I say 'Socratic', study, permeated throughout with uncertainty or lack of proof. Nobody *knows*, for example, what the images of the Parthenon frieze were intended to signify. A tally of the words 'perhaps', 'maybe' and 'possibly' within my text would amount (I fear) to a forbidding total.

A number of anonymous readers have made helpful suggestions towards strengthening the structure and scope of the book, and I have taxed learned colleagues with the onus of reading parts of the text. Here is the place to thank them: John Boardman, John Henderson, Ian Jenkins, Robin Osborne, Rolf Schneider, Bert Smith, Michael Squire, Jeremy Tanner and Carrie Vout. They are of course exculpated from any remaining errors or sins of omission.

Readers who already know *why* Greek sculpture is worth studying, and who consider themselves *au fait* with the jargon and historiography of the subject, may skip the introductory first chapter.

<div style="text-align: right">

Nigel Spivey
Emmanuel College, Cambridge

</div>

NOTE

Abbreviations for Classical authors, texts and learned journals etc. are mostly as prescribed in *The Oxford Classical Dictionary* (3rd edn), with the addition of *A–B* for the works of Posidippus as edited by Austin and Bastianini (Milan 2002). However, the spelling of Greek and Latin names in the text follows preference for familiar usage and is therefore inconsistent – so 'Akropolis' not 'Acropolis', but 'Erechtheum' rather than 'Erechtheion'.

References to Pausanias follow the numbering of the Penguin translation by Peter Levi S.J. (Harmondsworth 1971).

Dates in the text are all BC unless otherwise specified.

Lines from Seamus Heaney's *Electric Light* reproduced by permission of Faber and Farrar Strauss Giroux.

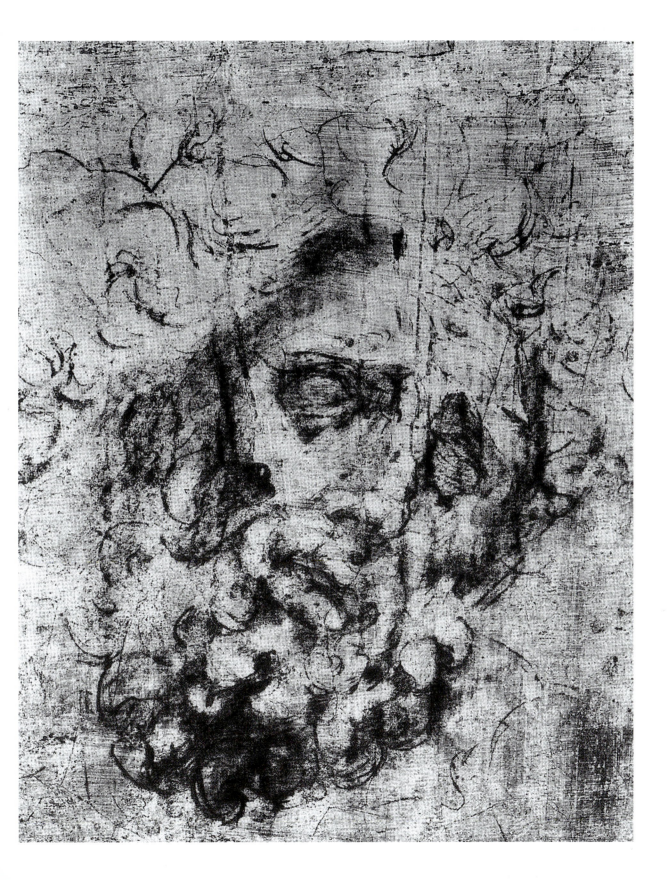

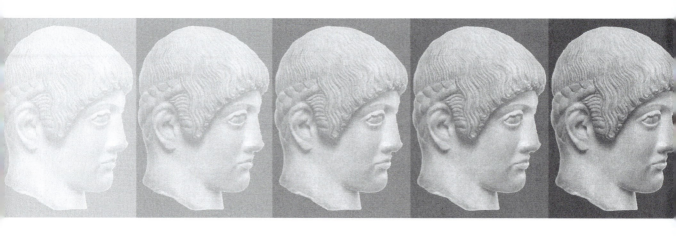

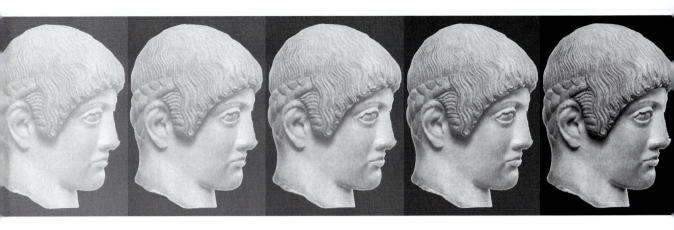

1

INTRODUCTION:
THE STUDY OF GREEK SCULPTURE

The primary motive for studying the art of ancient Greece can be easily stated: its sheer beauty, which beyond our delight and wonder may demand some explanation. But that is an aesthetic sentiment, and such sentiments carry little weight nowadays. So we are obliged to summarize why the endeavour involved in 'understanding Greek sculpture' is objectively worth our time and intellectual effort.

As a logical progression, the reasoning might go as follows. Whether or not we agree that Greek sculpture is generally 'beautiful' to behold, there is no doubt that the artists who created this work, and those who commissioned it, were aware of the capacity of three-dimensional images to cause delight, wonder and awe. The potential for enchantment was there from the beginning; we have not invented it. The archaeological contexts of early Greek sculpture make it clear that it was originally and essentially produced as 'gifts for the gods': as such, intended for marvellous display.

That certain craft techniques were developed by Greek sculptors with the aim of making their work 'marvellous' is equally evident, whether from the material remains of the work itself or circumstantial inscriptions and ancient literature. In the history of Western art, there is no place and period to compare with what happened in the Greek world between *c.* 800 BC to *c.* 300 BC: a half-millennium of technical innovation and refinement, rooted in a continuity of artistic tradition that was often passed on from father to son. An apprentice in Greek sculpture might very well start work aged 7 or 8 (a letter survives from the Athenian Agora, written to his mother by one very unhappy boy set to work in a foundry). It is tempting to relate this custom to the modern reductive calculus whereby 'genius' relies upon some 10,000 hours of practice.

At Cambridge University (for example), the study of Greek sculpture has been part of the Classics curriculum since the early 1880s; today, it is widely diffused in school and university courses, particularly those titled around the concept of 'Classical Civilization'. Why so? Because sculpture forms, along with architectural remains, the visible aspect of 'the Classical world' and so embodies various values traditionally attached to the cultures of Greece and Rome – or more specifically, the culture of Athens in the fifth century BC. This symbolic investment of Greek sculpture with such values – 'control', 'order', 'serenity', etc. – was established by the end of the eighteenth century; and, for all that it has since been challenged or repackaged, it remains a fundamental motive for academic and aesthetic homage.

WINCKELMANN'S *HISTORY OF ANCIENT ART*

The name of J.J. Winckelmann (Figure 1.1; Plate I) is often cited, and his work rarely consulted, by scholars of Classical antiquity. This reflects a peculiar sort of historical status. To some of his contemporaries, and to successive generations, Winckelmann was an inspirational figure – in Goethe's phrase, like an intellectual Christopher Columbus, finding a new world. To this day he is usually considered the 'founding-father' or *Gründungshero* of Classical art history. Yet when Winckelmann first published his thoughts on Greek art, in an essay of 1755, he had seen little of it beyond sundry engravings and casts. In appropriately majestic style, however, he summarized its characteristic qualities of 'noble simplicity' (*edle Einfalt*), 'calm grandeur' (*stille Grösse*) and 'serenity' (*Heiterkeit*).

When Winckelmann proceeded to publish his even more panoramic survey of ancient art – not only Greek, but also Egyptian, Etruscan and Roman – he had travelled from his native Prussia no further than to Florence, Rome and Naples. He dreamed of digging at Olympia; but he was not of an adventurous disposition and clearly felt, once he was ensconced in Rome as Prefect of Papal Antiquities (in 1763), that he had 'arrived'. It is not surprising, then, that in terms of its analytical detail Winckelmann's *Geschichte der Kunst des Alterthums* (Dresden 1764; with numerous subsequent editions and translations) is now almost worthless. The range of material available to Winckelmann was simply too limited for him to be able to make sound judgements: though he took pains to add supplementary considerations of *Monumenti inediti* ('unpublished pieces'), his narrative was largely based on what he could glean from ancient texts and what he knew from the collection of his first sponsors at Rome, the Albani family.

Like many north Europeans, Winckelmann appreciated the warmth of moving south, and was content to imagine that blue skies and solar power had some formative effect upon art. But there is a more telling index of how far he belonged to his times. Winckelmann saw history as a lifespan, complete with the basic stages of infancy, adolescence, maturity and decline. Rise, flourish, fall: the artistic output of antiquity could all be explained according to this biological (or biographical) narrative. Coupled with a conviction that 'Liberty' (*Freiheit*) created ideal conditions for 'the flowering of the arts' (*Pflegerin der Künste*) and the human spirit, this meant that Classical 'perfection', or the 'Classical' as properly understood, must be located in the period between the battles of Plataea (479 BC) and Chaeronea (338 BC) – respectively, when the democratic Greeks had thrown off the Persians but not yet succumbed to Macedonian domination. The word 'Hellenistic' only came into circulation in the nineteenth century, but Winckelmann's comments upon a piece such as the Louvre 'Seneca' (see Figure 9.13) – 'a web of stringy veins' that 'can hardly be considered worthy of the art of antiquity' – would set the tone for a tradition of disparagement that lingers to this day.

'*Art which received its life, as it were, from freedom, must necessarily decline and fall with loss of freedom.*' So what about the products of autocratic patronage? Winckelmann's problem was that certain works of ancient art he passionately admired – the Laocoon; the Belvedere Torso; a relief of Hadrian's favourite, Antinous –

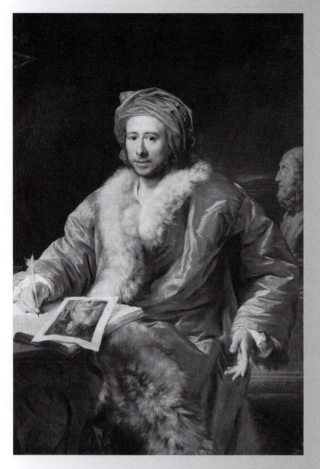

Figure 1.1 *Johann Joachim Winckelmann, by Anton von Maron, 1768. Painted when Winckelmann was at the height of his powers (but during the summer of the same year, Winckelmann was murdered in Trieste). A bust of Homer is in the background; on the scholar's escritoire lies an engraving of a relief-bust of Antinous (in the Albani collection). See also Plate I.*

manifestly did not belong to the period of 'perfection'. Again we must remember just how few were the existing examples of 'the Classical', strictly speaking, in Winckelmann's day. Yet we cannot help feeling that had he lived to see, perhaps, the sculptures of the Parthenon – soon to be 'made known' by Lord Elgin's adventures on the Athenian Akropolis – Winckelmann would have felt vindicated. He had, after all, declared the 'golden age of art' to have been those decades when Perikles presided at Athens. This judgement may owe something to ancient texts – in particular, Plutarch's *Life of Perikles* – and established opinion from Enlightenment figures – notably Voltaire. Nonetheless, it has the force of a prophecy fulfilled.

Ancient writing about Greek sculpture

There is no extant ancient 'history' of Greek sculpture. This is not to say that none was ever written. There are signs that towards the end of the fourth century, academics based at the school founded by Aristotle, and following Aristotle's own interests not only in classification, but in how various arts achieved their effect, began to create 'family trees' of sculptors and collected piquant 'sayings' (*apophthegmata*) related to individual masters. At least one fifth-century sculptor (Polykleitos: see p. 37) left a record of his working aims and practice; and it was an active sculptor – Xenokrates, a pupil of Lysippos – who in the third century composed several historical 'volumes' (*volumina*) about his craft (Pliny, *NH* 34.83). Antigonos is named as another such artist-author, and although their writings have not survived, these sources were to inform Pliny the Elder when he came to compile his *Naturalis Historia* in the mid first century AD.

'Nature, which is Life, is my subject.' Pliny did not write a history of art as such. The information he collects about Greek sculpture comes as it were incidentally, subsumed in those chapters of his thirty-seven-volume encyclopaedia devoted to mineralogy. So sculptors using gold and silver are discussed in Book 33, on gold and silver; bronze-workers in Book 34, on bronze; terracotta sculptors in a sub-section of Book 35 dealing with clay; and other sculptors in Book 36, mostly concerned with marble (plus some remarks on gem-cutting in Book 37).

In a sense Pliny did not need to write art history *per se*, since it already existed – as we might expect, given the late Republican Roman enthusiasm for collecting works of Greek sculpture. Pasiteles, a Greek sculptor from south Italy, active in the first half of the first century BC, had assembled five volumes of 'world masterpieces' (see p. 285); and for portraits, it appears that a comprehensive catalogue of *imagines* was drawn up by Varro by the late first century BC. Pliny's contemporary Quintilian, who specialized in rhetoric, incidentally shows an intelligent eye for style and attribution. Pliny himself seems to have harboured a certain distrust of art as potentially corrupting *luxuria*; his patrons were the 'down-to-earth' Flavian emperors who succeeded the notoriously flamboyant philhellene Nero. We can be thankful that prejudice did not override Pliny's omnivorous appetite for information and industrious habits of study (like Winckelmann, Pliny resented sleep as a waste of the scholar's time).

We are also indebted to Pausanias, an itinerant Greek from Asia Minor who during the second half of the second century AD composed a 'Guide to Greece' (*Periêgêsis tês Hellados*) in ten volumes. This work had a literary pedigree – one notable predecessor was Polemon, who in the second century BC made a particular study of dedications at sites such as Olympia, Delphi and the Athenian Akropolis – but there is no doubt that Pausanias actually made his own tour of the area, which then comprised the Roman province of Achaea (excepting Aetolia and the islands). The frequent citations from the *Periêgêsis* throughout this book show Pausanias as truly devoted in his eagerness to experience 'all things Greek', above all the sanctuaries. His travels, it has been observed, resemble a pilgrimage; his testimony about Greek sculpture is accordingly dominated by its active deployment in acts of worship. His curiosity can lapse in certain places (around the Parthenon, for example), and he may not have checked his information as thoroughly as we might wish; at least, however, Pausanias took the trouble to interview local people. For that reason alone we may set him apart from the more library-bound commentaries on art scattered in the writings of the 'Second Sophistic' – the period (first to third centuries AD) of an extended vogue for self-consciously 'clever' rhetoric. Lucian, Athenaeus, Callistratus and the Philostrati are among such sources, valuable to us chiefly because among favoured declamatory exercises was the *ekphrasis* – the verbal description (literally 'speaking-out') of any object, which might very well be an actual statue or painting.

The discipline of 'aesthetics' hardly existed as such in antiquity, but Second Sophistic texts are fertile in evidence for ancient concern about the sometimes opposed roles of 'imitation' (*mimêsis*) and 'imagination' (*phantasia*) in the artistic process.

The modern tradition

The 'reception' of Greek sculpture – which includes various attempts to classify it – is addressed in Chapter 12. Here our concern is merely to outline the development of the current system whereby surviving works are ordered into a chronological sequence and – if they carry no signature, as is mostly the case – assigned to particular names.

Winckelmann had relatively little interest in artistic personality. For him, individuals were subsumed by the prevailing ethos of the epoch; and in this respect, Winckelmann prefigured the Hegelian penchant for describing this or that period of history in terms of its *Zeitgeist*, or 'spirit of the age'. It was another German, Heinrich Brunn, who in the mid nineteenth century shifted the scholarly perspective away from *Geistesgeschichte* to *Künstlergeschichte* – that is, sought to create a narrative of the development of Greek art driven by a genealogy of 'names'. Beginning with Daedalus, Brunn created a generation-by-generation roster of master-sculptors. His sources were mostly literary; but he nobly incorporated epigraphic evidence even when this was difficult to reconcile with the literature (the inscribed names of sculptors employed in carving the Erechtheum frieze, for example, are more or less 'unknown' from ancient writers). Along with his fellow-countryman Johannes Overbeck – whose collection of ancient 'written sources' (*Schriftquellen*), published in 1868, is of enduring utility – Brunn laid the groundwork for the sort of study that would be pursued by his star Bavarian pupil, Adolf Furtwängler. This consisted in the application of 'perceptual understanding' (*Anschauung*) to philological expertise: that is, developing a visual sense for the personal style of this or that ancient sculptor, even when little or nothing has survived of that sculptor's original work. So the student of Classical art must hone the skills of *Kopienkritik* – the tracking of derivative pieces, allowing identification of those persistent traits that indicate the quality of the lost original. Furtwängler's best-known achievement remains his folio volume of 1893, *Meisterwerke der griechischen Plastik* (translated as *Masterpieces of Greek Sculpture* by Eugenie Strong in 1895).

Scholarly trends since then have moved, broadly speaking, from the study of individual sculptors to the interpretation of statues and monuments. That shift of focus is more or less reflected in the thematic organization of this book. The frailty of our knowledge about individual 'Great Masters' was starkly revealed by the discovery of the Riace Bronzes in 1972 (Plates IIa and b), and the problems of

constructing any kind of artistic biography are discussed in Chapter 7 with regard to Pheidias, one of the several proposed creators of those statues. To highlight those problems, however, is not to deny that the historical development of Greek sculpture was largely driven by rivalry between individuals. Meanwhile, as already cautioned, the attempt to establish symbolic meanings for Greek sculpture is fraught with its own uncertainties.

The periods and styles of Greek sculpture: a glossary

Like all academic disciplines, Classical archaeology is hedged about with its own terminology, some of it arcane. This summary is offered for the sake of readers not yet initiated into a chronological system now more or less standard across the subject.

Prehellenic This is not, strictly, a denomination of Greek sculpture. It implies a time when the inhabitants of those areas we think of as 'Greece' are not historically counted as Greeks (*Hellênes*), a period extending thousands of years, from the Stone Age to the decay of Bronze Age citadels by the end of the second millennium BC. Neolithic and Cycladic figures are encompassed by this span; so too the archaeological cultures known as 'Minoan' and 'Mycenaean'. Insofar as it can be assigned an absolute date, 'the Trojan War' took place *c.* 1250 BC. In later times – when Socrates was alive, in the fifth century BC – Greeks were accustomed to consider, albeit vaguely, that their 'Heroic Age' had drawn to a close when Odysseus finally regained his kingly domain on Ithaca – in Homer's narrative, ten years after the fall of Troy.

Early Iron Age Some archaeologists resort to the term 'Dark Age(s)' to describe an intermediate phase between the collapse of Mycenaean centres (*c.* 1200 BC) and the 'rise of the *polis*'

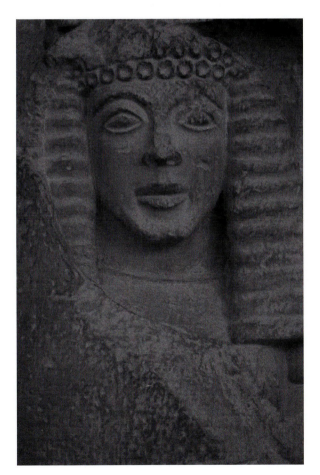

Figure 1.2 *Fragmentary limestone relief from Mycenae, c. 630. Ht 41 cm. A female figure, perhaps a goddess, in the gesture of veiling herself: from a series of metopes belonging to a temple of Athena erected on the acropolis of Mycenae.*

(*c.* 750 BC); others prefer the more general 'Early Iron Age', the more so as light is shed on this period. In any case, it is during the ninth and eighth centuries that our first stylistic category comes into currency. **Geometric** is a term introduced by Alexander Conze in the 1870s. It denotes art characterized by a fondness for certain shapes, tending towards abstraction; mostly the evidence for the style comes from painted pottery, but simple figures of humans and animals are also included (see Figure 2.3), and these develop into the idiosyncratic category of **Daedalic** (*c.* 700–600). Triangular heads, rhomboid torsos, circular earlobes – such are among the hallmarks of a Daedalic statue (Figure 1.2).

The period may be given wider context by noting that Homer is thought to have flourished, on the Ionian coast, *c.* 750–700 BC; Hesiod, in Boeotia, seems to have been his younger contemporary. The accession of the Saite pharaoh Psamtik (Psammetichus) I in 664 is usually taken as the date when Greeks began to make direct contact with Egypt.

Archaic Stimulated by external influence (from Egypt especially) and internal developments (particularly the rapid growth of sanctuaries), Greek sculpture 'takes off' in the Archaic period (*c.* 600–*c.* 480). A primary catalyst was the monumental growth of sanctuaries, requiring not only increasingly numerous and ambitious sculpted votive offerings, but also 'cult statues' (some using precious materials, such as gold and ivory) and temple decorations (including pediments, friezes, metopes and akroteria). Freestanding images of 'maidens' (*korai*) and 'youths' (*kouroi*) – both types essentially symbolic of aristocratic values – proliferated, not only as votive dedications, but also as gravemarkers (Figure 1.3). Limestone predominates at first, soon yielding to marble, especially from island sources such as Naxos and Paros; towards the end of the period, however, hollow-cast bronze-working became a favoured medium, at least

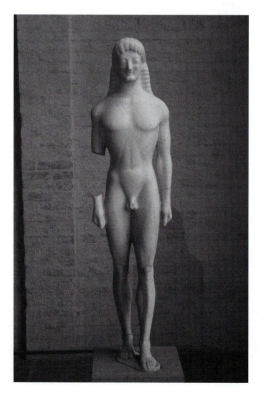

Figure 1.3 *Apollo of Tenea: marble kouros ('youth'), c. 560–550 BC. Ht 1.53 m. Found in a cemetery at Tenea (near Corinth) in 1840, this shows the mix of schematic and naturalistic elements that are hallmarks of the Archaic style.*

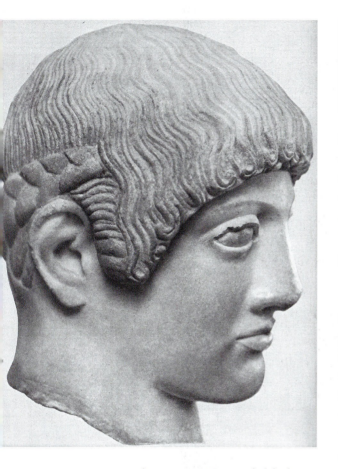

for individual statues. Its stylistic influence affected architectural sculpture in marble, as may be seen in the pedimental ensembles from the temple of Aphaia on Aegina – whose discovery in 1811 signalled the arrival of an 'Archaic' category in Classical archaeology (see p. 127).

Severe Style Translated from the German, *der strenge Stil*, this may seem an over-pedantic sub-division, applied to sculpture of the period *c.* 480–*c.* 450. (Some will prefer the label 'Early Classical'.) It is not, however, difficult to recognize the hallmarks of the Severe Style, epitomized by sculptures from the temple of Zeus at Olympia. The so-called 'Archaic smile' is gone, and in its place a facial expression tending to be sober, abstracted or downcast. Heavy-lidded eyes are a conspicuous feature of these solemn faces; and although hair is represented by a mass of simple wavy lines, hairstyles – for men especially – went through a phase of fussiness, as evident from the figure identified as Apollo on Olympia's west pediment and the exquisite head from the Athenian Akropolis known as Blond Boy (Figure 1.4).

Classical (*c.* 480/450–*c.* 330) More than any other, this term demands explanation, because it can be used in various senses. In this book, for example, 'Classical' can denote all of the Graeco-Roman period – as in 'Classical Civilization', or 'the Classical world'. Applied to sculptural style, however, 'Classical' sits between 'Archaic' and 'Hellenistic', with an implicit *apogée* around the time of the building of the Parthenon (447–432). The word derives from the Latin *classis*, literally 'rank' or 'class', but by the second century AD having the sense 'of first rank' and used for a work (of art, literature or other intellectual or creative endeavour) assigned such primacy by educated consensus. By the late first century BC, in fact, it is clear that a Roman who considered himself a 'learned man' (*homo doctus*) understood that the *floruit* of Greek 'wisdom' from the

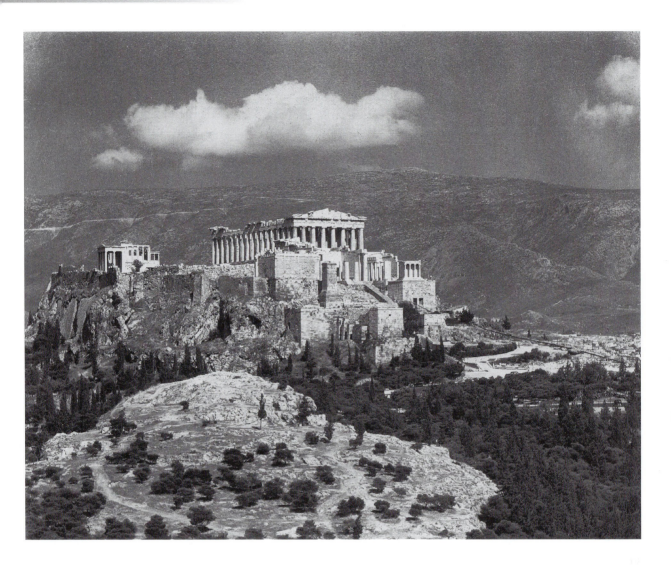

Figure 1.5 *View of the Athenian Akropolis from the north-west.*

time of Perikles (*c.* 450) to the rise of Macedon (*c.* 330) was a golden age, enshrining cultural models for respect and emulation.

Such 'flowering' of excellence took many forms, often presented as if interdependent: so advances in geometry may relate to the accomplishments in architecture; the great victory odes of Pindar *et al.* connect to a golden age of athletic excellence at the Panhellenic sanctuaries; the dramatic stagecraft pioneered by Aeschylus opened the way not only for the imaginative writing by Sophocles and Euripides, but also the large-scale theatrical 'scene-painting' techniques attributed to Agatharcus – and so on. It is in this 'crucible of genius' that we locate some of the 'great names' of Greek sculpture, including Myron, Pheidias, Polykleitos, Praxiteles and Skopas. One place dominates the monumental record: the Athenian

'CLASSIC DRAPERY'

A common perception of Greek sculpture is that it was obsessed with the human form unclothed – 'the nude'. Yet a primary means of defining the stylistic achievement of the Classical period lies with the techniques developed for representing drapery, especially upon female bodies. Archaic and Severe sculptors had tended towards simplicity, apparently depending on paintwork to add special effects to carved drapery. During the second half of the fifth century, however, exuberance prevailed – systematically underpinned by a series of artificial strategies. With little regard to how even loose-fitting garments actually 'hang' on bodies in either motion or repose, Classical sculptors used 'modelling lines' to emphasize bodily contours; 'catenaries', to create chains or bunches of suspended folds; 'motion lines', to indicate stretched or flying material; and 'illusionary transparency', whereby a pattern of delicate ridges appears on fabric adhering to its wearer. These strategies (eloquently identified by Rhys Carpenter) constitute one of the unifying elements of sculptures attached to the Parthenon (see e.g. Figure 12.10); though their most striking deployment comes on reliefs from the enclosing balustrade of the small Ionic temple of Athena Nike, perched on the edge of the Athenian Akropolis (Figure 1.6).

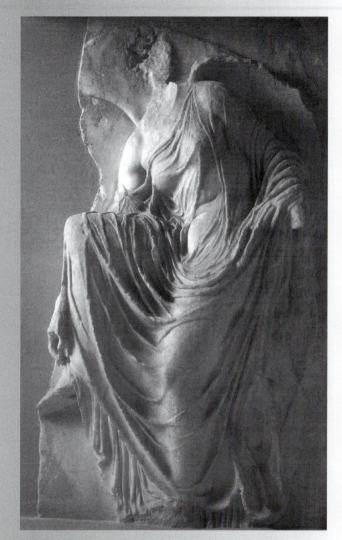

Figure 1.6 *Nike adjusting her sandal: one of the marble relief figures of winged Victory from the parapet of the temple of Athena Nike, c. 410–400 BC. Ht 1.07 m. Catenary folds here add grace and stability to what would otherwise be an awkward pose.*

Akropolis, as rebuilt with the political initiative of Perikles and the artistic supervision of Pheidias (Figure 1.5), a project including not only the Parthenon, but also the Propylaia, the Erechtheum and the temple of Athena Nike. Other notable monuments include the temple of Apollo at Bassae (see p. 170), the Nike of Paionios at Olympia (see Figure 4.8) and a series of poignant Athenian grave-markers (see Figures 5.12–14).

Hellenistic (323–31 BC) This category was invented by the Prussian historian Johann Gustav Droysen in the 1830s to denote a process of Greek and non-Greek synthesis necessary (as Droysen saw it) to explain the success of a strange Oriental religion founded by Jesus of Nazareth. In New Testament Greek (e.g. Acts 6.1) *Hellênistês* describes Jewish individuals or communities for whom Greek was the daily language of convenience: Droysen – who had listened to Hegel's lectures at Berlin – extended the term to epochal significance, determined by the expansion of Macedonian power under Alexander the Great, and Alexander's policy of using Greek language, and certain aspects of Greek culture, as unifying elements of the resultant empire.

The dates customarily assigned as parameters of the 'Hellenistic' period are given by the death of Alexander and the battle of Actium. Alexander's premature demise created the opportunity for several of his senior Macedonian associates to establish, in due time, their own kingdoms in territory conquered by Alexander: thus Ptolemy set up in Egypt, Seleukos in Syria, the Attalids at Pergamon and so on. These dynasties more or less flourished until the establishment of the Roman empire, which was a gradual phenomenon, but arguably marked by the victory of Octavian Caesar, later known as Augustus, over his Roman rival Mark Antony, and Cleopatra, last of the Ptolemies, in the waters off Cape Actium, on the north-west coast of Greece.

'Following Greek modes of thought or life' is one dictionary definition of 'Hellenistic'; for our present purposes, it will broadly entail 'Greek style' in sculpture and architecture, wherever that is manifest. There are problems in such usage: would it not include, for example, the Mausoleum of Halicarnassos, sponsored *c.* 360 BC by a non-Greek patron, but decorated by several leading Greek sculptors (see p. 222)? And since it can be proved that most artists and architects working within the Roman empire were Greek or Greek-trained, should 'Hellenistic' not apply also to their work? The reluctance, throughout this book, to describe any statue as a 'Roman copy' may be considered an implicit acceptance of that objection. But for the sake of custom we shall stay with the usual chronological boundaries. Some scholars like to construct capacious 'mentalities' for the characterization of Hellenistic art, stressing its 'theatricality', or penchant for 'realism', or elements of florid style (terms such as 'Baroque' and 'Rococo' may also be borrowed); a more simple approach is to indicate the prevalent circumstances of court-patronage. Alexander set the example, by employing the prolific and innovative Lysippos among his entourage. Greek craftsmen were always peripatetic; but now the training of sculptors and production of sculpture shifted eastwards, with Rhodes and Alexandria emerging among prominent new centres. For quality and quantity, however, the Hellenistic 'showcase' was the Attalid citadel of Pergamon (see p. 235). The elaboration of complex

groups; bold experiments with scale; ingenious variations of old themes – these are some of the virtues of Hellenistic art. A certain technical *impasse* makes it sometimes difficult to date – the Nike of Samothrace, for example (see Figure 9.12), can stylistically be placed across the span of three centuries – and, together with a perceived tendency towards 'frivolity' of subject, has earned Hellenistic art a reputation for 'decline' with respect to the Classical period. This is a matter of taste: objectively, there are few sculptural monuments in the world that can match the Pergamene Great Altar for sheer *brio* and virtuosity.

Roman period (31 BC–AD 324) Octavian, adoptive son and heir of Julius Caesar, took the title 'Augustus' in 27 BC. At about the same time, sculptors were at work on a monumental trophy of the victory at Actium, to be raised where Octavian had pitched his tent before battle, on a site to be known as 'Nikopolis' – 'Victory City'. The reassembling of thousands of fragments lately excavated from this site may enable us to define more clearly when, in formal terms, the 'Hellenistic period' ends and the 'Roman period' begins, for the iconography of a large rectangular relief frieze at Nikopolis contains elements that would become regular features of Roman imperial sculpture – drawn primarily from the institution of triumphal procession. An important advance: for the question of what is Roman about 'Roman art' has vexed scholars for over a century.

The problem may originate with Winckelmann, who maintained that there was no such thing as Roman art, only Greek art under the Romans. Some of this debate will be broached in Chapter 11; here we shall reiterate a working principle of the present study, which is to accept a basic continuity of craft tradition from the Hellenistic period onwards. (An enigmatic phrase in Pliny (*NH* 34.52) has caused some discussion about whether the technique of hollow bronze-casting lapsed, but this is undemonstrable.)

Technique, style, signatures and diverse circumstantial evidence – all point to the fact that the ethnic identity of sculptors working in Republican and Imperial Rome was normally Greek. This does not mean that 'Roman sculpture' does not exist. But it does allow a flexible attitude towards what we consider as 'Greek sculpture'. The *terminus* of the present study is part geographical, part ideological: AD 324 is the date of the founding of Constantinople, and whether or not that signifies the 'decline and fall of the Roman empire', it offers us the mercy of conclusion.

Sources and further reading

Some of the historiographical issues discussed here are explored further in A.A. Donohue, *Greek Sculpture and the Problem of Description* (Cambridge 2005). On the Germanic tradition of *Altertumswissenschaft*, English readers should consult S. Marchand, *Down from Olympus:*

Archaeology and Philhellenism in Germany, 1750–1970 (Princeton 1996). Despite the title, Salvatore Settis' monograph *The Future of the 'Classical'* (Cambridge and Malden 2006) has much to say about scholarship of the past.

Winckelmann The tradition of intellectual gratitude to Winckelmann goes back a long way, generating many *Festschriften*: a flavour of this may be found in the various contributions to T.W. Gaehtgens ed., *Johann Joachim Winckelmann, 1717–1768* (Hamburg 1986). I have also drawn upon the several elegant essays in *Johann Joachim Winckelmann 1768/1968* (Bad Godesberg 1968). Anglophone readers are now served by an annotated edition (with translation by H.F. Mallgrave): J.J. Winckelmann, *History of the Art of Antiquity* (Los Angeles 2006). See also F. Haskell, *History and its Images* (Yale 1993), 217ff., and A. Potts, *Flesh and the Ideal* (Yale 1994).

Ancient art history B. Schweitzer, *Xenocrates von Athen* (Halle 1932) remains fundamental. On Pliny, see J. Isager, *Pliny on Art and Society* (London 1991), and S. Carey, *Pliny's Catalogue of Culture* (Cambridge 2003). Pausanias is well-served by modern appreciation of his work, e.g. C. Habicht, *Pausanias' Guide to Ancient Greece* (California 1985) and K.W. Arafat, *Pausanias' Greece* (Cambridge 1996); Sir J.G. Frazer's *Commentary* of 1898, though archaeologically outdated, is nevertheless still worth using.

Modern tradition The first volume of H. Brunn, *Geschichte der griechischen Künstler* (Stuttgart 1857) is clearly presented, though anglophone readers will prefer H. Stuart Jones, *Select Passages from Ancient Writers Illustrative of the History of Greek Sculpture* (London 1895) and the more comprehensive survey provided by J.J. Pollitt, *The Art of Ancient Greece: Sources and Documents* (Cambridge 1990). Also valuable is Overbeck's 1868 *Schriftquellen*, as revised by Marion Muller-Dufeu: *La sculpture grecque. Sources littéraires et épigraphiques* (Paris 2002). There is a measured assessment of Brunn, Furtwängler *et al.* in the Introduction to O. Palagia and J.J. Pollitt eds., *Personal Styles in Greek Sculpture* (Cambridge 1996).

Periods and styles I add here a small selection of particular studies; further bibliography is attached to subsequent chapters.

Geometric B. Schweitzer, *Greek Geometric Art* (London 1971); J.M. Hurwit, *The Art and Culture of Early Greece* (Cornell 1985).

Daedalic R.J.H. Jenkins, *Dedalica* (Cambridge 1936) still makes a handy introduction to this category.

Archaic J. Boardman, *Greek Sculpture: The Archaic Period* (London 1978); B.S. Ridgway, *The Archaic Style in Greek Sculpture* (2nd edn, Chicago 1993).

Severe Style B.S. Ridgway, *The Severe Style in Greek Sculpture* (Princeton 1970); N. Bonacasa, *Lo stile severo in Grecia e in Occidente* (Rome 1995).

Classical J.J. Pollitt, *Art and Experience in Classical Greece* (Cambridge 1972), complemented (and complimented) by J.M. Barringer and J.M. Hurwit eds., *Periklean Athens and its Legacy* (Texas 2005). For further exposition of Classical drapery techniques, see R. Carpenter, *Greek Sculpture* (Chicago 1960), Ch. 5.

Hellenistic The problems of defining the art of the period are discussed by several scholars in P. Green ed., *Hellenistic History and Culture* (California 1993), 67–110. A number of recent compendium-volumes give a flavour of historical debate about the period, e.g. A. Erskine ed., *Companion to the Hellenistic World* (Oxford 2003). See also bibliography for Chapter 9 in this volume.

Roman O. Brendel, *Prolegomena to the Study of Roman Art* (Yale 1979); B.S. Ridgway, *Roman Copies of Greek Sculpture: The Problem of the Originals* (Michigan 1984).

Some years ago I was in the British Museum looking at the Parthenon sculptures when a young man came up to me and said with a worried air, 'I know it's an awful thing to confess, but this Greek stuff doesn't move me one bit.' I said that was very interesting: could he define at all the reasons for his lack of response? He reflected for a minute or two. Then he said, 'Well, it's all so terribly rational, *if you know what I mean.'*

E.R. Dodds,
The Greeks and the Irrational
(California 1951), 1

2

THE GREEK REVOLUTION

Horses are not easy to represent (for one thing, they hardly ever stay still). Yet in the global history of art, horses must be one of the most common subjects of representation – beginning with Palaeolithic times. So it is with due regard to innumerable other images of horses that we may present one marble horse-head as emblematic of the extraordinary achievement of Greek sculptors in the Classical period: from the Parthenon pediments, the horse which seems to capture the essence of all horsiness (Figure 2.1).

A British clergyman, Philip Hunt, was among the admiring viewers of this sculpture as it made its way from Athens to London in the early nineteenth century. Hunt, who assisted Lord Elgin in the transfer of the Parthenon marbles, was unstinting in his eulogy of the piece, claiming that it 'surpasses anything of the kind … in the truth and spirit of the execution. The nostrils are distended, the ears erect, the veins swollen, one might almost say throbbing. His mouth is open and he seems to neigh with the conscious pride of belonging to the Ruler of the Waves.'

This particular horse probably belongs to the chariot of a symbolic figure which is either Nyx (Night) or Selene (the Moon); and where Hunt saw urgent eagerness in its features, others register (more appropriately) a degree of equine fatigue. But niceties of interpretation apart, it is true to say that the response to this sculpture has been unequivocally enthusiastic, to the extent that it is referred to as the *Urpferd* – the original horse, the horse-archetype – a horse by which all other horses, in art or in life, must be measured.

This is extraordinary, absolute praise for a work of art. It can be traced directly to the German Romantic Goethe (1749–1832), who became some-what obsessed with finding *Ur*-forms in other fields: an *Urpflanze*, for example, 'the primal plant', from which all plant varieties must be descended. Referring simply to 'the Elgin horse-head' in one of his essays on morph-ology, Goethe asserted the statue to be so overpowering and yet 'ghostly' in appearance that if you compared it to horses in nature, you could only conclude that the sculptor had created 'the primal horse'.

Goethe's later compatriot, Ernst Buschor, would exclaim: *Das Pferd ist durch den Parthenon geadelt, ja geheiligt* – 'On the Parthenon, the horse

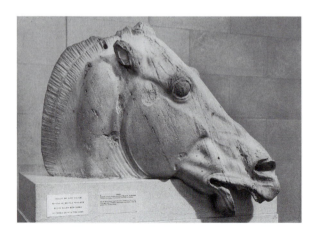

Figure 2.1 *The Urpferd: one of two horse-heads surviving from the east pediment of the Parthenon, c. 440 BC. Usually interpreted as belonging to the Moon-goddess, Selene.*

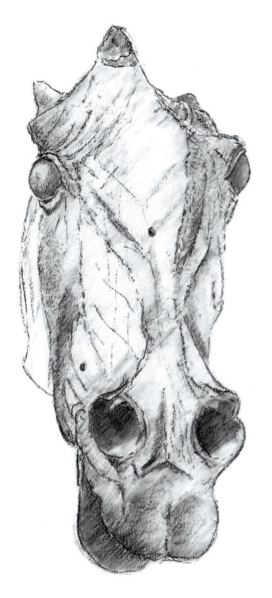

Goethe's own reasons for enshrining this (and other works of Classical art) as exemplary, and endowed with an almost divine validity, are partly explained by his contribution to a discussion in which some of the company opined that the Greeks had not been faithful in portraying animals, often showing rather stiff and 'imperfect' creatures. Here is Goethe's response:

I will not argue about that. But above all else we must distinguish at what time and by what artist such works originated. For no doubt examples could be produced in large quantities to show that Greek artists, in their representations of animals, not only equalled Nature, but surpassed it. The English, who are the best judges of horses in the world, are forced to admit that their two antique horseheads [from the Parthenon] are more perfect in form than those of any other breed extant today. These heads date from the best period in Greek art. But our wonder and admiration is not to be explained on the assumption that those artists were working from more perfect models than those which exist today. The reason is rather that they had, with the progress of time and art, themselves become such that they brought an inner greatness of spirit to their observation of Nature.

GOETHE, IN CONVERSATION WITH
ECKERMANN, 20 OCTOBER 1828

The final phrase of this judgement deserves emphasis, and explanation: for once it is

is ennobled, even sanctified.' It is difficult not to feel the same way while drawing the piece, as artists often have (Figure 2.2); and anyone who studies visitor-behaviour at the British Museum will observe the restraint it takes for viewers not to reach forward and stroke this petrified beast (as many have, to judge by the surface sheen). But why is it such a compelling image?

understood, then much of the reason for the 'Classic' status of Greek sculpture is revealed. Essentially the claim is that, in the first place, Greek artists *studied Nature* – they used, as models, the naturally occurring forms of the objects they were representing; and then that, secondly, some idealizing element was added, for the sake of 'correcting' or 'perfecting' natural forms. This gave 'greatness' to what was literally mundane; so the horse whose nostrils flare on the edge of the Parthenon pediment is at once astonishingly 'true to life' and yet unlike any horse we have ever seen.

Such is the achievement of the Greek Revolution, which it is the aim of this chapter to explain.

Defining the Greek Revolution

Art that is not produced from 'the observation of Nature' comes from a mental image – a concept, therefore yielding 'conceptual art'. That is not in itself a damnation: plenty of admirable conceptual art is produced, around the world, to this day; but, since we are seeking to elucidate a particular criterion of praise for Classical art, let us dwell upon the appearance of conceptual art in pre-Classical Greece. The Geometric period is rich in examples, in two or three dimensions; and for horses, Peloponnesian sites (especially Olympia) give us just what we need – a recognizable animal, most definitely a horse, yet almost reduced to a formulaic definition ('*Quadruped. Graminivorous*' etc.), and lacking any individually distinctive characteristics (Figure 2.3).

On an Athenian vase painted about two hundred years later we see the extent of artistic change (Figure 2.4). Though this is not an 'everyday' scene – inscriptions on the vase suggest a homecoming of the divine twins, the Dioskouroi, Castor and Pollux (or Kastor and Polydeukes) – it has been rendered in a domestic, familiar manner. The twins' mother, Leda, is there, and a slave who comes forward with a welcoming chair. But it is Castor's horse that dominates the scene. It has been given a name ('Kyllaros', 'the Scuttler') and is being patted above the muzzle by the boy's father, Tyndareos. And it has been drawn by an artist who has looked at the proportions and the

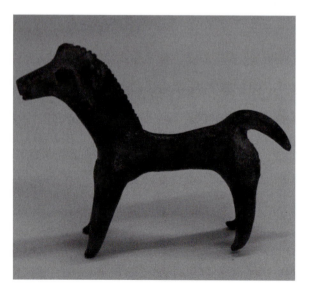

Figure 2.3 *Bronze horse figurine, c. 750–700 BC. Ht 6.3 cm. Provenance unknown, but stylistically classified as 'Elean' (i.e. probably from Olympia).*

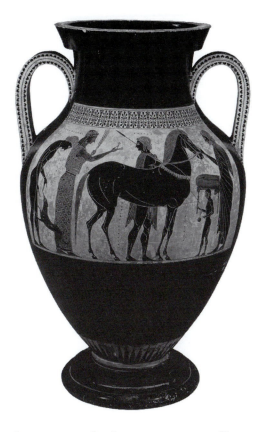

Figure 2.4 *Black-figure amphora by Exekias, c. 540 BC.*

anatomy of horses. Making comparisons between this 'Archaic' horse and our 'Geometric' specimen, that is the least we might say.

Now we belong to the postmodern age: we have seen artists celebrated for abstraction, even 'Primitivism', and so we are primed to withhold pronouncements about artistic 'progress'. In our eyes, change may occur for the sake of change. Past scholars, however, have taken a different view. For them, what was evident in the stylistic transitions of Greek art constituted a sort of growing-up, or 'emancipation' – as Greek artists ceased relying upon mental concepts and began to make images corresponding to natural appearances. Emmanuel Loewy, professor of Classical archaeology first at Rome, then Vienna (1918–38), was an influential advocate of this analysis. He hailed 'the discovery of nature' by the Greeks *c.* 600 BC as a particular phenomenon in the history of art: an absolutely new artistic attentiveness to the ways in which things appear, entailing the invention of various devices for its transmission to the viewer – in draughtsmanship, for example, the development of shading and planes, of rounding and foreshortening.

One of Loewy's pupils was Ernst Gombrich, who gave this phenomenon ('the discovery of natural forms') further dramatic emphasis. In Gombrich's popular account of *The Story of Art*, first published in 1950, it is hailed as 'the Great Awakening'. Various passages of this book indicate Gombrich's debt not only to Loewy, but also to the older tradition of Germanic writing about Classical art – beginning with Winckelmann: 'It was at the time when Athenian democracy had reached its highest level that Greek art came to the summit of its development' … 'The new-found freedom to represent the human body in any position or movement could be used to reflect the inner life of the figures represented' – and so on. Goethe's influence was honoured with illustrations supplied from the

Parthenon, reflecting 'this new freedom in perhaps the most wonderful way' (Figure 2.5). And in a subsequent and academically more influential study, *Art and Illusion* (New York, 1960), Gombrich summarized the historical event with a phrase that has stayed in some currency – 'the Greek Revolution'.

By adopting that title as a chapter heading we have acknowledged its essential propriety. Artists in ancient Greece did something that had never been done before: that fact is part of the justification for this book. But all revolutions have a cause: so what was it that caused the Greek Revolution? Although he echoed Winckelmann's liberal pieties regarding Athenian *Freiheit*, Gombrich knew enough about artists (and politics) to see that democracy was an insufficient explanation. He argued that the more significant factor here was the mode of storytelling developed by the Greeks, especially Homer. Concentrated not so much upon *what* occurred in a narrative, but rather *how* it occurred, Greek stories – as retailed by poets, dramatists and historians alike – were qualitatively quite different from the stories recorded in Egyptian and Near Eastern cultures. Descriptive detail was paramount; and such detail naturally encouraged 'illustration', or at least the enterprise of artists attempting to tell the same stories in images instead of words.

It has been observed, of Gombrich's persuasive prose, that this explanation comes with the air of a conjuror producing a rabbit from a hat. Grateful as one might feel for such a trick, there is the sense of wanting further enlightenment. Of course storytelling must be important, and we shall return to its influence shortly. But what of the social, religious, historical and technical factors? Do these have no bearing upon stylistic change? The complexity of such

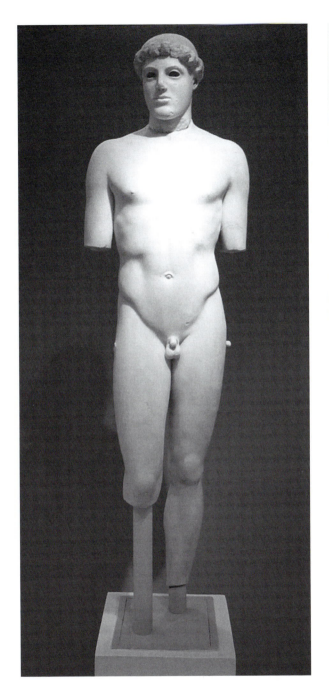

questions becomes apparent as soon as we consider one of the sculptures that has become emblematic of the Greek Revolution, the so-called Kritian Boy (Figure 2.6).

This was never the grandest of early fifth-century dedications on the Athenian Akropolis – the scale is under-lifesize, and a bronze piece would have been more conspicuous at the time – yet it serves as something like the 'cover boy' of the Greek Revolution. That is, its delicate form has been loaded with huge stylistic importance. In the words of one scholar: 'There is … no statue which looks forward more clearly to the full development of early Classical sculpture, none which is less reminiscent of the past.' Another (Kenneth Clark) hails it as no less than 'the first beautiful nude in art'.

So it is easy to forget that this statue once possessed a proper identity. One guess (and it is only a guess) is that it was a representation of the Athenian founding hero, Theseus. Another theory, hardly less speculative, holds that the statue can be reinstated with a base recovered from the Akropolis – fragments of an Ionic column (with capital) apparently inscribed with a pair of hexameter lines. The verses, if reconstructed rightly, draw attention not to the sculptor (who remains unknown) but rather to the Athenian citizen who paid for and dedicated the statue:

Victor in the boys' foot-race of the Panathenaia Kallias, son of Didymaios, dedicated this statue to Athena

A. E. RAUBITSCHEK, *DEDICATIONS FROM THE ATHENIAN AKROPOLIS* (CAMBRIDGE, MA, 1949), NO. 21; *CF.* NO. 164

If the base indeed belongs to Kritian Boy, then it provides a legend to the statue that may, in aesthetic terms, explain why the figure of the boy is at once both assertive and restrained. Here is an athletic victor, justifiably proud; yet his image is offered to Athena, a mode of gratitude for supernatural support. Subsidiary questions about image and inscription are, however, bound to proliferate. How significant was it to win the foot-race at the Panathenaic Games? What measure of piety was demonstrated by dedicating a statue at a sanctuary such as the Akropolis? Why was it important for the victor's father to be named? And is this a likeness of young Kallias – or else a thing of beauty in itself, presented *ex voto* to a goddess who will enjoy its presence? As noted, the statue is under-lifesize: would a larger statue have been regarded as too much in the way of self-promotion, perhaps a real political risk in a community that had recently invented the resort of ostracizing potential grandees?

To indulge such questions is to admit that the causes and circumstances of the Greek Revolution may lie beyond a single metaphor of 'freedom' or 'awakening'. The following discussion of various historical factors – political, social, religious, aesthetic – offers a prospectus for some possible courses of explanation; how far these combine is for readers to judge.

Style and democracy

Loose as it is, the association of naturalism and democracy has a distinguished academic pedigree. Winckelmann, as we have noted (p. 3), asserted that the 'perfection' of Greek art was indebted to political circumstances. How far Winckelmann's notion of 'liberty' squares with 'democracy' as practised in fifth-century Athens is debatable: Winckelmann knew about, and approved of, such democratic protocols as ostracism; yet *Freiheit* could be created by a benign autocrat inclined to patronage – such as the emperor Hadrian. In this broad understanding Winckelmann himself was influenced by the writings of the Third Earl of Shaftesbury (1671–1713), who argued that dictatorial or oppressive systems of government tended to impoverish the arts. Broadly, we may agree. But with a little reflection we shall also find it easy to see problems in applying the rule that art flourishes only when citizens feel 'free'. The artistic 'emancipation' saluted by Loewy occurred, chronologically, before the establishment of democracy at Athens and other Greek city-states; the 'anatomical

progress' shown in the development of the *kouros*-figure mostly took place during the sixth century, the age of tyrants. And how accurate is it to identify even the artists of Periklean Athens as active participants in the democracy? (As we shall see, their socio-economic status seems to have improved, gradually – yet most artists were looked down on as *banausoi*, mere manual workers, or *metoikoi*, resident immigrants; and in either case, they were excluded from the benefits of democratic citizenship).

Putting a political slant on the Greek Revolution may be encouraged, however, by a Classical Greek source – in the form of Plato. Plato, as is well known, was no enthusiast for democracy; nor did he have much time for artists, at least those whose commitment to naturalism led them to construct works of virtual reality designed to confuse or deceive the innocent viewer. So perhaps it is not surprising to find a protagonist in Plato's *Laws* – composed around the middle of the fourth century – applauding the 'rightful rules' (*kala schêmata*) that the Egyptians apply to art (and music) in their society. 'If you inspect their paintings and reliefs on the spot, you will find that the work of ten thousand years ago – I mean that expression not loosely but in all precision – is neither better nor worse than that of today; both exhibit an identical artistry' (*Laws* 656d, trans. Taylor). It is obvious from the context – and our knowledge of Plato generally – that this comment is intended as a compliment to the Egyptians. The response it draws in the dialogue is not 'How tedious!' but rather 'What an excellent system of government!'

Allowing for the notorious interlude of Akhenaten – the renegade pharaoh who built his capital at Amarna, towards the end of the Eighteenth Dynasty (*c.* 1350 BC), and who appears to have sanctioned disregard for many of the conventional proportions of art – we take Plato's point. Over some three millennia, it seems, the conceptual rules governing figurative and landscape representation in Egypt remained remarkably stable. As one Egyptologist has expressed it: 'invariance in form and production was the means by which an Egyptian craftsman successfully maintained himself as a specialist'.

If that is the case, then the strength of Plato's example is reinforced. It would be anachronistic to put a premium on 'originality' upon art in Classical Greece, yet true to say that an artist might gain success precisely by attempting projects that were variants on what had gone before. According to Hesiod's poetic legislation, 'Strife' (*Eris*) could be either destructive or useful to mankind (*Works and Days* 11–24): the sort of rivalry that pitched one artist or craftsman against another was of the latter sort, and there is plenty of evidence pointing to its prevalence among all manner of activities – whether writing a play or throwing a vessel.

Such competitive shows of skill did not rely upon democracy for their expression. But were artists in Greek cities aware that an environment of 'variance' and experiment set them apart from systems such as that of Egypt? We have scant evidence of such ethnic self-awareness; and apart from the possible foreign origins of some 'Greek' artists, we ought also to remember that artists in the Greek world were habitually peripatetic, taking commissions where they arose – including for non-Greek patrons. Darius, the king who did much to monumentalize the Persian centres of empire at Susa, Persepolis and Pasargadae, boasted that he had employed 'Ionian' craftsmen for the work – perhaps by force; and marks left by Greek stonemasons have been found at Persepolis.

So is there any value in trying to extrapolate, from Plato's implicit distinction between Greek and Egyptian art, a more general qualitative difference that would set 'Greek sculpture' apart from non-Greek work (Assyrian, Hittite, Phoenician, or whatever it might be) and that would, in the fifth century BC, help to define (democratic) 'Greekness' against (autocratic) 'Otherness'?

Historians debate the extent to which *dêmokratia*, 'the rule of the people', evolved through periods of tyranny in the sixth century before its protocols were established at Athens by Cleisthenes. But there is no doubt that very soon after the Athenian democratic constitution was set up, it was threatened from outside. By 500 BC, the armies of the Persian empire had already occupied parts of east Greece and were pointed towards Attica and the Peloponnese. We need not rehearse here the heroics of the battles – including Marathon, Thermopylae and Salamis – that ultimately prevented the Persians from colonizing Greece; but we should register that in 480 Persian forces occupied the Athenian Akropolis. They caused considerable damage there and left behind debris which the Athenians, on their return to the city, buried – unwittingly making a gift to future archaeologists (see p. 111). An exceptional survivor, still visible in Roman times (Pausanias 1.26.5), was an Archaic figure by Endoios of Athena seated. One statue, however, the Persians took away with them, as though a token of their triumph over Athens: the group known as the Tyrannicides, set up in the marketplace as an early but confident piece of 'democratic' art (see p. 136).

The ideological potency of this abduction may be confirmed less than two centuries later, when Alexander the Great allegedly recovered the Tyrannicides for Athens during his conquest of Persia; in any case the episode retrospectively seems to symbolize a divide of cultures. The Tyrannicides stand opposed not only to tyranny at home, but also to any foreign overlord (let us pass over the ethnic and political status of Alexander). So the style and subject of images produced by those divided cultures invite comparison.

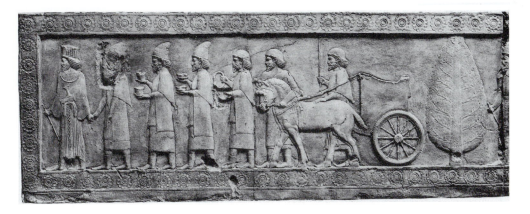

Figure 2.7 *Tribute-bearers, from the northern staircase of the Apadana palace (Audience Hall) at Persepolis (Iran), early fifth century BC.*

We have seen how the Parthenon frieze has been invoked as testimony to Greek artistic 'freedom'. Some scholars have wondered if the frieze were not designed as some sort of response to the sculpted reliefs decorating the royal reception hall at Persepolis – the 'Apadana', where the Persian king received tribute from his many subject states. The very workmanship of these reliefs, as noted, has some Greek involvement. Stylistically, however, there is little to compare. Lord Curzon's famous dictum regarding the Persepolis reliefs – 'all the same, and the same again, and yet again' – is overstated; yet patterns of repetition and 'invariance' at Persepolis are striking (Figure 2.7). As with Egyptian art, the formulaic representations of human, animal and landscape elements are rational enough: broadly speaking, they depend upon the several strategies of turning all bodily protrusions into profiles, cutting sections through three dimensions, or simply allowing priority to frontal views. Whatever one thinks of the result, it is plainly at odds with the effort of Greek artists to achieve the visual effects of substance and depth.

Narrative, truth and consequences

Storytelling is an activity germane to human cultures around the world, and seems always to have been so. And there are many ways of telling stories. But one basic distinction among these many ways is, as we have mentioned, that some stories are told with primary regard to *what* happens, while others are focused more upon *how* events unfold.

Drawing attention to this difference in his explanation of the Greek Revolution, Ernst Gombrich was careful not to present it as a necessary cause – and was mindful, too, that the essentially schematic and conceptual traditions of Egypt and

the Near East did not preclude artists from making images based on direct observation. (Exemplary are the dying lions on relief friezes from the palace of Ashurbanipal at Nineveh, *c.* 650 BC.) But if it was the case that Egyptian and Near Eastern verbal narratives were essentially reporting the *what* of a story – typically manifest in the ancient tale of Gilgamesh, which for all its urgency and conviction is not composed with the descriptive detail of a supposed 'eye-witness' – could it be that there was little incentive for artists to develop tricks of illusionistic representation? And by the same token, if Homer's poetry dwelt essentially upon the *how* of a story – for example, how heroes looked, how they felt, how they spoke and so on – did this sort of evocative enchantment challenge painters and sculptors to do likewise?

It was Plato who criticized Homer for the fictions of *mimêsis*, 'imitation'. Books 3 and 10 of Plato's *Republic* are dominated by the philosopher's anxiety about various sorts of *mimêsis*, including the practice of *diêgêsis dia mimêseos* – 'narrative through imitation'. The concern is largely about how 'falsehood' (*pseudos*) may become a habit in the mental disposition of young people brought up on the beguiling stories of Homer and the dramatists – the 'Classic' Athenian playwrights who, as one of their number (Aeschylus) put it, served up 'slices from Homer's banquet'. Homer cannot have been present on Mount Olympus, or on the battlefield at Troy. Yet he writes as if he were. For example, he will not relay what his characters say in an indirect form; rather, when putting words into their mouths, 'he does his very best to adapt his own style to whoever is supposed to be doing the talking' (*Rep.* 393c). To us this may seem a perfectly reasonable literary device, and later theorists – notably Aristotle – appreciated 'vividness' (*enargeia*) in all sorts of works of art. But in Plato's eyes this constitutes a form of fraudulence. So in Plato's copy of Homer, ideally, the text would be recomposed so that all the speeches were conveyed in terms of their content. Why should the narrator need to go 'playing a part' (*mimeisthai*) – for if the story is fiction, why must it be made 'believable'?

The answer would come first from Aristotle, with his doctrine of therapeutic emotional 'purging' (*catharsis*) from drama, and then of course from post-Classical voices, most famously S.T. Coleridge, who saw that a secret of dramatic enchantment was the 'suspension of disbelief' caused by pseudo-realism. Meanwhile, Greek sculptors before and after Plato pursued an essentially mimetic mode. Call it 'pseudo-realism' or 'naturalism': that it had become a criterion of aesthetic success by the early fifth century BC is undeniable. Among the signals of such success are the pediments of the temple of Zeus at Olympia, carved *c.* 470–460 BC.

Both pediments here represented stories that were perhaps well known at the time – yet never before visualized in such spirit of virtual reality. The temple itself

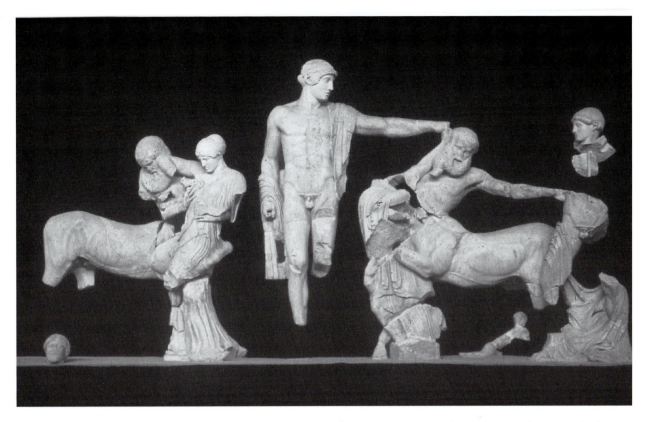

Figure 2.8 *Central ensemble of the west pediment of the temple of Zeus at Olympia, c. 470 BC. The colossal figure, though identified by Pausanias as Perithoos, is likely to represent the god Apollo, appearing as if to restore order.*

was a significant project, marking the resolution of a long-running dispute over control of Olympia (as a lucrative sanctuary) by two nearby polities, Pisa and Elis. Elis prevailed; and, according to Pausanias (5.10.2), it was with the spoils taken in the destruction of Pisa that the Eleans funded this monument. The architectural sculpture, which we can only assign anonymously to 'the Olympia master', included akroteria and metopes (see p. 160); though the building itself was complete by 456, an interior statue of Zeus, made by Pheidias, would not arrive until several decades later (see p. 191). But the pediments remain as perhaps they once were – the principal 'talking-points' of the temple.

The western gable framed a spectacular brawl: the eruption of lust and anger into what should have been a sacrosanct social occasion, a wedding-feast (Figure 2.8). Whether this was the wedding of Perithoos, prince of a Thessalian tribe known as the Lapiths (and close friend of the Athenian founder-hero Theseus), or nuptials of the daughter of an Elean king called Dexamenos, involving Herakles as a combatant, is open to debate; Pausanias (5.10.8) took it as the former, but Pausanias is not infallible.

Either way, this is a story of abused hospitality. In the spirit of neighbourly goodwill, Centaurs have been invited to a party; but these half-human, half-equine creatures, inflamed by drinking, have started an affray (one of their number, Eurytion, may be named as the original miscreant). The sculptors at Olympia catch the fighting at an ugly moment, with several Centaurs seizing Lapith women, perhaps the bride and her maids. Although divine intervention seems at hand – manifest in the ostentatiously calm central presence assumed to be that of Apollo – it is not yet clear which side will prevail. Viewers may disagree as to the wider meaning of the scene – a mythical analogue to justify exclusively Hellenic participation in the Olympic Games is just one suggestion – but no one can deny the verisimilitude of its representation. Has any of us ever set eyes upon a *real* Centaur? No: but this is art that prepares us for the experience – and presents a tableau of impromptu violence executed by sculptors who know what can happen in such situations (a Centaur caught in an arm-lock, for example, responds by biting into the forearm of his opponent).

The east pediment is markedly more static, yet nonetheless dramatic – and in quite a particular way, as if the protagonists of a play have come forward on a stage to introduce themselves, or to receive applause (Figure 2.9). As it happens, the story they will enact was scripted as tragedy by both Sophocles and Euripides (although these plays have not survived); and a great quantity of tragic drama will subsequently arise from the event about to take place. It is certainly a local story – but its ramifications spread far in place and time. At its core is the dark person of Oinomaus, legendary king of Pisa. Oinomaus had a much sought-after daughter called Hippodameia: but, either because he had been warned that he would be murdered by whoever married her, or (in a later version) because he loved her incestuously, Oinomaus blocked all attempts to win Hippodameia's hand. Suitors were challenged to a chariot race, which they lost on pain of death; and since Oinomaus possessed a team of magically swift horses, suitors regularly perished. Their skulls decorated the lintel of the king's palace.

This was the grim situation when Pelops arrived. Pelops, the son of Tantalos, came from Lydia, on the shores of Asia Minor. His adventures had begun at an early age – served up in a stew (by his father) as a meal for the gods, Pelops recovered to become a favourite of Poseidon. When the young man came to the land that would eventually bear his name – the Peloponnese, or 'Isle of Pelops' – he decided to take up the challenge of Oinomaus. Poseidon offered help: a golden chariot, and 'winged horses that never tire'.

So goes the story as we find it in verses more or less contemporary with the pediment (Pindar, *Ol.* 1). Oinomaus, whose body-language shows his arrogance, will find that he has met his match in Pelops. As usual with Greek mythology,

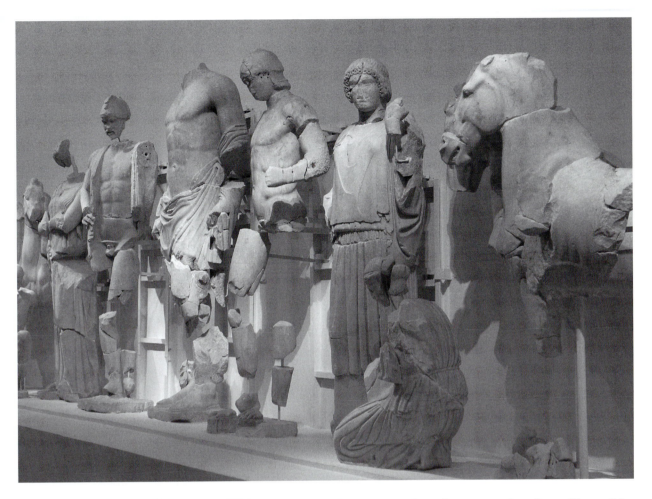

Figure 2.9 *Central figures of the east pediment of the temple of Zeus at Olympia. (The arrangement and identities of these figures are not definitive.) Zeus occupies the apex: to his right, Oinomaus (with hand on hip), his wife Sterope (arms folded); to his left, Pelops (who originally carried a shield, and some body-armour), and Hippodameia (adjusting her dress).*

however, the narrative breeds variants. Another telling of the story, attributed to a fifth-century Athenian writer called Pherekydes, tells us that Pelops resorted to trickery in order to win the race. In this 'cheating' version, Pelops bribes the king's charioteer, Myrtilos, to sabotage the vehicle that Oinomaus will use – by replacing the metal pins holding the wheels to the axle with wax replicas. As the chariot gathers speed, therefore, the wax pins will melt, the wheels fly off and the king will be thrown.

According to Pherekydes, this duly takes place; but then Pelops, having gained Hippodameia, refuses to honour the terms of the bribe. It may have consisted in the favours of his wife; at any rate, Pelops silences Myrtilos by drowning him. And as Myrtilos drowns, he delivers a curse – upon the descendants of Pelops.

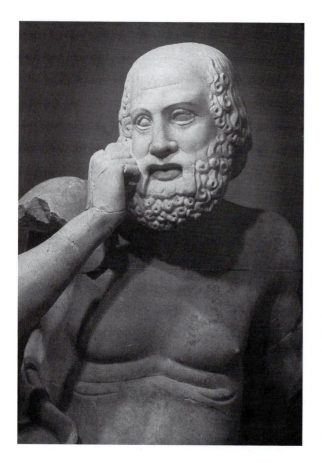

Figure 2.10 *Figure 'N' of the east pediment at Olympia. His age and attitude suggest a prophetic authority.*

Is this strand of the story sculpted upon the Olympia pediment? Pausanias seems to have thought so; and we may be persuaded by the presence of two seated elderly men, sometimes described simply as 'seers', or more specifically as Iamos and Klytios, the founders of two families that provided priests for the oracle at Olympia. The better-preserved of these figures is shown holding his hand to his face, frozen in an attitude of foreboding and alarm (Figure 2.10). Why should he be so concerned? Could it be that he foresees the long-term disasters that will befall the family line of Pelops? For among the offspring of Pelops and Hippodameia is Atreus, whose feud with his brother Thyestes will in turn affect the next generation, and generations thereafter: in short, the whole sorry saga of 'the house of Atreus' that encompasses Agamemnon, Clytemnestra, Orestes, Electra *et al.* – the subject of so much Classical tragic drama.

We cannot absolutely reconstruct the narrative programme of the pediment, only remind ourselves that within sight of this temple was the Bronze Age burial mound that was venerated as the tomb of Pelops, and also a wooden pillar, said to be all that remained of the palace of Oinomaus after Zeus blasted it with lightning. It is not absurd to claim that Olympia, at least by the time of Pausanias' sojourn there, offered a 'heritage trail' for visitors in search of some historical support for the 'events' of mythology. And however we choose to read the moment represented on the east pediment – and the most likely explanation is that it shows the solemn occasion when the two protagonists, prior to contest, take oaths before Zeus – again we must concede that the sculptors have made a priority of *mimêsis*. They have tried to imagine myth as actuality: the *how* of actions that must be terrible yet plausible.

That this narrative preoccupation significantly contributed towards the Greek Revolution is hard to deny. But is it the whole story?

The cult of beauty A bronze torso is found at a site on the shores of the Black Sea (Figure 2.11). As it happens, this is a part of the world once known to the Greeks. But even supposing it were not, we would not hesitate to say that this statue was cast by craftsmen who, if they were not actually Greek, were familiar with the repertoire of Classical Greek sculpture. The medium is partly indicative; but the form points more strongly to its source. One leg relaxed, tilting the hips; a ridge of muscle running over the tops of the thighs and the groin, framing a taut waist; the thorax delicately divided into compartments (the 'six-pack'); with defined pectorals and drawn-back shoulders emphasizing an athletic stance. And, of course, the figure is unclothed. We know little about the subject or dedication of this statue, but that ignorance cannot inhibit its basic attribution. This could only have been produced in the Classical cultural sphere.

How can we be so sure? The answer is lodged in another avenue of explanation for the Greek Revolution: the creation of canonical bodies in art which, for all its ideal development, has a social history – that is, the prizing of certain physiques ('somatypes') in life.

Let us begin with life: and the phenomenon of a contest that seems to have formed a significant part of one of the most prominent festivals of Classical antiquity, the Panathenaic (All-Athenian) Games. The contest was a challenge in *euandria*, 'fine manliness'. It may have involved certain spectacular tests of prowess and bravado – for example (apparently), riding two horses at once, while standing on their bare backs – but also some more considered assessments of personal appearance. We do not know what criteria were applied in the judgement of a prize-winning body, but images of youths and young men not only crowned with garlands, but also with ribbons tied about various parts – thighs, waists, arms – suggest an articulated

Figure 2.11 *Bronze torso from the sanctuary-city of Vani (Georgia), second century BC. Ht 1.05 m. The region was known to the Greeks as Colchis – birthplace of Medea.*

Figure 2.12 *Interior of an Athenian red-figure drinking cup by Oltos, early fifth century BC, showing a boy decorated with ribbons – perhaps the winner of some beauty contest.*

inspection, often saluted in vase-paintings by the inscribed acclaim of *ho pais kalos*, 'the beautiful boy!' (Figure 2.12).

Such competitions were not confined to Athens. There was one at Elis in the Peloponnese, also staged in honour of Athena, known as the *krisis kallous* – which might be paraphrased as 'the battle of the beautiful'; and another recorded at Tanagra, in Boeotia, dedicated to Hermes Kriophoros (Hermes the Ram-Bearer): here the prize for the lad displaying the most beauty (*kallisteia*) was to carry a ram around the city in Hermes' honour.

Further evidence for male beauty cults – and they were staged as votive events, on the assumption that a beautiful mortal is pleasing in the eyes of the gods – comes from inscriptions found in Hellenistic gymnasia. These inscriptions allude to a range of contests accommodating not only the overtly beautiful, but also those who tried hard in that direction. So one challenge, the *philoponia*, or 'love of training', evidently rewarded diligent attendance at gymnasium workouts. Another, the *euexia* ('good form') was a pure test of body-building, with marks awarded for bodily 'tone', definition and symmetry. Yet another, the *eutaxia* ('good discipline'), stressed proficiency at military drills.

Further circumstances of these contests and the appraisal of *euandria* need sketching. Pederasty prevailed at Athens and other Greek states in a regular fashion: that is, shaped by its own protocols, the courtship of younger men by their elders was perfectly lawful, even expected. And so far as it concerns the art historian, Greek pederasty is important because it encouraged the appreciation of male physical beauty. The Classical Athenian writer and soldier Xenophon, in the opening passages of his *Symposium*, describes how one youthful victor at the Panathenaic Games is sought after by an older admirer who requests (and is granted) paternal permission for a party in the boy's honour. On the entrance of the favoured guest, all present fall speechless as they gaze upon his athletic radiance. But it is clear from Xenophon and other accounts – notably Plato's *Symposium* – that beauty implied more than erotic charisma. *Kalos kai agathos*,

'beautiful and good', was the phrase that amounted to an equation; *kalokagathia*, 'beautiful goodness', a philosophical principle that gained currency in the world of Socrates and his followers – even if, notoriously, Socrates himself presented an exception to that principle (see p. 250).

This was a credo with aristocratic, indeed epic, pedigree. We find it voiced, implicitly, by Homer's description of the demagogue Thersites, who makes a brief but memorable appearance in the *Iliad* to protest at the conduct of the war. Limping, hunched, narrow-shouldered, scrubbily bearded and 'pointy-headed' (*oxykephalos*), Thersites is damned before he opens his mouth. No matter that – to the modern reader, at least – what he says makes some sense; Thersites must be, to judge by his physique, an ignoble coward. Railing against the high-born men who have (for the sake of a beautiful woman) brought the Greeks to fight at Troy, Thersites acts as befits his deformity. The response from his betters, in particular Odysseus, is to give him the beating he deserves (*Il.* 2.211–69).

Greek mythology supports this culture of male, morally invested beauty with

stories such as that of Adonis, rewarded for an act of kindness to Aphrodite with eternal youth and endless erotic adoration. The shepherd-prince Ganymede, plucked from Trojan hillsides by Zeus on account of his lithe desirability, similarly proves that the gods share human tastes in beauty (Figure 2.13). Then, of course, the Judgement of Paris made a prototype for female beauty parades – and in due time the controversial sculptural 'revelation' of the female nude would owe something to its mythical frame (see Chapter 8).

Figure 2.13 *Terracotta group of Zeus and Ganymede, from Olympia, c. 470 BC. Ht 1.1 m. Attributed to Corinthian sculptors, this seems to have been placed as an akrôtêrion at the apex of a small temple or treasury (it was found piecemeal in the stadium embankment). Ganymede holds a cockerel – the traditional offering from an older man to his boy-favourite; Zeus the knotty staff of a traveller – as if he has been roaming the hills in search of this youth.*

The importance of the ideal of *kalokagathia* will recur in this book (e.g. p. 132); here, it must help us to understand the process whereby sculptors arrived, at around the middle of the fifth century, at what was to become recognized as the 'classic' Greek male nude. This became a model so often 'quoted', borrowed or alluded to that its original importance may be hard to fathom. Basically, however, it is an athletic figure – and as such, not merely owed to a culture of training 'unclothed' (*gymnos*) in civic gymnasia, but related no less to the heroization of prize-winning athletes.

The custom of commemorating successful athletes with statues is discussed later (see p. 101). We may restrict ourselves here to considering how social history – the *euandria* contests, the prestige of athletic victory, plus the loading of a bodily type with the significance of moral and civic virtue – affects the aesthetics of Classical sculpture. It is easy enough to suppose that a 'gymnastic culture' among the patrons of statuary is reflected in images of trained, powerful youths: in Kenneth Clark's words, 'no wonder that [the male body] has never again been looked at with such a keen sense of its qualities, its proportion, symmetry, elasticity and aplomb'. And there is some evidence that Greek athletes and their trainers, by the fifth century, had developed programmes of exercise and diet favouring just such qualities ('proportion, symmetry, elasticity and aplomb' could be a checklist of targets for young men enrolling as followers of Pythagoras – who, beyond his genius for philosophy and mathematics, may also have been a successful coach to Olympic contenders).

But is the Classical male nude – as sculptors fashioned it – actually 'true to life'? In the second half of the nineteenth century, a circus strongman taking the name of Eugen Sandow applied himself to emulating 'the Grecian ideal' in developing a muscular physique – so launching the modern recreation of 'bodybuilding'. But looking at photographs of Sandow, or sampling any of the monthly magazines that parade the mighty hulks of our own time, one has to admit a lack of true similarity. A modern athlete may pose like a Classical statue and display an impressive shape: but it is not the same effect. And there is a fundamental reason why it never can be: because if we examine the Classical nude with a view to the laws of human anatomy, we become aware that this is a work of art – not nature.

Two original creations from the fifth century, the so-called Riace Bronzes, illustrate this point very well (Plates IIa, b; Figure 7.3); but it is evident enough from any median piece of 'gymnasium-statuary' belonging to the Roman world (Figure 2.14). Such sculptures were routinely set up in places where citizens of the Roman empire bathed or took exercise: these figures were, we may suppose, predictable advertisements for the principle summarized in the tag 'a healthy mind in a healthy body' (*mens sana in corpore sano*: Juvenal, *Sat.* 10.356). Front on, there is

Figure 2.14 *Polykleitan torso of the early first century AD, presumed after a fifth-century BC bronze statue of Herakles by Polykleitos (Pliny, NH 34.56). Ht 1.05 m. The figure evidently had one hand behind his back (cf. Figure 12.7) and was possibly resting on a club.*

the obligatory neatness of abdominal muscles arranged in six compartments and the distinctive ridge between midriff and thighs customarily referred to (at least by non-specialists in anatomy) as the 'iliac crest'. With determination, these are achievable features. Viewed from sideways and behind, however, the body becomes impossible. The iliac crest comes to a rise above the hips – and is then extended around the base of the back. The spinal cord makes a pronounced 'S' curve, descending by an unbroken groove into the cleft of the buttocks. The effect is one of symmetry, as if bisecting the body horizontally and vertically; but this is not how the human body is actually designed (for a start, we need a pad at the base of the spine to protect the bony structure of the coccyx).

Statues like the Riace Bronzes may be what Plato intended when he gave his blessing to 'images of excellence' (*eidôla aretês*: *Rep.* 600e4). What we witness here is an overriding of the principle of naturalism. Given that the Greek Revolution is sometimes presented as a triumph of naturalism, this is an important qualification to make. Archaic sculptors of *kouroi* may be imagined as marching on a course of steadily increasing anatomical accuracy. But by the mid fifth century, it seems, such accuracy is no longer a paramount concern. One sculptor's name in particular is associated with this shift in priorities: Polykleitos, who, in the appraisal of one Roman writer, went 'beyond reality' (*supra verum*: Quintilian, *Inst. Or.* 12.10.8).

No original work by Polykleitos survives. His reputation, nevertheless, is formidable – largely because his work, much admired by the Romans, generated stories about its creation. It is a Graeco-Roman writer, Aelian, who tells us about how Polykleitos once made, simultaneously, two statues of the same subject.

One of these was executed secretly, according to the sculptor's own rules; the other was done in public view, inviting comments and suggested improvements from visitors to the studio. When both statues were exhibited, the one that the public preferred was the statue Polykleitos had made in keeping with his rules (*VH* 14.8). A principled artist, this Polykleitos. But do we know what his principles were?

Our best snippet of information about Polykleitos, and it is no more than that, comes from Galen (physician to emperor Marcus Aurelius, in the late second century AD). Galen is in the course of explaining certain doctrines of a late third-century BC Stoic philosopher, Chrysippos:

Chrysippos … holds that beauty does not consist in the elements [by 'elements' are understood the properties hot, cold, dry, moist] of the body, but in the harmonious proportion of the parts – the proportion of one finger to another, of all the fingers to the rest of the hand, of the rest of the hand to the wrist, and of these to the forearm, and of the forearm to the whole arm, and, in short, of everything to everything else, just as described in the Canon *of Polykleitos. Polykleitos it was who demonstrated these proportions with a work of art, by making a statue according to his treatise, and calling it by the same title, the Canon.*

GALEN, *DE PLAC. HIPPOCRATIS ET PLATONIS* 5.448

So the reputation of Polykleitos rested not only upon his statues – but also on a written testimony of his technical aims and methods. The text itself has not come down to us: we surmise from Galen's reference that its basic tenet was one of continuity, with each section of the body relaying a fraction of itself to the next section, hence an accumulation summarized as 'and everything to everything' (*kai panton pros panta*). Unfortunately, though, we can do little to reconstruct in detail the ratios that Polykleitos specified in his treatise. One problem is that we do not know where to start – having no equivalent to the reference point that land surveyors rely upon to fix levels – but beyond this is the likely absence of anything that could correspond to a meticulous 'copy'. '*A well-made work is the result of numerous calculations, carried to within a hair's breadth.*' '*The work is trickiest when the clay is on the nail.*' These supposed citations from the *Canon* of Polykleitos indicate an extraordinarily fastidious degree of mensuration, even at the stage of making a clay model (so we are to imagine, it seems, the sculptor scraping with his fingernail). Renditions of 'Poly-kleitan' figures in Roman times are unlikely to have shared that obsession.

Because of its presumed precision, the aim of the *Canon* of Polykleitos has often been explained in terms of mathematical elegance. Some scholars perceive the influence of the Pythagoreans, who 'supposed the elements of numbers to be the elements of things' (Aristotle, *Met.* 985b) and proportion to be 'the bond of mathematics'. (The same influence has also been invoked for the spread of

THE DORYPHOROS OF POLYKLEITOS

Polykleitos not only worked for his home city of Argos (where he is said to have created a colossal cult statue for the temple of Hera), but also undertook commissions to represent victorious athletes at Olympia (see p. 104) and himself triumphed in an inter-artistic contest staged for the Artemision at Ephesus. His fame, however, rests principally with the Doryphoros, or 'Spear-carrier': an image of 'manliness' that from its first appearance (*c.* 440 BC) has left a powerful imprint upon our collective ideal of what constitutes the desirable male physique.

We do not possess the original Doryphoros, which was almost certainly cast in bronze. Nor can we be entirely sure that the sculptural type known (by some seventy-odd surviving 'copies') as the Doryphoros accurately represents the skill of Polykleitos, whose name (meaning 'well-known', or 'far-famed') was associated by ancient writers with extraordinary technical finesse (*akribeia*). It was only in 1863 that a marble statue in Naples Museum, probably excavated at Pompeii, was given the identity of being the sort of spear-bearing nude young male figure that Romans liked to install in their gymnasium-buildings or suchlike (Pliny, *NH* 34.18). Various Roman testimonies can then be combined to suggest that this generic figure, sometimes given the title of 'Achilles', was also the embodiment of the mathematical principles set down by Polykleitos in his *Canon* (Figure 2.15).

The overall message of the *Canon*, as reported to us by assorted ancient citations, puts emphasis upon careful calculations; unfortunately, the exact method of calculation practised by Polykleitos remains obscure, since although we can isolate 'good' and 'bad' versions of the Doryphoros, no two 'copies' are identical. Polykleitos did train a school of followers – including one son who took the same name – and these disciples were said to have obeyed their master's system 'as if by law'; yet the formulaic rules remain secret. Nonetheless, it is possible to recognize from the Doryphoros-type a meaningful 'Polykleitan' style. In Classical parlance, the Doryphoros presents a figure that is distinctly 'four-square' (*quadratus* in Latin; *tetragonos* in Greek). Partly this is due to sheer solidity of physique; but it is also an effect created by the stance, which sets up an equilibrium of opposing 'moments'. So, as the left leg relaxes, the right hip tilts, in turn requiring the left shoulder to rise. It is as if a series of rods has been passed through the body, each causing a shift in balance that must be countered. Technically this may be referred to as 'chiastic' – from the Greek *chiasmos*, implying diagonal tension – or, in Italian, as *contrapposto*, a matching of physical forces in human gait and posture.

Are we any the wiser about the subject of the statue? Not really: despite its nudity, the figure is not obviously that of an athletic victor – one minor but important detail is that the left hand must hold the sort of substantial spear deployed in war, not the slender and aerodynamic javelin reserved as an event of the pentathlon. Yet evidently it does not represent someone ready for the battlefield. The over-lifesize scale may suggest a hero, so 'Achilles' remains an obvious candidate.

Figure 2.15 *The Doryphoros: marble figure after a bronze original by Polykleitos, c. 440 BC. Ht 2.12 m.*

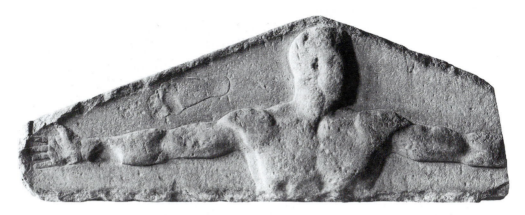

Figure 2.16 *Metrological relief, c. 450 BC, probably from east Greece. Various units of measurement are 'set in stone' here, including the fathom, or span of outstretched arms (if complete, these would equate to 2.08 m. here), the cubit (hand to elbow), the foot and the clenched fist.*

orthogonally gridded Greek town-planning in the fifth century.) A further hypothesis relates the Polykleitan ideal of symmetry to the codification of physiological balance by medics of the Hippocratic school – bound as they were to the quadruple system of bodily 'humours'. Others prefer to see in Polykleitos a Classical Greek answer to the Egyptian canon, which (as Plato recognized) had guaranteed a consonance of figurative representation over several millennia.

Such guesswork about the intellectual affiliations of the *Canon* is misguided. It is true that metrology – the science of weights and measures – became important, not least commercially, to the Greek city-states of the fifth century: special buildings must have been set aside for fixing standards, and the so-called 'metrological relief' in Oxford (Figure 2.16) probably once served as a lintel over the entrance to a room where measures were controlled. The adoption of bodily parts as units of measurement perhaps encouraged sculptors to look for examples of absolute accuracy or 'perfection'. But the description of the Polykleitan *Canon* as 'anthropometric' – based on measurements of the body, not some external matrix – must be qualified by its characterization as 'organic', which means that the method was flexible enough to accommodate female as well as male figures, young as well as old.

Elusive as the *Canon* remains, it is perhaps most plausibly evoked by the art historian Erwin Panofsky, who judged that it worked on the basis of 'organic differentiation', while stressing that it sought, in Galen's words, the definition of what 'constitutes beauty'. As such, it was never like the Egyptian canon, whereby a grid was laid out and the human form mapped onto it according to the positions where eyes, legs, feet and so on *should* be. Instead, Polykleitos started with a figure – a successful athlete, possibly a winner of the *euandria* contest – and tried to work out

how the constituent parts of this body, saluted as 'beautiful', related to each other. In this way, says Panofsky, Classical Greek art 'opposed to the inflexible, mechanical, static and conventional craftsman's code of the Egyptians an elastic, dynamic and aesthetically relevant system of relations'. And as Panofsky further points out, the assumptions on which this organic Greek canon rested were not seriously challenged until the third century AD, when the Neoplatonist theories of Plotinus and others, arguing (for example) that the soul was reflected in the eyes, caused the sort of distortion of Classical norms that became manifest in late antiquity and flourished in the early Medieval age. (Thersites, as a body-type, would have felt at home upon the carved portal of some Romanesque church.)

The logic of anthropomorphism

A Greek poem, composed perhaps in the seventh century BC, describes the following marvellous prehistoric scenario. The god Apollo is at large in the Aegean, seeking new sites for his own worship and new followers to staff those sites. Apollo is protean, capable of assuming many shapes, including zoomorphic: in one guise he is *delfinios*, like a dolphin, and as such he leads a vessel of mariners from Knossos in Crete to one of his chosen sites. The god first stages an epiphany in the sanctuary, 'amidst the priceless tripods'; then, 'swift as a thought', he shows himself to the crew. The guise he chooses here is anthropomorphic: 'in the form of a man, quick and well-built, in the full bloom of youth, his hair flowing over his shoulders'. He hails the sailors. They are not sure how to respond to this stranger: for all that he is fine and manly, he also bears a resemblance 'to one of the deathless gods'. They settle for nervous badinage; eventually Apollo declares his divine identity and issues appropriate instructions for his cult.

This episode – from the *Homeric Hymn to Pythian Apollo* (lines 388ff.) – is loaded with art-historical significance. Its evocation of Apollo as a young man, long-haired and athletic, has often been cited with regard to the appearance of those Archaic statues known as *kouroi* ('young men': see p. 130). Attention is less often drawn to the peculiar nature of Greek anthropomorphism revealed by this poetic incident. Apollo chooses to appear to the Cretan sailors as a *kouros*, seeming to share in their species, their *ethnos* and their language – yet they perceive from his frame (*demas*) and his stature (*phyê*) that he is more immortal than mortal. We have, then, something of a paradox: a deity who adopts human form, yet reserves a measure of divinity. This may be an example – to use the peculiar idiom – of 'having your cake and eating it'. In terms of art theory, it is naturalism and idealization both at the same time. The consequences of such a juncture add another aspect to our discussion of the Greek Revolution.

The worship of images is outlawed by the codes of several world religions. It is clear that the Greeks, by contrast, deemed the *absence* of images in worship as very peculiar. Herodotus, the fifth-century traveller and historian whose writings convey curiosity and tolerance towards non-Greek practice, noted that the Persians conducted their rituals in an open landscape, worshipping without the paraphernalia of altars, statuary or temples. They do so, he suggests, because 'they do not believe the gods to share the same nature with men, as we Greeks imagine' (1.131). Later Classical writers were less gentle, condemning iconophobic cultures as uncivilized. It required intelligence (they claimed) for the gods to be figured. And skill, too: for, in the words of one philosopher of the second century AD, Maximus of Tyre, 'the Greek manner of honouring the gods recruits whatever is most beautiful on earth [*en gê tois kallistois*], whether in terms of raw materials, human shape [*morphê de anthropinê*] or artistic precision [*technê de akribei*]' (*Orations* 2.3). *Akribeia* – finesse, precision, skill – is a virtue often ascribed to Greek sculptors in the records of literary approbation; and the artistic employment of precious substances, such as gold, amber and ivory, which made some cult statues into treasuries, is a rationalization of the 'extravagance' that would in turn disgust the Christian inheritors of Greek sanctuary sites. But the most interesting clause of this statement by Maximus concerns human shape. The most beautiful human bodies, he is saying, are characteristic of the divine. So it was natural to think of divine bodies making anthropomorphic appearances ('epiphanies').

Before we address the impact of this tenet upon the making of statues, it is as well to mention an oft-quoted and perhaps over-estimated 'in-house' objection to Greek anthropomorphism. It comes from a late sixth-century BC poet-philosopher called Xenophanes, who evidently disapproved of the way in which Homer and others had humanized the gods in bodies, clothes and speech (and hence motivation). Xenophanes takes a relativistic stance: the Ethiopians, he points out, say that their gods are black and snub-nosed; the Thracians, that theirs are blue-eyed and red-haired. 'If horses could draw,' he goes on, 'would their gods not be horsey?' And lions have lion-gods, and oxen ox-gods?

Combined with the fragmentary utterances of another Archaic sceptic, the Ionian philosopher Herakleitos (to the effect that praying before a statue is as efficacious as praying to a brick wall), this critique by Xenophanes has been taken – ever since it was preserved for us by an approving early Christian iconoclast, Clement of Alexandria – as a record of generic intellectual doubt concerning anthropomorphism; moreover, as suggesting that the production of cult images only satisfied a popular need. But it is unlikely that Xenophanes represents anything more than an eccentric voice of dissent. As far as we can judge, the general reaction to his protest would have been that the deities of other peoples were not the inhabitants of Mount Olympus, considered by the Greeks to be all-

powerful; as for the idea of horses and other animals either worshipping or making art, the point is that they cannot: both are essentially human activities.

Herodotus may be considered to confirm a widespread Greek faith in the civilized nature of anthropomorphism, simply by the astonishment, or at least polite bafflement (2.65), he registers at the Egyptian tradition of worshipping cats and deities with the heads of dogs or cows. The Egyptian extension of anthropomorphism into zoomorphism is, for Herodotus, almost as odd as the Persians having no images at all. Thus it is a feature of Greek self-definition, this manner of visualizing the gods; and because Greek religion is also polytheistic, it becomes a matter of importance to all those frequenting Greek sanctuaries to distinguish one deity from another. It was possible for a cult statue to be 'aniconic' – without human or animal form – but if that were so, then special guidance was necessary. Pausanias tells of some fishermen from Methymna on Lesbos who caught a mask-like piece of olive-wood in their nets: 'the features had something divine about them, yet they were foreign, not the usual features of the Greek gods' – so oracular advice was taken at Delphi, where the find was pronounced an image of the god Dionysos, to be venerated accordingly (10.19.2).

The Greeks had various words to denote a statue: among them is the term *baetylia*, which implies a non-figurative object of cult – such as the large pointed stone worshipped (into Roman times) at Aphrodite's sanctuary at Paphos on Cyprus. We might be tempted to assume that such objects became redundant, or outmoded, as the figurative identities of the gods took shape and became increasingly naturalistic, but this does not seem to have been the case. Certain terms, notably *xoanon* and *bretas*, were reserved for the protohistoric phase of this figurative development, and many statues so categorized were still to be seen in Greek sanctuaries when Pausanias made his tour in the second century AD. Sometimes attributed to the mythical person of Daedalus, these 'antiques' were recognized as technically immature. 'If Daedalus were around now, and producing those old-style statues of his, everyone would laugh at him', observes Socrates in Plato's *Hippias Major* (282a). But age, as we shall see, was not necessarily detrimental; and a deity was not restricted to any one style or moment of epiphany. The creation of a gleaming and colossal statue of Athena Parthenos ('Maiden') for a new temple on the Akropolis (subsequently known as 'the Parthenon') did not render outmoded a much older, smaller and more simple effigy of olive-wood, the so-called Athena Polias ('of the city'). This probably Daedalic statue (see p. 57), safeguarded when the Akropolis was occupied and sacked by the Persians in 480 BC, was eventually housed in the shrine known as the Erechtheum; for ritual purposes, its presence continued to dominate the Akropolis, despite the splendour of the Parthenos and the earlier dedication of a bronze Athena 'Promachos' – 'Frontline-fighter' – funded by spoils from the Persians, and so prominent that the

figure's helmet could be seen from several miles away by sailors approaching the port of Athens, the Piraeus.

The most common Greek word for 'statue' is *agalma*, which in the lexicon carries the connotation of 'something that brings joy' – so, in the statue of a deity, joy to that deity represented, and joy also to any mortal viewer (this may be why so many Archaic statues wear a permanent smile). *Agalmata* (pl.) were perhaps originally understood as being images of deities. And these did not have to be huge. Herodotus uses the word *kolossos* for massive images he saw in Egypt, but the word did not have a germane sense of massive dimensions: in early usage, *kolossos* seems only to have implied a 'double' or simulacrum of some person or divine being.

Idruma, less commonly used than *agalma*, entails an object 'set up' or 'dedicated' – so the verb *idrusasthai* can mean 'to erect a statue' – and *aphidruma* seems to refer to a divine image that derives from or replicates a more important statue at another sanctuary: the Olympic Zeus, for example, served as a model for statues at several other sites. *Andrias*, with overtones of 'manliness', was usually reserved for statues of mortals rather than gods – and was especially suitable for portraits – so, as *agalmata* may strictly belong to sacred places, *andriantes* may pertain rather to civic settings.

A 'progressive' view of Greek anthropomorphism, whereby the aniconic *baetylia* and rough-hewn or totemistic *xoana* evolve into more 'naturalistic' images of deities, seems untenable. It is also hard to establish a checklist of terms with which the Greeks distinguished different types among the forest of statues surrounding them. Epigraphical evidence from Aphrodisias in Asia Minor, for example, reveals a Hellenistic or Graeco-Roman populace happy to trade all sorts of words around the concept of public 'images' (*eikones*). What does this tell us?

If the system of statue-categories was never consistent, it was all the more essential that deities in sculpture were given 'personal' attributes – signals of identity that facilitated recognition and encouraged appropriate salutation from their viewers. The identity might be local and parochial, or else Panhellenic; in any case, as we shall see, the logic of anthropomorphism permitted a divine identity to develop and change. Chapter 8 addresses the image of Aphrodite, whose appearance as a 'nude' in the fourth century seems at first to have shocked, and then delighted, the Greeks who worshipped her. But the sacrosanct nature of divine representation also allowed what some might regard as a lacuna in the Greek Revolution. That is, as mentioned, images perceived as 'old-fashioned' or 'unnaturalistic' were not discarded on that account. Apollo, for example, may eventually become the slight youth known as the Apollo Belvedere (see Figure

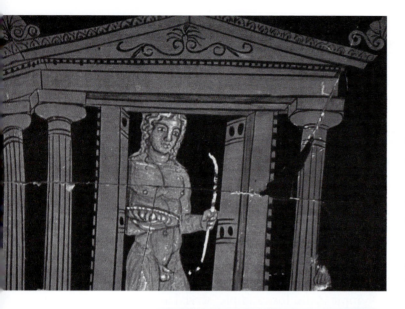

Figure 2.17 *Apollo in his temple: detail of an Apulian krater, fourth century BC.*

12.3); equally he may conserve the aspect of the long-haired, broad-shouldered athlete as described in the *Homeric Hymn* (Figures 2.17 and 2.18).

Roman patrons of Greek sculpture appreciated the charm of *vetustas* – understood as 'the state of belonging to a remote time; archaic quality' – and commissioned numerous 'period pieces' of pseudo-sacrosanct statuary for their gardens.

Despite eventual pressure from Judaeo-Christian critics, there is no doubt that statues throughout Classical antiquity enjoyed sustained respect as vehicles of the divine. There is plenty of evidence from Greek sites in the Roman world that sacred statues, whether old-fashioned or stylistically up-to-date, maintained their status as more than representations. A passage from a Graeco-Roman author denoted as 'Pseudo-Lucian', probably writing in the third century AD, may illustrate what anthropomorphism might entail in terms of cult practice – and spectacle. Our author is describing an eastern variant of the Apollo cult, noting that in one temple of Apollo there is a statue of a bearded Apollo – unusual in presenting the god as a mature man, and unusual in other respects too:

About his deeds I could say a great deal, but I will describe only what is especially remarkable. I will first mention the oracle. There are many oracles among the Greeks, many among the Egyptians, some in Libya and many in Asia. None of the others, however, speaks without priests or prophets. This god takes the initiative himself and completes the oracle of his own accord. This is his method. Whenever he wishes to deliver an oracle, he first moves on his throne, and then priests immediately lift him up. If they do not lift him, he begins to sweat and moves still more. When they put him on their shoulders and carry him, he leads them in every direction as he spins around and leaps from one place to another. Finally the chief priest meets him face to face and asks him about all sorts of things. If the god does not want something done, he moves backwards. If he approves of something, like a charioteer he leads forward those who are carrying him. In this manner they may collect the divine utterances, and without this ritual they conduct no religious or personal business. The god also speaks of the year and of all its seasons, even when they do not ask …

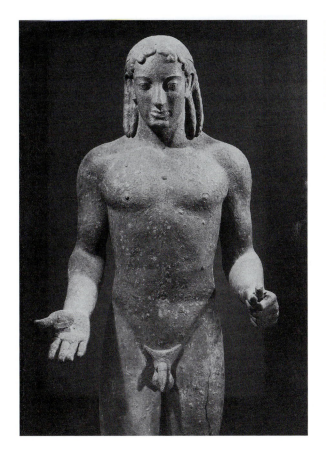

Figure 2.18 *The Piraeus Apollo: bronze statue of perhaps the second century BC, but fashioned as if made in the late sixth century. Ht 1.92 m. As in the previous image, the god carried a bow and with his right hand held a shallow bowl (phialê) for libations.*

I will tell of something else which he did while I was present. The priests were lifting him up and beginning to carry him, but he left them below on the ground and went off alone into the air.

PSEUDO-LUCIAN, *DE DEA SYRIA* 36–7

To the modern cynic, this will seem like priestly manipulation of gullible pilgrims at Greek sanctuaries. And undoubtedly some trickery went on. In Copenhagen there is a bust of the philosopher Epicurus which has a special duct leading to the mouth from the back of the head. Experiments with tubes and funnels have demonstrated that the statue can thus be made to 'speak' by a concealed ventriloquist – and so (presumably) cajole some credulous supplicant into accepting an oracle or other piece of expensive advice. This is an example from later antiquity, but we suppose that there was a history to such devices, from the numerous testimonies of statues moving, sweating, bleeding and weeping.

At the Spartan temple of Artemis Orthia a notorious ritual took place: boys submitted themselves to public flogging on a competitive basis, to see who could hold out the longest and so become the 'altar-winner' (*bômonikos*). Ancient in its origins, the ritual eventually became a tourist attraction in Roman times, and a theatre was built around the altar to accommodate spectators. Pausanias, when he witnessed the event (3.16.7–11), noted that the priestess supervising the whippings held an archaic image (*xoanon*) of Artemis. If the thrashing weakened, the image 'drooped' – a signal for the tempo and effort of the flogger to be stepped up. What is interesting here is how a statue (or statuette, in this case) is deemed to be an agent: Artemis registers, she *feels*, what is going on in her precincts and preserves her reputed taste for the spilling of blood.

'Some of the gods whom we honour we see clearly, but of others we set up statues as images, and we believe that when we worship these, lifeless [*apsychous*] though they

be, the living gods [*empsychous theous*] beyond feel great goodwill towards us and gratitude.' So Plato struggled to account for the image-making machinery of Greek cults (*Laws* 931a). Commentators assume that by 'gods … we see clearly' he means the stars; but how can we clarify the rapport he postulates between 'lifeless' statues and 'living gods beyond'? Most Greek worshippers must have preferred to accept what their own language implied: that a statue served as the 'seat' (*hedos*) of a deity, and the temple it stood in could properly be regarded as the god's home or *oikos*. (No matter, incidentally, that a god could have more than one image and more than one home: being ubiquitous is a sign of divinity in Greek eyes.)

When Graeco-Roman travellers visited Egyptian Thebes (modern Luxor), they paid special homage to the so-called 'Colossi of Memnon' because the two enthroned figures were heard to 'speak'. Modern guidebooks explain this phenomenon as a sibilance emitted by a crack in one of the figures as the stone heated up in the morning. In ancient times this was said to be the voice of the Abyssinian Memnon, slain at Troy, enjoining his mother Eos (Dawn) to staunch her tears (the dew). Such are the poetics of animated statues. Pindar (*Paean* 8) describes a fantastic bronze temple of Apollo at Delphi, with a frontage containing six Sirens or 'enchantresses'. These figures, he says, were capable of singing. And, still within the realms of literary fantasy, Homer imagines the smith-god Hephaistos making dogs and lions from gold, silver and bronze, and giving them 'breath' (*psyche*), so that they could serve as effective guardians – for the palace of King Alcinous, for example (*Od.* 7.91–2).

We could dismiss these as travellers' tales and poets' dreams – were it not for the further evidence regarding the attribution to statues of power to monitor, approve or punish human behaviour; and the power, moreover, to act in some protective mode on behalf of supplicants. Greek art and literature yield numerous examples of such faith. The image of Cassandra clutching at a statue during the fall of Troy (Figure 2.19) is a recurrent vignette on Greek vases, and Aeschylus, in his *Seven Against Thebes*, dramatizes the effort made by the Theban women to save their city by appealing to the 'regiment' (*strateuma*) of the city's 'old statues' (*archaia brete*). It is true that in this particular play, the account of the women's action is flavoured with misogyny – trust the likes of womankind, complains the king of Thebes, to suggest such a futile recourse – but there seems to have been a general belief that 'cult images' were talismans, both protective and to be protected. In the tale of Troy's destruction an important turning-point comes when Odysseus and Diomedes abduct the so-called 'Palladium' – the time-honoured figure of Athena that guarantees Troy's safety (*Aen.* 2.162–79); historically, we may compare the evacuation of the Athena Polias statue from Athens to Salamis in 480 BC, when the Persians invaded Attica.

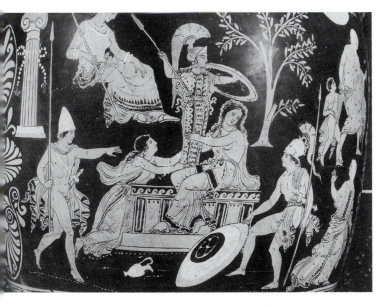

Figure 2.19 *Detail of an Apulian volute-krater by the Iliupersis Painter, c. 380–370 BC. As Troy falls, Cassandra and other Trojan women seek refuge by a statue of Athena. There are narrative reasons why refuge fails, but we may note that the male attackers are not deterred by a statue – even an armed statue.*

Greek religion was generally reciprocal in its function. Before the statue of a deity, offerings were made and prayers were said; some divine goodwill was expected in return. How could such a bargain be maintained unless the statue had eyes and ears and was receptive to the many vanities of human wishes? So statues of the gods should be made as if capable of sensory perception. But at the same time this *desideratum* generates some odd consequences. The story of the young man who falls in love with a statue of Aphrodite is notorious, and is discussed elsewhere (p. 207); yet such behaviour, while regarded as bizarre or 'unnatural' (*para phusin*), was apparently not otherwise unknown. We are told about one pilgrim to Delphi who, having removed a statue from its base and spent the night with it, was not reprimanded.

He was merely requested to leave behind a wreath 'as the price of intercourse'; and Apollo expresses satisfaction through his oracle (Ath. 606). Why indeed should the priesthood object, since it is in their interest to encourage belief in the animated, responsive powers of cult images?

And so we apprehend the potential effect of this belief upon responses to images at large: that the primary and popular Greek criterion for judging the worth of a statue becomes '*How far is it lifelike?*'

One could quote instances of this criterion in literature and inscriptions *ad nauseam*. Here is a sample of the poetic plaudits attached to a statue of a heifer made in the fifth century by Myron (of Discobolus fame: see p. 103), as recorded in *The Greek Anthology*:

I am Myron's little heifer, set up on a base. Goad me, herdsman, and drive me off to the herd.
A calf died beside thy heifer, Myron, thinking that the bronze had milk inside.
In vain, bull, thou rushest up to this heifer, for it is lifeless. The sculptor of cows, Myron, deceived thee.

The lead and stone hold me fast, but otherwise, thanks to thee, sculptor Myron, I would be nibbling lotus and rushes.

The statue is lost, and none of its many epigrammatic compliments does much to help us visualize its actual appearance (or its original commission); they only give voice to its *effect*. Such dramatization is typical of Hellenistic literary wit, even when parodying popular appreciation of images – *Idyll* 15 of Theocritus, for example, or the fourth *Mime* of Herodas – and we may wonder if a sophisticated intellectual audience were supposed to laugh at such naivety. Yet Ptolemaic Alexandria, home of the learned poets, was also the place where great processions were staged, involving complex *tableaux* of 'animated' myths and divinities – for example, an enormous figure of Nysa, the nurse of Dionysos, designed to rise automatically, pour a libation of milk, then sit down again (*cf.* p. 231). How can we judge what the creators and spectators of these events 'believed' was happening here?

The ancient literary testimonies about the utility of images to assist in realizing a faith in supernatural forces are manifold. But the archaeological and historical contexts are enough to suggest that a particular 'aura' or 'appeal' of such images largely consisted in the acceptance of true *representation* – or even *presentation*. For the sculptor working to religious commissions was perceived as an essentially vicarious agent: through him came glimpses, even revelations, of the divine.

Conclusion: 'Pygmalion's power'

Our search for the causes of dynamic stylistic change in Greek sculpture has explored the traditional explanations and also advanced along routes of explanation less frequently taken. It is time to attempt a conclusion.

Gombrich described the enterprise of the sculptors of the Greek Revolution as a display of 'Pygmalion's power'. What sort of power is this? The story of Pygmalion is best known from its rendition by the Roman poet Ovid (*Met.* 10.243–97), where Pygmalion is introduced as a Cypriot sculptor (in other versions he is a king of Cyprus). This Pygmalion is a bachelor, confirmed in his view that no living woman is good enough for him. So he makes an ivory statue of the most beautiful woman he can imagine and begins to treat this idol as his darling – whispering fond messages to it, bringing gifts, dressing it up with fine clothes and jewels, placing it tenderly upon a couch. Then, on the occasion of a festival of Aphrodite, Pygmalion prays that his ivory doll may become his bride. The goddess signals approval: and gives Ovid the opportunity to describe a sensuous metamorphosis, as Pygmalion kisses and caresses a form that turns

gradually to warm flesh. Nine months later a daughter, Paphos, will be born to the couple. The idol, the ideal, has been realized; art has 'come alive'.

A fantasy: yet 'Pygmalion's power' is as good as any other way of encapsulating the determination of Greek sculptors to reconcile the ideal with the natural; and, ultimately, this is what explains the Greek Revolution. Its prime motivation was what we would call 'religious' – and that remains a general motivation, since religious activity in ancient Greece can scarcely be distinguished from the everyday strategies of social, political and even economic business. As we have seen, aesthetics, politics, social history and modes of storytelling – all these were contributing or supplementary factors. Yet if one had to identify the underlying basis for the stylistic dynamism of Greek sculpture, it must be the conviction that the divine and the supernatural are not beyond human imagination to visualize. If there was such a horse that gave traction to the Moon, that beast must be both extraordinary – and yet a horse. Images of greater things made them part of the facts of the world: in this sense, we can say that Greek sculptors regarded nothing as beyond their scope.

Sources and further reading

The quotation from Philip Hunt comes from a *Memorandum on the Subject of the Earl of Elgin's Pursuits in Greece* (2nd edn, London 1815), 16. Goethe's denomination of the *Urpferd* relates to an essay written *c.* 1823, and the phrase cited here comes from vol. XXXVI (*Zur Morphologie*, ed. W. Wasielewski) of *Goethes Werke* (Berlin-Leipzig n.d.), 286. For the original text of the passage quoted from Eckermann, see J.P. Eckermann, *Gespräche mit Goethe* (Basel 1945), vol. I. 278. The phrase from Ernst Buschor is the opening line of his *Pferde des Pheidias* (Munich 1948). Geometric horses: J.-L. Zimmermann, *Les chevaux de bronze dans l'art géométrique grec* (Mainz-Geneva 1989).

'Greek Miracle' W. Deonna, *Du miracle grec au miracle chrétien* (Basle 1945–8); cf. *Ant. Class.* 6 (1937), 181–230; and D. Buitron-Oliver ed., *The Greek Miracle* (New York 1993).

'Discovery of nature' E. Loewy, *The Rendering of Nature in Early Greek Art* (London 1907).

Kritian Boy Quotation from H. Payne, *Archaic Marble Sculpture from the Acropolis* (London 1936), 45. See J.M. Hurwit, 'The Kritios Boy: Discovery, Reconstruction, and Date', *AJA* 93 (1989), 41–80.

Egyptian Canon Quotation from W. Davis, *The Canonical Tradition in Ancient Egyptian Art* (Cambridge 1989), 220. See also H. Schäfer, *Principles of Egyptian Art* (Oxford 1974) and G. Robins, *Proportion and Style in Ancient Egyptian Art* (London 1994).

Greek sculptors in Persia J. Boardman, *The Diffusion of Classical Art in Antiquity* (London 1994), 28–39.

Narrative This topic has an extensive literature, at least since the fundamental study of Carl Robert, *Bild und Lied* (Berlin 1881): discussion and further reading in M. Stansbury-

O'Donnell, *Pictorial Narrative in Ancient Greek Art* (Cambridge 1999). On 'reading' the Olympia pediments, see J.M. Barringer, *Art, Myth, and Ritual in Classical Greece* (Cambridge 2008), 8–58; also H. Westervelt, 'Herakles at Olympia: The Sculptural Program of the Temple of Zeus', in P. Schultz and R. von den Hoff eds., *Structure, Image, Ornament* (Oxford 2009), 133–52.

Cult of beauty Various essays on the *euandria* etc. by N.B. Crowther collected in his *Athletika* (Hildesheim 2004), 333–50. See also D.G. Kyle, 'The Panathenaic Games: Sacred and Civic Athletics', in J. Neils ed., *Goddess and Polis* (Princeton 1992), 77–101; T. Scanlon, *Eros and Greek Athletics* (Oxford 2002); and I. Weiler, 'Der griechische Athlet', in M. Krüger ed., *Menschenbilder im Sport* (Schorndorf 2003), 51–83. On the philosophy of beauty: E. Grassi, *Die Theorie des Schönen in der Antike* (Cologne 1962).

Polykleitos and the *Canon* Further to A.H. Borbein's summary essay on Polykleitos in O. Palagia and J.J. Pollitt eds., *Personal Styles in Greek Sculpture* (Cambridge 1996), 66–90, see the comprehensive collection of essays in W.G. Moon ed., *Polykleitos, the Doryphoros, and Tradition* (Wisconsin 1995). Also: A.F. Stewart, 'The Canon of Polykleitos: A Question of Evidence', *JHS* 98 (1978), 122–31; and E. Panofsky, *Meaning in the Visual Arts* (Harmondsworth 1970), Ch. 2. On the School of Polykleitos, see D. Arnold, *Die Polykletnachfolge* (Berlin 1969) – plus A. Linfert in H. Beck, P. C. Bol and M. Bückling eds., *Polyklet: Der Bildhauer der griechischen Klassik* (Mainz 1990), 240–97. The creative flexibility of Roman 'copying' is made clear by M. Marvin, 'Roman Sculptural Reproductions or Polykleitos: The Sequel', in A. Hughes and E. Ranfft eds., *Sculpture and its Reproductions* (London 1997), 7–28.

Measuring relief E. Fernie, 'The Greek Metrological Relief in Oxford', *Antiquaries Journal* 61 (1981), 255–63.

The logic of anthropomorphism Several of the issues mentioned here are discussed more thoroughly in D.T. Steiner, *Images in Mind: Statues in Archaic and Classical Greek Literature and Thought* (Princeton 2001). E. Bevan, *Holy Images* (London 1940) makes a good introduction to the subject of 'idolatry'. See also N.J. Spivey, 'Bionic Statues', in A. Powell ed., *The Greek World* (London 1995), 442–59; B. Alroth, 'Changing Modes in the Representation of Cult Images', in R. Hägg ed., *The Archaeology of Cult in the Archaic and Classical Periods* (Athens-Liège 1992), 9–46; A. Schnapp, 'Are Images Animated: The Psychology of Statues in Ancient Greece', in C. Renfrew and E. Zubrow eds., *The Ancient Mind* (Cambridge 1994), 40–4; J. Elsner, *Roman Eyes* (Princeton 2007), 29–48; and V. Platt, *Facing the Gods* (Cambridge 2011). On guardian statues, C. Faraone, *Talismans and Trojan Horses* (Oxford 1992). On the bust of Epicurus (and similar devices), F. Poulsen, 'Talking, Weeping and Bleeding Statues', *Act. Arch.* 16 (1945), 178–95. On depictions of statues on Greek vases, M. De Cesare, *Le statue in immagine* (Rome 1997), and W. Oenbrink, *Das Bild im Bilde* (Frankfurt 1997); one particular Apulian vase in New York (MMA 50.11.4) has generated much discussion, e.g. L. Todisco in *Mélanges d'arch.* 102 (1990), 901–57. Ovid's Pygmalion: J. Elsner, *Roman Eyes*, 113–31.

For further (and more critical) approaches to Gombrich's 'Greek Revolution', see R. Neer, *Style and Politics in Athenian Vase-Painting* (Cambridge 2002); J. Tanner, *The Invention of Art*

History in Ancient Greece (Cambridge 2006), Chs. 2–3; and J. Elsner, 'Reflections on the "Greek Revolution" in Art', in S. Goldhill and R. Osborne eds., *Rethinking Revolutions through Ancient Greece* (Cambridge 2006), 68–95. Richard Neer has also made a substantial case for a shaping aesthetic of 'wonder' in this period: *The Emergence of the Classical Style in Greek Sculpture* (Chicago 2010): reviewed by the present author in the *British Journal of Aesthetics* 52.1 (2012), 107–10.

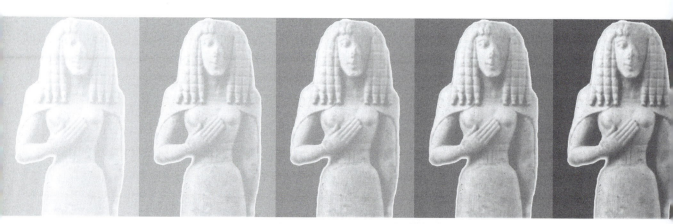

Measurement began our might:
Forms a stark Egyptian thought
Forms that gentler Phidias wrought.

W.B. Yeats,
Under Ben Bulben, IV

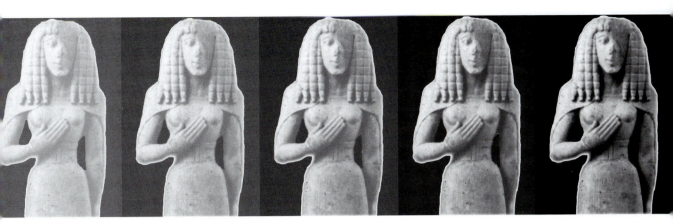

3

DAEDALUS AND THE WINGS OF *TECHNÊ*

The vocabulary of procreation is much favoured by Classical art historians and archaeologists. Many accounts of Greek art are framed in terms of 'seeds' being 'sown', techniques 'hatched' or 'conceived', forms 'born' and so on. But to anyone surveying the various accounts of the 'birth' of Greek art, the genesis-metaphor must soon lose its usefulness: for the claimed parentage turns out to be less a matter of forensic certainty and more to do with political correctness or partisan bias. Thus Turkish authorities will claim ancient Anatolia as an indispensable supplier of motifs, monsters and other decorative devices; Jewish scholars may be inclined to stress the role of the Phoenicians, and not only as commercial transmitters of Eastern objects; Egyptologists insist that only a knowledge of 'the Egyptian canon' and Egyptian stone-cutting methods could have enabled the Greeks to have progressed from figurines to monumental statues; while staunch philhellenes will argue that Cycladic, Minoan and Mycenaean sites yield all the necessary precedents and prototypes for the figurative styles we now generally salute as 'Greek'.

What is at stake here? In the over-arching narrative of Western art history, it is the origin of an artistic tradition that runs from Classical antiquity to our own time: a hiatus from Byzantium to the late Middle Ages, then 'rebirth' with the European Renaissance and thence an unbroken artistic-academic flow of inherited ideals to modernity. (It does not matter if there have been periods of revolt and reaction against 'the Classical' – the fixed point of absolute 'perfection' is still there.) According to this narrative, the 'great names' of art history – including, say, Leonardo, Michelangelo, Titian, Velazquez, Delacroix, Manet, Cézanne, Picasso – essentially built their work upon an awareness of what had been achieved by artists in ancient Greece – even if the work of those artists (such as the fourth-century painter Apelles) has disappeared, and even if (in the case of Cézanne and Picasso, at least) an awareness of non-Western and prehistoric art was also there.

So it becomes a loaded question – to ask, how did it start? But the very attempt to locate a time and place for the 'genesis' of Greek art is probably a misguided effort. As long ago as 1774, the German philosopher J.G. Herder argued (against his contemporary Winckelmann, whose view of the supreme achievement of Classical Greek sculpture we have already encountered) that it was futile to hold up Greek art next to Egyptian and claim superiority for Greece. Protesting against Winckelmann's complaint of 'lack of movement' in Egyptian statues, Herder defends the suitability of these Egyptian figures for their own social circumstances. 'They're supposed to be mummies!' cried Herder (*Mumien sollten sie sein!*): why expect them, then, to demonstrate 'action' or 'movement'? Egypt under the pharaohs has, in Herder's language, its own cultural centre of gravity: art does its job perfectly well, according to local expectations.

Herder's protest establishes a sort of relativism, a suspension of absolute judgement, to which we must in the end resort if we do not want to join the game of locate-the-birthplace. It does not imply a blanket denial of foreign factors in the shaping of early Greek sculpture (or later Greek sculpture, come to that); nor does it release us from the task of deconstructing the carapace of independent ingenuity that the Greeks created for themselves. But it does shift the emphasis of inquiry away from what is now commonly called 'Orientalizing' as a period of Greek history and towards the process of Greek self-definition in art. In this way, without slighting civilizations which are chronologically senior, we can account for the appearance of early Greek sculpture in Greek terms: that is, by looking to the archaeology of Greek sanctuaries and Greek city-states to tell us why sculptors were first motivated to try their hands at that risky and laborious business – the large-scale shaping of stone (especially marble) and metal (especially bronze).

There is a process here that can be glossed with a pseudo-economic analysis of innovation and change: the so-called 'multiplier effect' – the tendency for inventions to spread themselves and develop in ways that may never have been foreseen by those responsible for devising or introducing such inventions. So technical changes in vase-painting – for example, using a freehand brush to outline details formerly etched through a black glaze – may have affected techniques of producing relief sculpture; or the methods of making bronze or wooden statues may have directly led to new modes of cutting stone. In that sense this chapter must be regarded as incomplete, since our evidence for certain categories of Greek art – wooden sculpture, large-scale painting, chryselephantine statues and even hollow-cast bronzes – is tenuous. But gaps in the evidence should not deter us from creating a non-diffusionist account of how innovations passed through the hands of Greek sculptors. The question must always be: what was the cultural *advantage* of this or that technical development?

To deny diffusionist approaches is not a display of Classical superiority. Before we go any further, however, we must dismantle the Greeks' own extravagant claims to artistic independence.

Daedalus: the invention of the arch-inventor

By his works he is known: the works were *daidala*, he was Daedalus; and 'Daedalic' is the usual denomination for the earliest style of Greek sculpture. If only it were so simple.

The first thing to acknowledge is that while he gives his name to the 'first' Greek statues, Daedalus carries a truly mixed reputation. One scholar has

registered 'the hint of treachery which often accompanies the glamour of *daidala* in the earliest literature'. This criminal resonance can be sensed into Roman times and beyond, as the name of Daedalus continues to be evocative of tricks, ingenuity and a knowing sort of arrogance. It was Daedalus who fashioned wings for the first airborne humans – only his son Icarus who tried to fly at an impossible altitude.

The flight, now best known of Daedalic exploits, occurs in the mythological context of an escape from the labyrinth of King Minos of Crete. Daedalus – without Icarus – arrives in Sicily, where his clever energies are soon harnessed for all sorts of useful projects: hot baths, dams and other pioneering feats of civil engineering. Apart from providing a rather obvious metaphor for the process of Greek colonization in the western Mediterranean, this legendary amalgam of artist, engineer and aviation specialist may tempt us to compare Daedalus with Leonardo da Vinci. But there is a single, substantial difference. Many of the works and the notebooks of Leonardo survive; whereas for Daedalus, there is no fragment of direct attestation. The historical Daedalus does not exist.

Some ancient writers thought differently. Pausanias tells us that he has come across statues which he – or at least his local informants – believed were made by Daedalus (9.40.2). (Pausanias tends, all the same, not to use the term *daidala* for olden statues – preferring the term *xoana*.) His eye can detect that execution of *xoana* is primitive, or primitivist; yet both despite this and because of it, he sees that they are venerable works, even when crafted by 'latter-day' sculptors such as Myron (who made a *xoanon* of Hekate for an Aeginetan sanctuary: 2.30.2).

Revealing of his attitude is the account given by Pausanias of a visit to the sanctuary of Herakles in Boeotian Thebes (9.11.1). First, Pausanias notes the statue of Herakles Promachos, carved in marble by two local sculptors. Then there is the *xoanon* of Herakles, which the Thebans claimed was made by Daedalus – 'and I thought so too', adds Pausanias – and dedicated at the sanctuary by Daedalus himself, in gratitude to Herakles. This local lore is a cue for a story, a variation on the usual myth: according to this tale, Daedalus and Icarus escape from Crete by devising a boat powered by sails – so fleeing the oar-driven boats of King Minos. But Icarus proves a poor hand at the tiller and is lost overboard somewhere off Samos. The boy's body is feared lost, but Herakles finds it and does him the honour of burial. Daedalus, then, thanks Herakles with a statue.

Why this statue should have been dedicated at Thebes is not clear – but Pausanias passes no comment on that. How Daedalus operates in the same chronological ambience as Herakles is likewise obscure, but neither does this worry Pausanias. He briskly proceeds to the rest of the sculptural decoration of the sanctuary: temple

gables showing select Heraklean Labours, by Praxiteles; and two colossal figures of Athena and Herakles, commissioned by Thrasyboulus and executed by Alkamenes. Thus Daedalus is unquestioningly placed in the general run of Greek artistic genius; his distance as a mythical forerunner accordingly diminishes.

In conflating myth and history around the name of Daedalus, Pausanias is only following a Graeco-Roman tradition which saluted Daedalus as a *prôtos heuretês* – a 'first finder' of assorted tools and techniques, a name to be blessed by all those subsequently indebted to such dodges and innovations. When Pliny came to make a list of *primi inventores*, he accredited Daedalus as the discoverer of the saw, the axe, the plumb-line, the drill and two types of glue (*NH* 7.198: *two* types of glue is a nice touch of Pliny's knowingness in handicraft matters). By Pliny's time, Daedalus functioned as a virtual patron saint of Roman craftsmen, particularly carpenters (Pliny's list of Daedalic discoveries is classified under *fabrica materia*, 'making things', but looks more concerned with woodwork than with sculpting). Other writers in the Roman world, such as Diodorus Siculus (late first century BC), extended the genius of Daedalus to large public works and stressed his all-round capabilities: Daedalus was therefore characterized by his *philotechnia*, his 'love of craft'.

The mythical/historical traditions on which Pliny and Diodorus were drawing must remain ultimately obscure and are certainly difficult to trace beyond the eighth century. Homer knew about Daedalus and located his domicile as Crete (*Il.* 18.592) – and the Cretan connection may predate Homer, if Linear B experts are right in reading a reference to Daedalus (*da-da-re-jo-de*) in one of the Knossos tablets (KN Fp 1.3) – implying a cult chapel to Daedalus around 1300 BC.

Be that as it may, there is little doubt as to when and where the mythical receipt of Daedalus into the Classical tradition took place. It was in fifth-century Athens that Daedalus became (in the words of Sarah Morris) 'a sculptor, an Athenian, a relative of Hephaistos, a protégé of Theseus, and the hero of a local community'. Daedalus, for the Athenians, was not only removed from Crete to become one of them (hence one *deme* of Athenian citizens was known as the *Daidalidai*); he was also popularized in Athenian culture as the paradigmatically ingenious artist – a pioneer, as it were, of the Greek Revolution, making figures unbelievably lifelike and mobile. 'This likeness by Daedalus – does everything but talk!' exclaims a band of satyrs in a play by Aeschylus (*Theoroi* fr. 78). Socrates adds a metaphorical slant. Philosophical opinions, he says, are like the statues (*agalmata*) of Daedalus: 'if they're not fastened up, they play truant and run away' (*Meno* 97d). A (lost) comedy by Aristophanes was entitled *Daidalos*; its plot appears to have hinged on the mischief caused by statues deserting their bases. Then earnest Aristotle

briefly pondered just how it was that Daedalus gained this reputation for moving statues: could it be that he made them hollow and filled them with quicksilver (mercury) (*De An.* 406b)?

The background to this fascination with 'lifelike' statuary – half-admiring, half-suspicious – and its attribution in the first place to Daedalus is a general Greek perception that, in other countries, sculpture has different aims. We have already discussed Plato's comments on Egyptian art, implying as much. And when Socrates, in the reference mentioned above, refers to wandering statues by the 'Athenian' Daedalus, he comforts his perplexed interlocutor by saying: 'Ah, perhaps they don't make statues like this where you come from' (Meno is from Thessaly). So we can see the self-defining element in this mythology.

But there is also a sense in which the myth of Daedalic resourcefulness serves a further Greek cultural need: what might be called the *Eureka!* mentality – the faith in accrediting specific individuals with perceived 'discoveries' or 'inventions'. Never mind that such individuals, like Archimedes in his bath, made their discoveries more by accident than design. Pliny's account of 'the first terracotta sculpture' (*NH* 35.151) tells how a Greek potter, one Boutades of Sikyon, was so moved by his daughter's distress over a departing boyfriend that he drew an outline around the boy's shadow, filled it with clay and then fired the clay into a lifesize keepsake. This was pure 'happenstance': from paternal impulse, Boutades unintentionally 'discovers' how to make relief sculpture. The anecdote is typical of a wish to detach innovations from any kind of gradual or collaborative development and fix them instead upon some personal drama.

Yet another purpose of the mythical Daedalus was to define artistic status in Classical Greece. Peripatetic, cunning, loyal only to his own cleverness; half-worshipped, half-mistrusted by his contemporaries, Daedalus reflects the ways in which artists of the fifth century BC were both despised and lionized. They were – as their work of course demonstrates – experimental risk-takers; they could also win prestigious commissions, perhaps to their own enrichment; yet they were nonetheless essentially excluded from 'proper' society. Their rank was, in the language of the day, *banausic* – grubby-fingered, laborious, sweaty. Later on the essayist Lucian, possibly recalling his own career options, would highlight this peculiarly respected but unenviable position. One might have become a sculptor, he muses, and a successful sculptor at that. 'But even if one were a Pheidias or a Polykleitos, and produced many great marvels, everyone may have praised one's skill [*technē*], sure – but no one would have wanted to change places. However successful, the sculptor is always a rude mechanical [*banausos*] – a manual labourer, who knows nothing else but working with his hands' (Lucian, *Dream* 9).

Inverting this sentiment, we can say that sculptors, despite their banausic status, earned reverence. When a mythographer records that Daedalus was the 'first to represent the gods' (*deorum simulacra primus fecit*: Hyg. *Fab.* 274), this charts not only a certain artistic ambition, but also the means for an artist to gain public respect. The artist displayed skill, *technê*, by his representation of the divine; he also demonstrated a mysterious, semi-divine status – since to be able to *represent* the gods he must have 'seen' them, if only in his mind's eye. So Daedalus stands at the head of a tradition that imputes numinous insight to the artist, eventually pervading the Renaissance hagiographies of Giotto, Michelangelo *et al.* – the artist as a vehicle for divine communication, therefore a 'divine maker' (*deus artifex*).

Pausanias has an interesting observation to make in this respect. He notes, in the course of describing a religious festival at Plataea called the Daidala (9.3.2) that Daedalus 'the Athenian' actually got his name from a type of wooden cult image. Pausanias knows this type more usually as a *xoanon*, but in these parts (Plataea and Boeotia) it is also known as a *daidalon*. From his description of the festival, it is evidently an image carved from an oak tree, destined to be burned as a sacrificial altar. The name 'Daedalus', for Pausanias, is rooted in the production of the oldest cult images of the Greek world.

It is clear from such accounts that we have lost the evidence for the earliest large-scale Greek sculpture, which was made from wood – rarely surviving in the archaeological record. Pausanias himself (8.17.2) lists the following as trees generally used for *xoana* or *daidala*: ebony, cypress, cedar, oak, yew and lotus. He adds juniper as an exception, and we should add olive as an oversight on his part. It is apparent from some of his descriptions (e.g. of the *xoanon* of Aphrodite at her sanctuary near Megalopolis, in the central Peloponnese: 8.31.6) that additions in stone could be made to a basically wooden figure – such as hands, face and feet; and that these statues were often gilded and/or painted, and decked with garments, garlands and accoutrements. But apart from saying that these statues look 'old' (*archaios*, or *palaios*), or have 'something venerable' (*entheos*) about them, Pausanias leaves us with no firm formula for reconstructing a typical *xoanon*. The *xoana* were made out of wood – but did that mean their shape was essentially columnar, or plank-like? (That would depend on whether a tree trunk or prepared beam was used.) And should we assume that wooden sculpture implies less articulated human forms? Egyptian wood sculpture from *c.* 2500 BC onwards makes adroit use of tenon joints to produce extended limbs for wooden figures, while the limewood sculptors of Gothic Europe achieved dramatic folds and gestures with figures taken from a single block.

An intimation of how much is lost to us, and how insecure any statement about the origins of Greek sculpture must remain, is yielded by excavations at the site of

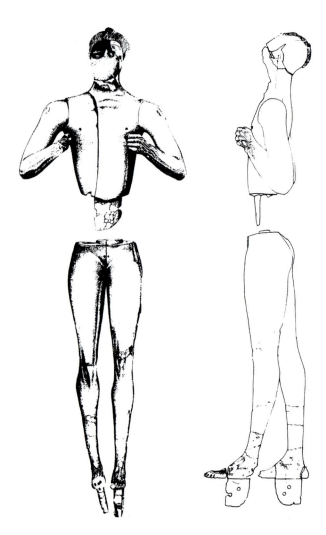

Palaikastro, at the eastern tip of Crete. The charred pieces of a composite statuette, described by its excavators as a 'chryselephantine *kouros*' (Figure 3.1), are enough to demonstrate the extent of delicate craftsmanship in the Late Minoan period (*c.* 1500 BC). The figure is mainly made from lengths of hippopotamus ivory, jointed together with wooden dowels, and surmounted by a head of serpentine. (The eyes were inlaid with rock crystal.) It would have slotted into a base by means of two drilled pegs below its feet. The ingenuity of its assembly is impressive, and its pose is striking: the left leg advanced, and arms bent at the elbow, with hands raised as if to give (or receive) some votive tribute (or perhaps, in a Minoan setting, to grasp the horns of a bull). Details, including the veins on the hands, are carefully worked; and although the context of recovery fails to define the statue's identity or purpose, its vague description as a 'youthful deity' seems plausible.

Such figures probably also existed on a much larger scale. At Knossos, Arthur Evans thought he had come across the remains – bronze locks of hair, with a mass of charcoal – of a colossal wooden effigy measuring some 2.8 m. high (*Palace of Minos* vol. III, 522).

The Palaikastro *kouros* may have more claim to Daedalic authorship than any other extant statue. But the term 'Daedalic' has already been appropriated to describe a style of sculpture from a later period, and not only on Crete (though Crete looks like its earliest home); and while no one seriously supposes that the mythical Daedalus had anything to do with these sculptures labelled 'Daedalic', we are obliged to indulge the misnomer – it has lodged too long in the parlance of Classical archaeology.

'Daedalic' covers a variety of media and dimensions, ranging from small anthropomorphic pots to large pieces of architectural sculpture, yet its stylistic

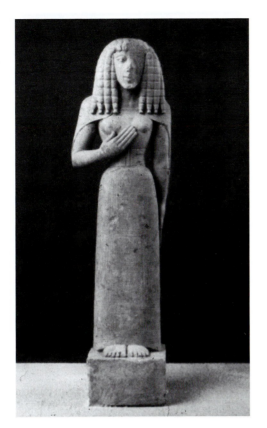

Figure 3.2 *The Auxerre Goddess, c. 640 BC. Limestone; ht (inc. base) 75 cm. It remains unclear how this figure found its way to Burgundy ('discovered' in the basement of Auxerre Museum in 1907, it was subsequently transferred to the capital); Crete is a suggested findplace. A deity, a dedicant – or a funerary piece?*

features may be readily summarized. First, it depends on a frontal approach from its viewers. There is little depth to Daedalic figures: faces are mask-like, bodies plank-like; the profile view tends to be minimal. Secondly, the style is formulaic, bordering on the geometric. Faces are turned into triangles, heads flattened at the top, hair arranged in blocks (the 'judge's wig') and detail rendered according to essentially pictorial conventions. Looking at one of the best-known examples of the style, the so-called Auxerre Goddess (Figure 3.2), we may wonder if the gesture of this figure is not, as it seems, a hand upon heart, but rather to be read as reaching forward in supplication: for the rules imposed by frontality would demand that an arm extended at the elbow be carved as lying across the body. (If so, a votary rather than a goddess may be intended.)

The appearance of this and other Daedalic pieces encourages the hypothesis that they may originate as renditions of wooden *xoana* in stone, bronze or terracotta. As we have seen, their attachment to the name 'Daedalus' is naive. But we can put some substance into the claim for 'Daedalic' statuary to be considered 'Greek'. Its centres of production were once identified as predominantly 'Dorian' Greek areas – Corinth, Rhodes (Kameiros), Crete and Sparta – but where Daedalic statues were made may be less important than where they were found. Evidently they travelled and were displayed at burgeoning eighth- and seventh-century sanctuaries: of Zeus at Olympia; of Hera at Argos and Perachora; of Apollo at Delphi and Delos – to name the more obvious. These were places where Spartans, Argives, Corinthians, Athenians and so on shared and developed

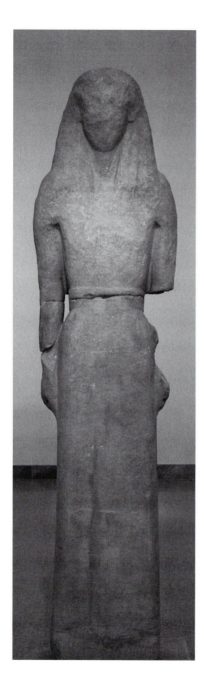

Figure 3.3 *Marble korê from Delos, dedicated by Nikandre, c. 650 BC. Ht 1.75 m. Found in 1878 near the Artemision. The inscription (below the belt) addresses 'the far-shooting maiden'; some take the statue to represent Artemis.*

what they had in common: Greekness; these were places in which sculptures appear that can properly be called 'Greek'.

R.J.H. Jenkins, whose 1936 monograph *Dedalica* did much to spread the use of the term 'Daedalic' as a stylistic category, claimed that 'our earliest large Greek statue in stone' was made *c.* 650 BC. He was referring to a votive *korê* ('maiden') now in Athens but found on Delos and probably made on Naxos (Figure 3.3). We know who dedicated the piece – Nikandre, who was probably a priestess at the sanctuary of Artemis on Delos; we know the names of Nikandre's father, brother and husband. However, the sculptor remains anonymous. Whether he was one of those 'followers' of Daedalus known to ancient commentators – Endoios, Dipoinos, Skyllis, Tektaios *et al.*, the so-called *Daidalidai* – must remain unknown. But it is time to address those technical factors that help us (as they helped Pausanias) to distinguish 'early' Greek sculpture from what ensues. The discussion here focuses upon a quartet of 'basic' materials – limestone, marble, bronze and terracotta; attention to the more 'spectacular' projects of chryselephantine statues is reserved for Chapter 7.

Technê: limestone and marble

If Greek stone sculpture essentially developed out of a tradition of woodworking, then it was natural to make an early use of limestone – known to the Greeks as *poros* or *porinos lithos*. There are soft and hard varieties of limestone: the soft varieties can be carved with tools very similar to those used for wood, such as gouges, knives and

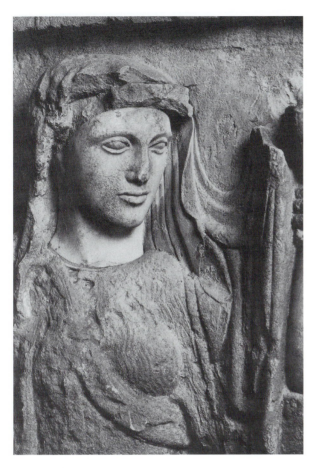

Figure 3.4 *Detail of metope from Selinus (Selinunte), Temple E, c. 480 BC. The scene shows Hera unveiling herself to Zeus, so it was especially important that her face be bright and conspicuous.*

scrapers. Though the mass of limestone is actually not much less than that of marble – so transport costs may not have been significantly less – the effort (in man-hours) required for its extraction and shaping was lighter.

Allowing for the ancient custom of painting most sculpture (an aspect we shall discuss later in this chapter), it remains the case that limestone tends not to sustain the same degree of surface finish as marble and takes less detail. The material contrast between limestone and marble is conveniently exemplified by some metopes from Temple E at Selinus, in Sicily. Sicily as an island has no marble quarries, so for large projects limestone was more or less obligatory. At Selinus, nevertheless, sculptors apparently wished the female figures in their relief-vignettes to strike the viewer as female: that is, to display pale and delicately shaped features. So for the figure of a goddess, or an Amazon, portions of marble – imported from Paros – were inset, for flesh parts. The respective qualities of the two types of stone are made clear – not least in durability (Figure 3.4).

The economic distinction of marble was undoubtedly acknowledged in Archaic times. Herodotus recounts (5.62) how, at Delphi, the Peisistratids and Alkmaionids, rival political dynasties in late sixth-century Athens, competed in their endowments to the temple of Apollo, with the latter 'upgrading' pedimental sculptures in Parian marble. (This was an effort of portage much more challenging than moving small portions of Parian to Sicily.) Finds at Delphi indicate that there was indeed a change of material in the pediments on the late sixth-century temple, with sculptures of the west side done in volcanic stone (tufa) from Parnassus, and the east side in marble from Paros. The motive for this conspicuous expense plainly lay in winning oracular favour from the god.

Since marble subsequently becomes a preferred stone for sculptors in the later European tradition – Michelangelo, Bernini, Canova *et al.* – it is natural to imagine that, by its esteem for the stone, Archaic Greece lays down a foundation for Western art. Strictly speaking, the Archaic Greeks were not absolute pioneers: in the third millennium BC, marble from the Cycladic islands was shaped into figures, rarely more than *c.* 30 cm. in height, from pieces of stone found naturally. Scraped with obsidian, abraded with emery and sometimes given painted detail, the result has a certain appeal of simplicity – though it cannot be regarded in any direct sense as a precursor of Archaic Greek sculpture. (As far as we know, these 'Cycladic figurines' lay mostly buried in graves until the nineteenth century.) But it was in various Greek locations that marble quarries were first opened up, beginning in the seventh and sixth centuries. The Cyclades were productive, notably Naxos and Paros; other sources include the northerly island of Thasos, Krokeai in the Peloponnese (south of Sparta), Pentelikon in Attica and Larissa in Thessaly.

Expertise in the methods and logistics of extracting marble in large blocks is thought to have come to Greece via Egypt or the Near East. Egyptian stone-masons of the Old and Middle Kingdoms would use a bronze punch to stun their rocks (granite, porphyry, assorted sandstones; rarely alabaster, and never marble); the Greeks preferred an iron pick, plus wooden wedges; both methods, however, involved hewing a trench around a potential block before levering it out. At Aswan, an abandoned obelisk for Queen Hatshepsut (who ruled 1490–1468 BC) indicates the size that might be extracted from granite; centuries later (*c.* 580), the Naxian sculptors who made a colossal Apollo for dedication on Delos were proud to advertise that their statue, about 10 m. high, was 'of one stone, figure and base' – though it seems that the plinth, at least, was separately carved.

Traces of marble-quarrying are to be found at several Naxian sites. The earliest appears to be at Apollonas, to the north of the island. The name is misleading, for the half-finished statue abandoned in the quarry above the shore-side settlement was surely not intended to represent Apollo (Figure 3.5). To what stage of the quarry's chronology it belongs is open to speculation, but a reasonable guess is somewhere between the mid sixth and mid fifth centuries. Had it come to completion, the figure would have stood 10.66 m. high. It looks as if it were intended to be draped and bearded – so we may presume that this was an image of Dionysos in the making: Dionysos who was legendarily (with Ariadne) connected to Naxos, and whose characteristic drinking-cup, the *kantharos*, was a motif on early Naxian coinage.

It is clear from the evidence at Apollonas that whoever was entrusted with extracting a suitable piece of marble for a large statue of (say) Dionysos was also

Figure 3.5 *Unfinished statue* in situ *at Apollonas, Naxos.*

responsible for shaping that piece of marble to within a centimetre (in some places) of its intended finished surface. The stages of the operation can be simply retraced. Having identified a suitable layer of stone, the masons cut a trench around it, wide enough for them to stand in while working on the basic shape of the statue. They then used metal punches to strip the block of as much stone as possible, prior to attempting to move it. (This entails confident knowledge of what the statue was going to look like when it reached its final, polished state.) Then came the trickiest part of the process: levering this shaped piece from its bedrock, having perhaps 'honeycombed' the underlying stone with multiple bore-holes. It was at this stage that something went wrong with the Naxian Dionysos: a fault in the marble was revealed – possibly the fissure that is today visible across the upper part of the figure. The project went no further; thousands of man-hours had been wasted.

Marble is not so dense as granite. Still, at something like 2.7 tons per cubic metre, it is a formidable weight to move around – which is why, we suppose, a large statue was created as far as possible *in situ* prior to transport. That operation, assisted wherever possible by waterborne means, was fraught with risk: further abandoned statues on Naxos, near the quarries of Melanes in the interior, testify to accidents of transit. But our interest in this process is not only technical, but also, as it were, vocational. In modern parlance, the stonemason or quarryman does one job, the sculptor another. This is a division of labour which Italians in the sixteenth century marked by defining one profession *tagliapietra* and the other *scultore*. Michelangelo, about whose working practices we are relatively well informed, was probably unusual in the degree to which he supervised, or even participated in, the quarrying stage; but while he designed waggons to carry blocks of stone to his studio, blocks they remained – until his genius 'released' the statue within.

Modern preconceptions of a distinction between 'stonemason' and 'sculptor' – one denoting a 'craft', the other an 'art' – have led some scholars to suppose that there may have been some prevalent canon in antiquity, enabling a statue to be

roughed out in the quarry, then sent elsewhere to be finished, by a separate workforce; but this seems highly unlikely. The Naxian Dionysos conforms to no other surviving 'type', whether in terms of its scale or its subject: so how could the ('unartistic') quarrymen have known what the ('artistic') sculptor had in mind? It is more sensible to imagine the sculptors doing as much work as possible prior to transport; in any case, what suits a marble-cutter best is to have his block lying flat on the ground, or slightly off horizontal, for as long as possible – it makes wielding a mallet less wearisome. Working in the quarry also allowed sculptors to discover flaws in a block before going too far with it.

THE SAMOS *KOUROS*: EGYPT AND GREECE

From first impressions, no one would doubt that large-scale early Greek sculpture was fundamentally indebted to Egypt. To walk into the court of Ramesses II at the temple of Luxor (Figure 3.6) is to be struck by the resemblance of a series of over-lifesize statues (representing the pharaoh himself) to the pose and bodily proportions of certain early Greek statues, such as *kouroi* from Sounion (see p. 131).

Figure 3.6 View of the court of Ramesses II, Luxor temple, c. 1290 BC. Each figure, carved in granite, stands (with base) about 7 m. high.

First impressions are all very well. But just when and how would Greek sculptors have seen monumental figures such as these? Herodotus (2.154) tells us that in the

period when Egypt was ruled by Psammetichos I (664–610 BC), commercial contacts between Greeks and Egyptians were fostered, with permission granted for a Greek settlement in the Nile Delta, at Naukratis (see p. 117). This provides a historical context for some sort of cultural exchange. If Greeks did not venture as far up the Nile as Thebes (Luxor) or Aswan, there were colossi to be seen at lower sites such as Memphis and Tanis. Just one ancient author, however, explicitly alludes to early Greek sculptors adopting Egyptian working methods: Diodorus Siculus, whose *Library* (1.98) mentions a fraternal pair, Telekles and Theodoros, who made an image of Apollo according to some formulaic matrix. Or so we suppose: according to Diodorus, one half of the vertically bisected statue was made by Telekles on Samos (where the statue was due to be dedicated), while Theodoros made the other half across the water at Ephesus: 'when the parts were joined together they fitted so exactly that the whole figure appeared to be the work of one artist'. This method, says Diodorus, was typically Egyptian *philotechnia* – and the resultant image looked very like an Egyptian image.

Diodorus may not be reckoned an absolutely dependable source (though he did visit Egypt himself and is unlikely to have concocted this story). Other writers know the names of Telekles and Theodoros – yet this creative duo is, so far, only attested in the literature. However, sustained investigations at the Samos Heraion have produced some evidence for the use of Egyptian proportions in early Greek sculpture – as manifest in the remains of a colossal *kouros* recovered piecemeal along the Sacred Way or processional route leading to the temple (Figure 3.7).

A reasoned case has been made for claiming that this figure, though still not complete, conforms to a gridding system similar to that used by Egyptian artists. Basically this means that an image is allocated, part by part, to a system of squares mapped out on a surface (or block): thus for a human figure, so many squares were allowed from the neck to the knees, so many from the knees to the feet and so on. A Samian unit of measurement, the *ell*, was reportedly derived from the Egyptian royal cubit – in our terms, 52.5 cm. – a formalized calibration of the distance from the point of the elbow to the tip of the little finger (the Greek *pêchys*). So it would be relatively straightfoward to transfer an Egyptian canon for local use – and this, it seems, is how the *kouros* dedicated by Ischys was made. As we have noted (p. 25), the regularity of Egyptian art became almost proverbial to Classical Greeks, and there is no suggestion that Greeks in the Archaic period actually copied from Egyptian models (one

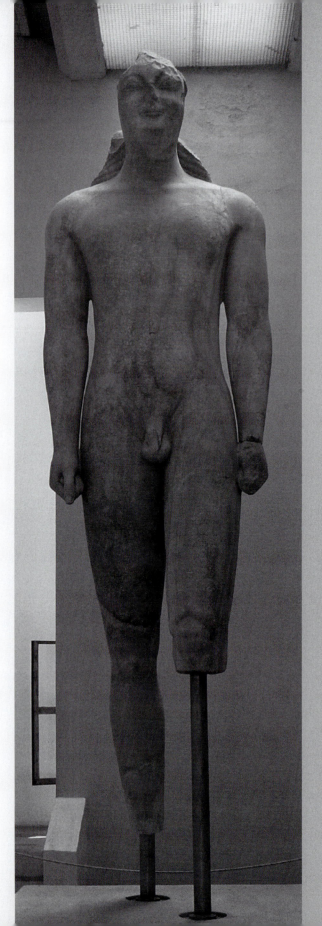

obvious difference is the habit of nudity). But images such as those of Ramesses II, created for the sake of emphasizing a divine magnitude to the pharaoh ('Ramesses the Great', who is eventually Shelley's 'Ozymandias'), demonstrated to Greek sculptors a scaling-up method that was entirely appropriate to their own purposes – responding to ambitious commissions for images of gods and demi-gods.

Figure 3.7 *The* kouros *dedicated by Ischys in the Samos Heraion, c. 590–580 BC. Ht 4.75 m. German excavations in the 1920s located pieces of two colossal statues that once stood along the Sacred Way. The discovery of further fragments, including the face, in the 1980s has made possible the reassembly of one of them – interpreted (by Helmut Kyrieleis) as the image of an ancestral hero. The variegated marble used for the statue would have been concealed: the figure was painted in reddish-brown ochre, with hair, eyes, moustache, lips and pubic hair picked out in other colours.*

Figure 3.8 *Unfinished figure from Dionysos, near Pentelikon, Attica, sixth century BC. Ht 48 cm. Work on defining the arms, feet, and extended left leg was halted, presumably by discovery of some flaw in the stone.*

We have no ancient sculptor's handbook of technical procedures. But from archaeological evidence, and some comparative trade insights, the stages of carving a figure from marble can be outlined as follows:

1 Sketch or incise the profile of the intended figure on opposite sides of the block.

2 Partially carve the profile.

3 Sketch or incise the front view of the intended figure.

4 Partially carve this front view. The result so far will look semi-distinct (Figure 3.8), but can then be improved by:

5 Rounding off, and cutting into interior or 'negative' space, e.g. between arms and legs, with some preliminary smoothing. Transport may not be contemplated until this stage – as evident from the abandoned *kouroi* on Naxos (Figure 3.9). Finally:

6 Definition of forms such as hairstyles and facial features; addition of incised details (e.g. markings of abdominal muscles) and fine polishing of the surface. White marble, as we know, offers the potential for a fine surface sheen and partial translucency. Although Greek sculptors customarily painted their statues, there is some evidence that these luminous qualities were appreciated, especially for the representation of flesh parts; we shall return to this evidence later.

Carving a relief is a simpler proposition: its stages may be readily comprehended by comparing two limestone metopes from the east side of a temple at the Foce del Sele sanctuary north of Paestum (Poseidonia), in south Italy. They come from a series illustrating a skirmish between Herakles and Centaurs – a project apparently never finished, so we find one of the Centaurs left in outline (Figures 3.10 and 3.11; *cf.* Figure 6.9).

Roughing-out of figures was generally done with single-pointed tools – picks, pick hammers, punches and pointed chisels. Finer modelling was done at an oblique angle using chisels with flat, round or serrated edges. (The latter sort, known as the claw chisel, seems to have been introduced to Greek workshops in the early sixth century.) Various types of drill were also developed in the Archaic period.

Figure 3.9 *Unfinished* kouros *at Melanes, on Naxos (sixth century BC). The statue lies where it was abandoned, apparently in the course of being transported from a nearby quarry. An unfinished* korê *may be seen (by those who search) further up the hill.*

There was no mechanical power to rotate the iron bits, which could be up to 20 mm. in diameter. Turning the bit by means of a strap or a bow, the sculptor (perhaps with an assistant) could not only bore holes, but also move the drill along to create grooves. A drill was useful in quarrying to 'honeycomb' stone from which a block must be separated. As for dexterity with the 'running drill' in the latter stages of carving, it is gloriously displayed on the draperies of the later sixth-century marble 'maidens' (*korai*) dedicated on the Athenian Akropolis (see p. 111).

These *korai* also demonstrate the structural devices by which Greek sculptors evaded monolithic marble labour. It was all very well to take pride in carving a figure from a single block, but that could involve much tedious and expensive, not to mention risky, effort. Ingenuity lay in making a composite piece *appear* entire. So separate pieces of marble were used for the head or legs, for example, and statues made more spatially ambitious with arms inserted at discreet junctures (Figure 3.12). No glue was required for fixing these pieces. Metal dowels might be used for extra strength, and the joins sealed with a light, scarcely visible cement; but basically the technique relied on perfectly measured socket-and-tenon joints.

Archaic Greek sculpture is sometimes applauded for its 'direct carving' by admirers who value expressive spontaneity in art – and so resent the thought of sculptors having a prototype to copy. But it is unlikely that early Greek sculptors commenced carving without a model of their intended piece of at least one-third its scale, if not 1:1. The two youths found at Delphi, usually known as Kleobis and Biton, may possibly not represent the two brothers of these names mentioned by Herodotus – see p. 128 – but they are certainly sculptural 'twins', based on a single model.

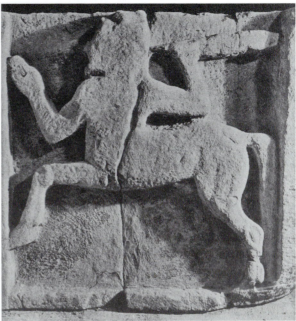

Figure 3.10 and 3.11 *Adjacent metopes (in sandstone) from the east side of the so-called 'Thesauros' at Foce del Sele, mid sixth century BC. Ht c. 83 cm. A number of metopes from this site survive in a two-dimensional, 'cut-out' state, leading some scholars to suppose that details were added in paint – but the more likely theory is that for some reason the project was cut short in its final phase.*

What developed in the fifth century was a method of 'pointing-off' to transfer measurements from a model to the stone being carved. This practice, requiring calipers and plumb-lines, would be refined in later Greek and Roman times, but essentially involved making 'reference-points' by which the three-dimensional progress of a statue could be checked against its model. Sometimes, due to oversight or lack of time, such points will be apparent as small indented nodules: some of these can be noticed, for example, on the pedimental sculptures from the temple of Zeus at Olympia (*cf.* Figures 2.8–9). The literature speaks of *paradeigmata* and *proplasmata* as key preliminary stages in the sculptural process – and Pliny notes that the models created by Arkesilaos, a sculptor active in Rome during the late Republic, actually fetched higher prices on the Roman art market than the finished works of some other sculptors (*NH* 35.155).

Models could be made of assorted materials – for large-scale projects, a wooden or wire infrastructure would be needed – but predominantly the medium was clay, or 'fired earth' (terracotta). In this respect, it may be misleading to emphasize, as some scholars do, a difference between 'plastic' and 'glyptic'

Figure 3.12 *Diagram showing the construction of a marble* korê *from the Akropolis (no. 682).*

techniques (the one based on moulding, the other on cutting) to characterize the distinction of approach to bronze and marble respectively. A 'plastic' model was usually the first stage, regardless of the medium of the final piece. (And of course terracotta *per se* was a valid substance, as we shall see.)

However, despite the ingenuity of tenon joints, and prior to Hellenistic virtuosity in fashioning complex group compositions from single large blocks of marble, it is true to say that bronze sculpture offered, to exponents of the Greek Revolution, more excitingly 'lifelike' possibilities than marble, lime-stone or any other stone. It is to the first essays in bronze that we now turn.

Technê: bronze and terracotta

In Book 18 of Homer's *Iliad*, Thetis, mother of Achilles, pays a visit to Hephaistos, divine craftsman. She is on a maternal mission: having been warned that her son will die on the battlefield, she wants to procure for him a set of supremely protective armour. Homer throws himself into a characteristically rich account of the episode (lines 369ff.), beginning with an evocation of the smith-god's workshop. We register, again, the Greek mixture of distaste and admiration for skilled labour as exemplified by the image of Hephaistos: lame, cantankerous, consigned to sweat, dust and toil, and consequently asthmatic, he is nevertheless a figure of immense power. Thetis comes across him putting the final touches to some golden *automatoi*: wheeled tripods which have their own robotic momentum. Hephaistos may be physically disabled and psychologically twisted, but his consort here is specified by Homer as 'Grace' (*Charis*), and what he produces for Thetis is dominated by a shield as beautiful as it is useful – five concentric layers of bronze, and a surface teeming with figurative relief.

For all the eye-witness impression, Homer shows an uncertain grasp of what bronze-working entails. He is clear that the armour is made of bronze (*chalkos*); but his vignette of Hephaistos at work is a high-temperature farrago of crucibles, funnels, tongs and hammers, all stoked up by the smith-god's magical (self-inflating) bellows. It looks suspiciously as though Homer is muddling bronze with iron, for bronze – an alloy of copper and tin, with the proportion of tin governing the extent of malleability – is generally hammered cold, and with light tools. It is iron that is forged red-hot. But as a poet, Homer is more fascinated by the end result of all this din and effort. He is vague about the method whereby Hephaistos inlays (presumably with different metals: a Mycenaean art) a series of figurative scenes on the shield, but enchanted by the virtual sound effects emitted from this creation. Hephaistos shows people singing, cattle lowing and a stream that babbles: no wonder we might forget that this object is supposed to ward off a hurled heavy spear.

But metal armour was primarily a thing of beauty and prestige in Archaic Greece. The earliest bronze body-armour must have been a good deal less protective, and more restrictive, than multiple-layered hide, yet it glittered, and so was awesome to an enemy. Herodotus tells us how Psammetichus was so impressed by the East Greek 'men of bronze' (*chalkeoi andres*) pirating around the Nile Delta in the seventh century that he hired them as mercenaries. Perhaps they were wearing corselets of the sort discovered in several Late Geometric graves, made from hammered bronze plates to close-fitting specifications. The best-preserved example, from Argos, and dated to around 720 BC, looks to have been shaped for a trim athletic warrior, whose pectorals were properly accommodated, and whose abdominal muscles were also marked on the corselet. The art of the armourer is here very close to the art of the bronze sculptor.

In fact, early Greek bronze statuary was made using more or less the same technique as body-armour – *sphyrelaton*, which means 'beaten' or 'hammered'. The resulting objects (*sphyrelata*) were sometimes beaten out of a single disc of bronze, just as bronze vessels could be, but more often they were composite: plates shaped by hammering both sides were then overlapped and riveted together. A late eighth-century statue, perhaps of Apollo, from Dreros in Crete, about half lifesize, was assembled from over thirty separate pieces, and the riveted seams are mostly not visible to anyone viewing the statue front-on.

It used to be supposed that a carved wooden core-figure was key to such figures, arising from the religious practice of embellishing wooden *xoana* with bronze attachments. But a freehand technique is more plausible, allowing sculptors to work on bronze sheets both from the inside out (*repoussé*) and from the outside in (chasing). The figure from Dreros (plus two female companions, discovered on

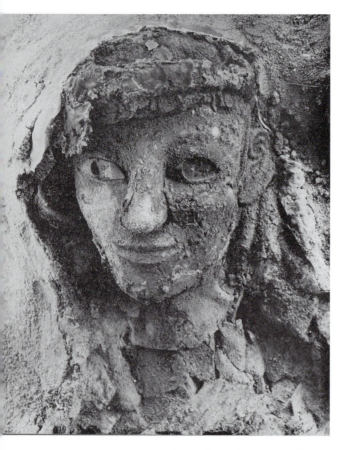

Figure 3.13 *Detail of a sphyrelaton from Olympia, early sixth century BC – as discovered in 1965. Part of a figure of a winged deity; one eye of inlaid bone survives.*

the same altar) has neither a wooden core, nor inner armature of any sort. Provided the scale was modest, none was structurally necessary. An inner lining of bitumen was enough to provide extra weight and durability; details such as eyes could be inlaid (Figure 3.13).

Among the range of *sphyrelata* are the great ceremonial tripods, dedicated at various Greek sanctuaries from the ninth century onwards, with *protomai* – figured 'extensions' – projecting from their rims (usually gryphons or similar beaky creatures). The Samos Heraion has proven particularly rich in these objects, with over 200 *protomai* so far recovered; and from this evidence it appears that during the seventh century a major technical change took place, whereby the figures were no longer hammered into shape, but cast.

Here is a nice case of intersection between archaeology and literary testimony. The Greek claims for the 'invention' of bronze-casting are hardly reliable – bronzes had been cast in Egypt and the Near East long before, in the third millennium – but one place dominates the confused literary account of where in Greece bronze-casting was first practised. This is the island of Samos. Two individuals, Rhoikos and Theodorus, are sometimes singled out (e.g. Pausanias 7.14.8) – although archaeology has failed to attest their existence. What archaeology has supplied, however, is evidence that on Samos, in the late seventh century, *hollow-cast* bronzes began to be produced: first the tripod-attachments, which would have been awkward to attach if solid cast, then independent statues – *kouroi*, horsemen and so on.

Solid-cast bronzes were not a great technical challenge. Beyond early examples from Crete, vast numbers of solid-cast figurines have been found at sanctuaries which were becoming popular in the eighth century: at Olympia, especially, but also Delos, Delphi and Dodona. These votives were probably made in temporary workshops set up for particular festivals and ceremonies. The solid-casting technique involved making a figure in wax, which was then given a

clay 'coat', but leaving an aperture. The figure was fired, turning the clay to terracotta, and the melted wax leaked out via the aperture. Into the now-hollow figure was poured molten bronze. Once this bronze was cooled and set, the clay jacket could be chipped off. All that remained was to smooth the figure, with perhaps some minor engraving. The wax model, of course, was lost; but beeswax, when warmed, is a pliable and easily shaped material, and another miniature horse or mannikin might be made within minutes.

It follows that solid bronzes beyond a small scale are very rare. Apart from being prodigal in the use of metal, and producing cumbersome statues, there are technical problems in solid-casting large pieces. As it cools, bronze contracts, releasing gases and bubbles; cracks and disfigurements occur more frequently as size increases. To be able to cast figures hollow, by contrast, opened up a world of three-dimensional space that could not be matched by marble or any other solid material – especially if the means could be devised of casting parts separately (so that if one part went wrong – say, the arm of a figure – it did not necessitate recasting the entire statue).

Why was Samos so significant in the development of casting techniques? The answer is simple, up to a point: Samos was unusually exposed to Near Eastern and Egyptian *objets d'art* – including examples of hollow-cast bronze. As with marble-working 'influences', this does not explain how technical expertise was transferred; nor, unfortunately, do we possess any ancient account of bronze-working to compare with that of Benvenuto Cellini, the Renaissance sculptor whose reputation was partly based on 'rediscovering' lost Classical mastery.

The following scenario for the making of a *kouros* statuette from Samos (Figure 3.14) offers

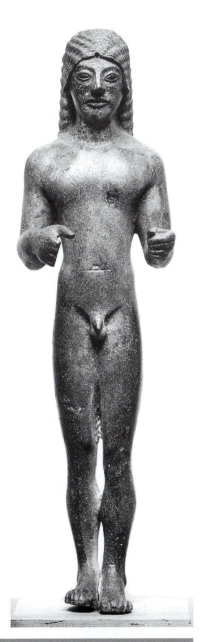

Figure 3.14 *Kouros-statuette from Samos, c. 530 BC. Ht 28 cm. (Parts of the arms and legs of this figure are solid cast.)*

an imprecise summary of complex procedures. This votive figurine appears to have been made from two moulds – one for the back, and one for the front. These moulds may be called 'intermediate': they will have been taken from an original image made of clay, or else carved from wood or ivory, and they give negative impressions of the desired bronze version (another figurine of the same style and dimensions has been found at the Heraion, implying that there was indeed a single original from which both bronzes were produced). The intermediate moulds would be lined with wax – this is the wax lost in the 'lost-wax' (*cire perdue*) method – and a 'core' created within. Such a core would be a slurry of sand and plaster, or liquid clay, perhaps. Once this core was consolidated, with the wax adhering to it, the outer intermediate moulds could be removed. Around the waxed core was constructed a network of 'gates' and 'vents', with a main funnel. This structure, in wax, was necessary to conduct molten bronze around the core figure (flowing from the base upwards), and to provide ventilation for gases. Then, around the core figure, and incorporating the network of funnel, gates and vents,

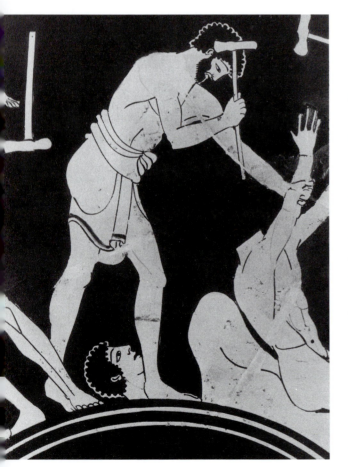

was added a coarse clay exterior coat – the so-called 'investment mould'. Pins would stabilize the core model to this outer clay blanket: these were essential, since once the clay was fired, and the wax oozed out, only these pins would support the core within its mould.

All that remained was to heat the bronze and pour it in. The gap created by the lost wax might vary – thicknesses of bronze range from 2 to 25 mm., but average around 5 mm. The outer mould would then be chipped off. If the statue were being made in parts – as most Greek hollow bronzes were – it would also be possible, once the bronze had cooled, to hack out the inner core too. We see this, apparently, in scenes on an Athenian drinking-cup which show two large bronze statues, of an athlete and a warrior, being made (Figure 3.15). Also from Athens comes a

Figure 3.15 *Detail of the Foundry Cup, early fifth century BC. Conceivably this shows the bronzesmith joining part of a statue's arm; but the body-language more plausibly suggests he is about to use the end of his hammer to prise out the inner core of a hollow-cast figure (whose head, cast separately, lies nearby).*

partial insight into what the clay invest-ment mould of a *kouros*-figure would have looked like (Figure 3.16).

Subtle welding and joining tech-niques were developed to make statues cast piecemeal appear as if cast entire; tangs on the surface of the bronze could be scraped off with a tool strikingly similar to the *strigil* used by athletes for skin-toning; and a certain amount of fine detail might be added with inlays and engraving. We have noticed else-where the finesse of detail achieved in the actual casting (p. 38). Gazing fur-ther at the delicate sinews on one of the Riace figures (Plate IIa), and meditating on the fiery technical hazards that haunted various stages of casting large-scale bronzes, we appreciate once more the competitive mentality that must have catalysed the bronzesmith's art. As with Hephaistos, the work was utterly unenvi-able – yet redeemed by its marvellous result.

The maker of terracotta sculpture, the *koroplastês*, was less honoured among artists. Certainly the technical process, compared to bronze-working, was far more simple. From a master model, or *patrix*, of any material, moulds were taken – mostly in clay, sometimes plaster. A single mould would yield reliefs and plaques; with a double mould, either solid or hollow figures could be produced by lining the mould with wet clay (which shrinks on drying, and is therefore easy to coax out of the mould). The dried figure – sometimes glazed – was then fired, in several stages, prior to painting.

In central Greece, terracotta figures were mostly small scale and prone to generic appearance – such as the so-called 'Tanagra' statuettes of draped ladies. Children's toys, votive offerings, grave goods, household ornaments, theatrical souvenirs – these are typical of their use. In terms of quantity they might be described as mass-produced – but surprisingly few duplicates are found, implying a brisk turnover in moulds.

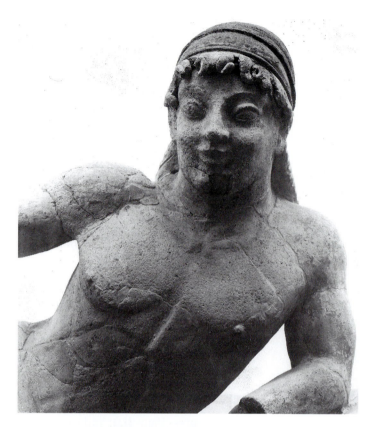

Figure 3.17 *Draped reclining youth on the lid of a cinerary urn from Cerveteri, early fifth century BC. Length 90 cm.*

In the Western colonies, however, and also in Latium and Hellenized Etruria, terracotta statuary was taken more seriously. Literary traditions (e.g. Pliny, *NH* 32.152) record that an aristocratic exile from Corinth called Demaratus came to Italy in the seventh century, bringing with him three craftsmen (*fictores*) who specialized in terracotta decoration. It is around this time that the production of terracotta statues and architectural components – figured antefixes and gutter-mouldings, for example – begins in Etruria, and flourishes thereafter. During the late sixth and early fifth centuries, complex pedimental groups (Pyrgi offers a good example) and confident essays on Greek themes, such as the reclining *kouros* from Cerveteri (Figure 3.17), were achieved. In Sicily and south Italy, meanwhile, sculptors who did not avail themselves of imported (mostly Parian) marble demonstrated that large-scale terracotta statuary, freestanding as well as architectural, could be worked to similar levels of fine detail – without losing the lightness of touch inherent to the medium. The 'dancing girls' from Rhegion are exemplary of this effect (Figure 3.18).

The colour on ancient terracotta sculptures survives more persistently than the colouring of stone – but we should not let that deceive us. As was

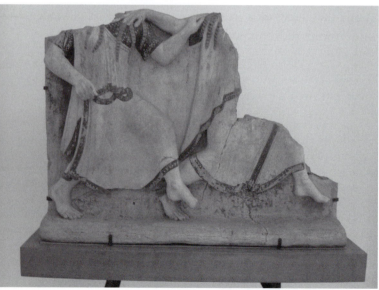

Figure 3.18 *Terracotta relief – perhaps a metope – from Rhegion, late sixth century BC. Ht. 69 cm. (Possibly a representation of the Leukippidai.)*

observed long ago of the Greeks (by William Gell), 'no nation ever exhibited a greater passion for gaudy colours'. This passion can come as a somewhat unpleasant surprise to modern viewers, but polychromy was, whether we like it or not, an integral part of the final effect – and the conservation – of all Greek sculpture.

'The colours of white' Gold, silver, ebony, ivory, copper, bronze, marble – these are among the prestigious and difficult materials of Greek sculpture. So what does it mean to say that 'polychromy' was part of 'all Greek sculpture'? Some reassurance may be supplied immediately: of course some precious materials were coloured in their own right. Gold and silver needed only regular polishing to maintain their natural effect, while for ebony and ivory, oil should suffice to prevent their deterioration. We know that the quality of 'gleam' (*augê*) was widely prized, in art as well as nature: there were various ways of creating it. The proportion of tin to copper in bronze would affect its effulgence, of course; in any case, bronze statues were routinely treated with various substances to maintain shininess and prevent corrosion or the formation of patinas. (If a statue of a female figure were made in bronze, we can only presume that its flesh parts were somehow tinted to a pale finish.) But it is doubtful whether figures such as the Riace Bronzes, with copper inlaid for their lips and nipples, were painted in any kind of opaque way. Callistratus (11.435K) describes a bronze statue of a youth by Praxiteles with 'blushing' cheeks, saying that this is 'a ruddiness born of the bronze' (*chalkou tiktomenon ereuthos*). The 'colouring' of a male nude, whether of bronze or marble, only needed to suggest – for the sake of naturalism – a sun-tanned skin tone. And why go to the trouble of using special vitreous paste for inlaid eyes, if eyes could be simply painted? Clearly there was an aesthetic value to *perceiving* that sculptures were made of this or that material – and that value extended to marble, with a number of writers (mostly Roman, but some Greek) celebrating, for example, the glittering or 'dazzling' (*lygdineos*) quality of marble from Paros (e.g. Posidippus *AB* 126). When statues are shown on Greek vases, they tend to be painted with added white.

Nonetheless it remains the case that in the modern connoisseurship of Greek sculpture there has been a tendency to evade, ignore or cover up the extent to which ancient statues were painted in 'gaudy colours'. Winckelmann is sometimes cited as the one who canonized the notion that the surface of Classical marble was finished to a cool translucent white, complementing his esteem for the 'noble simplicity and calm grandeur' of Praxiteles *et al*. But the habit of appreciating carved marble for the sake of its own texture had already been nurtured by Michelangelo and others during the Renaissance. And this was not just a matter

of taste: from Galileo onwards, the technical virtues of shaping hard material into the likeness of soft or fluent forms were lodged in discourse about art. We find Bernini, for example, explaining ways of suggesting facial coloration by carving alone and, eventually, J.G. Herder asserting it as a rule that colour serves not to enhance but to conceal form.

The development of Neo–Classical style in candid purity by the likes of Canova and Thorvaldsen (see p. 314) fostered the prevalent belief that ancient work had been similarly unadorned. So when the French antiquarian Quatremère de Quincy surmised, on the basis of ancient texts, that colour had once been used on Classical sculpture, his theory (published in 1814) seemed radically *nouveau*. But archaeologists were at least alerted to the precaution of examining newly excavated finds for traces of pigment prior to having them cleaned.

In fact already in 1811 the excavators on Aegina had noticed colours still evident on the pedimental sculptures there. Charles Newton, exploring the remains of the Mausoleum at Halicarnassos in the 1850s, made diligent notes on the traces of vivid colour apparent on the building and its sculptures (they faded after exposure). But it was in the 1880s that finds on the Athenian Akropolis showed beyond doubt the extent of surface polychromy, especially on the Archaic *korai* – and here records were immediately made with watercolour reproductions (Plate III). How durable such paintwork would have been in antiquity is open to question: the most effective way of adding colour would have been encaustically, i.e. 'burning in' pigments with hot wax.

Modern techniques of spectroscopic analysis and ultraviolet fluorescence photography have enabled researchers to go further in establishing original paintwork. Thanks to such scrutiny, it has become clear that statues were not only painted, but periodically repainted: so the well-known 'restoration' of the 'Peplos Kore', as exhibited in Cambridge since the 1970s, is not the only possible version: the statue's garments evidently also (at one time) featured a painted rendition of woven or embroidered figure scenes. And awareness of such ornament may be germane, in some cases, to understanding the ancient significance of a sculpture. If the Peplos Kore once wore a painted robe richly figured with animals, does that suggest she was no ordinary 'maiden', but an image of the goddess Artemis – with an extended left arm holding not a pomegranate, rather a bow?

Research into pigments used points to a range of mostly inorganic sources, from minerals or natural earth substances such as ochre, with some synthetic mixtures (e.g. 'Egyptian blue' – a compound of calcium, silicium and copper), and a few organic derivatives ('vine black', for instance, is extracted from the carbonized remains of that plant). That 'loud' colours were preferred, such as cinnabar red (from mercuric sulphide), seems incontestable. It has to be admitted

that modern attempts to replicate the original effect of brightly painted and intact statues are, by and large, hideous to behold. This may be partly due to the wish of some modern scholars to shock us – with a resort to unsubtle colours, thickly applied – but it also speaks to the power of our habituated Western aesthetic penchant for 'pure' form.

We may prefer to contemplate the more muted effect of residual hues when weathered by age (Plate IV).

The evidence about colour may go so far as to attest a division of labour, with Pliny (*NH* 35.133) suggesting that the handiwork of a painter (*grapheus*) was part of a really fine statue. An Apulian krater in New York shows a statue of Herakles being painted – or repainted – by a specialist in the encaustic technique: he appears to have a servile assistant to prepare the pigments.

Finally, and in connection with this discussion of the ancient 'ornamental order' (*kosmêsis*) of sculpture, we should mention the evidence for one further mode of enhancing sculpture, namely gilding. It is hard to quantify how many statues were once embellished with gold leaf, since the residual particles of such treatment will usually only be revealed by the intense magnification of spectrometric analysis. However, if the island of Delos provides a fair sample, the practice may have been quite common: a number of pieces have been found to carry traces of the process, including the well-known marble after Polykleitos' Diadoumenos.

Sources and further reading

A digest of current views on the technical aspects of Greek sculpture is given in O. Palagia ed., *Greek Sculpture: Function, Materials, and Techniques in the Archaic and Classical Periods* (Cambridge 2006): this also contains full reference to specialist studies about the working of marble, bronze and other materials.

Origins For an example of national bias in the discussion, see E. Akurgal, *The Birth of Greek Art* (London 1968). The quotation from J.G. Herder comes from his *Auch eine Philosophie der Geschichte* (ed. M. Rouché [1774]), 144–6; see also A. Potts, 'Herder's *Plastik*', in J. Onians ed., *Sight and Insight* (London 1994), 341–51.

Daedalus F. Frontisi-Ducroix, *Dédale: mythologie de l'artisan en Grèce ancienne* (Paris 1975); a more complex reconciliation of myth and archaeology is S. Morris, *Daidalos and the Origins of Greek Art* (Princeton 1992). I have quoted from the review of this book by S. Sherratt in *Antiquity* 67 (1993), 915–16. On the disparagement of *banausic* activity, see R. Mondolfo, 'The Greek Attitude to Manual Labour', *Past and Present* 6 (1954), 1–6, and M. Pipili, 'Wearing an Other Hat', in B. Cohen ed., *Not the Classical Ideal* (Leiden 2000), 153–79.

Precedents The Palaikastro statue published in J.A. MacGillivray, J.M. Driessen and L.H. Sackett eds., *The Palaikastro kouros* (British School at Athens 2000) – where the piece is argued to represent a divinity: Diktaian Zeus or Orion.

Sculpture in wood Literary evidence surveyed in R. Meiggs, *Trees and Timber in the Ancient Mediterranean World* (Oxford 1982), 300–24; see also A.A. Donohue, *Xoana and the Origins of Greek Sculpture* (Atlanta 1988). Little has been said here about statuary composed with piecemeal stone parts (*akroliths*): for a discussion of two fine examples of this technique, see C. Marconi, 'Gli acroliti da Morgantina', *Prospettiva* 130/1 (2008), 2–21.

Egyptian influence The most forthright assertion – devil's advocate, perhaps – of indigenous development remains R.M. Cook, 'Origins of Greek Sculpture', *JHS* 87 (1967), 24–32 – arguing against R. Carpenter's *Greek Sculpture* (Chicago 1960), 3–26.

Samos *kouros* H. Kyrieleis, *Der grosse Kuros von Samos* (Bonn 1996). For the Oriental bronzes from Samos, U. Jantzen, *Ägyptische und orientalische Bronzen auf dem Heraion von Samos* (Bonn 1972).

Armoury J.F. Kenfield, 'The Sculptural Significance of Early Greek Armour', *OpRom* 9 (1973), 149–56.

Polychromy My sub-heading borrows the title of an anthology of essays published to coincide with a major touring exhibition, *I colori del bianco* (Rome 2004). Notes on technique in D. von Bothmer, 'Enkaustes Agalmaton', in the *Bulletin* of the Metropolitan Museum 9 (1951), 156–61. The leading voice recalling ancient polychromy is Vinzenz Brinkmann, author of *Polychromie der archaischen und frühklassischen Skulptur* (Munich 2003): see also Brinkmann ed., *Bunte Götter* (Munich 2004), and Brinkmann ed., *Gods in Color* (Munich 2007). On coloured marbles, L. Lazzarini, *Poikiloi lithoi* (Pisa 2007).

Gilding The Delian evidence presented by B. Bourgeois, P. Jockey and A. Karydas in *Asmosia* 7 (*BCH* Supplement 51, 2009).

With the aid of ancient literature and illustrations the expert may be able to restore in his mind's eye the activities in house or market, the visitors who entered the temple with their offerings, the long processions which led to it at the festivals, and the varied disarray that filled now empty spaces. But the best-trained imagination has its limitations. Take, for instance, that altar-stone outside the temple – it rises grey and worn, with flowers in the crevices and round about, amid grass and aromatic bushes gay with butterflies and bees: here the Greeks heard the bellowing of frantic cattle, watched the flies blacken the widening carpet of blood, and smelled a reek that was fouler than in any slaughter-house.

A.W. Lawrence, *Greek Architecture*
(Yale 1996), 212

4

ANATHÊMATA: GIFTS FOR THE GODS

Most Greek sculpture was originally intended for installation in one sanctuary or another; and it is obligatory for us to remind ourselves that however 'picturesque' the ruins of a Greek sanctuary may now appear, what we know of ancient Greek cult practice is not pretty. The principal activity within cult precincts was animal sacrifice: the killing of cattle, sheep, goats and pigs was carried out on a daily basis, and occasionally on a large scale (a deity honoured as *hekatomboios*, such as Zeus at Olympia, was literally 'worth a hundred oxen'). Slaughtering techniques were basic – an axe-blow to the skull, and/or a knife-slash to the throat – and beyond the sight of blood, the smell of death and the shouts of worshippers, we must add the piercing sound of animals in panic. A detail of the Parthenon frieze, poetically saluted as 'that heifer lowing at the skies' (in Keats' *Ode on a Grecian Urn*), patently evokes that panic (Figure 4.1).

Figure 4.1 *Detail of Parthenon frieze (south side, slab XLIV). Cows and sheep are the sacrificial animals figured in the procession of the frieze: on this side, 10 cows were shown, probably as a decimal proportion of the 100 regularly offered to Athena at the Panathenaic Festival. Each beast is accompanied by handlers, and some animals look distinctly restless: it is hard to accept the suggestion that this anxiety is really an eagerness to be first to the altar. Date c. 440 BC.*

It was Christian doctrinal disdain for this custom that caused the formal closure of many Greek sanctuaries in the late fourth century AD

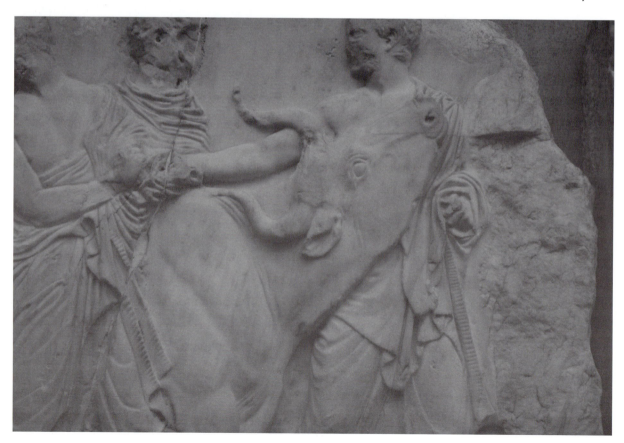

(Christ's own blood was sufficient: *cf.* Hebrews 10.12). But of course the practice of animal sacrifice is only one aspect of Greek sanctuaries that creates a categorical and imaginative distance between ourselves and the past. We now tend to separate 'religion' from day-to-day business in a way that immediately makes it difficult for us to sympathize with a society in which the distinction between 'the sacred' and 'the secular' was often obscure. Ancient Greece, arguably, was like that; and whatever the relative status of matters that were deemed 'sacred' and those that were not, the fact remains that a predominant quantity of Greek sculpture comes from sanctuaries: so the challenge of understanding Greek sculpture must include the effort of recreating, in the mind's eye, how the sanctuaries of Classical antiquity once flourished and, in particular, how far the presence of sculpture contributed to their prodigious, albeit transient, success.

Anathêmata, 'things set up', is the generic Greek term for these offerings: the lexicon reminds us that in archaic usage – for Homer, at least – the meaning more broadly entails 'ornaments' that bring delight: to mortals and deities alike.

The economics of idolatry and the archaeology of cult

In the late second century a Stoic scholar called Polemon compiled descriptions of *anathêmata* to be seen at various sanctuaries, including Delphi – but only fragments of this work survive (*FHG* 3.108–48). A lengthy inscription from Rhodes, the so-called 'Lindian Chronicle', dated to 99 BC, shows the efforts of officers at one sanctuary – that of Athena at Lindos – to document a history of past dedications at the site. And, of course, we have our faithful Pausanias. Yet even when Pausanias was making his travels around the sanctuaries of Greece, as we have noted (p. 5), the process of ruination was under way. Votives, evidently, were not permanent even during antiquity.

So how much have we lost? Nowhere indicates the enormity of this question better than the site of the sanctuary of Artemis at Ephesus in Asia Minor. One of the ancient 'Seven Wonders', the temple at this site was already a byword for size and opulence in the sixth century BC; for over the subsequent 800 years its sacred status was maintained by priests, pilgrims and donors. What remains today, however, seems a stark lesson in fallen grandeur: a solitary column, reassembled in the middle of some swampy ground; a nesting-place for storks.

Archaeologists are making amends. Austrian excavations at the temple site have established, for one thing, that the cult statue within the Artemision was probably a simple *xoanon* of ebony wood, legendarily 'fallen from Zeus' (*diopetes*), and rendered extraordinary by being festooned with globules of amber. This seems to be the iconographic basis for the statue type known as the

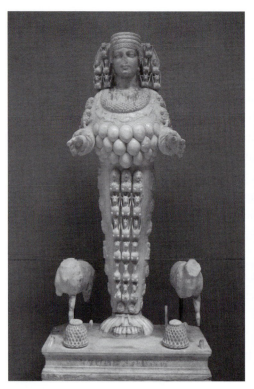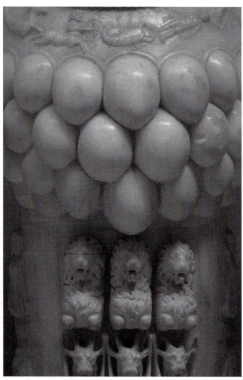

Figure 4.2a, b *Artemis Ephesia: marble figure based on the 'cult image' of Artemis at Ephesus, found in the Prytaneion in the city of Ephesus; with detail. Second century AD. Ht 1.74 m. A hundred or so statues of this type have survived. Many show Artemis holding two animals on leads, suggestive of her reputation as 'Mistress of the Beasts' (Potnia Thêrôn). A common feature is the turreted polos headgear, indicating her role as a Tyche figure for Ephesus (cf. p. 271).*

'Artemis Ephesia' (Figure 4.2a, b), in which the amber globules appear rather to suggest a figure of the goddess as 'many-breasted' (*polymastos*). This is not a definitive explanation – for one thing, there are no nipples marked – but historically it suited the detractors of pagan religion to accentuate the 'licentious' aspect of the Artemis cult. A yet more fantastic view of the 'bulbs' takes them to derive from bulls' scrota, presumably given to the cult statue after sacrifice. In fact the visual ancestry of this statue-type can be traced back to the cults of prehistoric Anatolia, indicating that the Artemis worshipped at Ephesus was effectively 'syncretized' or assimilated with an older divine 'Mistress' (*Potnia*) of the region. Nonetheless, the resultant image must have seemed bizarre to many visitors – and in particular, visitors of Jewish, Christian or Zoroastrian faith, whose practice, as we have noted, was essentially non-idolatrous (see p. 43).

In the course of his Christian mission St Paul came to Ephesus *c.* AD 54 and spent a little over two years in the area. The New Testament records how he disputed with Greek philosophers, ministered to the sick, preached to both Greeks

and Jews locally, and organized bonfires of their books: thus 'the word of the Lord increased and prevailed' (Acts 19.20).

But not without some controversy: an episode that tells us a good deal about the nexus of sculpture and worship in the Classical world. There was at Ephesus a certain silversmith called Demetrios, who specialized in making miniature silver shrines of Artemis. He convened an assembly of his fellow *technitai* and pointed out the threat that this preacher was posing to their livelihoods. A part of Paul's message, Demetrios rightly saw, was that 'there are no gods which are made by hands': and if this message gained popular acceptance, then not only would local craftsmen be out of business, but the goddess Artemis, worshipped both in Asia and abroad, would be insulted. Demetrios succeeded in raising an uproar: rallying to the cry, 'Great is Artemis of the Ephesians!', a crowd rushed into the theatre at Ephesus in what appears to be an attempt to lynch the apostle (Acts 19.23–41).

Partly by virtue of Paul's discretion in lying low and shortly afterwards slipping away to Macedonia, but mostly by the calming invocation of Roman law, the situation was defused. Paul was judged legally blameless of either 'temple robbery' (*hierosylia*) or blasphemy. Yet anyone coming to this incident with an archaeological knowledge of Greek religion will see why Demetrios and other Ephesians were so provoked. Theological hostility towards the fabrication of sacred images would not only lead to the demise of an artistic tradition – and a lively trade – but also bring about the eclipse of a long-established deity. The local combination of Artemis with a 'Mistress' or 'Mother Goddess' of greater antiquity (perhaps to be associated with Cybele), and the likely veneration of Artemis as the tutelary spirit of the city, can only have made the issue more explosive.

On the other hand, many readers of this book will belong, like its author, to a broadly Judaeo-Christian background, or else (and also, perhaps) adhere to the modern tradition of scientific rationalism. As such, we may side with Paul and take a sceptical view of the operations of Demetrios and the priests who encouraged his activity. It is easy to suppose that pilgrims to the Artemision were thoroughly fleeced, cajoled into believing that the great Artemis would heal their afflictions, gratify their desires, punish their enemies or make their crops grow – just so long as they were liberal with offerings for sacrifices, libations, votives or souvenirs. We may, like Paul, condemn this brazen manipulation of credulity or go further and dismiss it in Marxist terms as a sort of 'opium of the people' administered by a cunning and controlling priesthood in league with political authority.

We have approached the phenomenon of votive statuary by the ideologically unsympathetic route of modern rationalism and Christian disapproval; it is time to listen to the testimonies of original cult practice.

A simple epigram attributed to the third-century poet Callimachus (*AP* 6.347) may be typical of sentiments attached to gifts made to deities by the ancient worshippers at Greek sanctuaries: 'Artemis, to you Phileratis dedicated this image here: May you accept it, Mistress, and keep her safe.' An image (*agalma*) has been brought to an altar and left there with a request – for some favour from the deity. Multiply this votive act by many thousands and it soon becomes obvious why Paul's mission at Ephesus was so controversial. But of course it is not easy to guess just what was in the mind of Phileratis when she made her votive offering. Possibly she shared the faith voiced by Callimachus in his *Hymn to Artemis* – saluting the goddess as fierce yet not implacable: a goddess with special concern for women and maternal welfare. Or was this Phileratis, as we might say, merely 'going through the motions' of customary observance? And if this is a dilemma for us, was it necessarily so in the past?

The collection of Classical statuary at the Fitzwilliam Museum in Cambridge includes the upper part of a colossal caryatid (Figure 4.3). It is in a battered state,

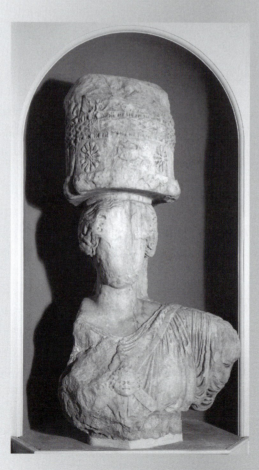

and most visitors to the museum pay it little regard, which is a pity, for a great deal of trouble was taken to bring the piece from Greece to Cambridge. Its Greek site was Eleusis, ancient home of a powerful cult to Demeter ('the Mysteries'), where the statue's presence had been noted by a British botanist, George Wheler, on his travels with a French antiquarian, Jacob Spon, in 1678. Wheler and Spon could claim to have 'discovered' the statue and 'identified' it as Ceres or Demeter. But although the statue was weathered, it was by no means lost or obscure to those living in its vicinity.

Figure 4.3 *Upper part of a colossal caryatid from the Inner Propylaea at Eleusis; probably late first century BC. Ht 2.09 m. The figure carries the kista or round box in which holy items for the Eleusinian 'Mysteries' were contained. (Part of a 'twin' statue is preserved at Eleusis Museum.)*

Another traveller, Edward Dodwell, visiting Eleusis in the late eighteenth century, reported seeing the figure 'in its full glory, situated in the centre of a threshing-floor' and tells us that the local farmers 'were impressed with a persuasion that their harvests were the effect of her [the statue's] bounty'. Previous attempts by predatory tourists to remove the statue had failed: having been dragged to the port for embarcation, 'Demeter', according to the locals, had magically flown back to where she belonged.

'Like the virgin of Loretto [sic]', comments E.D. Clarke – the man who eventually succeeded in transferring the statue from Eleusis to Cambridge. His strategy for wresting it away from its credulous keepers was simple and ruthless:

I found the goddess in a dunghill buried to her ears. The Eleusinian peasants, at the very mention of moving it, regarded me as one who would bring the moon from her orbit. What would become of their corn, they said, if the old lady with her basket was removed? I went to Athens and made an application to the Pacha, aiding my request by letting an English telescope glide between his fingers. The business was done.

W. OTTER, *LIFE AND REMAINS OF REV. E.D. CLARKE* (LONDON 1824) 505

Neither an 'enlightened' British scientist – Clarke would become a Professor of Mineralogy at Cambridge – nor a Muslim governor – the Turkish 'Pacha' referred to by Clarke is the same person who would later allow Lord Elgin to take 'one or two pieces of stone' from the Athenian Akropolis – could care very much for residual Greek faith in sacred statues. (As if to prove a point, Clarke returned to Eleusis a year after his removal of the fertility-bringing goddess and claimed that, despite her absence, there had been a bumper harvest.)

It is beyond the scope of this book to explore at length the tension that existed in antiquity between 'faith' and 'reason'. We know that such tension *did* exist: reference has already been made (p. 43) to the strictures of Xenophanes regarding divine images, and in general the pre-Socratic philosophers have been described as 'ignoring with astonishing boldness the prescriptive sanctities of religious representation'. It is also worth mentioning the peculiar and sometimes 'adversarial' rapport that prevailed at the therapeutic sanctuaries of the god Asklepios, where the tradition of 'faith-healing' may seem to sit uncomfortably with the development of 'clinical' medicine attributed to Hippocrates and his followers from the fifth century BC onwards. The Greek language itself perhaps betrays a basic unease with the protocols of established cult when it allows an ambivalence to the word *deisidaimonia*, which can signify either a healthy 'respect for the gods' or an unhealthy 'superstition'.

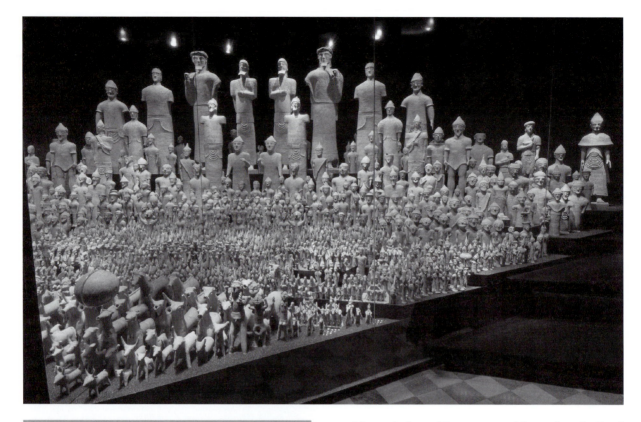

Figure 4.4 *Terracotta votives from Ayia Irini (Akdeniz), Cyprus. The Ayia Irini ensemble includes not only anthropomorphic and animal figures, but also some fantastic creatures (e.g. half-man, half-bull). Of the 'human' figures, many appear armed as if for battle, with numerous possible subdivisions of rank and military function; others have been identified as priests. Ht of larger figures is c. 60 cm. Mostly 700–600 BC.*

Nonetheless, if we reconsider what St Paul sought to achieve at Ephesus, we must recognize that his attack on idolatry was aimed at the very heart of ancient Greek religious practice. Images were dedicated in order to record and perpetuate prayers. It may be ambiguous whether such images represent deity or votary, but essentially that does not matter. What matters is that the dedicant leaves within the sanctuary a visible and tangible form of worship.

Archaeological precedents for this basic protocol can be traced in the Near East to at least the early third millennium BC. And the impingement of Near Eastern practice upon the Mediterranean area may be most spectacularly evident on Cyprus, where from some of the island's Iron Age shrines we gain strong impressions about the quantity and quality of votive statuary. In particular, the cult site of Ayia Irini, on the north-west (now Turkish) coast, has shown how a 'crowd' of images might form around an altar (Figure 4.4). Swedish excavators found over 2,000 Archaic terracotta figures *in situ* at Ayia Irini, ranged in a semi-circle around a stone altar: the effect is recreated in museum displays in Nicosia and

Stockholm, with dedications arranged in order of size, from diminutive (at the front) to about one-third lifesize (at the back).

Remains of some fifty terracotta figures found on the northerly Cycladic island of Kea (Keos) – from a site also called Ayia Irini – suggest that the practice of representing votaries and deities by statues was established in the Aegean during the Bronze Age (*c.* 1500 BC), with some Minoan–Mycenaean precedent perhaps attested for the processional use of such statuary – *theophoria*, or 'god-carrying', as it would eventually be termed. Of the well-known Greek sanctuaries, Olympia provides firm evidence for votive offerings becoming habitual practice by the eighth century; and if no Classical site has yet yielded a host of figures to match those from Ayia Irini on Cyprus, this may only be because popular Greek sanctuaries had to be periodically decongested of their statue populations. The enthusiasm of dedicants could cause practical problems of access and movement within the *temenos* or sacred enclosure of a sanctuary. From the Asklepieion on Rhodes comes a third-century decree regarding votive donations which includes the following rule:

No one is permitted to request that an image [andrias] be raised, or some other votive offering [anathêma] be set up in the lower part of the sacred precinct ... or any other place where votive offerings might obstruct the passage of visitors.

Yet ostentation was an essential facet of personal piety: so we are obliged to indulge the enormous quantity of votive offerings in an ancient sanctuary as the accumulated 'showing off' of pilgrims and worshippers who had no desire for gaining divine favour in secrecy. It is in a satirical context that we find the caricature of 'Petty Pride', *Mikrophilotimia*, embodied by a man who 'having dedicated a bronze finger or toe at the temple of Asklepios, is sure to polish it, wreathe it, and anoint it every day' (Theophrastus, *Characters* 21; see p. 257); but this satire only works because it was generally understood that *philotimia*, 'love of honour', could be signalled by the size and quality of an offering, whether it be in the form of a wreath, some fruit or harvest, an animal for sacrifice, an attribute of the deity – or a statue. And of all these gifts to the gods, statues not only had the potential for long-term display – but also offered the possibility of catching, and perpetuating, a 'presence': human or divine.

Votive occasions and votive sculpture

Misfortune or success: these were the two basic motives for votive dedications, expressing respectively hope or gratitude to higher powers (*cf.* Plato, *Laws* 909e). But before we proceed to compile a more precise catalogue of sculpture commissioned with overt devotional intent, we should remind ourselves that all gifts to the gods were made in the

spirit of reciprocity, or 'commerce' (*emporikos*). The gods grant favour; mortals either beseech or thank them for such favour; and this exchange is of mutual benefit, with mortals offering honour and gratitude in return for happiness and security (*cf.* Plato, *Euthyphro* 14). Accordingly, the sentiments of votive dedications often have a pseudo-contractual tenor to them, even when expressed in verse, as in the following lines saluting a goddess 'helpful in childbirth' (*eulochos*): 'Come again, Eileithyia, answering the call of Lykainis, alleviating her birth pangs and giving a trouble-free delivery. Just as you have now received this, lady, as thanks for a daughter, so will your fragrant abode receive something else in thanks for a son' (Callimachus, *Epigr.* 54).

Gifts to the gods are therefore usually made either in a spirit of gratitude or else on a conditional basis. By establishing a reciprocity of favours, in Walter Burkert's words, 'the insecure future is psychologically mastered'. With this in mind we may now survey the various occasions when votive dedications were made and give some examples of the statuary generated by such custom. (The headings that follow offer specific categories: overlaps, however, are always possible.)

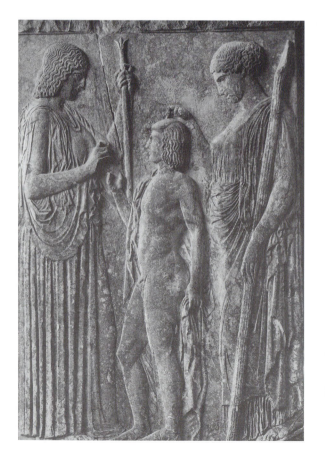

Tithes and first-fruits Any deity might be rewarded for ensuring a good harvest, or invoked to do so in the future, by dedicating a share of agricultural produce – a 'tithe' (*dekatê*, 'one-tenth') or the 'first-fruits' (*aparchai*). The piety implicit in this gesture is surely evoked in a number of Roman copies of Hellenistic statue-types that show aged 'rustics' carrying foodstuffs or livestock: including, perhaps, the well-known so-called 'Old Market Woman' in New York, whose wicker basket is filled with cheeping chicks. It was incumbent not only upon farmers and peasants to offer such tribute: a craftsman

Figure 4.5 *Relief from Eleusis, c. 440 BC. Ht 2.20 m. Demeter, one hand raised to hold a sceptre, gives a sheaf of grain (originally added in metal, probably gold) to the young Triptolemos (once wearing a gold crown). Behind Triptolemos stands Persephone (also known as Kore, 'maiden'), cradling a torch and blessing the youth.*

might present some sample of his skill; a trader, some portion of his goods; and so on. A nice example comes from the Athenian Akropolis, where in the late sixth century a potter (Euphronios or Pamphaios may be his name) dedicated a relief showing a seated figure flourishing two drinking-cups – a memorial, most probably, of two vessels left at the sanctuary for Athena's benefit. But of course Demeter's cult was particularly appropriate for the dedication of first-fruits, given the mythology which evolved around the abduction and seasonal return of her daughter Persephone. At Eleusis we find sculptures articulating gratitude with the imagery of this myth: for instance, by representing the moment at which a young local prince, Triptolemos, is entrusted with receiving the gift of grain from Demeter – along with the mission to instruct mankind in the skills of agriculture (Figure 4.5).

THE SIPHNIAN TREASURY

The principle of tithing was not confined to agriculture. During the sixth century, the small island of Siphnos in the Cyclades enjoyed a period of heightened prosperity thanks to the local extraction of precious metals. We might call it a 'windfall': since mining was delegated to slave labour, the enrichment of citizens was direct. Accordingly, the Siphnians rendered a portion of their good fortune to Apollo at Delphi, where, as Herodotus notes (3.57), they endowed a treasury 'as valuable as any to be found there'. A fire had swept through Delphi in 548 and rebuilding was probably still in progress when c. 525 the Siphnians were able to secure a prominent position within the sanctuary: a bastion by the lower reaches of the Sacred Way – the processional route that had to be followed by all pilgrims making their way up to the oracular temple of Apollo.

Located during excavations in 1894, the Ionic Treasury of the Siphnians deserves the term *bijou* to convey its charmingly precious aspect – and substance. It showcased the qualities of island marble both as a construction material and a surface for embellishment. (The cost of shifting so much marble from the Cyclades to Delphi must have been 'awesome'.) What visitors saw as they ascended the Sacred Way was the east-facing back of the building – with a pedimental scene of Apollo and Herakles struggling over the Delphic tripod, and, below that, a frieze of fighting at Troy (the moment when the

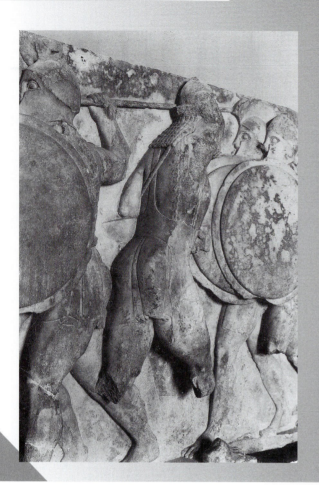

Figure 4.6 *Detail of the north side of the Siphnian Treasury frieze: Hermes (identified by a partially legible inscription on the baseline) in combat with Giants (equipped with helmets and shields). Ht. 64 cm.*

gods decide the fate of the Trojan ally Memnon). However, the frieze as it ran along the north side was effectively the most visible: and here it showed male and female Olympians confronting Giants armed and serried in formation like hoplites (Figure 4.6). The 'contemporary' appearance of the Giants has encouraged suggestions of a highly specific allegory of political strife here. But perhaps most visitors to the sanctuary were content to read the decoration of the Treasury as illustrative of nothing less than divine superiority and, over time, as Pausanias records (10.11.2), a symbol of divine nemesis – for the greed of the Siphnians caused them to neglect their obligation of a tithe, and the mines were duly ruined by inundation.

War To deities belonged a share of the spoils of war; or else, with battle imminent or in progress, deities were to be enjoined by gifts to take one side or the other. (Any Greek familiar with the *Iliad* knew that the Olympians were not aloof from human quarrels.) The inventories of the Parthenon reveal that the temple was cluttered with signs of military success: shields, missiles, spears, breast-plates, helmets, greaves, swords and bridle-bits – either captured from an enemy or deposited by thankful veterans. A nineteenth-century reconstruction of the temple of Apollo at Bassae, showing trophy-stands between the interior columns, is perfectly credible in this respect (Figure 4.7). In the more open spaces of a sanctuary, prows of ships might be displayed, festooned with naval paraphernalia. Greeks did not celebrate triumph with the spectacular formalities developed by the Romans, nor erect triumphal arches as such; but other modes of commemoration were imaginatively pursued.

The establishment of 'treasuries' (*thesauroi*) at Olympia and Delphi shows us one such mode. We know that military hardware was put on display at these small but highly conspicuous buildings, and that is important to remember when

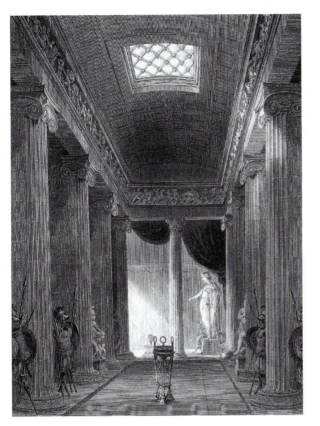

assessing their sculptural decoration. Of the treasury put up at Olympia by the Megarians, Pausanias relates: 'On the pediment of the treasury is represented the battle between the gods and the Giants, and above the gable is a shield with an inscription stating that the treasury was dedicated by the Megarians from the spoils of the Corinthians' (6.19.13). Though we remain unsure about the historical conflict between the two city-states, it is likely that the reliefs offered a sculptural motto for Megara's victory.

The Greek habit of aggrandizing victory by investing it with some mythical analogue is a phenomenon we shall explore more thoroughly elsewhere (Chapter 6). A lesser but nonetheless typical example is the memorial at Olympia mentioned by Pausanias (5.26.7) dedicated by the colonists of Heraklea Pontica who, having vanquished a 'barbarian' tribe in their vicinity (on the southern shore of the Black Sea), celebrated victory by presenting images of selected Labours of Herakles – the mythical founder of their settlement.

The heroization of historical personages did not necessarily depend upon mythical association. It could be achieved by the simple representation of divine sanction. This explains the remarkable assembly of bronze statues set up at Delphi by the Spartans in the wake of their naval encounter with Athens at Aegospotamoi in 405 BC – an encounter which brought to an end the Peloponnesian War. It showed the Spartan commander, Lysander, along with his pilot and his soothsayer, surrounded by partisan deities: Zeus, Apollo, Artemis, the Dioskouroi – with Poseidon, of course, conferring a crown upon Lysander – and no fewer than twenty-eight named captains of Lysander's fleet. The inclusion of the soothsayer is a significant reminder of the importance of oracular cult in military affairs; and it could be argued that the crowd of Spartan and allied admirals goes some way to 'democratizing' the glory of Lysander. All the same, the inscription recovered from the base of the monument, an epigram composed by Ion of Samos, left

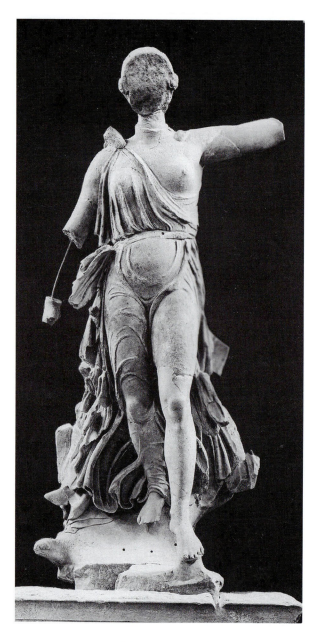

Figure 4.8 *The Nike of Paionios, c. 420 BC. Ht of statue without base 1.95 m. Recovered in 1875 from the Altis of Olympia, the statue (once brightly coloured) stood on a triangular pillar partly decorated with shields in relief. The figure's extended left arm held out her himation, to billowing effect; a palm-branch was probably cradled in her right hand. The inscription names the Naupaktians as co-dedicants with the Messenians; the phrase naming the sculptor specifies that he too 'was victorious' (enika) – in a contest to make not only this piece but also the akroteria of the temple.*

passers-by in little doubt that Lysander, as dedicant, was strategically responsible for making Sparta 'the akropolis of Hellas' – an emphatic claim in the surrounds of this major Panhellenic site.

Commemoration of victories over foreigners was eminently suitable for Panhellenic sanctuaries: at Delphi, therefore, the Athenians marked their success against the Persians in battle by the River Eurymedon (in 469 BC) with a bronze palm tree bearing not only fruit in its branches, but two of Athena's owls; a gilded image of the goddess stood nearby (Pausanias 10.15.3). But declarations of military prowess manifested by one Greek city-state over another gained particular piquancy in a Panhellenic location – especially when juxtaposed. At Olympia, for example, the Spartans had erected a statue of Zeus, 3.6 m. high, in the early fifth century, after quelling a rebellion by citizens of their subject state, Messenia. This was placed near the temple of Zeus with the accompanying inscription: 'Accept, Lord, son of Kronos, Olympian Zeus, this fine statue; and bless the Lacedaimonians [Spartans].' Yet the Messenians were not finished. During the Peloponnesian War, in 425 BC, they joined an Athenian-led attack upon the Spartan garrison-island of Sphakteria, near Pylos; and they marked the success of this raid in spectacular fashion. A tithe of the spoils from Sphakteria funded the commission of a sculptor called Paionios, from Mende in northern Greece, to install a marble personification of winged Victory (*Nikê*) in the same precincts at Olympia once favoured by the Spartans (Figure 4.8). The inscription at the base of the base,

which raises the statue to about thirty feet (8.8 m.) high, stops short of identifying the enemy (and indeed the occasion of conflict, leaving even Pausanias in some doubt: 5.26.1). Given the proximity of monuments generated by such long-term inter-Greek hostility, it hardly needed spelling out.

Games and contests In George Orwell's memorable phrase, sport may be defined as 'war minus the shooting'; and some nineteenth-century scholars (including Nietzsche) chose the ancient Greek concept of an *agôn* or 'contest' as definitive of ancient Greek culture generally. Whether or not the Greeks rationalized athletics as a sublimation of human aggression, it is true that they respected 'Strife' (*Eris*) as a divine force with creative no less than destructive effects (Hesiod, *Works and Days* 11–26). Competitions were held in numerous and diverse areas of mortal endeavour: so not only in racing chariots, performing acrobatics, or throwing a javelin, but also (for example) reciting a poem, playing an instrument, staging a play, or turning a vase on the potter's wheel. Victory meant prizes, similarly varied in nature – tripods, crowns, jars of oil and so on; and all of these were available for votive display, not to mention objects involved in the contest (e.g. a discus). But sculptors did not just take part in their own contests of sculptural skill (see p. 39). They were also on hand to contribute to the commemoration of winning as winning deserved: with due acknowledgement to the gods.

The colossal image of Zeus created by Pheidias for the temple of Zeus at Olympia showed the god *Nikêphoros* – holding Victory like a doll in his right hand (see Plate VI). The poetry produced in honour of individual victors makes it clear that while mortals earned praise for their efforts, victory was nonetheless a gift from on high – and, as such, required gratitude. Such poetry, associated with the names of Pindar, Bacchylides, Ibycus and others, is called 'epinikian' ('victory-related'). We may borrow this literary term to encompass the vast quantity of sculpture generated by the custom of marking victory with a prize – or rendering thanks for victory *ex voto*.

The tradition of epinikian statues began in humble fashion. From early deposits at Olympia there survive thousands of miniature figures of horses and oxen (*cf.* Figure 2.3), many relating to a period when the site served perhaps as a venue for livestock-breeders to test their animals. Formal 'Games' at Olympia, conventionally dated to begin in 776 BC, evolved only gradually into a fixed sequence and duration by the early fifth century. By then, the scale of individual offerings had greatly increased, and not only at Olympia. The well-known charioteer figure from Delphi (Figure 4.9) is a thanksgiving for victory in a race, in either 478 or 474 BC, from Polyzalos, brother of Gelon and Hieron, the tyrants of Syracuse; and a similarly dressed marble figure recovered from Motya seems to have been part of a comparable chariot-victory dedication (Figure 4.10).

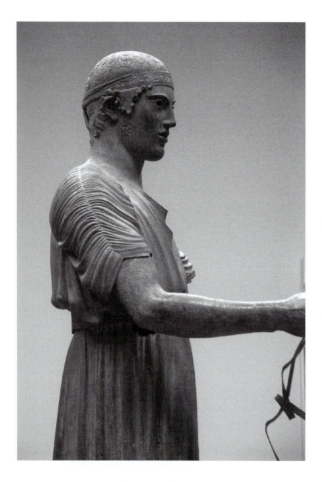

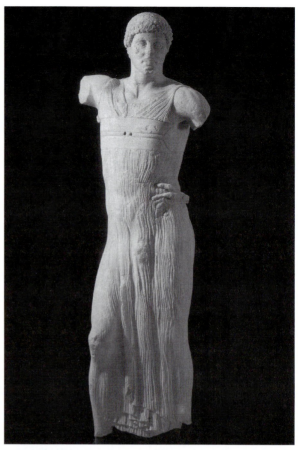

Figure 4.9 *The Delphi Charioteer, c. 474 BC. Ht 1.8 m. The reins in the right hand are relics of a group that included four horses, and one or two stable-boys, perhaps leading reserve horses. It is not clear if another figure stood beside the driver in the chariot; nor can we be sure that the accompanying inscription ('Polyzalos dedicated me: favour him, O glorious Apollo') means that victory belonged to Polyzalos or his elder brother Hieron. The fragments (found in 1896) survive because they suffered in an ancient landslide – but the group was once prominent on a base just to the north of the temple of Apollo.*

Figure 4.10 *The Motya kouros, early fifth century BC. Ht 1.81 m. Motya, a tiny island in a lagoon just off the western tip of Sicily, was the site of a Phoenician settlement. This provenance has led some scholars to suggest a Phoenician cultic identity for the statue – an image of the god Melqart, perhaps. The figure is hardly a kouros in the formal sense, and the drapery is stylistically distinct. Yet it seems close to Greek ideals and craftsmanship. The long tunic (xystis) of a charioteer is carefully modelled to show the lineaments of a proud athlete: a raised right arm may well have been holding a victory crown. The most likely explanation is that this was part of a monument raised in honour of a victorious athlete from one of the Greek colonies in Sicily (quite possibly Syracuse), subsequently seized as booty in the course of Phoenician–Greek hostilities.*

It is a moot point how often the owner of a chariot-team was actually the driver; and a moot point, too, how far a successful athlete is individualized by a commemorative statue. An early (sixth-century) statue-base from Olympia (*CEG* 394) specifies that the image it carries is 'equal to the

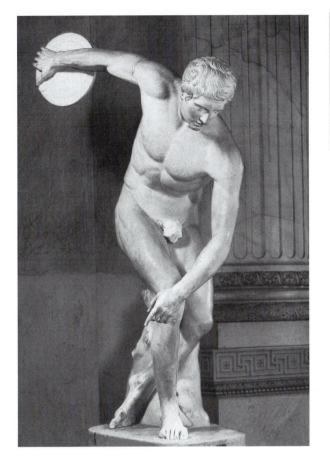

Figure 4.11 *Myron's Discobolus: marble version (c. AD 140) of a bronze original made c. 455 BC. Ht (to head) 1.27 m. Much replicated and famed by the Romans (e.g. Quintilian, Inst. Or. 2.13.8), Myron's 'freezing' of athletic torsion is deceptive: the upper part of the body is captured at a different moment of the discus-throw from that of the lower, creating a poised dynamic. This is the 'Lancelotti' type discovered in 1781 on the Esquiline (see also p. 321).*

height and sturdiness [*pachos*]' of the victorious athlete. A passage in Pliny (*NH* 34.4.16) implies that portrait features were only granted to athletes who had triumphed three times. What seems certain, however, is that the right to offer a votive statue was intrinsically part of victory's reward. To attempt a distinction between what was truly votive and what looks like sheer self-promotion is probably futile: after all, the successful athlete has gladdened the gods by his performance, while earning the right to express a personal sense of achievement. (Although an athletic victory undoubtedly brought glory to the athlete's city-state, the record of inscriptions indicates that relatively few statues at the Panhellenic sites were commissioned overtly at the behest of an athlete's homeland.)

That sculptors would set up 'shop' at the sites of major athletic festivals for the purpose of meeting votive commissions is highly likely. The bronze-worker Pythagoras, although originating from Rhegion in south Italy, must have maintained some kind of operational base at Olympia, for his epinikian statues are recorded at almost every Olympiad between 484 and 452 BC (his presence is attested at Delphi, too). Among the epinikian specialists prominent at Olympia from the late sixth to mid fifth century are Hageladas, Glaukias and Kalamis (the latter renowned for equestrian groups); but the two names pre-eminent in the art-historical record are Myron and Polykleitos. Neither worked exclusively on epinikian statues; but both must have relied upon the 'statue habit' of commemorating successful athletes as a steady source of income – and each, over time, added much to his own reputation by the dignity he brought to the epinikian genre. In Myron's case, this came from a remarkable gift for conveying the 'movement' (*kinêsis*) of athletes in action. Sources report that Myron even managed to catch a sprinter in full flight; but he remains best known for his 'Discus-thrower' (Figure 4.11), which achieves a three-dimensional

synopsis of the event (once part of the ancient pentathlon – though we do not know the identity of the original athlete). As for Polykleitos, we have already encountered (p. 38) his fastidiously intellectual approach to creating harmony by a system of measurements; here we should add some comment on his stylization of the votive pose.

POLYKLEITAN BASES

Several bases of epinikian statues by Polykleitos have been recovered from Olympia. The information they convey is not, unfortunately, definitive: one base, commemorating the victory of a young boxer called Kyniskos *c.* 460 BC, which Pausanias attributes to Polykleitos, does not actually carry a sculptor's name; others give rise to various epigraphic problems, and in the case of the example reproduced here, we cannot be sure if the 'Polykleitos' inscribed is *the* Polykleitos or rather a pupil (his son or nephew). However, examination of the socket-holes for the statue's feet does permit some speculation as to the pose of the missing figure.

Figure 4.12 *Base of a bronze statue in honour of Xenokles, by Polykleitos, late fifth century. Found incorporated into a Byzantine wall not far from the base of the Nike of Paionios, the inscription sets the name of Polykleitos at an oblique angle to the main aspect of the statue – but the artist's name (POLYKLEITOS EPOI[E]SE, 'Polykleitos made [this]') is nonetheless not inferior in size to that of the victorious Xenokles, here saluted with his father's name (Euthyphronos) and city-state (Mainalos, in nearby Arcadia). An attached epigram helps us to know that Xenokles prevailed in the wrestling by saluting him as aptes (= aptôs, 'not thrown' (by an opponent)); the plant of the feet suggests that the figure may have been shown crouching forward, as if to engage. Ht of base 50 cm.*

One posture of athletic commemoration 'canonized' by Polykleitos was that embodied in a celebrated statue known as *ho diadoumenos*, 'the boy binding his

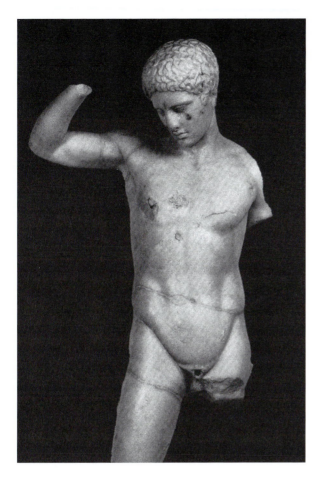

Figure 4.13 *Fragmentary copy of the Westmacott Ephebe made in the first century AD, perhaps after a bronze original by Polykleitos in the mid fifth century. It was Adolf Furtwängler who first proposed that this statue-type, known in numerous copies, be identified with the votive dedication in honour of Kyniskos, victor in the boys' boxing c. 460 BC (IvO no. 149; Pausanias 6.4.11). The proposal remains acceptable, though doubted by some Polykleitan specialists on grounds of style; what cannot be denied is the statue's celebrity and influence, down to the nineteenth century (one of the many Roman copies was once owned by the Neo-Classical sculptor Sir Richard Westmacott, who gave it to an institution of which he was a shaping spirit – the British Museum). Ht 98 cm.*

hair' (Pliny, *NH* 34.55): although a mythical identity for the figure cannot be discounted, we know that victorious athletes were indulged with the pseudo-royal acclaim of adorning themselves with a *tainia* (headband, or 'fillet') akin to the *diadêma* worn by Persian kings. A sixth-century terracotta vessel from the Athenian Agora shows a youth kneeling down as he ties the ribbon; Polykleitos added the element of votive modesty by showing the victor pensive in demeanour and downcast in pose (see Figure 11.6). Such 'temperance' (*aidôs*), as we understand from the epinikian poets, was deemed a sign of piety; it also probably contributed to the erotic appeal of glory. At Olympia, as part of the victory celebrations, athletes were showered with flowers and foliage, so we may expect an epinikian figure to have once carried a palm branch in one hand. But again, from considerations of votive decorum, it is worth questioning whether the gesture of raising one hand should be described as 'an athlete crowning himself' (*autostephanoumenos*): so it has been suggested that the movement we see on the so-called 'Westmacott' type of statue by Polykleitos (Figure 4.13) is actually that of removing the victory-garland – perhaps for dedication in a temple – or else an almost oratorical acknowledgement of acclamation, as if to say, 'Please, no more applause: my triumph I owe to the gods ...'

An individual athlete could be shown receiving the accolades of victory direct from Nike personified, or from one of the Olympians, or from both together. In the case of a team event, such as martial ('Pyrrhic') dancing, or a relay race

Figure 4.14 *Votive relief dedicated by Lysima-chides, late fourth century. The piece was found on the west slopes of the Akropolis, where a shrine to Amynos, a local 'hero-doctor', once existed (and became the site of the city's Askle-pieion). Ht 71 cm.*

with torches, a votive plaque might be dedicated showing some or all of the winning squad.

Illness and calamity Many of the gods could be called upon to assist in crises of personal health and safety; a suitable sobriquet served to define this auxiliary role. Thus Apollo Alexikakos, 'Repeller of Harm'; Artemis Soteira, 'Saviour'; Athena Hygieia 'Health[giving]'. Votive gifts were due to these gods accordingly. It was, for example, as a specific (and generous) gift to Apollo Epikourios, 'the Helper', that the temple of Apollo at Bassae was raised in the mountains of Arcadia *c.* 420 BC, because the god had brought relief from plague – the same epidemic, we suppose, as that which caused great loss of life in Athens *c.* 425 (*cf.* p. 170). But this did not preclude the development of particular healing cults – and a tradition of votive statuary within these cults can consequently be documented.

A fourth-century relief from Athens, set up by one Lysimachides, makes a good introduction to such votives (Figure 4.14). It shows us two aspects of dedicatory sculpture. The first consists in the presentation of modelled body-parts. Many ancient (and some modern) sanctuaries testify to the practice of offering a model of some afflicted body-part – including internal organs. Here we see Lysimachides steadying an outsize image of a leg – presumably his own, probably made in terracotta – which bears obvious signs of varicose veins. That Lysimachides is at some shrine, adding to a stock of similar dedications, is indicated by a pair of feet set in a niche in the background. The size of the leg may be intended to convey the seriousness of the complaint, or the status of the donor – or perhaps the miraculous nature of the cure, for the relief itself fulfils the second votive function of thanksgiving.

Healing cults of the sort frequented by Lysimachides became popular towards the end of the fifth century, in particular those focused upon Asklepios, deemed a son of Apollo but nevertheless a hero whose sense of mortality was keen enough to advance his epic vocation as the 'blameless physician'. Epidauros, legendarily his birthplace, became the principal cult centre of Asklepios, and a chryselephantine

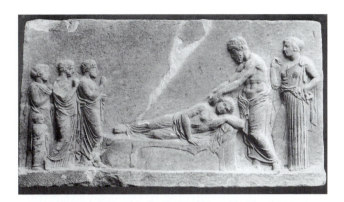

Figure 4.15 *Votive relief from the Piraeus Asklepieion, c. 400 BC. The bearded figure 'laying hands' upon the comatose patient is Asklepios; behind him, one of his daughters – possibly Panacea ('All-Healer'), more probably Hygieia. The figures lined up by the bed must be the family of the patient. Similar scenes of incubation are known for another 'hero-doctor', Amphiaraus, in whose honour a major cult developed at Oropos, on the borders between Attica and Boeotia.*

statue was created there by Thrasymedes in the early fourth century, similar in concept (though not size) to the Olympic Zeus. Another important sanctuary was established on the island of Kos, where 'descendants of Asklepios' (as Greek doctors often styled themselves) included Hippocrates, whom we credit as the pioneer of 'clinical' medicine. In fact it is notoriously difficult to separate a 'scientific' component from the 'faith-healing' apparatus of ancient healthcare; and when we seek to explain a visualization of a cure, such as that shown on a relief from the Asklepieion in the Piraeus (Figure 4.15), we must allow for a combination of the pragmatic and the supernatural. Patients did submit to a regime of sleeping, bathing and the psychotherapeutic analysis of dreams – but surgical intervention, pharmacological remedies and holistic approaches to diet, climate and behaviour may all have been integrated.

Within this category of 'health and safety' concerns must come the diverse monuments of gratitude for escapes from death or disaster. As we shall see, the notion of *Tychê*, 'Fortune', was divinely constructed in antiquity (p. 270); plain 'good luck' did not exist. Plenty of maritime images and items of sea-faring equipment were therefore dedicated in port-sanctuaries by sailors thanking some deity (Poseidon, Aphrodite or others) for safe voyage. Herodotus (1.23–4) relates a charming story about a sixth-century poet called Arion, who after a lucrative tour of Sicily and south Italy was *en route* home to Corinth when he was attacked by pirates and thrown overboard. Arion sang for help; a dolphin obliged; and upon landing safely in the Peloponnese, at the southern peninsula of Cape Tainaron, where there was a sanctuary to Poseidon, Arion gratefully dedicated *ex voto* a bronze figure of a man riding a dolphin. The statue was still to be seen at Tainaron when Pausanias visited (3.25.7). While the story may strain our credulity (and Pausanias feels it necessary to add that he himself has once seen someone astride a dolphin), the act of thank-offering is entirely consonant with ancient practice.

Rites of passage Birth, puberty, maturity, marriage, death: all these stages of human experience are reflected in the votive tradition. Despite their own deplorable record of infidelity, Zeus and Hera were patrons of wedlock. Aphrodite received dedications hopeful of consummation, and the sculptural development of her cult is of great importance in the history of art (see Chapter 8). But above all, the benefit of descendants was what most worshippers sought. Both Hera and Artemis served the function of the nursing deity; another goddess, Eileithyia, whose cult can be traced to Minoan times, might intervene specifically to ensure an 'uncomplicated' childbirth (she may be represented on her knees, a customary birthing position: *cf.* Pausanias 8.48.7). Hestia, keeper of the household, Leto, mother of Apollo, and the generally bountiful Demeter, are among other divine powers called upon to ensure *kalligeneia* ('fair offspring'). The Christian adoption of this cult happened easily: an image-type of Hera from her sanctuary at the mouth of the River Sele, near Poseidonia (Paestum) in south Italy, holding a baby in one arm, with a pomegranate in her other hand, can plausibly be recognized as an archetype of the 'Madonna del Granato' venerated to this day in the hills near Capaccio.

The image of the child at its mother's breast would appear to be simple and elemental: but of the Greek image-type known as *kourotrophos* ('child-nursing') it has been claimed that 'nowhere in the world, either before or after, has any other art explored so extensively and for so long the possibilities of form, content and symbolism in the group of the child-bearer'. It is true that Greek sculptors turned many variations around this basic theme. A fragment of Archaic relief is enough to show the potential for emotional range (Figure 4.16). Though this probably belongs to a funerary *stêlê*, it catches an exquisite moment of eye

contact between parent and child; and we notice that although the size of the cradling hand around the child's head suggests a small baby, the impression is that of a miniature *kouros*.

Votive solicitation to the various deities of pregnancy and birth was common because miscarriage and death in labour were common; and customarily infants were not named until ten days old, because so many died in their first week. (Even then, the chances of surviving until adulthood have been estimated as about 50 per cent in the Classical period.) So we can sympathize with the several celebrations designated for a child's progress towards maturity – for instance, the annual Anthesteria, a Dionysiac festival at which children were given their first taste of wine, symbolic of their initiation as members of the community. Here we can perhaps locate one of the masterpieces of Classical sculpture, the so-called Hermes of Praxiteles (Figure 4.17). Pausanias saw this group in the Heraion at Olympia (5.17.3), where it was retrieved in 1877; much scholarship since has been preoccupied with the problem of whether it is indeed the handiwork of Praxiteles (as Pausanias says) or an accomplished copy. The votive occasion of the piece has gone largely overlooked. Speculatively, it is likely that the image of Hermes *kourotrophos* – which sanctified his role as a finder of foster homes for orphans or foundlings – was here transformed into a symbol of a child's 'discovery' of wine, and thereby a step towards maturity: appropriate enough for some festival akin to the Attic Anthesteria, when jugs (*choai*) of fresh vintage were broached.

We shall look more specifically at funerary monuments in the next chapter: their inclusion here would overstretch the sense of the term 'votive'. But one grave-marking statue deserves comment in this context, because its dedication poignantly refers to a rite of passage unfulfilled. This is the well-known *korê* of Phrasikleia, recovered in 1972 from a cemetery at Merenda in Attica and pertaining to an inscribed base that reads: 'Marker [*sêma*] of Phrasikleia. Maiden [*korê*] I shall always be called; the gods allotted this name for me in place of marriage. Ariston of Paros made me' (*IG* I3 1261). Wearing a crown of lotus buds and flowers, and also holding a lotus bud, Phrasikleia confirms visually her status as a virgin (*parthenos*); her jewels indicate her promise as a bride – while the dark cinnabar red of her *peplos* is suggestive of her death and funeral. The poignancy of this monument is heightened by two possible translations of the girl's name, as either 'Famous-for-her-thoughts' or else 'Conspicuously-of-good-report'. We cannot know how far she merited the name while alive; but there is no doubt that, posthumously, Phrasikleia's image served to accrue respectful lament.

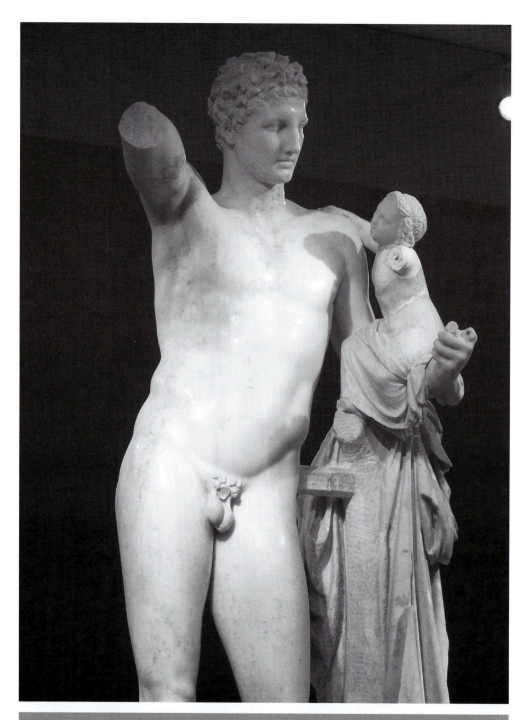

Figure 4.17 *Hermes with the infant Dionysos: marble group in the manner of Praxiteles, from the temple of Hera at Olympia. Hermes is thought to have held a bunch of grapes in his raised right hand, as if teasing the baby Dionysos. The relaxed angle of the elder deity's stance is typically 'Praxitelean', but technical features of the piece (including the base, the strut and the surface sheen) arguably indicate a Hellenistic date.*

THE ARCHAIC *KORAI*: DEFINING THE 'DOMESTIC GODDESS'?

It was a wintry day in 1886 when archaeologists on the Akropolis came across a cache of fourteen statues buried not far from the Erechtheum, most of them representing (in the words of Panayotis Kavvadias, leading the excavation) 'a standing woman clad in chiton and himation, raising the hem with the left hand, and with her hair arranged in long tresses falling in front and in back'. The type was already known from the archaeology of the Akropolis. These were anonymous 'maidens' (*korai*) – some with right hand extended, as if to offer a gift, others with the right hand held to the chest, as if in supplication. The gestures imply a votive moment; associated inscriptions, however, make it clear that these statues were in themselves votive offerings – from men. Athena was the principal divine focus, but not exclusively: one dedicatory base tells us that it carried a *korê* for Poseidon (whose cult was also long established on the Akropolis), in thanksgiving for one fisherman's remarkable catch.

Korai have been found in sanctuaries across the Greek world, but nowhere in such concentration as upon the Akropolis. As many as 75 may have been displayed, beginning around 566 BC (the inaugural year of the Panathenaic Festival) and continuing through to *c.* 480. Yet despite the quantity, and a quality of individualization that gives each *korê* the aura of being a portrait (Figure 4.18), we remain unsure about the meaning of these images. Undoubtedly they presented a visually striking ensemble: brightly coloured (see p. 82), richly bejewelled, some were over-lifesize in scale – and while they may seem to offer a distinct difference from their male 'equivalents', the *kouroi*, by being clothed, it has to be said that these maidens use their clothes to erotic effect. To describe the *korai* as 'sexy' is not lewd, nor anachronistic: the way in which strands of plaited hair emphasize the shape of breasts, and how the motion of tugging a skirt reveals a firm outline of thighs and backside (Figure 4.19), combined with the glamour of cosmetics and 'accessories', can readily be shown to harmonize with the poetics of female beauty in Archaic Greece.

Figure 4.18 Korè dedicated by Euthydikos, c. 490 BC. Ht of this piece 58 cm.; a lower part, on an inscribed plinth, was found separately. Notorious as 'the pouting one' ('la boudeuse'), this figure marks the end of korai as a type.

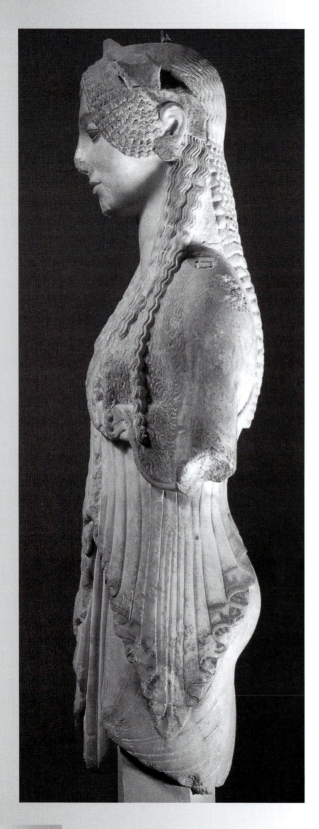

And this creates one problem of interpretation: because the suggestion that these figures may represent priestesses, cult attendants or divinities (not only Athena, but also Artemis and Leto are among those suggested) is made intuitively incredible by their overt sex-appeal. In later Classical times, Xenophon's worthy Athenian citizen Ischomachos deplores his wife for resorting to make-up, high heels and other adornments (*Oec.* 10.2); and from several Classical sanctuaries we have records of laws explicitly proscribing the wearing of fine garments and glittering jewels (plain white was deemed appropriate: see Plato, *Laws* 956a). Yet the Akropolis *korai* seem to exult in their gaudiness, as if it were some mode of 'power dressing'; certainly they are more likely to represent aristocratic women than the 'courtesans' (*hetairai*) with whom 'flowery dress' would later be associated.

The significance may be more specific. Historically it can be demonstrated that in pre-democratic Athens it was integral to a woman's social status that she could appear exquisitely dressed – and thereby exhibit her own skills at weaving. And jewels signified not only family wealth: they may also have indicated the richness of dowry brought to marriage. As for the gesture of pulling the skirt, this may serve to animate the statue, as if anticipating the preliminary movement of a dance; but it may not be fanciful to imagine that in this device there is some primal element of natural selection: the female of the species making it clear, by tightening the drapery around her hips, that she is well-equipped for child-bearing.

Combining such considerations, it is tempting to suppose that the Akropolis *korai* were virtually advertisements for the perfect wife: devout, young (virginal), beautiful, from a wealthy family, skilled at the loom, and physically primed for the rigours of childbirth and breastfeeding. This is over-deterministic: just as some *kouroi* represented Apollo, so some *korai* represented Athena. But such ancient ambivalence only encourages us to conclude that these 'maidens' generically embody the rather paradoxical ideal of the 'domestic goddess' – a persistent male fantasy.

Memorials of honour and office

Priesthoods in ancient Greece were often hereditary; and in the democratic *polis*, participation in public life was each citizen's duty. Neither of these factors inhibited the practice, increasingly common from the fourth century onwards, of temple officials and public servants making votive commemorations of their stints – as city magistrate, gymnasium superintendent, army general, curator of sacred treasures and so on. In what ways honorific statues of such officials can be regarded as 'portraits' is a question we shall address later (see p. 262). As the quantity of such dedications became greater, so their quality tends to suffer: statues of priestesses in sanctuaries within the Roman empire are mostly lumpen and formulaic, and sometimes deservedly left to weather *in situ*. But an early example of such

Figure 4.20 *Statue of Nikeso, from Priene, c. 300–250 BC. Ht 1.73 m. Nikeso was a priestess of the shrine of Demeter and Persephone, where this statue was found (at the entrance); the inscribed base of Nikeso's image also carried the names of her father and husband.*

Figure 4.21 *Moschophoros ('Calf-bearer') from the Akropolis, c. 560 BC. Ht of entire statue estimated as 1.65 m. The figure wears a cloak, which some take to be a sign that he is a herdsman, bringing one of his own stock. Alternatively he may be a victor at the newly established Panathenaia (566 BC): a later inscribed list relating to the Panathenaic Games indicates that winners of certain group events were awarded bulls as prizes – and the animal here is defined as a bull-calf, not a heifer.*

commemoration, though decapitated, shows a certain delicacy of carving – not to mention the solid decorum befitting the office (Figure 4.20).

The religious calendar

From what has been surveyed so far, it will be perhaps already evident that Greek sanctuaries were busy places – and that is without considering the observance of regular rites and festivals throughout the year. Many of these involved the practice of 'dressing' a deity's statue in special robes: among the many documented instances of this practice is the annual presentation of a newly woven *peplos* for the *xoanon* of Athena Polias. On Athena's 'birthday', deemed to occur on the twenty-eighth day of the month of Hekatombaion (more or less equating to our July), this ancient and probably very simple effigy, carved of olive wood, was made resplendent by a gown traditionally decorated with scenes of Gigantomachy.

It is a significant point of etymology that the Greek term *leitourgia*, which gives us 'liturgy', makes no essential distinction between civic and priestly duties. But despite the quantity and regularity of festivals – at Athens, no fewer than 120 days a year were set aside for official cult activities – many details of ancient liturgy remain obscure to us. So we rely upon a certain amount of intuition when it comes to interpreting the votive sculpture that survives from these observances. What exactly was the occasion behind one of the earliest, and finest, lifesize dedications made on the Akropolis – the Moschophoros or 'Calf-bearer'

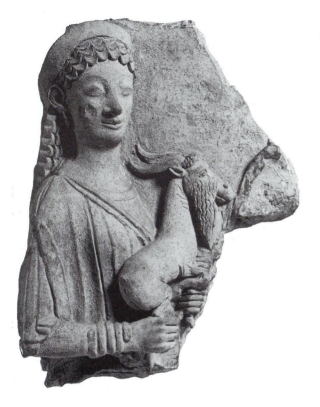

Figure 4.22 *Fragmentary terracotta plaque from Gela, Sicily, late sixth century. Ht 29 cm. Images of women carrying sacrificial animals (here a goat) have been found in some quantity at various sanctuaries in and around Gela, 'city of Persephone' – first systematically explored by Paolo Orsi in 1901. This relief was probably a dedication to Artemis.*

commissioned by one Rhombos (the name is not certain: *cf. IG* I3 593), presumably in memory of a vow? Justly celebrated for its genial evocation of affinity between man and beast, this statue (Figure 4.21) belongs to a tradition of figures carrying animals on their shoulders – e.g. a colossal, if unfinished, figure found on the island of Thasos, shown bearing a ram, and many small bronze versions of a similar type recovered from the sanctuary of Hermes Krio-phoros, 'Ram-bearer', at Viannos, on Crete.

Cattle were generous gifts for an individual, so too pigs; but if, in the 'cuisine of sacrifice', lesser animals (piglets, goats, sheep) or fowl were not affordable, various fruits and cakes might be offered, all usually accompanied by wine – and all usually done in the spirit of communal relaxation, with not only prayers, but dancing and singing too. Plenty of sculptures record this ephemeral activity (Figure 4.22); and we should bear in mind that when the simulacrum of some votive object was dedicated, it may either commemorate actual practice or else serve as substitute. To dedicate a terracotta piglet to Demeter may have consoled the worshipper who had, in fact, no animal to spare. But in the case of the Thesmophoria festival of Demeter and Persephone (Kore), which was primarily organized by and for citizen women, the sheer quantity of terracotta images representing the *act* of offering – from sanctuaries not only in Sicily, but also at Corinth, Gortyna on Crete and Cyrene on the north African coast – suggests that carrying a statuette may itself have played a prominent part in the ritual.

Propitiation and atonement The narratives of ancient epic and tragedy make it clear that mortals offend deities at their peril; however, opportunities existed to seek atonement by votive offerings – the nearest thing to 'forgiveness' in Classical

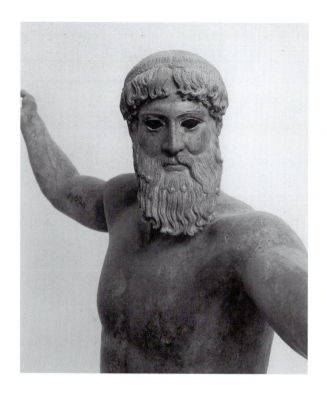

Figure 4.23 *'The Artemision god', c. 460 BC. Ht of entire statue 2.09 m. This over-lifesize figure from a shipwreck off north Euboea has been claimed as an image of Poseidon (with trident), perhaps originally commissioned as a thank-offering for victory over the Persian fleet in the Artemision area. Whether Poseidon or Zeus, however, this remains a vigorous evocation of divine justice.*

religion. Accordingly, we find at Olympia, for example, a number of statue-bases remaining from penitential dedications made by athletes who were caught cheating. Pausanias (5.21) saw the statues, displayed conspicuously by the entrance to the stadium: he tells us that they were bronze images of Zeus, known locally as *Zanes*, and he lists the crimes of the athletes punished by the obligation to pay for such images (bribery of opponents predominates, though cowardice is also mentioned as culpable). We presume that the statues showed Zeus launching a thunderbolt: the type survives in figurines, and arguably in an imposing bronze recovered from waters off Cape Artemision in the 1920s (Figure 4.23).

Civic misdemeanours, including neglect of duties and breaking of oaths, were similarly open to the expression of repentance through statuary. Plutarch (*Them.* 31) reports that when the fifth-century general Themistokles held office as overseer of the Athenian water supply, he used the fines collected from those caught diverting water to dedicate a bronze *korê* to Athena.

Conclusion: *Eusebeia* and 'Greekness'

Philosophically it was not easy to define 'holiness' (*to hosion*) in Classical times: such, at least, is the upshot of Plato's *Euthyphro*, where Socrates queries – among other things – the theology of 'bartering' with the gods. For Socrates, condemned on a charge of 'impiety' (*asebeia*), it was highly important to know just what constituted 'piety' (*eusebeia*). To the modern archaeologist, however, it is clear from widespread and copious evidence that the practice of votive offerings, along with acts of sacrifice, satisfied a general expectation of religious duty in the Greek world. Our survey of the sculpture generated by this practice has indicated how frequently the occasion

for offering arose: it could fairly be claimed as a part of 'everyday life' – and certainly a major mechanism in the ancient economy.

It was something else besides: a primary defining element of pre-national Greek identity. As Herodotus put it: 'this is our Greekness – our shared blood and language, the temples of our gods, our rituals' (8.144). As an historical definition of 'Greekness' (*to Hellênikon*) this fourfold analysis is often cited to prove an ethnic awareness among Greeks of the fifth century; here we should note that its narrative context is specifically an appeal for alliance between Athens and Sparta against the Persians – and an exhortation to take action, indeed, because the Persians have destroyed altars and images of Greek deities. The art and architecture of Greek sanctuaries (both images and buildings may be entailed by the phrase used by Herodotus, *theôn hidrumata*) were in this respect significant statements of 'Greekness' wherever they were found – notwithstanding regional variations of style and cult.

We may appreciate this further significance of votive sculpture by contemplating a small sample of statues excavated outside Greek territory, yet nicely illustrative of symbolic interaction between Greek states. The site is that of Naukratis, in the Nile Delta, which the Greeks themselves referred to sometimes as a city (*polis*), sometimes as a trading-post (*emporion*). Herodotus tells us that a settlement of Greek merchants here came as a concession from the pharaoh known as Amasis, or Ahmose, whose rule can be dated to 570–526 BC. Amasis granted these foreign traders the right to create their own sanctuaries. Of the resultant shrines established at Naukratis, Herodotus reports (2.178), the most prominent was the Hellênion, 'founded jointly by the following cities: of the Ionians, Chios, Teos, Phocaea and Clazomenae; of the Dorians, Rhodes, Knidos, Halicarnassos and Phaselis; of the Aeolians, just Mytilene … Apart from this the Aeginetans have founded by themselves a sanctuary of Zeus, the Samians another of Hera, and the Milesians one of Apollo.'

Naukratis was discovered in 1883 by the distinguished Egyptologist Flinders Petrie. How he located the site is worth our notice. At an antiquities bazaar in Giza, near Cairo, Petrie was offered an alabaster statuette of a male warrior figure. He immediately recognized it as non-Egyptian: to be precise, as 'Carian' work. Where might Carian statuary have come from? Since Herodotus lists two Carian cities, Halicarnassos and Knidos, among those with Naukratite interests, Petrie realized that he might be on the Naukratis trail. He snapped up the figure and asked where he could find more like it. Eventually he was led to a sandy waste near Nebeira, prone to inundation, where – as he memorably describes it – his feet crunched over a carpet of exposed Greek pottery.

Figure 4.24 *Fragmentary statuette in gypsum, from Naukratis, mid sixth century BC. Ht 13.6 cm.*

Figure 4.25 *Fragmentary kouros in gypsum from Naukratis, early sixth century. Ht 10 cm. This and the following piece are stylistically assigned to the 'Sounion Group' of kouroi – cf. Figure 5.5.*

Subsequent excavations were hasty but productive, investigating several sanctuary enclosures, and recovering a number of votive figures and inscriptions. The inscriptions reveal partisan loyalties: Apollo as worshipped at Naukratis is hailed (presumably by visitors from Miletos) as Apollo Milesios or Didymaios – never Naukratitês. But there are also invocations of 'the Greek gods' generally, in a formula echoing the 'Panhellenic' oath quoted by Herodotus (5.49: *pros theôn tôn Hellêniôn*). As for the statues, they are mostly of poor workmanship, using local stone (alabaster or gypsum), and somewhat hybrid in appearance: traces of Egyptian, Syrian and Phoenician influence have been detected, with Cypriot elements uppermost. Yet for all these extraneous

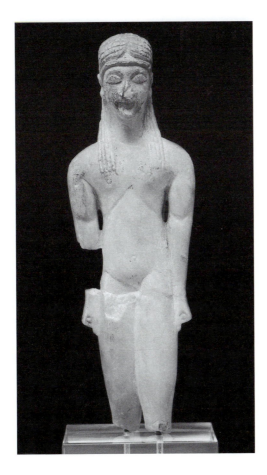

Figure 4.26 Fragmentary kouros in alabaster from Naukratis, early sixth century. Ht 26 cm.

factors, the essential 'Greekness' of the Naukratis pieces remains – as Petrie perceived. Some, while lacking in scale, are surely aspiring to the symbolic status of *kouroi* (Figures 4.24 and 4.25); others capture the act of bringing gifts to the gods (Figure 4.26). Naukratis, as we can imagine, was a peculiar situation for Greeks and locals alike: a busy point of commerce, with relatively few long-term Greek residents, it was watched over by a substantial garrison of Egyptians. Traders from various parts of the Greek world came and went; they paid their vows at various altars. What they needed was symbolic assurance that, in a strange land, among powerful and suspicious 'barbarians', they had an enclave of feeling at home. The sculptures around the altars were, in that sense, part of a cultural welcome.

Sources and further reading

A fundamental resource for understanding the material surveyed in this chapter is the *Thesaurus Cultus et Rituum Antiquorum* (*ThesCRA*) (Getty 2005–).

Artemis Ephesia Archaeological evidence for the cult statue (although 'heaven-sent', also attributed to Endoios, pupil of Daidalos: *cf.* Pliny, *NH* 16.214) is collected in A. Bammer and U. Muss, *Das Artemision von Ephesos* (Mainz 1996), 71–8; on the statue-type, H. Thiersch, *Artemis Ephesia* (Berlin 1935); see also L. LiDonnici, 'The Images of Artemis Ephesia and Greco-Roman Worship: A Reconsideration', *Harvard Theological Review* 85 (1992), 389–415. For a detailed discussion of Paul's adventures at Ephesus, see R. Strelan, *Paul, Artemis, and the Jews in Ephesus* (Berlin 1996).

Eleusis caryatid Cf. J.G. Frazer's investigation of 'Spirits of the Corn', in *The Golden Bough* (3rd edn., London 1912), pt v, vol. I 64ff.

Ayia Irini votives All are from Swedish excavations begun in 1929 – see E. Sjöqvist, 'Die Kultgeschichte eines cyprischen Temenos', *Archiv für Religionswissenschaft* 30 (1932), 308–59. Miriam Caskey's publication of the figures from **Ayia Irini on Kea** includes discussion of the probability that the female figures were not only all standing or dancing (many garlanded) as if to celebrate the epiphany of a deity, but also that one statue-head eventually became detached from its body and was set up in later centuries within the temple as if to suggest the 'coming up' (*anodos*) of Dionysos – known to have been worshipped at the same site in the Archaic period: M.E. Caskey, *Keos II: The Temple at Ayia Irini. Pt. I: The Statues* (Princeton 1986). (Material displayed in the Archaeological Museum of Ioulida.)

Rhodian inscription regarding ex-votos Full text in F. Sokolowski, *Lois sacrées des cités grecques: supplément* (Paris 1962), no. 107.

My catalogue of votive occasions follows (with minor modifications) the order and nomenclature of W.H.D. Rouse, *Greek Votive Offerings* (Cambridge 1902). For an updated survey, see F.S. van Straten, 'Gifts for the Gods', in H.S. Versnel ed., *Faith, Hope and Worship* (Leiden 1984), 65–151; on animal sacrifice, van Straten, *Hiera Kala: Images of Animal Sacrifice in Archaic and Classical Greece* (Leiden 1995).

Siphnian Treasury R.T. Neer, 'Framing the Gift: The Politics of the Siphnian Treasury at Delphi', *Classical Antiquity* 20.2 (2001), 273–336, gives a nuanced interpretation; though L.V. Watrous, 'The Sculptural Program of the Siphnian Treasury at Delphi', *AJA* 86 (1982), 159–72, is also worth reading. For a partial reconstruction of the polychromy of the frieze, see V. Brinkmann, *Die Friese des Siphnierschatzhauses* (Ennepetal 1994).

Delphi monuments A. Jacquemin, *Offrandes monumentales à Delphes* (Paris 1999); for inscriptions related to Lysander's dedication, see *Fouilles de Delphes* III. 1 (Paris 1929), 24–41 (though there are some subsequent addenda).

Epinikian statues The literature has grown considerably since W.W. Hyde published his *Olympic Victor Monuments and Greek Athletic Art* (Washington 1921). A selection of more or less recent additions: W. Raschke, 'Images of Victory', in W. Raschke ed., *The Archaeology of the Olympics* (Wisconsin 1988), 38–54; L. Kurke, 'The Economy of *Kudos*', in C. Dougherty and L. Kurke eds., *Cultural Poetics in Archaic Greece* (Cambridge 1993), 131–63; F. Rausa, *L'immagine del vincitore* (Treviso/Rome 1994); C. Mattusch, *The Victorious Youth* (Getty Museum 1997); N. Spivey, *The Ancient Olympics* (Oxford 2012), 151–69; R.R.R. Smith, 'Pindar, Athletes, and the Early Greek Statue Habit', in S. Hornblower and C. Morgan eds., *Pindar's Poetry, Patrons and Festivals* (Oxford 2007), 83–139. To the Polykleitan bibliography cited for the Doryphoros (above) one should add further discussion of the *Diadoumenos* and 'Westmacott' types in R. Bianchi-Bandinelli, *Policleto* (Florence 1938) and S. Settis, 'Policleto, il Diadumeno e Pythokles', in S. Bondí ed., *Studi in onore di Edda Bresciani* (Pisa 1985), 489–98.

Myron's Discobolus Comments on pose and 'moment' in H. Thliveri, 'The Discobolus of Myron', in F. Macfarlane and C. Morgan eds., *Exploring Ancient Sculpture* (London 2010), 7–70.

'Hermes of Praxiteles' I have sidestepped the vexatious debate about the workmanship of this statue; for readers otherwise inclined, see A. Corso, 'The Hermes of Praxiteles', *Num.Ant. Cl.* 25 (1996) 131–56.

Asklepios reliefs U. Hausmann, *Kunst und Heiltum* (Potsdam 1948) remains a valuable discussion, though subsequent studies have shown that various Asklepieia seem to have offered specialized cures (e.g. for eye-problems at Athens). See also A. Petsalis-Diomidis, 'Amphiaraos Present: Images and Healing Pilgrimage in Classical Greece', in R. Shepherd and R. Maniura eds., *Presence* (Burlington 2006), 205–30.

***Kourotrophos* images** See T. Hadzisteliou Price, *Kourotrophos* (Leiden 1978); also J. Baumbach, *The Significance of Votive Offerings in Selected Hera Sanctuaries in the Peloponnese, Ionia and Western Greece* (Oxford 2004). Representations of childhood more generally in the Classical past are surveyed in J. Neils and J.H. Oakley eds., *Coming of Age in Ancient Greece* (Yale 2003).

Phrasikleia M. Stieber, *The Poetics of Appearance in the Attic Korai* (Texas 2004), 141–78.

Korai Literature before and after the standard catalogue – G.M.A. Richter, *Korai* (London 1968) – should be consulted. For the Akropolis finds, the definitive publication is that of H. Schrader, E. Langlotz and W. H. Schuchhardt, *Die archaischen Marmorbildwerke der Akropolis* (Frankfurt 1939); a nice sample of stylistic concerns in 1930s archaeology is given by H. Payne and G. Mackworth-Young, *Archaic Marble Sculpture from the Acropolis* (London 1936). That the Athenian *korai* represent divinities is argued in C.M. Keesling, *The Votive Statues of the Athenian Acropolis* (Cambridge 2003); personally I am more persuaded by the interpretations given in K. Karakasi, *Archaic Korai* (Getty 2003), which is so far the most comprehensive survey.

Demeter cults Much votive statuary collected in the various contributions to C.A. Di Stefano ed., *Demetra* (Pisa/Rome 2008); more specifically, see M. Sguaitamatti, *L'offrante de porcelet dans la coroplathie géléenne* (Mainz 1983).

Naukratis The case for Cypriot production of the statuettes is made by Ian Jenkins in *AJA* 105 (2001), 163–79; for a full re-examination of the material, see Ursula Höckmann's contribution to her edited volume *Archäologische Studien zu Naukratis* (Worms 2007), vol. II, 13–307.

The bodies were there, the belief in the gods was there, the love of rational proportion was there. It was the unifying grasp of the Greek imagination which brought them together. And the nude gains its enduring value from the fact that it reconciles several contrary states. It takes the most sensual and immediately interesting object, the human body, and puts it out of reach of time and desire; it takes the most purely rational concept of which mankind is capable, mathematical order, and makes it a delight to the senses; and it takes the vague fears of the unknown and sweetens them by showing that the gods are like men, and may be worshipped for their life-giving beauty rather than their death-dealing powers.

Kenneth Clark,
The Nude (London 1956), 22

5

HEROES APPARENT

Of the great and the good Heroes play the lead roles in Greek mythology and litera-
ture; hero-worship was an important element of ancient
Greek religion. This chapter is about the visualization of the hero in Greek
sculpture – the definition of a physical type that has exerted a powerful influence
on ideals of male appearance in various times and places, including the present.
Although notice will be made of the image of the virtuous woman in Classical
Athens, this is, historically, a male phenomenon – as emphasized by the mould of
heroism familiar to most Greeks from the Archaic period onwards: that is, heroism
as embodied by the characters of Homer.

Homer's heroes are not all alike: if they were, the *Iliad* and *Odyssey* would each
make a dull tale. But there are certain qualifications for being a hero in Homer's
world. The first of these is to be big and strong. A hero may occasionally use his
brain, but he cannot lack muscle and bulk. A recurrent Homeric device for
marking the distance between a hero and the ordinary mortal is to describe the
hero easily throwing a rock which 'nowadays two of the best men in the city
could scarcely heave onto a waggon' (*Il.* 12.445, of Hector). It is no surprise that in
antiquity, when chance discoveries were made of the fossilized remains of some
prehistoric mastodon or suchlike, the relics were venerated as bones of heroes:
Ajax, for example, whose skeletal remains (as Pausanias relates: 1.35.3) included
knee-caps as big as a junior's discus. The popular understanding was that
heroic stature measured about 10.5 cubits – about 4.5 metres (*cf.* Philostratus,
Heroikos 8.1).

The Homeric hero is not only gigantic, but also well-formed to the point of
being 'god-like' (*theoeides*). King Priam says of his favourite son, Hector, that 'he
was a god among men, and he seemed to be the child not of a mortal but of a god'
(*Il.* 24.258–9). Agamemnon's appearance is described in a series of divine com-
parisons: 'in eyes and head like Zeus who delights in thunder, in girdle like Ares, in
chest like Poseidon' (*Il.* 2.478). Plainly these assimilations only make sense to an
audience accustomed to 'seeing' their gods. It may therefore become rather
difficult, in iconographic terms, to distinguish a hero from a god.

Homer was seemingly aware of hero-cults as religious practice in the eighth
century. In his description of the funeral games of Patroklos (*Il.* 23), the poet
could be imagining the institution of a hero-cult with the contest staged by
Achilles to commemorate his beloved friend. And Homer's warriors are very
mindful of the honours they may receive in the event of their death. Here is one
of Homer's most attractive characters, Sarpedon, the Lycian ally of Troy, and a
son of Zeus, enjoining a fellow-countryman to fight with him 'in the front line'
(*meta prôtoisi*):

'Glaukos,' he said, 'why do the Lycians at home distinguish you and me with marks of honour, the best seats at the banquet, the first cut off the joint, and never-empty cups? Why do they all look up to us as gods? And why were we made the lords of that great estate of ours on the banks of Xanthos, with its lovely orchards and its splendid fields of wheat? Does not all this oblige us now to take our places in the Lycian van and fling ourselves into the flames of battle? Only so can we make our Lycian men-at-arms say this about us when they discuss their Kings: "They live on the fat of the land they rule, they drink the mellow vintage wine, but they pay for it in their glory. They are mighty men of war, and where Lycians fight you will see them in the van."

'Ah, my friend, if after living through this war we could be sure of ageless immortality, I should neither take my place in the front line nor send you out to win honour on the field. But things are not like that. Death has a thousand pitfalls for our feet; and nobody can save himself and cheat him. So in we go, whether we yield the glory to some other man or win it for ourselves.'

<div align="right">IL. 12.310–28, TRANS. RIEU</div>

This emotive articulation of *noblesse oblige* finds a substantial narrative response when Sarpedon enters the fray caused by Patroklos and duly meets his death (*Il.* 16.419–683: when he falls, it is like a huge tree crashing down). Stripped of its panoply – which will become a prize in the games held for Patroklos – Sarpedon's body is in danger of mutilation. So Zeus – who cannot prevent his son's death – commands Apollo to catalyse the process of heroization. The corpse is lifted to safety, anointed with ambrosia and marvellously transported to Lycia, where Sarpedon's kinsmen will 'give him burial, with mound and pillar, as the dead deserve'. So Sarpedon's own prophecy about his 'fate' (*moira*) is realized; and while his end is terrible, pitching him into a cold darkness, it is also glorious. He becomes, literally, *athanatos*, 'deathless': an individual whose fame will resonate to all posterity (*cf.* p. 220).

The concept of a 'beautiful death' (*thanatos kalos*) was not confined to the romance of epic. It provided a cogent ideology in societies where it was normal for most male citizens not only to keep in regular training for the eventuality of war, but also to have firsthand experience of close combat. They needed no cameramen to teach them the realities of battle. At their drinking-parties or *symposia*, men who belonged to the same hoplite formation craved the ennobling entertainment of epic poetry such as Homer's: though tactics had changed, the premium attached to being a 'frontline fighter' was no less significant in the hoplite phalanx than it had been in Sarpedon's time – if anything, it had increased. Witness the testimony inscribed below a funerary *kouros* of a young man

apparently killed in action towards the end of the sixth century: 'Stay and mourn by the monument of dead Kroisos, whom furious Ares destroyed one day as he fought in the front ranks.' This appeal to passers-by is explicit about the bravery of Kroisos: he had perhaps volunteered to fight 'in the front ranks' (*eni promachois*), where the chances of being killed or seriously wounded were much higher than if one were bringing up the rear.

Death on the battlefield could be ignoble or cowardly: that is one meaning of the word *kakos*, and on an early Classical gravestone we find an inscription specifying that a soldier called Pollis did *not* perish that way (Figure 5.1). He is represented carrying shield, spear and sword, yet otherwise naked: this may constitute 'heroic nudity', a category we shall explore presently; it may further signify a casualty of war, since being 'stripped', *gymnos*, can refer not only to athletes, but also to the misfortune of having one's body-armour removed in the combat zone (with one or two spectacular historical exceptions, Greek warriors did not fight unclad).

Readers of Homer know that he does not spare 'the gory detail' when it comes to descriptions of fighting. Verbal pictures of disembowelling and decapitation were not translated by sculptors and painters, although a degree of physiological realism is noticeable in some Hellenistic representations of death (see p. 238). However, the challenge of evoking an epic tumult was not avoided. An early and impressive

Figure 5.1 *Stēlē of Pollis, from Megara, c. 480 BC. Ht 1.49 m. The epigraphy is not wholly clear: one reading suggests that Pollis died under torture, possibly as a prisoner of the Persians.*

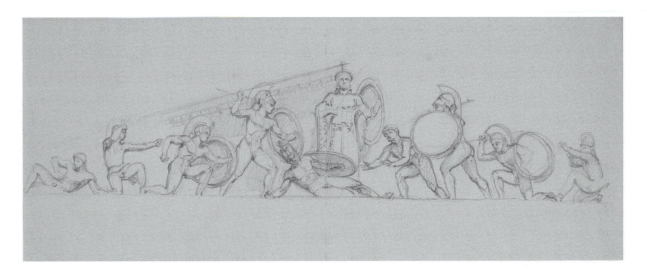

effort is evident from the pediments of the Aphaia temple on Aegina, where two 'master sculptors' appear to have competed as to which of them could best represent a Trojan *mêlée*. The west side, probably completed *c.* 490, is generally judged the less successful, with some awkwardness of figures within the composition (Figure 5.2). Whoever created the east pediment looks to have studied more carefully the postures of heroic death (Figure 5.3). Even though armour and accoutrements would have been added in bronze, the torsion caused by a hero's last breaths is made clear. We may bring to mind the immediate reaction of the Achaean warriors when Hector is finally despatched by Achilles: prior to acts of vengeance, they register the 'beautiful death' of their enemy, and gaze 'in wonder at the stature [*phuê*] and awesome appearance [*eidos agetos*] of Hector' (*Il.* 22.370).

'Say not that the good die'

In the first book of Herodotus' *Histories*, the early sixth-century Athenian law-giver Solon, a man of legendary wisdom, is posed a question by Croesus, the fabulously wealthy king of Lydia. Croesus asks Solon to nominate people he considers to have been supremely happy, and among those named in Solon's reply are two young men from Argos called Kleobis and Biton. Prizewinning athletes, their greatest test of strength occurred when their mother, a priestess, was due to celebrate an important festival of Hera. The team of oxen due to provide her transport to the local sanctuary failed to materialize, so Kleobis and Biton harnessed themselves to the waggon – loaded not only with their mother, but also presumably all her official equipment – and dragged

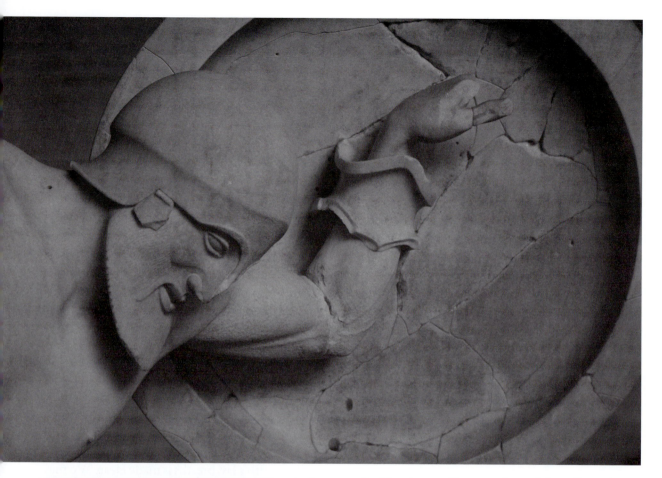

Figure 5.3 *Detail of the figure of a dying warrior on the east pediment of the temple of Aphaia, Aegina, c. 480 BC. The figure has been plausibly identified (by Dieter Ohly) as Laomedon, king of Troy and father of Priam, here fatally wounded by Herakles, who joined a punitive expedition against Troy led by Telamon, father of Ajax. Laomedon's grave was by or above the city's Scaean Gate (portentously disturbed when that gateway was enlarged to accommodate the Wooden Horse); the precarious position of this figure on the edge of the pediment may suggest that Laomedon died on the battlements.*

it along to the Heraion, a distance about 8 km. from Argos itself. Solon continues the story:

After this exploit, which was witnessed by the assembled crowd, they had a most enviable death – a heaven-sent proof of how much better it is to be dead than alive. Men kept crowding round them and congratulating them on their strength, and women kept telling the mother how lucky she was to have such sons, when, in sheer pleasure at this public recognition of her sons' act, she prayed the goddess Hera, before whose shrine she stood, to grant Kleobis and Biton, who had brought her such honour, the greatest blessing that can fall to mortal man.

After her prayer came the ceremonies of sacrifice and feasting; and the two lads, when all was over, fell asleep in the temple – and that was the end of them, for they never woke again.

The Argives had statues made of them, which they sent to Delphi, as a mark of their particular respect.

<div style="text-align: right">HERODOTUS, 1.31, TRANS. DE SELINCOURT</div>

Solon's purpose, within the Herodotean narrative, is to puncture the inflated egotism of Croesus, who thinks that his wealth – made ostentatious by some extravagant gifts to Delphi – should confirm him as enviably the happiest man in the world. And Solon's advice, advocating fatal acts of piety as a route to happiness, is not as perverse or pessimistic as it might seem. The idea that individual virtue is rewarded by a 'holy sleep' (*hieros hypnos*) is echoed in Greek elegiac literature; and while we might feel inclined to read the story of Kleobis and Biton as some sort of tragedy – that the boys died of exhaustion – it is a significant part of the story that the 'blessing' (*makarismos*) of their demise is brought about by a prayer. So it is not so much an end as an apotheosis, or divine assumption.

This interpretation helps explain why, centuries later, images of Kleobis and Biton hauling a cart enter the repertoire of motifs deemed suitable for the decoration of Roman sarcophagi. For our present purposes, however, the story is significant for its rapport with the production of those Archaic statues generically known as *kouroi*. Memorials to Kleobis and Biton were set up at Argos (Pausanias 2.20.2); but, as Herodotus relates, the Argives took care to commemorate the two boys at a Panhellenic site, where such commemoration would be more widely recognized. So when in the early 1890s two statues were excavated at Delphi – clearly a pair, if found separately, not far from the Athenian Treasury – and associated plinths inscribed, albeit not completely, with Archaic Argive letters, it was irresistible to suppose that the very statues mentioned by Herodotus had been recovered. Here, then, we appear to have two *kouroi* with a known historical context.

In fact the identification is not completely certain, with suggestions that perhaps the Dioskouroi, or else a couple of victorious athletes, are intended. But the strong probability is that the statues now on view in Delphi Museum (Figure 5.4) do represent the Argive brothers. And they are worth a journey: photographs do not do justice to the actual presence of the statues. For one thing, only close inspection now reveals that both figures are wearing soft ankle boots, marked in faint relief (and probably once painted). That detail alone may be suggestive of a hike across the Argive plain. After seeing the statues from various angles, it is also not fanciful to describe each of the boys as a bovine type (*boupais*) – and to see in the flexion of their biceps muscles some allusive reminder of the heroic act of haulage narrated by Herodotus.

The statues of Kleobis and Biton are akin to many other Archaic funerary monuments, as we shall discover, insofar as they are memorials of brave young people set up by their parents. But what does it mean, to classify them within the genre of *kouroi*? The term *kouros* signifies youth, manhood and sometimes warrior status; etymologically it is related to a word (*koros*) that signifies a seedling, or the shoot of a plant. (A relic of this significance survives in Sicily, where *caruso* remains a form of endearment for any promising male infant.) The *Homeric Hymn to Demeter* tells how the goddess was entrusted with a nursling, Demophon, and steeped him in ambrosia – the divine nourishment for this 'young sprout' (*neon thalos*), which soon had everyone marvelling at 'how full in bloom he came to be'. Demophon would grow up as a *daimôn*, a god or demi-god, of whom ordinary mortals would declare, 'to look at him is to gaze upon the gods' – and whom they would duly feel inclined to worship.

To be 'in the bloom of one's prime' undoubtedly had erotic associations (*cf.* Plato, *Rep.* 474e). But primarily it contributed to the heroizing intention of the *kouros*-type. The old question of whether *kouroi* represent gods (especially Apollo) or mortals is essentially misleading. Whether the *kouros* is set up as a votive offering (*anathema*) in a sanctuary, or as a marker (*sêma*) or memorial (*mnêma*) in a cemetery, its intention is always heroizing. We have already seen (p. 42) how closely the poetic descriptions of Apollo correspond with the appearance of the *kouroi*. Even when hairstyles change, and dandy young men of the later sixth century prefer to tie their hair up, we should not be deceived: they are still 'unshorn' (*akersekomês*), like Apollo. But a specific resemblance to one god or demi-god (the hero is often 'half-god', *hêmitheos*, in Greek parlance) was not the expectation. It was the evocation of a determined heroic 'look' and stature that was important.

THE SOUNION *KOUROI*

Cape Sounion is the very first site mentioned by Pausanias in his *Periegesis* of ancient Greece – and it is not a promising start. He tells us nothing about this spectacular promontory except that there is a temple to Athena to be seen, but the only conspicuous temple there has been definitively identified with the cult of Poseidon, not Athena. Excavations have, however, uncovered a lower sanctuary, likely to have been Athena's, near to a Bronze Age tumulus traditionally associated with Phrontis, steersman to Menelaos (*Od.* 3.278); and a number of *kouroi*, mostly fragmentary, have been recovered from both sanctuary areas. The most visible of these must have been four statues on a colossal scale, including the well-known 'Sounion Apollo' (Figure 5.5). In fact, not since its discovery (in 1906) has this figure been seriously supposed an image of Apollo: Staïs, the excavator, speculated that two of its fellow statues might have represented the Dioskouroi, but beyond doubt the quartet made an imposing sight, aligned on their bases at a slightly oblique angle as if to be more clearly viewed from afar – perhaps by those at sea. Probably damaged during the Persian Wars, the 'landmark' statues were buried in a pit, and so were invisible to Pausanias. In the absence of his comment, and any dedicatory inscription, we cannot be certain of their original purpose. However, a recent re-examination of traces of surface paintwork indicates that the best-preserved figure was once ribboned with a *tainia*, flowing down the sides of his

Figure 5.5 Kouros *from Cape Sounion, c. 590 BC. Ht (as restored) 3.05 m.*

chest: so, given the context of a local hero-cult to Phrontis, it has been suggested that the four *kouroi* – all over-lifesize, though not on exactly the same scale – were 'heroic' in significance, possibly the *archêgetai* or 'founders' of cult observance (including games) in honour of the lost helmsman.

The *kouros* may seem rigid in stance. This is deceptive, for, with the left leg slightly advanced, the figure was surely intended as appearing ready for action. The tensed striations or *quadrillage* of the thorax evident on the earliest *kouroi* hint at such readiness; so too the pronounced definition of the knee-joint, which may have epic resonance. When, in the thick of battle, Menelaus prays to Athena for

extra strength, Homer is quite specific about where the goddess instils it: in his knees and shoulders (*Il.* 16.569). A rush of adrenalin can have crippling effects: the hero must therefore be *laipsêra te gouna*, 'quick in the knees'.

The diffusion of *kouroi* is geographically quite distinct: most come from Attica, Boeotia, and the islands and coastlines of the Aegean, with relatively few examples from the Peloponnese and Magna Graecia. Within these areas, some regional variations of the ideal body-type can be distinguished: so Cycladic sculptors seem to prefer a more attenuated shape, while figures from Samos and Miletos seem more generously padded with flesh. Nonetheless, and even allowing for Egyptian influence upon its origin (see p. 68), it is fair to characterize the *kouros*-type as 'highly standardized' and a symbolic mode of 'interaction' between the numerous independent Greek polities of the sixth century. As many as 20,000 of the type may have been produced – if so, we might even describe *kouroi* as 'ubiquitous'. This does not detract from the broad characterization of the *kouros* as exemplary of 'aristocratic' values: the bodily image of what it means to be a brave, self-controlled and desirable young man.

Plato (*Prot.* 339b) quotes the poet Simonides regarding the tradition whereby the 'good man' (*andr' agathos*) should appear 'blamelessly built', 'in hands and feet and mind foursquare'. But perhaps the best way of understanding the value-system associated with the *kouros*-type is to witness how it could be parodied – as in the *Clouds* of Aristophanes, written for an Athenian audience in 423 BC. This comedy is best known as a satire on the teachings of Socrates, but it includes a nice sketch of the Athenian notion of 'the good old days' when men were men and did not while away their days with idiotic philosophizing. The spokesman for this sentiment is 'Mr Right', who calls upon the veterans of Marathon – the *Marathô-nomachoi* (line 986) – for his moral authority. There is talk of strict discipline, plenty of fresh air and so on; a vigorous, no-nonsense homosexuality is also entailed. And when it comes to describing the physical specimens that this old educational system (*paideia*) produced, Mr Right could almost be describing a typical *kouros*. If you were brought up in those days (the battle of Marathon took place in 490), you were likely to have 'a glowing tan, a manly chest, broad shoulders, a modest tongue, huge buttocks and a dainty phallus' (*Clouds* 1011–14). By contrast, the pale 'pencil necks' of today (continues Mr Right) are so ashamed of their puny bodies that when it comes to doing a Pyrrhic dance, they have to hide behind their shields.

We know about the *Pyrrhikê*, or armed dance, as an event of the Panathenaia: a relief on a base in the Akropolis Museum (inv. 1338) shows two groups of such dancers displaying taut bodies that Aristophanes' Mr Right would deem exemplary. How can we tell? Because they hold their shields aloft – revealing that they

wear no clothes – and they appear proudly aware of their unclothed state. This brings us to a particular cultural feature of ancient Greece which has a direct, even notorious, impact upon the development and reputation of Greek sculpture: the habit of nudity. Well-known, but sometimes misunderstood, this cultural peculiarity deserves a brief discussion to itself.

'Heroic nudity' A passage in Thucydides (1.6) suggests that the Greeks were well aware of nudity as a defining trait of their ethnic identity. The Spartans, it seems, were first to strip, for the sake of athletic contests, and rub down with oil after exercise. Thucydides implies that this custom was then instituted at the Olympics, and so became an exclusively 'Hellenic' phenomenon. Other sources relate that it came about accidentally, at Olympia, when a sprinter at the Fifteenth Olympiad (720 BC) lost or discarded his loincloth – and won. At any rate, the expectation for athletes to be *gymnoi*, 'unclad', was formalized when the first 'gymnasia' were created in Athens and other Greek cities during the mid sixth century. A *gymnasion* was literally a place where little or no clothing was normal; outside this space, and the venues of athletic competition, of course, to be undressed was subject to more or less the same taboos as in most other human societies.

The advent of female nudity is a separate topic, which we shall address later (Chapter 8). Here our preliminary task is to clarify what may seem to be a minor semantic dilemma in our own language, the difference between being 'naked' and 'nude', and proceed to define a special category of 'heroic nudity' that will serve us well in understanding Classical images of the unclad male. When artists show athletes in action, the gymnastic or agonistic context is sufficient to explain the absence of clothes: Myron's discus-thrower, for example (see Figure 4.11), would seem odd if shown wearing a *perizoma* (loincloth); and the boys apparently playing an archaic version of hockey (Figure 5.6) are represented naturally enough in a state of undress.

'To be naked is to be oneself.' This dictum (from John Berger) enables a crucial distinction to be made between nakedness and nudity. The term 'nude' – from the Latin *nudus*, which, like the Greek *gymnos*, has associations of being unprotected and vulnerable – does not enter English usage with an artistic connotation until the eighteenth century. Then it signifies a 'posed' figure: that is, a

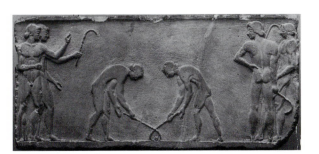

Figure 5.6 *Relief base of a kouros, c. 500 BC. Ht. 28 cm. Hoplites and chariot decorate the other side of this base – as if characterizing the 'lifestyle' of the young man commemorated by the statue.*

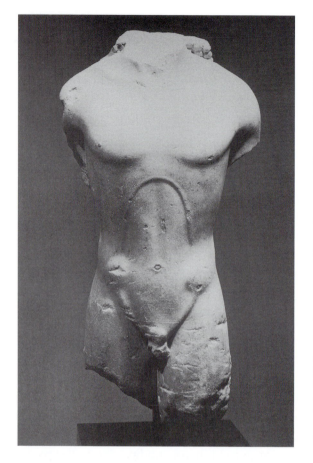

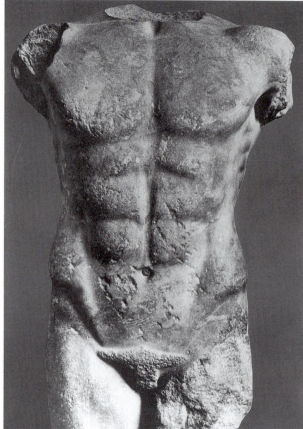

Figure 5.7 *Kouros-torso of unknown provenance, c. 550 BC. Ht 62.5 cm. (Assigned by Richter to the Melos Group.)*

Figure 5.8 *Fragment of a colossal statue from Miletos, c. 480 BC. Ht 1.32 m. (Probably the source of Rilke's celebrated poem: see p. 320.)*

figure used as a model for artistic study, or the image generated by such study. So nudity entails a process of 'objectification'; or (to borrow again from Berger's rhetoric), 'nakedness reveals itself', while 'nudity is placed on display'.

And so a sort of paradox arises: that 'nudity is a form of dress' – a 'costume' that can be put on for the sake of being viewed, or even (to stretch the paradox) for the sake of covering up.

This seems initially confusing. After all, Classical archaeologists (notably Gisela Richter) have established a chronological classification of the *kouroi* based upon the analysis of anatomical accuracy: over the course of several decades, it seems very evident that sculptors make 'progress' in defining, for instance, the *serratus magnus* muscle of the male torso and the transverse divisions of the *rectus abdominis* (Figure 5.7 and 5.8). If anatomical accuracy is so important, how can the appearance of the unclothed body be considered a 'costume' or 'disguise'? And yet with both

of these examples there may be some influence from the armourer's craft – a stylization sometimes known as the *cuirasse esthétique* – and equally, in both cases, one could argue that a certain symmetry has been imposed upon the male torso. The earlier example, with its ribcage outlined by a hoop, and triangular groin, seems geometrically ordered; while the later piece, for all its heightened physiological definition, prefigures the mathematical 'gridding' of the human frame formally developed by Polykleitos (see p. 38).

One influential discussion of 'ideal nudity' in Greek art explains it as a mode of 'heroic transfiguration' (*heroische Verklärung*). Such terminology has raised the protest that no 'transfiguration' was necessary, given the historical ambience of ancient gymnastic culture. Who is to say that (for example) the figure 'posing' on the 'Ilissos *stēlē*' (see Figure 5.15) is not more or less 'true to life'? Without labouring the issue, however, one is obliged to point out that the human body, even when honed by diet and exercise, does not tend to such regular, predictable form. (Allow this beefy young man to be a champion wrestler – as some suppose: where are his scars, his broken nose, and all that?) And in any case, the context requires us to accept that the image of nudity *in a cemetery* is not, as it were, 'normal'.

Sex-appeal was not absent from the postures of male nudity in Greek sculpture. But the essential motive for display was couched in terms of *noblesse oblige*. 'Nobility and dignity, self-abasement and servility, prudence and understanding, insolence and vulgarity, are reflected in the face and the attitudes of the body whether still or in motion.' Xenophon's assertion of moral value in physical bearing (*Mem.* 3.10.5) relates clearly enough to the ethic of *kalos k'agathos* as developed by Socrates and his followers, but of course it implies the opportunity of scrutinizing the body for these signals. If, as Plato argued (*Laws* 815a), nobility of spirit was inherent in a body held 'upright' (*orthos*), limbs 'running in a straight line' (*euthypherês*) and sinews 'finely taut' (*eutonos*), then such a virtuous physique – the opposite of all beggarly stooping and limp cowardice – must be open to view, available for assessment. Robes would cause obscurity.

It is by a process of repeated association that this ideal elides with the visual definition of the hero; and it is, again, a matter of context and decorum, when we may apply the term 'heroic nudity'. For instance, even allowing that the short cloak (*chlamys*) worn by young men in Classical Athens was liable to revelation, it is highly unlikely that a cavalcade of riders at a sacred ceremony such as the Panathenaic procession would indulge in such flagrant display of genitalia as visible on the Parthenon frieze (see Figure 2.5): therefore this is some other cavalry occasion, or else the riders are to be understood as extraordinary.

If we now turn to some examples of overt heroization, it will become clear why the concept of 'heroic nudity' holds good. By artistic tradition, individuals

worshipped as heroes were often shown without clothes. Nudity, therefore, becomes a costume that may be donned by anyone eligible or aspiring to be counted among their number.

The Tyrannicides

The statue-group known as The Tyrannicides or Tyrant-Slayers (Figure 5.9) furnishes us with a powerful example of the heroic image. This is despite a number of historical ambiguities surrounding the event commemorated by the statue, and the fact that we are probably left not with a copy of the original statue, but copies of (or visual allusions to) a replacement created after the original statue was taken from Athens (see below). Even at this remove, the group functions as an epitome of Classical heroism – and in particular, as an emblem of individual bravery on behalf of the community at large.

The heroes of the piece are two Athenians named Harmodius and Aristogeiton. They were heroized not long after their deaths in 514. How they met their end is a story freighted with anti-tyrannical sentiment, yet plausible enough. The tyrants were the Peisistratids – namely Peisistratos, who ruled Athens from 560 to 527, and his successor-sons Hippias and Hipparchus (see p. 157). Whether the Peisistratids as a ruling dynasty were deeply unpopular at Athens is not proven, but not actually important to the tale of the Tyrannicides as it comes down to us. At the Panathenaic Festival of 514, Harmodius and Aristogeiton assassinated the younger Peisistratid, Hipparchus. Some say they had originally intended to kill Hippias, but found Hipparchus an easier target. In any case, they both nursed grudges against Hipparchus: Aristogeiton because Hipparchus was repeatedly making overtures to his boyfriend, Harmodius; Harmodius because Hipparchus had lately insulted his sister. In the tumult of the attack, Harmodius was himself killed; and though Aristogeiton escaped, he was then captured and tortured to death by Hippias.

Thucydides (6.54–9) is the source for an account of this event that stresses its non-political motives, credibly telling us that Harmodius and Aristogeiton acted as they did from the passions of a 'love pain' (*erôtikê lypê*). If their plot became 'tyrannicide', that was accidental.

Nor, strictly speaking, did they effectively rid Athens of tyranny. Hippias remained in power a further four years, growing ever more malevolent towards his subjects, until a coalition of the Alkmaionids – a powerful Athenian family, exiled by Hippias – and a Spartan army, instructed by the Delphic Oracle to 'liberate' Athens (see Herodotus 5.63), succeeded in ousting Hippias. It was probably during the next decade that the original statue-group of Harmodius and Aristogeiton, made in bronze by Antenor, was raised in the Athenian Agora.

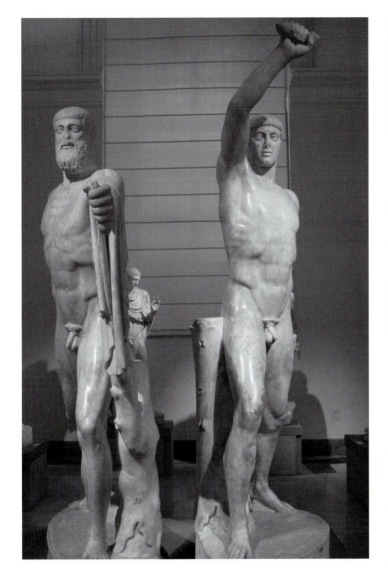

What this group looked like is not certain, for it was abducted by the Persians when they occupied Athens in 480, and although we are told that this was eventually recovered by Alexander the Great when he took the palace of Susa, and returned to Athens by Alexander or some other Hellenistic monarch, we can only suppose that a replacement piece, entrusted to the sculptors Kritios and Nesiotes *c.* 477, was more or less similar to Antenor's original.

Pausanias implies by his account (1.8.5) that both groups were on view in Roman times; what became of them later is unknown. A chance find of debris from a Roman sculpture workshop at Baia, on the Campanian coast, in the early 1950s, brought to light a fragmentary cast, taken direct from bronze in antiquity, of the head of Aristogeiton – recognizable from Roman copies of the Tyrannicides – but stylistically it is not obvious whether this cast was taken from the earlier or the later group. Let us put aside this problem, however, for what matters more is that the site chosen to commemorate Harmodius and Aristogeiton was central to Athenian civic life. It is no exaggeration to say that their images would become symbolic cornerstones of the Athenian democracy as it developed in the fifth century. It remains to be established exactly where in the Agora the monument was sited – apparently in or near the Orchestra, probably in the north-west corner – but it is safe to say that the Tyrannicides Group would have been glimpsed almost daily by many Athenian citizens. Subsequently, a long

rectangular base would be erected in the same vicinity, bearing images of the 'Eponymous Heroes' – legendary founders of the 'tribes' of Attica, originally ten in number, which became the voting-districts of the democracy. By its juxtaposition, this monument would confirm the status of Harmodius and Aristogeiton as prime movers of Athenian democracy. (And by celebrating their action as 'tyrannicide', Athenians might conveniently erase in vulgar consciousness the role of Spartan forces in expelling the last Peisistratid.)

The dynamic of the composition is simple enough. The viewer is virtually placed in the position of Hipparchus as his assailants make their move. Aristogeiton lunges forward with the sheath of his sword advanced, and his right arm drawn back to strike; Harmodius attacks from above, his blade more likely to slash than stab. Between them, they can hardly fail to inflict a fatal blow. That the pair act in unified resolve is emphasized by the mirror-image of their forward motion; that they were a pederastic couple, Aristogeiton *erastês* (the lover), Harmodius *erômenos* (the beloved), is made clear by the older man's beard, while Harmodius appears as Thucydides would describe him, 'in the full bloom of youth' – an object of desire both to the man he is killing and the man beside him.

The occasion chosen for assassination was the Greater Panathenaia, when the Agora would be crowded. The tradition relates that Harmodius and Aristogeiton concealed their weapons in bundles of myrtle-branches – aromatic fuel for an act of sacrifice – but both men would naturally have been clothed suitably for a religious event. All we see is Aristogeiton's cloak, forming a sort of protective foil to his partner. So here is a firm example of 'heroic nudity'. Soon after their deaths, Harmodius and Aristogeiton were officially accorded the status of heroes: that is, a cenotaph was established for them in the Kerameikos, where annual offerings (*enagismata*) were made to them by the city's war-minister (*polemarch*), as if categorically including the pair among those fallen in battle. In this sense, the *cult* of Harmodius and Aristogeiton focused not so much upon the concept that they ended the tyranny, but that the tyranny ended them.

The reputation that their images were 'portraits' (Pliny, *NH* 34.70) probably derives from the privileged position of the Tyrannicides Group in Classical Athens, where constraints on honorific statues were generally strict (we possess, for example, no image of Kleisthenes, who is historically accredited with creating the radical structures of democracy at Athens). Certainly the image became talismanic, an epitome of the democratic *polis* not only replicated in cities allied to Athens, but also referred to on coins, shield blazons and various other media. The striking gesture of Harmodius ('the Harmodius blow') became an attitude visually resonant in Classical art at large – and since 1853 (when the statue-types were first recognized, by Carl Friedrichs, as 'The Tyrannicides' of antiquity) the group has offered a prototype for sculptors commissioned to evoke some sort of collective determination.

The statues of the Tyrannicides have survived better than ancient hymns of praise in their honour. But the songs are worth mentioning here, for they articulate the potency of cult behind 'heroization'. Drinking-songs, or *skolia* ('twisters'), were customary at ancient *symposia*: chanted to the accompaniment of a lyre, they might be organized by rote, even competitively – with participants holding a myrtle-branch, to be passed on to the next singer. The use of myrtle-foliage gave special piquancy to the invocation of Harmodius and Aristogeiton, of course; but in any case it was normal for heroes to be addressed. A number of such lyrics survive in celebration of Harmodius and Aristogeiton. Some flagrantly exaggerate the political purity of their intentions by addressing them as founders of *isonomia*, 'equality of rights', at Athens; others are content to salute the reward of an heroic deed:

Dearest Harmodius! You are not dead for sure:
They say you live forever in the Islands of the Blessed,
Where also dwells Achilles, swift of foot,
And, they say, brave Diomedes, son of Tydeus.

<div align="right">ATH. 15.695; CF. PMG 894</div>

Rowdy and drunken the occasions of such choruses may have been, yet the vigorous denial of death contained in this *skolion* to Harmodius is a highly significant element of the heroizing process, and demands further exploration.

Heroes beyond the grave

In 399 BC Socrates was condemned to death by an Athenian court. His valedictory words, as recorded in Plato's *Apology*, carry an inspirational and self-consolatory line of reasoning. Is Socrates dismayed by the verdict? No, he replies: for death simply presents us with two options. Either it is a complete cessation of consciousness, in which case it will come like a deep and dreamless sleep – blissful oblivion. Or else it is as many eschatologies and poets predict: the migration to another place – a nether world of spirits which is like a vast accumulative club of all who have gone before. This, too, says Socrates, must be regarded as a pleasant prospect. 'What would you not give, gentlemen, to be able to question the leader of that great host against Troy, or Odysseus, or Sisyphus, or the thousands of other men and women one could mention, to talk and mix and argue with whom would be unimaginable happiness?'

The Socratic gloss on self-extinction is attractively defiant, even if the way in which Kleobis and Biton settle down forever in death's 'holy sleep' implies that it need not be a choice: seemingly one could become an honoured member of the eternal community of the dead *and* enjoy uninterrupted slumber. But we must not press our Greek literary and philosophical sources for too much consistency in this

matter. What concerns us here is how far such sources contribute to our understanding of funerary sculpture.

Both the sympotic salutation of Harmodius and the farewell speech

from Socrates offer a particular destination to the deceased: that is, of mingling 'in the world beyond' with the heroes of old. This single aspect of Greek beliefs about the afterlife goes a long way towards making sense of the images we find on grave-markers or *stêlai*. We have already seen how the *kouroi* could serve as grave-markers and represent a man who died in old or middle age as being in the physical prime of youth. The defined age may anticipate a rejuvenation to come, or leave behind a reminder of appearance at its peak – but more importantly, it puts the deceased in the ranks of the great and the good. At one sanctuary in Boeotia – the oracular site of Apollo Ptoios – some 120 votive *kouroi* may have been on view: though not grave-markers as such, these must have seemed like an immortalized host, the flower of Boeotian manhood, bound to join Achilles and Agamemnon and all the recreations of Elysium. And from another Boeotian site, Tanagra, comes the double memorial raised by one Amphalkes for Dermys and Kittylos (Figure 5.10). This is presumed to come from a cemetery, and the two figures thought to be the sons

Figure 5.10 *Limestone stêlê of Dermys and Kittylos from Tanagra, c. 600 BC. Ht of monument 2 m.; it would probably have been crowned with the figure of a sphinx.*

(possibly twins) of Amphalkes. An inscription says merely that Amphalkes set the monument 'over' (*epi*) the pair. Simple as it is, the piece freezes the boys as heroically nude, with knees flexed for action; they seem to step out of the stone, defying any viewer who would regard them as inert.

Appearance could be sufficient to dignify a name, such as the well-known *kouros* now in Athens simply inscribed 'of Aristodikos'. Where epitaphs are added, they may reinforce the visual message – for example, the legend on a late Archaic statue-base from the Kerameikos: 'In memory of Kleoites, lost son of Menesaichmos; look, and pity him for dying, so beautiful [*hôs kalos*]' (the statue seems to have shown the boy seated, but nonetheless his physique must have been made clear). Or inscriptions direct the viewer more prescriptively: from Athens, again, in the mid sixth century, we find the following: 'Whoever beholds your marker, Xenokles, the *sêma* of a spearman, will stand and appreciate your manliness' (*CEG* 19).

Images of the moment of death were generally avoided. The Athenian *stêlê* of a runner wearing a helmet, despite appearances, probably does not show the subject dead or unconscious (Figure 5.11). His pose is better read as one of triumph: crossing the finish gloriously. The monument reassures those who knew the deceased (and informs those who did not) that he has gone to a realm where his fleet-footedness will be useful; whatever his athletic prowess while alive – most probably the race in armour, or conceivably the armed dance – he is now to be imagined in the company of Homer's nimble heroes.

Grave monuments are numerous – over 10,000 survive from Athens and Attica – but they were costly. From Athens, and elsewhere, we have evidence of intermittent legislation aimed at curbing expenditure on funerary protocol. The *polis* was obliged to honour those who died defending it; in democratic Athens, state funerals for casualties of war were overtly heroizing, with a 'People's Grave', the *Dêmosion Sêma*, providing a designated area in Classical times. Here, by an ample avenue (simply

Figure 5.12 *Fragment of marble stêlê, c. 525 BC, reportedly found in the Horti Sallustiani, Rome. Ht 68 cm.*

known as the *Dromos*, leading towards the Academy gymnasium, eventual site of Plato's school), lists of the dead were inscribed on marble slabs: this is where Perikles would deliver his famous Funeral Oration, and where Perikles himself would be buried – in company with Kleisthenes and (if not an actual grave) the Tyrannicides.

'Dying in battle seems to be a splendid thing in all sorts of ways. Even if a man is poor, he receives magnificent burial …' (Plato, *Menex.* 234c). But state burial – sometimes referred to as the *Polyandrion*, literally entailing 'many men' in a communal grave – was evidently insufficient glory in certain quarters at Athens. The cavalry units were traditionally drawn from aristocratic families, who liked to display their status. So we notice, on the lower part of a *stêlê* shaft that once showed a standing warrior, the secondary figure of a boy on horseback, carrying two spears and a sword (Figure 5.12). This may be a retrospective image of the deceased, marking him out as a cavalryman (*hippeus*) – or else an image of his squire. Over a century later, this allusion to equestrian status is developed into overt heroization with the 'Dexileos Relief' (Figure 5.13). Though inscribed in honour of Dexileos as 'one of the five knights' killed in action at Corinth during the campaigns of 394–393 BC, this *stêlê* does not mark a burial place: following state protocol, Dexileos was interred nearby in the *Dêmosion Sêma*. The image adorned his family's reserved grave precinct in the Kerameikos (Figure 5.14) and proudly records the young man (who died aged just 20) not as a victim, but triumphant over his foe. The enemy's identity is not visually or epigraphically specified – historically we happen to know this was a skirmish between Athens and Sparta – but in any case *his* nakedness may be taken as a sign of disarray and vulnerability, while Dexileos is represented in at least partial battle-dress (helmet and body-armour are missing, as is any protection for the horse, prescribed by contemporary strategists – see Xenophon, *On Horsemanship* 12 – but dowel-holes on the sculpture indicate that some of these details were added in bronze). Clearly the relief, like the images of riders on the Parthenon frieze, heroizes its subject. And the archaeology of the precinct indeed suggests that it

Figure 5.13 Marble stêlê of Dexileos, early fourth century BC. Ht 1.75 m. The inscription is unusual in giving dates of birth and death for its subject.

Figure 5.14 Replica of the Dexileos monument as erected in situ. Though displayed in a family enclosure (peribolos), the relief was set on a high curved base, conspicuously emphasizing the sacrifice made by Dexileos (and his parents) in service to the city.

may have functioned as a hero-shrine: among presumed offerings found at the site were a number of small wine-jugs, including one decorated, perhaps symbolically, with a red-figure sketch of the Tyrannicides.

The Dexileos memorial shares with many others of Classical antiquity the poignant fact that it was raised by the parents of a deceased child. The same circumstance applies to another well-known fourth-century relief, the so-called Ilissos *stêlê* (Figure 5.15), in which the sentiments of the living are made apparent. The youthful subject of the monument, relaxed against a low pillar, seems to gaze out at us (or has the vacuous fixed expression of the dead). He in turn is regarded by an old man, probably his father, in appropriately pensive mood. 'Regarded by' … and yet, of course, despite the powerful physique represented here, this

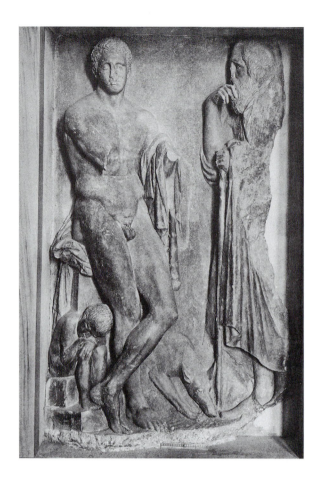

tombstone marks a palpable absence. A lean hunting-dog miserably sniffs the ground where once his young master trod; and hunched upon a step is the figure of a boy, perhaps slave or valet, who looks to have wept himself into a state of exhaustion.

Greek tombs were places of worship – places where a fellowship (*koinônia*) was established and maintained between the living and the dead. Many grave-markers show the motif of a hand-shake (*dexiôsis*) between the deceased and the living, symbolic of a bond that does not cease with death. We may readily sympathize with the grief of parents who have had to bury their own children; we should also be aware that in ancient Greece there was a strong social obligation, and some legal requirement, for parents and grand-parents to be honoured by their offspring. This called for regular visits to the grave and the performance of various rituals. Grave-stones were to be decorated with wreaths and ribbons. Food would be brought to share with the dead: honey cakes, or perhaps some once-favourite dish (one tomb is recorded as receiving plates of fried fish). Sacrifices were also conducted, releasing 'blood for the ghosts' (warm blood is what even the heroes crave when, in Book 11 of the *Odyssey*, Homer conducts us down to Hades); there might then also be a meal for the participants. On some grave-reliefs such pieties are represented: we may see the extended family group, processing to the cemetery with their intended objects of sacrifice (Figure 5.16).

Since the difference between tomb-cult and hero-cult is only one of degree, it is fair to categorize ancestor worship as a sort of heroization – even when such heroization is couched in familiar terms (epitaphs tell of a child remembered by his nickname of 'Chatterbox', or a wife commended because she loved her husband more than her clothes and jewellery). Ancestors were accorded a grandeur of status that could translate easily in sculptural terms. A Spartan relief shows this almost to the point of absurdity (Figure 5.17). The enthroned couple are so dominating that

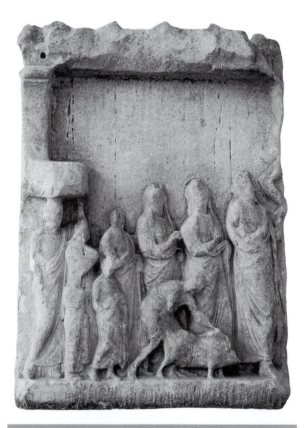

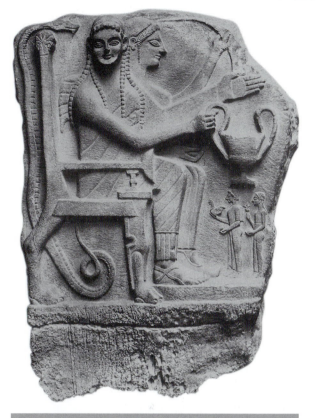

Figure 5.16 *Fragment of an Athenian marble relief showing a family's procession to a tomb. Fourth century BC. Ht 66 cm. A small pig is led to sacrifice; more food (or equipment) carried on the head of the rearmost figure.*

Figure 5.17 *Stêlê from Chrysapha (Lakonia), c. 550 BC. Ht 87 cm. A number of similar reliefs, made from local blue-grey marble, have been found in the area.*

some commentators have wondered if they represent Pluto and Persephone, presiding deities of the Underworld. But they are more probably intended as the heroized ancestors of the diminutive figures seen dutifully bringing tribute – a hen and an egg from the male, a pomegranate and a flower from the female. A serpent, symbolic of the Underworld, rises behind the throne. Is the Dionysiac drinking-cup or *kantharos* extended by one of the Giants a sign of posthumous bliss, or demanding to be filled by the worshippers? However, the message seems clear. Those who have died may have disappeared, buried out of sight; but conceptually they are greater than ever and are accordingly not below but above the living. They are members of a society requiring respect; they are 'the powerful dead'.

Corpses were generally not represented as such; but allusions may be made not only to the manner, but also the moment of death. A number of reliefs appear to

VIRTUOUS WOMEN

The concept of the heroine in Greek literature is not well-defined. But that is not to deny the existence of 'positive role-models' in Homeric epic. Hector's wife Andromache is one such, fearful on behalf of her man yet obedient to his orders (*Il.* 6.395ff.); while Penelope, wife of Odysseus, makes a paragon of chaste loyalty throughout the *Odyssey*. Such types offered artists an alternative model, albeit rather dull, to the spectacle of tragic or militant female behaviour (Amazons, Clytemnestra, Medea, Niobe *et al.*). We do not know the original context for a statue-type that was created of Penelope during the fifth century, but it may be considered as a mode of female heroization, epitomizing the ideal citizen-woman as beautiful yet modest, well-kept yet diligent in her housework (Figure 5.18). The type is recalled on numerous Classical Athenian grave *stêlai* (Figure 5.19). Poetic epigrams and funerary inscriptions supplement the simple visual

Figure 5.18 *Fragmentary statue of Penelope, in Pentelic marble, c. 460 BC. Ht 85 cm. Later versions make it clear that the figure sat with bowed and veiled head, as if at a loom. This Severe Style piece was found at Persepolis, perhaps once sent as a gift to the Persians.*

Figure 5.19 *Stêlê of Mnesarete, c. 380 BC. Ht 1.64 m. Mnesarete ('mindful of virtue'), seated, gestures as if to make a veil with her himation; her maidservant stands before her. An accompanying epitaph emphasizes the goodness (aretê) of the deceased.*

vocabulary for symbolizing virtuous qualities: baskets, wreaths, keys (for temple access) are among the indicators of good domestic management and public office. (During the Hellenistic period, women would become more prominent in civic and benefactory roles – but the portrait statues accordingly awarded to them maintained the same Classical stereotype.)

indicate women suffering fatal pangs of childbirth (Figure 5.20). We may also note a Hellenistic *stêlê* from the Kerameikos in memory of a Semitic seafarer known as Shem in Phoenician and Antipatros in Greek: it seems he met his death in dramatic circumstances, being mauled by a lion. Where this happened is not clear: the tombstone is synoptic, showing the deceased on a funerary couch, a big cat attacking on one side, a companion trying to fend it off from the other and a ship's prow looming up in the background. A six-line epigram (in Greek) 'explains' the imagery, accusing 'the hateful lion' and praising the bravery of the dead man's friends for (eventually) fighting it off.

From the case of the Tyrannicides we appreciate that no great lapse of time was necessary for the dead to be recognized as heroes. And although Homer sets his poems in an 'heroic past' – vaguely equivalent to the 'Mycenaean period' of modern parlance,

maybe – neither Homer nor his successors were concerned to establish an annalistic chronicle of when the Trojan War took place. (Broadly speaking, the 'heroic age' ended when Odysseus returned to resume rule on Ithaca.) Time was readily telescoped: what mattered was the continuity that enabled (for example) the Peisistratids to claim direct descent from Nestor of Pylos.

Geneaology aside, the 'fame' (*kleos*) and 'glory' (*kudos*) accrued by Homer's heroes were not monopolized by them: that is, these were gains or attributes which any athlete or warrior could aspire to possess. The sculptural contribution to such a heroic and heroizing culture was substantial. Sculptors created the physical tone

Figure 5.20 Detail of a marble funerary lekythos from the Kerameikos, c. 340 BC. Ht of unrestored piece 78 cm. A woman named Theophante collapses onto a chair, with midwife (?) and husband powerless to save her.

for the practice of emulation. Their handiwork embodied those measures of appearance and self-presentation that showed heroes as both larger than life and yet at the same time credible, fallible and attainable.

Sources and further reading

Defining the hero G. Nagy, *The Best of the Achaeans* (Baltimore 1979) has become a classic of Homeric exposition; on the heroic interpretations given to ancient palaeontology, see A. Mayor, *The First Fossil Hunters* (Princeton 2000), 104–29.

Kleobis and Biton For a proposed reading of *Polydeukes* on the leg of one of the figures, see *BCH* 106 (1982), 509–25.

Kouroi Waldemar Deonna's inventory of *Les 'Apollons Archaïques'* (Geneva 1909) corrected – as his title implies – the assumption that the *kouros*-type represents Apollo and made a valuable start to establishing the chronological sequence of statues developed in Gisela Richter's *Kouroi* (3rd edn, London 1970). Deonna's perception of the heroizing intent of the type has more or less become the consensus: see A.F. Stewart, 'When is a Kouros not an Apollo? The Tenea "Apollo" Revisited', in M. del Chiaro ed., *Corinthiaca* (Missouri 1986), 54–80; A.M. d'Ono-frio, '*Korai e kouroi* funerari attici', *AION* 4 (1982), 135–70; V. Zinserling, 'Zum Bedeutungs-gehalt des archaischen Kuros', *Eirene* 13 (1975), 13–33; and D.T. Steiner, *Images in Mind* (Princeton 2001), 212–16. 'Apolline' elements should not, however, be discounted: see B.S. Ridgway, *The Archaic Style in Greek Sculpture* (2nd edn, Chicago 1993), 61–89. The estimate of *kouros* numbers at 20,000 is made by A.M. Snodgrass, in P. Garnsey, K. Hopkins and C. R. Whittaker eds., *Trade in the Ancient Economy* (London 1983), 21; for *kouroi* as 'symbols of interaction', see C. Renfrew and J. Cherry eds., *Peer Polity Interaction and Socio-Political Change* (Cambridge 1986), 11–12.

Heroic nudity A fundamental contribution to this topic, though not easy to follow, is N. Himmelmann, *Ideale Nacktheit in der griechischen Kunst* (Berlin 1990); see also L. Bonfante, 'Nudity as a Costume in Classical Art', *AJA* 93 (1989), 543–70; A.F. Stewart, *Art, Desire, and the Body in Ancient Greece* (Cambridge 1997), Ch. 2; and J.M, Hurwit, 'The Problem with Dexileos: Heroic and Other Nudities in Greek Art', *AJA* 111 (2007), 35–60. The Cleveland torso is assigned to 'the Melos Group' by Richter (*Kouroi*, 112), though it is not a straightfor-ward member of that category. Of the Miletos piece, Richter comments (p. 150): 'Clavicles, trapezium, serratus magnus, thorax, rectus abdominis, flanks, lower boundary of abdomen, shoulder blades, spinal furrow, erector spinae, depression over great trochanter all modelled in naturalistic manner.' (As such it belongs to a small assemblage of statues forming an 'Epilogue' to the *kouros*-series.)

The Tyrannicides S. Brunnsåker, *The Tyrant-Slayers of Kritios and Nesiotes: A Critical Study of the Sources and Restorations* (2nd edn, Stockholm 1971); D. Castriota, 'Democracy and Art in Late Sixth- and Fifth-Century BC Athens', in I. Morris and K. Raaflaub eds., *Democracy 2500? Questions and Challenges* (Dubuque 1998), 197–216; J.W. Day, 'Epigrams and History: The Athenian Tyrannicides, a Case in Point', in M. H. Jameson ed., *The Greek Historians: Papers Presented to A.E. Raubitschek* (Stanford 1985), 25–46; C.W. Fornara, 'The Cult of Harmodios and Aristogeiton', *Philologus* 114 (1970), 155–80; C. Landwehr, *Die antiken Gipsabgüsse aus*

Baiae (Berlin 1985), 27–47 (on Roman casts of the group); A.J. Podlecki, 'The Political Significance of the Athenian "Tyrannicide" Cult', *Historia* 15 (1966), 129–41; T.L. Shear Jr, 'They Made Athens a City of Equal Rights: The Agora and Democracy', in W.D.E. Coulson, T. L. Shear Jr, H. A. Shapiro and F. J. Frost eds., *The Archaeology of Athens and Attica under the Democracy* (Oxford 1994), 225–48; B.B. Shefton, 'Some Iconographic Remarks on the Tyrannicides', *AJA* 64 (1960), 173–9; M.W. Taylor, *The Tyrant Slayers: The Heroic Image in Fifth Century BC Athenian Art and Politics* (2nd edn, Salem 1991); R. Thomas, *Oral Tradition and Written Record in Classical Athens* (Cambridge 1989), 238–82; R.E. Wycherley, *Agora* vol. III: *Literary and Epigraphical Testimonia* (Princeton 1957), 93–8, nos. 256–80.

Heroes beyond the grave For a discussion of ancestor worship and heroization, see S. Humphreys, 'Family Tombs and Tomb Cult in Ancient Athens', *JHS* 100 (1980), 96–126. Archaic *stêlai*: G.M.A. Richter, *Archaic Gravestones of Attica* (London 1961); subsequent material is collected in the seven volumes of C.W. Clairmont, *Classical Attic Tombstones* (Kilchberg 1993–5); K.F. Johansen, *The Attic Grave Reliefs of the Classical Period* (Copenhagen 1951) makes an easier introduction. Sympathetic commentary on Archaic material in C. Sourvinou-Inwood, *'Reading' Greek Death* (Oxford 1995). **Dexileos relief** S. Ensoli, *L'Heróon di Dexileos nel ceramico di Atene* (Rome 1987); **Ilissos *stêlê*** N. Himmelmann, *Studien zum Ilissos-Relief* (Munich 1956). For the monument to Antipatros, see J.M.S. Stager, '"Let no one wonder at this image": A Phoenician Funerary Stele in Athens', *Hesperia* 74 (2005), 427–49. **Virtuous women** S. Dillon, *The Female Portrait Statue in the Greek World* (Cambridge 2010), charts the rise and persistence of the 'virtuous wife/mother/daughter' stereotype. On reliefs recording deaths in childbirth: A. Stewart and C. Gray, 'Confronting the Other: Childbirth, Aging, and Death on an Attic Tombstone at Harvard', in B. Cohen ed., *Not the Classical Ideal* (Leiden 2000), 248–74.

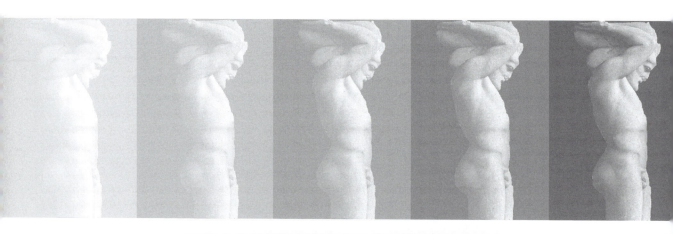

[The Greeks] knew that the decisive events of history are not momentary coincidences, mere collisions – as of two planets in space; they instinctively felt that what made them significant was the moral context in which the accident occurred. Hence a mere happening was not a subject for serious art: it was … the business of an artist to immobilize in a symbolic form a whole complex of passions and actions. In plastic art this can only be achieved by resorting to allegory.

Roger Hinks,
Myth and Allegory in Ancient Art
(London 1939), 66

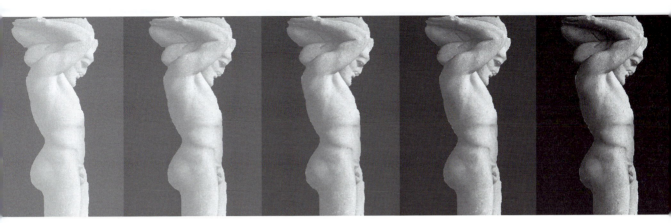

6

TEMPLE STORIES

No ancient author cares to tell us why Greek temples were decorated the way they were. We know that the construction of a temple was a major political and financial commitment: we may suppose that the embellishment of a temple gave 'added value' to an already valuable edifice – enhancing a sense of indebtedness between those dedicating the temple and the divinities in whose honour it was dedicated. What else is to be expected? Some sort of religious instruction, presumably: some visual statement of what was intended as the ritual and spiritual function of the building. Subsequently this sacramental element might be encompassed (in Christian parlance) by the term 'liturgy', which transliterates a Greek word for 'public duty' (*leitourgia*); but it is not clear whether temple decoration was so specifically prescriptive as to instruct worshippers on their actual conduct within the sacred precinct (*temenos*) – or to provide, as one scholar phrases it, 'prayers in stone'. (Still less is it clear that such decoration served as if 'scripture for the illiterate'.) Rather, images were evocative of the cosmological, mythical and historical *reasons* for ritual, and veneration of the gods. Images set the scene: images articulated local and Panhellenic systems of praise and shame, heroism and cowardice, virtue and wrongdoing. And it was in the nature of Greek imagery to generalize not only the rules of these systems, but also their application.

An excerpt from a brief but deeply influential Aristotelian text, the *Poetics*, justifies this practice. Aristotle is discussing literary media; but what he says about 'poetry' is transferable to 'art'.

The poet's function is to describe not the thing that has happened, but a kind of thing that might happen, i.e. what is possible as being probable or necessary. The distinction between historian and poet is not in the one writing prose and the other verse – you might put the work of Herodotus into verse, and it would still be a species of history; it consists really in this, that the one describes the thing that has been, and the other a kind of thing that might be. Hence poetry is something more philosophic and of graver import than history, since its statements are of the nature rather of universals, whereas those of history are singulars.

POETICS 1451B, TRANS. BYWATER

To approach what remains of the sculptural decoration once affixed to Greek temples with this text in hand may seem preposterous. After all, there must have been elements of decoration that were simply conventional – for example, placing winged figures on rooftops and gable-ends as akroteria; or even, we may presume, choosing a theme for some metopes for no better reason than that this theme had appeared on other temples. Such is the nature of decorum, as powerful as the architectural 'orders' – Doric, Ionic, etc. – that governed temple design. Nonetheless, we should imagine a commissioning process in which proposals for sculptural 'programmes'

were tendered competitively and were subject to discussion by local priests and funding bodies. Adding sculpture to a temple was a substantial investment.

The question may be asked: how much was it worth? After all, once architectural sculpture was installed, it almost invariably became difficult to comprehend as a whole: viewers on the ground were challenged by imagery raised perhaps over 12 m. high, in lighting conditions that varied from fierce sunlight to gloomy interiors, or columns obstructing vision. One scholar has drawn attention to the result: art that surely had great significance, yet tended to be put beyond visual comprehension (the paradox of 'high meaning and low communication'). So perhaps it is wisest if we consider the logistical origins of such sculpture. In the first place there were plans and models. Tendering for commissions, sculptors would have submitted small-scale maquettes of their proposals and presumably had to negotiate not only with the architects of a temple, but also with presiding priests and local interests. If only we had access to the evidence of this planning stage, we should be spared much hazardous speculation about the meanings of 'temple stories'. As it is, each body of surviving sculpture demands an approach of more or less informed guesswork. What follows is not a comprehensive survey, but a series of *exempla*, some well known and some less so, showing how far such reasoning may take us in reconstructing ancient intention – and reception.

The Corfu pediment

The earliest large-scale pedimental decoration known to us comes from a limestone temple on Corfu (Korkyra), built a little after 600 BC. Both pediments of this temple, dedicated to Artemis, carried scenes carved in deep relief, with much delicate surface detail originally heightened with bright colours. Metopes, also carved, are very fragmentary. The only well-preserved portion is the west pediment, recovered in 1911. Immediately it poses the modern viewer with challenges of interpretation. The elongated

Figure 6.1 *The west pediment of the Artemision at Corfu, c. 590–580 BC.*

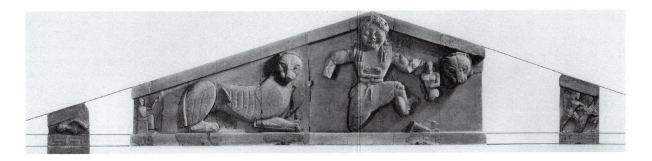

triangle of the pediment (the *tympanon*) is fully occupied with various figures (Fig 6.1); in thematic terms, however, what holds this medley together?

At least the central subject appears unmistakable. With her wide-eyed grimace and lolling tongue, snakes fringing her brow, writhing from her nape and inter-locked around her waist, she must be a Gorgon, caught in the high-knee sideways posture of sprinting, yet with fully frontal face. So a Gorgon's face makes the apex of the pediment (Fig 6.2). Or does it? After all, the sanctuary is an Artemision, where it might be reasonable to expect an image of Artemis, notorious as 'Mistress of the Beasts' (*Potnia Thêrôn*) – and either side of this figure are two enormous felines whose pelts are patterned in such a way as to suggest leopards. But they are crouched, while she is running; and in any case, two intermediate figures have to be accounted for. One is now mostly lost, but was clearly a winged horse, prancing on its hindquarters. The other is a goggle-eyed boy, heraldically match-ing the winged horse in his position.

Now the viewer is required to summon up details of a story. Fortunately, we have a fairly good idea of what the story might have been, thanks to its recapitu-lation by Hesiod (*Th.* 280–3), *c.* 700 BC, plus a number of allusions and retellings by later Classical authors. It is part of the tale of Perseus, the young hero whose best-known deeds were the beheading of the Gorgon Medusa and the rescue (from a dragon) of the Ethiopian princess Andromeda. Tradition related that there were three Gorgons, sisters, of which the one known as Medusa had the power to petrify any mortal who met her gaze. Though Hesiod does not mention the trick, Perseus managed to decapitate Medusa without coming under her deadly stare – his aim guided by her reflection in his shield – and had winged sandals, supplied by Hermes, to help him flee the sisters' furious chase. Seemingly Perseus has fled from the space of the pediment, for we cannot find him here. But we are left with a problem of interpretation. If we are following Hesiod, the two figures flanking Medusa will be

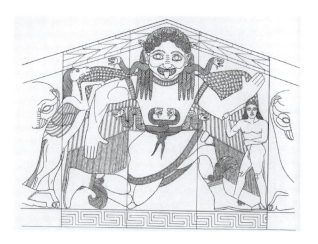

Pegasus on one side, and on the other a youth called Chrysaor, 'golden blade' (on the relief, his right arm was probably brandishing a sword). These offspring came after Perseus chopped off the Gorgon's head; they were born, as Ovid put it, *de sanguine matris*. So how can they be shown, while Medusa seems intact?

Looking beyond the big cats, to the far angles of the pediment, we find no answer to this

Figure 6.2 *Central figure of the west pediment of the Artemi-sion at Corfu. Ht 2.8 m.*

question, only further problems of interpretation. The extreme corners are each occupied by a recumbent, possibly moribund figure. Then there are two distinct-ive but similar groups. One shows an enthroned figure being threatened by a warrior with a spear; the other a half-kneeling figure about to be struck by another figure wielding some ballistic implement – recognizable, to the *cognoscenti*, as a thunderbolt.

It has been proposed that the two recumbent figures in the angles are the bodies of dying Titans; that we also see young Zeus, bringing down another Titan with his thunderbolt; and that the enthroned figure may be Priam, about to be slain during the Sack of Troy. There is not the space here fully to explain these proposals, but readers may rightly wonder what would unite them within the pediment in any case. The entire ensemble, we must admit, is lacking in unity. If the central action shows the birth of Pegasus and Chrysaor from the cut-off head of Medusa, it lacks unity of time – this scene alone would be a *synopsis* of two moments in a narrative sequence (*cf.* p. 28). If the felines belong to Artemis, not the Gorgon, it lacks unity of subject (not to mention the other seemingly disparate elements). Apparently it lacks unity of place – wherever the Gorgons had their lair, it was not near Priam's Troy; and clearly it lacks unity of scale.

In the face of such difficulties, some scholars conclude that the Corfu pediment amounts to an inexperienced attempt on the part of the sculptors. (We can at least agree that the angular contraints of the architectural space make it difficult to create a naturalistic composition.) And, of course, the existence of a text is a mixed blessing. Suppose the sculptors were not guided by those very lines of Hesiod familiar to us? What if the Medusa is intact because the boy waving a sword is not Chrysaor but Perseus, carefully facing away as he attacks her – and Pegasus is merely an 'attribute' of the Gorgon?

Hesiod is not alone in telling us that the three Gorgon-sisters were embodiments of 'great Fear' (*megas Phobos*: *Asp.* 237). Homer knew that too: in his description of Agamemnon's shield (*Il.* 11.31ff.) he draws attention to a central *gorgoneion*, there to spread 'Terror and Rout'. So one well-tried way of understanding the Gorgon-image is to classify it as 'apotropaic' – a device for 'turning away' (evil), or instilling a sense of caution in the visitor. It would be suitable enough as temple decoration, insofar as it signals a place in which both fear and reverence are due. The 'Oriental' animals add to that effect – and may indeed add the implication that they are controlled by the goddess worshipped here; and, as we shall see, it will not be uncommon for either the battles of the Olympians to establish cosmic order or the Sack of Troy to furnish illustrations of the force of divine will.

Our 'reading' of this pediment may go further – if and as we wish. Corfu was a Corinthian colony, established by one branch of a tightly knit aristocratic ruling

group at Corinth known as the Bacchiads. During the seventh century, the Bacchiads at Corinth were displaced by a tyrant, Cypselus. The incomplete histories we have of the tyranny of Cypselus and his son Periander suggest that a part of their foreign policy was to assert ascendancy over those Bacchiads settled on Corfu. It may be that the Cypselids accordingly endowed the island with a Doric temple and commissioned a pedimental symbol of central Corinthian power. What makes this theory attractive is the fact that the numismatic hallmark of Corinth, from the earliest coins onwards, is the image of Pegasus. Legend connected many of the adventures of Pegasus with Corinth – he became the steed of the Corinthian hero, Bellerophon – so an image featuring the genesis of the winged foal would be an appropriate way of reminding the colonists on Corfu of their Corinthian loyalties. It is also worth noting that *gorgoneia* dominate early temple decoration in Syracuse, another Bacchiad colony of the late eighth century. So Medusa, by her maternal association with Pegasus, was not only religiously apt for a Corinthianizing temple, but politically correct.

Temples on the Archaic Akropolis

Herakles, it is often observed, was a sort of hero for everyman. His exploits were numerous and geographically diffuse. His 'lifespan' was elastic: it both predated the main Trojan War and encompassed the foundation of the Olympic Games. Being a son of Zeus by a mortal woman, he was condemned (by Hera's jealousy) to strive against adversity to win his place on Olympus. So it is no surprise that he was a recurrent choice for temple decoration, a paragon of virtuous submission to trials amidst the horrors of mortal existence. We find him on the east coast of the Aegean, at Assos, on both an architrave-frieze and the metopes of a mid sixth-century temple of Athena; we find him in west Greece near Paestum, on architectural reliefs from the Foce del Sele Heraion – fighting centaurs, wrestling down the Nemean lion and so on.

Since the life of Herakles essentially offered prescriptions for human fortitude, we may suppose that on the level of individual conduct, the opportunities for allegory with Herakles were numerous. Images of the hero were a preferred subject for personal possessions, such as engraved sealstones and finger-rings, throughout antiquity. But what if Herakles could be used as a *political* symbol – and become part of a programme of temple decoration that equates to a 'propaganda'? This may be what we should deduce from the remains of several temples erected on the Athenian Akropolis during the sixth century.

The Akropolis – geologically a rock rising above and at the heart of the city of Athens – was a fortified sanctuary of Athena and other deities with prehistoric ancestry. Up until the sixth century, the sacred precinct (*temenos*) of Athena was

marked, it seems, by a shrine, with two wooden columns *in antis*. The 'heaven-sent' wooden idol known as Athena Polias (see p. 48) was probably lodged here. Around the time of Solon – *archôn* or 'chief magistrate' of Athens in 594/3 BC – a more imposing structure appears to have been erected, close to where the Erechtheum would later stand. Also during Solon's time, apparently, the so-called *Hekatompedon* or 'hundred-footer' was built. (Invisible to us now, its base is thought to lie more or less underneath the later Parthenon.) Relics of Solon's poetry indicate his enthusiasm for the cult of Athena as the city's guardian-goddess. But insofar as any absolute chronology can be fixed on the Archaic Akropolis, it seems that Solon's initiatives were only the groundwork for more spectacular development by his successors, the Peisistratids.

Peisistratos and his sons are historically categorized as 'tyrants', and therefore politically undesirable (see p. 136). But even historians nurtured by democracy were obliged to admit that the Peisistratid regime, lasting from *c.* 560 until 510, was on the whole beneficial, indeed 'a golden age' (*Ath. Pol.* 16.7) for Athens. 'They made the city beautiful', concludes Thucydides (6.54) – an especially significant comment, when we remember that much of what the Peisistratids achieved in monumental building was ruined when the Persians occupied Athens in 480.

We know that the Peisistratids did much to promote the Panathenaic Festival (officially founded in 566 BC), with its great procession that climaxed, as it were, on the Akropolis. It is unlikely that either Peisistratos or his sons actually lived on the Akropolis themselves, but it does seem plausible that they and their supporters sponsored a range of sacred projects there. These included the building, enlargement and embellishment of temples, and, to judge from epigraphic and other testimonia, a number of votive *oikêmata* – chapels and treasuries.

From these buildings a considerable quantity of sculpture survives. Carved from the same soft coastal limestone (*poros*) as the architectural elements, it preserves many traces of its original paintwork. The vexatious issue of which pieces belonged to which building is one we may evade. Our concern is to assess what iconographic coherence these sculptures may show with Peisistratid rule.

There are some large heraldic groups of animals; a Gorgon too; and appearances by Athena – her birth, and leading role in the battle of the Olympian gods against the Giants. Overall, however, the thematic range is dominated by Herakles. Pragmatists may say that Herakles was a shrewd choice for pedimental groups, since a number of his monstrous adversaries have long or coiling tails, very useful for filling the tight extreme angles of a pediment. Yet at this time Herakles was not an obvious choice for heroic celebration on the Akropolis: the deeds of Theseus were more profoundly and aetiologically connected with Athens and Attica.

Figure 6.3 *Part of a limestone pediment from a temple on the Akropolis, c. 550 BC, showing Herakles against Triton. Ht 75 cm.*

Even in their fragmentary state, the scenes chosen for representation display not only respect for Herakles, but a palpable affection too. From a tiny shrine comes a pedimental *tableau* of Herakles, vigorously laying about the multiple hissing snake-heads of the Hydra; next to him, nervously looking back at the action, and eager to be off, is his charioteer Iolaus, while the horses of the chariot take this opportunity to graze. (In the corner is the giant crab, sent by Hera, in her 'quenchless grudge' against Herakles, to add a further peril.) Another small building showed Herakles manhandling the sea creature, Triton, a theme repeated on a larger scale, and no less gaudily coloured, for one of the two large temples on the Akropolis (Fig 6.3; Plate V). Herakles, on his knees, looks to be struggling to keep hold of his slippery foe. On the same scale, and probably from the other corner of the same pediment, is a triple-bodied monster known (from its paintwork) as 'Bluebeard' (Fig 6.4). How Herakles dealt with such a hybrid is not known from any literary source and is difficult to reconstruct here. But we can see, quite clearly, that 'Bluebeard' is holding three different objects or attributes. One is a bird; another a wave; and the third either a sheaf of grain or perhaps a torch. What could this mean?

To shrug one's shoulders and merely allow this monster to be of 'Oriental' origin is an inadequate response. Some think it to be Nereus, the marine deity with powers to change his shape. It seems not to be hostile, with the leading member of the threesome holding up an arm in greeting (to a presumed figure of Herakles). But what if it has an allegorical purpose? Herodotus tells us (1.59) that Peisistratos established a power-base for his tyranny by uniting three factions in Attica: the 'People of the Shore', the 'People of the Hills' and the 'People of the Plain'. Could it

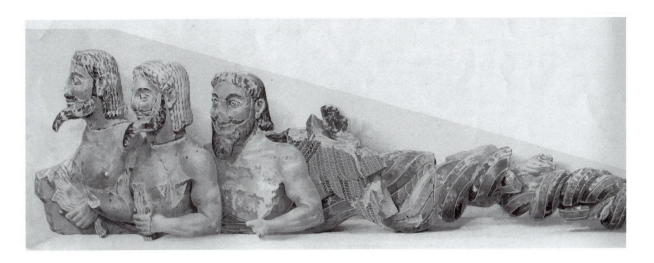

Figure 6.4 *The Bluebeard Group, probably from the same pediment. Length approx. 3.25 m. As well as snake tails, the creature also has wings.*

be that this smiling 'tricorpor' is an embodiment of those three factions – symbolized by a wave, a bird, and a wheatsheaf respectively?

No ancient source explicitly informs us that Peisistratos used Herakles as a mythical *alter ego*. We are told, however, that he employed bodyguards who carried, in Heraklean style, wooden clubs; and Herodotus has a story (1.60) of how Peisistratos once staged a melodramatic entry into Athens by finding a girl who was almost 1.8 m. tall, dressing her up like the armed Athena and driving towards the city in a chariot with her – preceded by heralds announcing that Athena herself was escorting Peisistratos to the Akropolis. A charade it might have been; but it points nevertheless to a politician aware of the potency of claiming divine or heroic affiliation (the Peisistratid family tree was proudly rooted with Homer's Nestor, ruler of Pylos).

Recurring themes on sixth-century Athenian painted pottery have been claimed as further proof of Peisistratid favour for Herakles. There was of course one important element in the Herakles story that made the hero particularly attractive as a model: with the aid of his divine protectress Athena, he is ultimately assumed as one of the Olympians. So any ruler who took on the role of being a 'second Herakles' – and we know that this was done by Alexander the Great (see p. 258), and several Roman emperors, not to mention a number of monarchs in Europe's *ancien régime* – could avoid possible accusations of impiety by claiming to be only Herakles the mortal, tirelessly striving to win divine favour.

Peisistratos and sons (Hipparchos succeeded in 527), sustaining this conceit, included in their aggrandizement of the Akropolis a pediment probably representing the Apotheosis of Herakles (Fig 6.5). The scene is sympathetically presented.

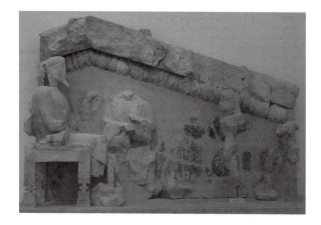

Figure 6.5 *Introduction of Herakles to Olympus, from the pediment of an oikêma on the Akropolis, mid sixth century BC. (The suggestion that this may show Herakles in the Underworld, approaching Hades and Persephone, seems inherently unlikely.) Ht of Zeus is 94 cm.*

A relatively enormous Zeus is enthroned near the centre of the pediment; his wife, Hera, responsible for the woes of Herakles since his infancy, stands by, as if at last placated. Next to her, we suppose, was Athena, who must introduce her *protégé*. Then comes Herakles, marked by the lionskin drawn up over his head. His eyes are directed to Zeus: a filial rapport has finally been made.

Metopes of the temple of Zeus at Olympia

Could a tyrant 'annex' a Panhellenic hero? Readers reluctant to follow the path of such particular interpretation may prefer to consider the more general questions of significance posed by Herakles as he appears a century later on the temple of Zeus at Olympia. We have already referred to the pedimental sculptures of this temple and the 'commentary' absorbed *in situ* by Pausanias (p. 29). The sculpted metopes, located above the porches at either end of the temple, number twelve in all: Pausanias merely notes that they show 'most of the deeds' (*ta polla tôn ergôn*) of Herakles (5.10.9). We may have to be more pedantic than Pausanias (whose text omits to mention one of the twelve) and refer to the dozen challenges undertaken by Herakles in the service of King Eurystheus as *athloi* (usually translated as 'labours'), making the *Dodekathlos*, 'Twelve Labours'. It remains a moot point whether the sculptural choice of *athloi* at Olympia followed or created a canonical selection. Both the literary and iconographical records suggest a multitude of Heraklean adventures, which mythographers sometimes divide into 'deeds' (*praxeis*) and 'incidental deeds' (*parerga*). The sum of these adventures would be an incredible total, but no one in antiquity was concerned to keep the tally. More important was the ubiquitous possibility for people and places to lodge their own claims upon 'the Herakles theme'.

It has been suggested that a commissioning principle at Olympia was to make the cycle of metopes inclusive of Greeks from around the Mediterranean – reflecting the Panhellenic scope of the Olympic Games. So six of the Labours are set in locations beyond the mainland – to the north (the mares of Diomedes), to the south (the Cretan Bull), to the east (the Amazonian girdle) and westwards (Geryon, Atlas, Cerberus). Yet there are no very clear links here with the Greek

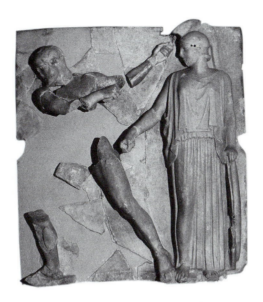

Figure 6.6 *Herakles cleansing the stables of King Augeas: marble metope from the temple of Zeus at Olympia, c. 460 BC. Ht 1.6 m. 'Just the kind of story to appeal to an audience of cattle-farmers' (Ashmole).*

colonies that participated so enthusiastically (and successfully) in the Olympic festival, and in any case the ideal of Olympian Panhellenism was not articulated as such before the late fifth century. And the other six Labours are firmly Peloponnesian, with at least one of them surely to be classified as of purely 'local interest'. This is the scene of Herakles cleansing the Augean stables (Fig 6.6) – nicely described by a distinguished modern poet:

My favourite bas-relief: Athene showing
Herakles where to broach the river bank
With a nod of her high helmet, her staff sunk
In the exact spot, the Alpheus flowing
Out of its course into the deep dung strata
Of King Augeas' reeking yard and stables.
Sweet dissolutions from the water tables,
Blocked doors and packed floors deluging like gutters

SEAMUS HEANEY, *ELECTRIC LIGHT* (LONDON 2001), 41

Aside from the nose-wrinkling element of burlesque in this story – the very thought of a king who has so much livestock that he cannot manage its manure – there is the objection, raised by ancient mythographers, that the stratagem adopted by Herakles here was hardly equivalent to extreme combat – so in some versions of the story, King Eurystheus is made to discount this as an *athlos*. Visitors to Olympia from Sicily, say, might have felt similarly inclined. But presumably they were told, as Pausanias must have been told (5.1.9), that Herakles was involved in the abrasive local history of Elis (where Augeas once ruled) and Arcadia; and this would have substantiated Olympia's claim upon Herakles as a founder-figure of the Games. Pindar (*Ol.* 10.42–59) hailed Herakles as instigator of the cult of Zeus at Olympia in celebration of sluicing out the stables: demarcating the extent of the Altis, formulating the contests. The stadium at Olympia

was, like other Greek stadia, 183 m. in length – yet it was longer than other stadia, a fact that was rationalized (originally, it was said, by Pythagoras) with the explanation that it had been paced out by Herakles, who was proportionally larger than his fellow men. Herakles was also deemed the primal enforcer of the Olympic Truce.

Mythographers disagreed whether King Eurystheus reigned at Mycenae, Argos or Tiryns – and where in the Argolid Herakles himself might have ruled, as a vassal-lord. But in any case it was the area of Mycenaean strongholds – and a myth-historical ambience of stock-raiding, contested territories and regal tributes. The Olympia metopes evoke an olden age, yet not so long ago: they illustrate Olympia's own institutional justification as a site where the laws and norms of 'bread-eating' societies were sanctified when history began with the first Olympiad (776 BC). So it is possible, in modern terms, to view these sculptures as a series of essentially binary oppositions – Herakles versus a Horror, the Domesticated versus the Wild, 'Culture' versus 'Nature', 'Civilization' versus 'Savagery', 'Greek' versus 'Barbarian' – with the (no less essential) third-party presence of divine assistance. In compositional terms, this makes them appropriately simple and (on the whole) easy to understand.

Their sequential order is disputed. But there can be little doubt that a beginning must be with victory over the Nemean Lion, for there we find Herakles still unbearded, a 'boy' (*pais*), though not without the battered ears of a hardened wrestler. He is shown in a state of exhaustion – as if anticipating the Hellenistic creation of a 'Weary Herakles' type – and so viewers are made aware, as Pindar would repeatedly stress, that Olympic glory only comes with immense effort. This is not to say, however, that brute force resolves all problems. The Lernaean Hydra must be despatched with cunning – the trick of cauterizing the wounds left by decapitation. The Stymphalian fowl – a nightmare, pre-Hitchcock, of birds become malevolent – have to be scared into flight with bronze castanets procured, via Athena, from Hephaistos. The Erymanthian Boar is not to be killed but captured alive and brought to King Eurystheus. That the king thereupon jumps into a huge storage jar testifies both to the terrifying nature of the beast and the local status of Eurystheus: he collects tribute and controls food supplies. Catching the Keryneian Hind (for its antlers) may have been a test of pure stamina, for in one version of the story Herakles, not wishing to shoot the golden-horned animal (because sacred to Artemis), stalks it, for a year, until exhausted; at Olympia he has the creature in what looks like a wrestler's lock.

The adventures abroad belong to the same sort of basic oppositions. The horses of Thracian Diomedes are man-eating and so deserve a special sort of 'breaking-in' by Herakles. The story goes that he fed them with their owner before bridling

them for regular use; at Olympia, the hero apparently has one of the beasts under such control, though he brandishes his club instead of a whip. A similar composition communicates the capture of the Cretan Bull: Herakles has it by a rope, and it is bucking powerfully, yet bowing to the hero's superior strength. The Amazon queen Hippolyta lies prone on the ground as Herakles moves off with her girdle; whether she is dying is not clear – there were various tellings of the story – but she has yielded up a piece of regalia, and so Herakles has dealt a blow against the primal threat of a matriarchal tribe: women, like animals, were meant to be domesticated. That exploit, set vaguely in Asia, is matched in the West by the commission to raid the cattle of Geryon, a triple-bodied monster spawned from the Gorgon's son Chrysaor. Here the metope shows a moment of full-on combat, with Herakles poised to club down the third remaining portion of his opponent. A substantial (though lost) poetic account of this story, the sixth-century *Geryoneis* by Stesichoros, implies that the tale had further twists. But it is part of the effect of these metopes that they create a rhythm of action, alternating fury and calm, and making an equilibrium of vertical, horizontal and diagonal movements. So it is with distinctly nervous attitude that Herakles tugs at the leash he has attached to Cerberus, the mastiff of Hades. (Hermes shadows the

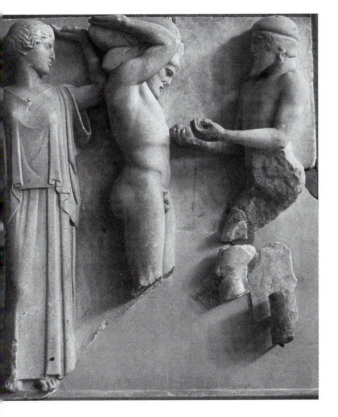

scene, as the *Psychopompos* or 'Spirit-conductor' appropriate to this mission.) And finally – though we cannot say if it was actually placed at the 'end' of the sequence, however that was judged – there is what may be deemed the most engaging metope of the cycle, the Apples of the Hesperides – Herakles' passport to Olympus (Figs 6.7. and 6.8). Pausanias misread this relief, thinking Herakles to be the figure carrying the apples; he may have been confused by a number of variants to the story, which introduce a quarrel with Atlas and other complications. The idea that Herakles needed a pillow comes in Pherekydes; but the sculptors at Olympia have no space, and perhaps no inclination, for elaborate sub-plots. So they present the moment when Atlas, the Titan condemned to carry the heavens on his

Figure 6.7 *The Apples of the Hesperides: metope from the temple of Zeus at Olympia, c. 460. Ht 1.6 m.*

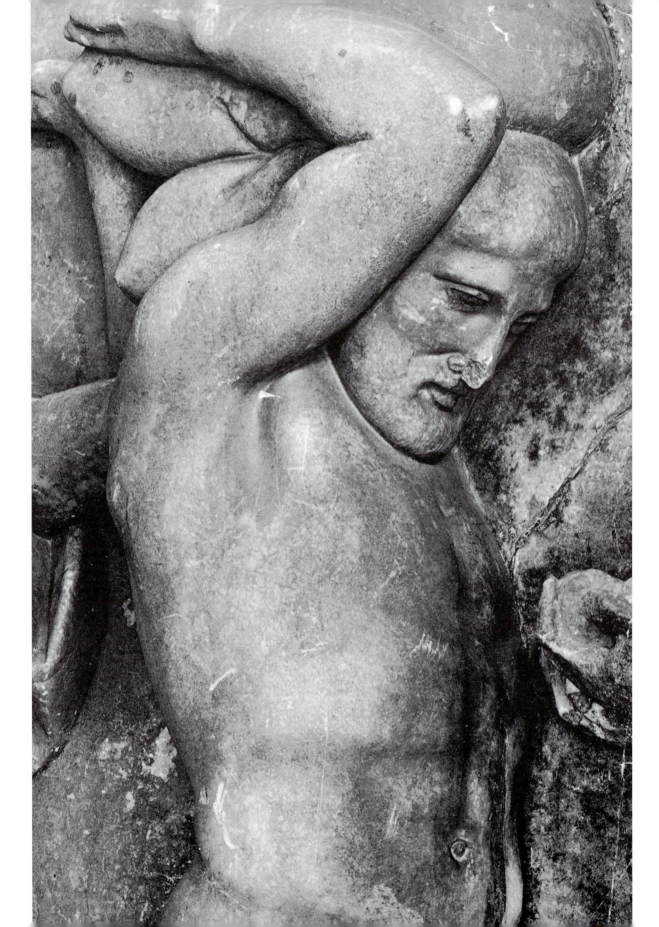

shoulders, brings the three apples to Herakles. The hero has volunteered himself as substitute while the apples are fetched. But he is not so huge as Atlas, so requires a cushion or two; and while his face is a study in bowed concentration, we see that behind Herakles stands Athena, effortlessly adding her own support. It is of course a supremely practical intervention from the goddess, since there must otherwise be an awkward moment when Herakles lets go of the heavens, to accept the apples, and Atlas resumes his burden. Yet the metope seems to summarize the overall message of the *Dodekathlos* as imagined at Olympia: that glory is rooted in toil and the conquest of fear – and the benefit of divine help. This was entirely appropriate to the building and its situation.

The Parthenon frieze

Notwithstanding the paradox of 'high meaning and low communication', we would suppose that the stories chosen for installation upon a temple were intended to be 'legible' from a distance. Common sense dictates as much: even if the 'viewer's share' entailed a certain amount of assumed knowledge, the visual calls upon that knowledge had to be clear. The artistic virtue of sending a clear signal may be illustrated by one metope from the Heraion at Foce del Sele (Fig 6.9; *cf.* p. 73). It is probably unfinished; and it belongs to a medley of mythical vignettes whose meaning as an ensemble remains elusive – we lack the resources to supply a programmatic explanation. Nonetheless, thanks in part to a number of inscribed vase-paintings with a similar image, there is no doubt what it represents. Ajax, having been denied the inheritance of the Arms of Achilles by his fellow Greek commanders, goes berserk among animals, imagining that he is killing Odysseus, Agamemnon *et al.*; then, on a lonely shore, he commits suicide by falling on his sword. Reaching for such literary discussion of the theme as survives – chiefly the *Ajax* of Sophocles – we can propose a moral *raison d'être* for the scene as temple decoration, juxtaposed with images such as that of Sisyphus, condemned to eternal punishment in the Underworld. Plausibly it relays a message about divine power: justice lies in the hands of the gods, and those, like Ajax, who take it upon themselves, risk heaven-sent madness and consequent disgrace.

So what are we to make of the Parthenon frieze – which, for all that it is a 'manifestly wonderful work', can never have been easy to see, let alone understand, *in situ*? True, it is assumed to have been brightly coloured (*cf.* Fig 7.1); and is said to be carved in slightly deeper relief towards the top of the slab, aiding the view from the ground. All the same, faced with a densely figured relief running 160 m. along two long flank walls and over the porch columns of the temple ends, and placed 12 m. high, beneath

Figure 6.8 *Detail of same.*

Figure 6.9 *The suicide of Ajax: sketch of a sandstone relief from the Heraion at Foce del Sele, c. 560 BC. Ht 85 cm.*

a coffered stone ceiling, it is tempting to wonder, with Bernard Ashmole, if the designer of this project 'had taken leave of his senses'. When Ashmole was consulted (along with J.D. Beazley and Donald Robertson) in the late 1920s as to how the Parthenon sculptures should ideally be displayed in the British Museum, he naturally wished for all concern about 'their former decorative function as architectural ornaments' to be put aside. They were 'primarily works of art'. The resultant display of the frieze, almost at eye-level, and occupying an ample space not earned by any other artefact in the museum's entire collection, seems to redeem the folly, or 'artistic *hubris*', of its original placement.

The Olympia metopes were similarly located. But they were episodic, and confined to the porch ends of the temple, while the Parthenon frieze seems continuous and occupies all four sides. Its compositional logic is that two branches of a procession move eastwards, converging at an assembly of seated Olympians. This was the end of the temple where the chryselephantine image of Athena was installed within the *cella*; the central scene of the east side of the frieze might therefore be regarded as especially important – and has duly given rise to a great deal of speculation (Fig 6.10).

So what does it show? Though the carvings are eroded, the action is more or less legible. The tallest figure, robed in the long tunic of a priest preparing sacrifice, is bearded and handling a folded piece of cloth, which he is either giving to or receiving from a child attendant, of now-indeterminate gender. To the left are three female figures: the two girls carry cushions and stools on their heads, and one also has a footstool in her free hand. The folded piece of cloth is most probably the garment known as a *peplos*, and so this portion of the frieze is often referred to as the '*peplos* scene'.

Either side of this scene are the seated deities, carved on a larger scale. Again, these are not too difficult to comprehend: with attributes once picked out in paint or bronze fittings – a trident for Poseidon, perhaps, or a snake-fringed *aegis* for Athena – they must be 'the Twelve Olympians' already canonized in Athens by an altar in the Agora. From the Agora, too, comes a clue to identifying a group of standing male figures, more or less homogenous in size and appearance: visually

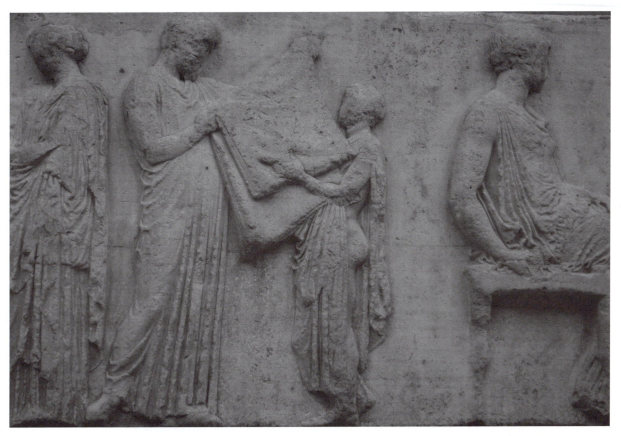

Figure 6.10 *Detail of the Parthenon frieze, east side: the 'peplos scene'.*

they may recall the Eponymous Heroes, whose monument in the Agora set the appearance of the ten mythical patriarchs of the 'tribes' (*phylai*) constituting the voting-districts of democratic Attica.

Though some observers prefer to see the latter group as city magistrates, we have a fair idea of the subjects so far. Our confidence may grow as we reach the edges of the east frieze: here are files of female figures, some carrying jugs and libation-bowls; surely they represent the head of the processions advancing from both the north and south sides of the temple. Figures of cattle and sheep can also be seen, with handlers, ahead of youths carrying trays (*skaphai*) or water-jars (*hydriai*), and musicians, some with the lyre (*kithara*), some the pipes (*aulos*). There can be no doubt that all these images relate to the act of sacrifice (*cf.* Fig 4.1). Then come groups of older men, evidently in conversation (Fig 6.11). Behind them − and still keeping basic symmetry of composition on north and south sides − are chariots and drivers, with young men apparently boarding or disembarking the chariot platforms while in motion; and these are followed by a cavalcade: mounted

horses, sixty on either side, mostly caught in a neat prancing movement of equestrian dressage. The west aspect of the frieze shows this cavalcade mustering.

So far, so good. The greater part of the long north and south sides of the frieze consists of chariots, horses and their riders; and in itself this, too, is not problematical. We know that Athens staged a regular contest that involved young men nimbly performing a 'stepping-off' (*apobasis*) from moving chariots; we know also that equestrian displays were an important part of Athenian ceremony, especially after Perikles reorganized the cavalry, increasing its numbers from 300 to 1,000. Not only does the presence of so many horses and riders serve to give a rhythmic pulse to the frieze, but on inspection it is possible (on the south side) to differentiate the dress of the riders into ten groups of six – reflecting, surely, the decimal democratic principle by which the Periklean cavalry was ordered.

The visual components of the frieze, then, are not in themselves problematic. But – as readers will have guessed – a crisis of interpretation arises when we try to put them altogether. It is natural enough to make the attempt, since the action on the frieze appears to be unbroken, or, at least, it seems to possess unity of time and place (though not scale). That it captures a moment, however, is not easily demonstrated. Pausanias, alas, seems not to have even noticed its existence; so as for the subject of this temple story, we have no guidance whatsoever from any ancient source. Our first witness is Cyriac of Ancona (see p. 306), who, some 2,000 years after the frieze was made, could only hazard that it represented 'Athenian victories in the time of Perikles'.

The interpretative vacuum is enlarged by the absence of any contemporary description of the protocols of either the Greater or Lesser Panathenaia. Following the suggestion first made by Stuart and Revett in their *Antiquities of Athens* (1762), the supposition has been that the frieze alludes to the Panathenaic Festival – with the '*peplos* scene' possibly representing the presentation of a newly woven *peplos* for the statue of Athena Polias at the quadriennial Greater Panathenaia. Such historical sources as we possess regarding the Panathenaic procession are late and

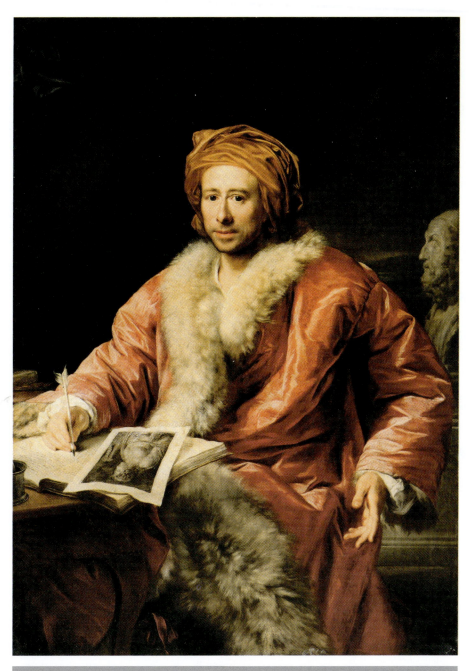

Plate I *Portrait of J.J. Winckelmann, by Anton von Maron, 1768. Weimar, Schlossmuseum.*

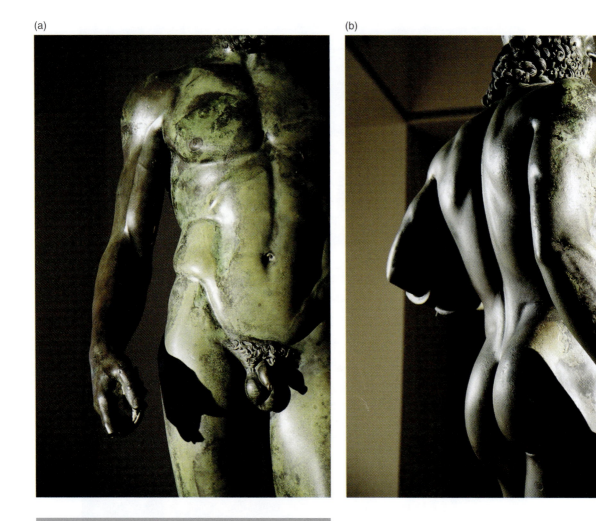

(a)

(b)

Plate II (a) Detail of Riace Figure 'B'. (b) Detail of Riace Figure 'A'. Reggio Calabria, Archaeological Museum.

Plate III *Detail of painted drapery on Athens Akropolis korē no. 594, as recorded at time of excavation.*

Plate IV Part of a fragmentary Attic funerary stêlê, c. 540 BC: girl with flower. Berlin, Staatliche Museen. (Further parts of the same monument are in the New York Metropolitan Museum.)

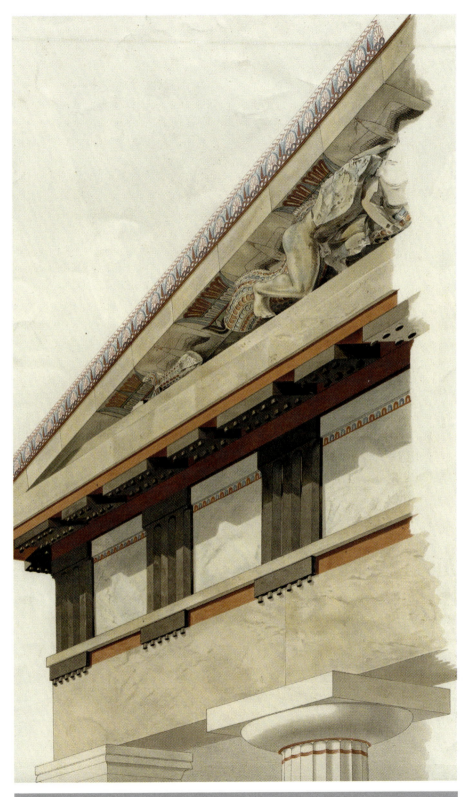

Plate V *Reconstruction of the Triton pediment. (Original fragments in Athens, Akropolis Museum.)*

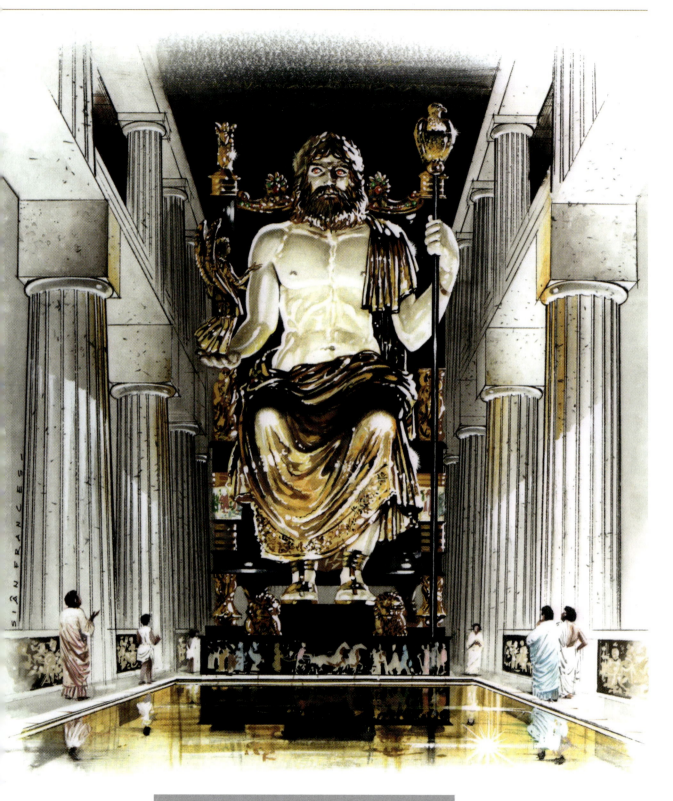

Plate VI *Reconstruction of the chryselephantine Zeus at Olympia.*

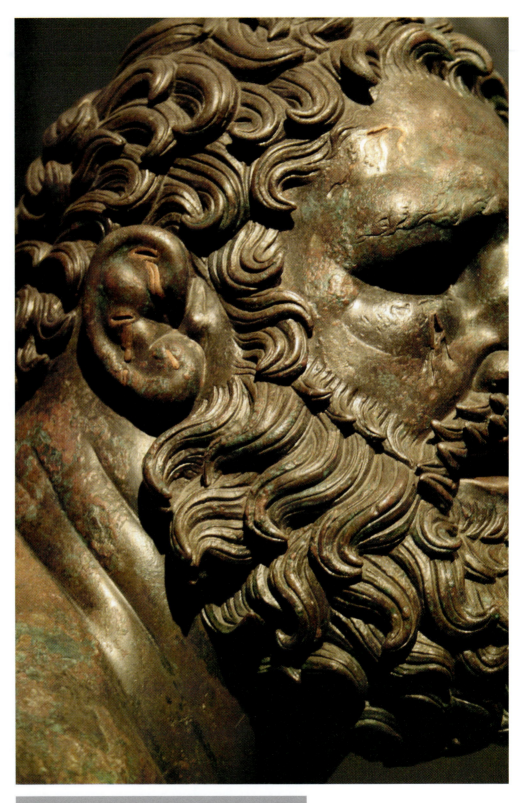

Plate VII *Detail of the Terme Boxer. Rome, Palazzo Massimo.*

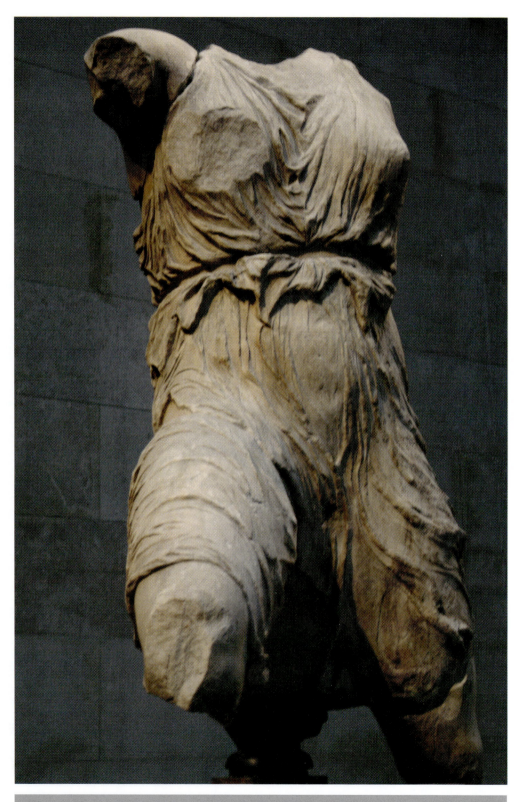

Plate VIII *Figure 'N' – usually identified as Iris – from the Parthenon west pediment. London, BM.*

indistinct, but it is clear that conspicuous elements of the imagery – including the cavalcade and the chariot race – cannot belong to this religious occasion, not to mention, as noted elsewhere (p. 135), the impropriety of young men exposing their bodies – however marvellous to behold – in front of women equipped for solemn ritual.

Most scholars accept that the Athena Parthenos was a votive image, not the recipient of a cult – which explains why the Parthenon seems not to have needed an altar, at least in Classical times. But the frieze need not of course represent liturgy particular to the Parthenon. So what else should we look for? One inviting direction lies with Athenian myth-history. Local legends conspicuously provided the themes of the temple pediments. For the central scene of the east side, therefore, it has been proposed that daughters of the legendary Athenian king Kekrops are involved, along with another obscure proto-regal hero, Erechtheus (often identified or confused with Erichthonios, 'earth-born' from the seed of Hephaistos). Another hypothesis is that the '*peplos* scene' represents Erechtheus, his wife Praxithea and their three daughters preparing for a propitiatory (human) sacrifice that will save the city of Athens from a besieging enemy. This theory helps to explain the conspicuous peculiarity of the Olympian deities all facing the other way – they cannot bear to witness this tragedy (as tragedy it was, scripted *c.* 422 by Euripides) – and illuminates other details of the imagery, such as the *hydriaphoroi*; but it does little to explain the cavalcade, which is, as noted, such a dominant element of the relief.

With regard to that element, a more historical interpretation has been advanced. We may suppose that a primary motive for building the Parthenon lay in commemoration, albeit belated, of victory against the Persians. Was Cyriac half-right in his deduction of 'Athenian victories in the time of Perikles'? It can be readily shown that in the time of Perikles, the victory most honoured (and hyped) by the Athenians was their remarkable success, against all odds, over the Persians at Marathon in 490 (see p. 26). Is it sheer coincidence, then, that the numbers of horsemen on the frieze – patently heroized warriors – can (with a measure of creative accountancy) be reckoned at 192, matching the well-known total of Greeks who died at Marathon? Might those senior men in the procession even be 'portraits' of surviving *Marathonômachoi* – veterans of the legendary encounter?

Far-fetched or plausible (depending on one's approach), these are some of the manifold possibilities opened up by the Parthenon frieze – and inhibited by the whole of the monument as comprehensive explanations. In the end we are bound to admit that the precise story of this temple decoration continues to elude us. It is half-consoling to imagine that ancient viewers, craning their necks

to see the sculpture, may have been similarly perplexed. But they could assume then – as we must assume now – that whatever was represented on the frieze must attest protective loyalty to and from the goddess whose dwelling-place it adorned.

The Bassae frieze

Apollo was the deity who presided at Bassae, a sanctuary located in highlands of that part of the Peloponnese known as Arcadia. Shrines to the god were established there since at least the seventh century; and up until quite recently – when conspicuous measures were taken to protect the site from the elements – Bassae retained, to the Romantic visitor, an aspect and atmosphere of antique sanctity (Fig 6.12).

The visible ruins are those of a temple commissioned from the Athenian architect Iktinos, after 429, in thanksgiving (so Pausanias relates: 8.41.7–8) for deliverance from plague. Apollo was given the epithet Epikourios, 'the Helper'; his image inside the temple, it seems, represented the god seated serenely with his lyre.

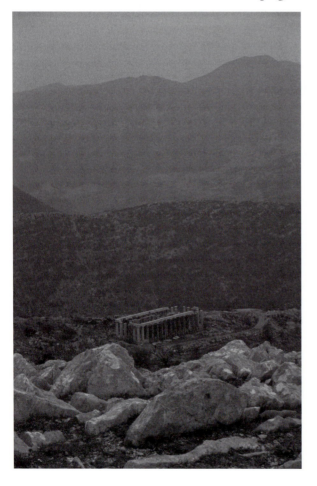

Some very fragmentary metopes survive from the temple porches. Whether the pediments once contained sculptures is doubtful: it has been suggested that they were removed in antiquity. By necessity, then, modern attention is focused upon a frieze that was installed within the temple *cella* (see Fig 4.7).

Viewed by flickering lamps, or such natural light as was obliquely admitted by the door, this interior frieze challenged the viewer's full comprehension. But here, at least, the sculptors seem to have made some allowance for the problems of seeing their work. The subject of the frieze was kept relatively simple – roughly divided between battles with Amazons and a

Figure 6.12 *Photograph of Bassae c. 1984. The temple's unusual length-wise axis (north–south) appears contingent upon its situation within the landscape. 'Its geometric, abstract form stands out as an expression of human and Olympian order against the chaotic hills' (Scully).*

Centauromachy, with various reconstructions possible; and the style, too, may have been deliberately adjusted for the sake of clarity. The relief figures, described by one observer as 'extraordinarily gross, contorted, and exaggerated in form', have sometimes been taken for provincial workmanship, or else carved in keeping with the spirit of the local landscape; more probably, they belong to the melodramatic *chiaroscuro* of their setting, in a composition built around forceful diagonal movements.

How far the imagery of combat with Amazons provided fifth-century Greeks with an analogue for war against Persians is debatable. That myths offered parables for contemporary events we need not doubt – unfortunately (for us), however, ancient authors were not inclined to expound such metaphors. But from the Centauromachy at Bassae we can identify at least one core visual message made clear to the ancient viewer. The fracas between the 'uncivilized' Centaurs and 'civilized' Greeks (the Lapith tribe) is represented here, as on the Olympia pediment (see p. 29), in full affray. And here at Bassae the extent of Centaur brutality is emphasized. As at Olympia, the creatures attack women: at Bassae, we see that some of the women have infants at the breast, making this something like a 'massacre of the innocents'. What can the women do? By tradition keepers of the faith at shrines and altars, they seek protection from an ancient cult-image or

xoanon (Fig 6.13). One of these suppliants casts out her arms, as if to the viewer; while the other, her robes being torn away by a rampaging Centaur, can only cling to the idol. A Lapith combatant has this Centaur by the neck, yet the situation looks desperate: so how will help arrive? The viewer must search around the frieze. And sure enough (though its original position is not definitely established) the requisite scene is found. The 'real' Apollo and his sister Artemis appear just when they are most needed, driving a chariot drawn by

Figure 6.13 *Marble slab (no. 524) from the frieze of the temple of Apollo at Bassae, c. 420–400 BC. Ht 64 cm. Women seeking refuge at the shrine of a female deity (perhaps Artemis).*

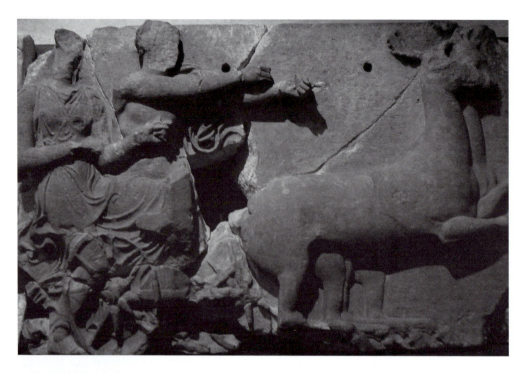

Figure 6.14 *Further relief (no. 523) from the same frieze: Apollo (dismounted and firing his bow) and Artemis (holding the reins) arrive in a stag-drawn chariot.*

stags (Fig 6.14). Faith in the idols will be rewarded: and so the sculptures at Bassae confirm, for the ancient pilgrim, that this temple, remote as it seems, is yet another place 'where prayer has been valid'.

Sources and further reading

Surprisingly, there is no thorough survey of Greek temple decoration. Some general considerations may be found in E. Lapalus, *Le fronton sculpté en Grèce* (Paris 1947); B. Ashmole, *Architect and Sculptor in Classical Greece* (London 1972); B.S. Ridgway, *Prayers in Stone* (California 1999); I. Jenkins, *Greek Architecture and its Sculpture* (London 2006); and C. Marconi, *Temple Decoration and Cultural Identity in the Archaic Greek World* (Cambridge 2007). The 'paradox of high meaning and low communication' is argued in Tonio Hölscher's contribution to P. Schultz and R. van den Hoff eds., *Structure, Image, Ornament: Architectural Sculpture in the Greek World* (Oxford 2009), 54–67.

Corfu pediment To the exemplary publication of material by G. Rodenwaldt, *Die Bildwerke des Artemistempels von Korkyra* (Berlin 1939), add J.L. Benson, 'The Central Group of the Corfu Pediment', in *Gestalt und Geschichte: Festschrift Karl Schefold* (Berne 1967), 48–60.

Temples on the Archaic Akropolis Th. Wiegand's folio *Die archaische Poros-architektur der Akropolis* (Cassell/Leipzig 1904) provides illustrations used here. The fragmentary state of the evidence may readily be gauged from Rudolf Heberdey's monograph, *Altattische Porosskulptur*

(Vienna 1929). For summary information, see J. Hurwit, *The Athenian Akropolis* (Cambridge 1999), 105ff.

Olympia metopes B. Ashmole and N. Yalouris, *Olympia: The Sculptures of the Temple of Zeus* (London 1967) remains the most handsome presentation of the metopes. On Herakles and the Olympics, see W. Raschke, 'Images of Victory', in W. Raschke ed., *The Archaeology of the Olympics* (Wisconsin 1988), 38–54, and N. Spivey, *The Ancient Olympics* (Oxford 2004), 226–9. A comprehensive, if somewhat strained attempt at interpretation is given by M.A. Pimpinelli, 'Eracle ad Olimpia: le metope del tempio di Zeus', *Ostraka* 3 (1994), 349–416.

Parthenon frieze Quotations from B. Ashmole, *Architect and Sculptor in Ancient Greece* (London 1972), 116, and M. Robertson, *The Parthenon Frieze* (London 1975), 3. Best photographic documentation comes in F. Brommer, *Der Parthenonfries* (Mainz 1977); but for the current arrangement of the frieze, see I. Jenkins, *The Parthenon Frieze* (London 1994). That the '*peplos* scene' shows Erechtheus and his daughters is argued by J. Connelly, 'Parthenon and *Parthenoi*: A Mythological Interpretation of the Parthenon Frieze', *AJA* 100 (1996), 53–80; and that veterans of Marathon are shown, by J. Boardman, 'The Parthenon Frieze: A Closer Look', *RA* 99:2 (1999), 305–30. But since the literature on the frieze has grown very large, readers are referred to the bibliography provided in J. Neils, *The Parthenon Frieze* (Cambridge 2001), with the subsequent addition of I. Jenkins, 'The Parthenon Frieze and Perikles' Cavalry of a Thousand', in J.M. Barringer and J.M. Hurwit eds., *Periklean Athens and its Legacy* (Texas 2005), 147–61.

Bassae frieze Quotations from V. Scully, *The Earth, the Temple and the Gods* (Yale 1979), 124 and 126; note also the paradigmatic use of the site and temple in M. Beard and J. Henderson, *Classics: A Very Short Introduction* (Oxford 1995). Discussion of the arrangement of the frieze in O. Palagia and W. Coulson eds., *Sculpture from Arcadia and Laconia* (Oxford 1993), 57–77. My final sentence cites, with due awareness of anachronism, a line from T.S. Eliot's *Little Gidding*.

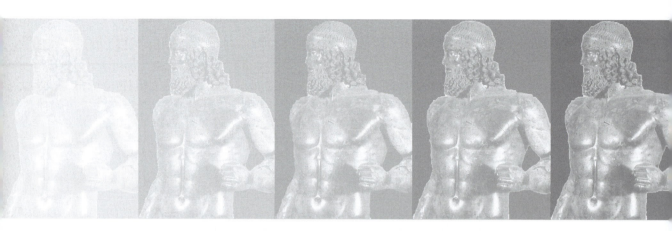

Here … is one of the most profound contradictions of Greek civilization. Greece, particularly in the fifth and fourth centuries, was a 'civilization of the craftsman'; but its ideology, that of the ruling class (as expressed, for example, in the works of Plato), denies the importance and the effective role of the craftsman. He is condemned to the shadows: to be none other than 'the secret hero of Greek history'.

Translated from F. Frontisi-Ducroix,
Dédale
(Paris 1975), 25

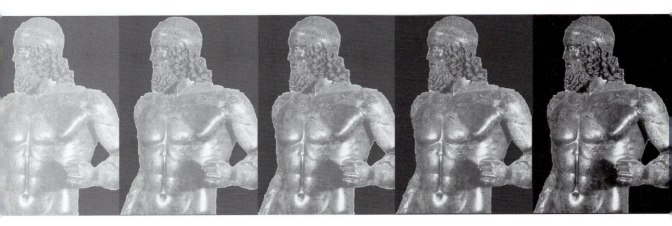

7

IN SEARCH OF PHEIDIAS

Opus LX of the Dutch-born Victorian painter Sir Lawrence Alma-Tadema may not rank as an absolute masterpiece, but it evokes a moment in history that naturally appeals to the artistic imagination. *Pheidias showing the Frieze of the Parthenon to his Friends* (Fig 7.1) recreates, with studied detail, a supposed 'private view' on the Akropolis *c.* 440 BC. Pheidias, scroll in hand, stands before the freshly finished relief, while sundry prominent Athenians – Perikles with Aspasia, and (in the foreground) Socrates with young Alcibiades – stand on scaffolding planks to inspect the piece: as well they might, since, for all its bright paintwork (boldly yet credibly recreated by Alma-Tadema), this is a work of art which will be very difficult to see properly once the scaffolding is down.

Here is a powerful image of Pheidias the immortal sculptor: Pheidias the *divino artista*, the 'great master' – the paragon of creative energy in that nursery of genius, Periklean Athens. This is the Pheidias apostrophized in the lines of a sonnet celebrating the arrival of 'the Elgin Marbles' in London:

Figure 7.1 Pheidias showing the Frieze of the Parthenon to his Friends, *by Sir Lawrence Alma-Tadema (1868).*

Pheidias! thou hast immortalized thy name
In these thy handy-works, and they will tell
Loud as ten thousand thunderings thy fame
Wherever truth and beauty deign to dwell.

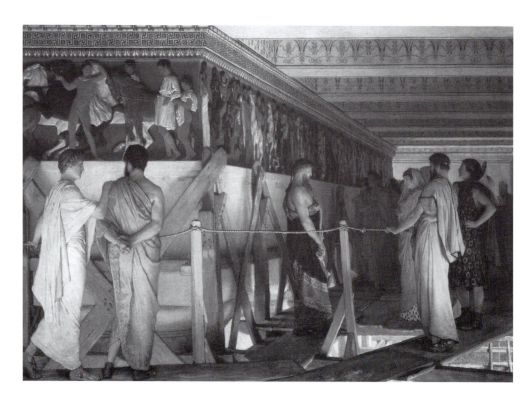

(The sonnet is from *The Gentleman's Magazine*, January 1818, 65; the probable author is Benjamin Robert Haydon, a painter who led the way in recognizing the exceptional beauty of the Parthenon sculptures – despite their battered state.)

Amateurs and experts became united in their enthusiasm. In 1871, John Ruskin saluted 'the noble hand' responsible for the Parthenon frieze, claiming that the artistry of Pheidias was directly apparent in the work: 'you may recognize the decision of his thought, and the glow of his temper, *no less in the workmanship than the design*' (my italics).

This is praise born of true esteem. So it seems mean-spirited to make the pedantic observation that not a single work survives that can be certainly attributed to an artist called Pheidias. As we shall see, there is a *possibility* that the Riace Bronzes may be from the workshop of Pheidias; and there is a sense in which Alma-Tadema could rightly show one man standing to take credit for the Parthenon frieze: some*one* – say Pheidias, though no ancient source specifically attests this – probably sketched its design, even if some forty other sculptors actually carved it. Yet Pheidias is, with other 'great masters' of Greek sculpture – notably Myron, Polykleitos, Praxiteles and Lysippos – better known by his *fame* than by direct acquaintance with his work. This is not to deny his existence: historically there is no doubt that a certain Pheidias created a series of 'masterpiece' statues during the fifth century, several of them monumental projects that earned him renown during his lifetime and further posthumous glory as the Classical sculptor *par excellence* who matched 'beauty with grandeur' (*kallos kai megethos*). The fact that none of these projects survives, however, poses peculiar problems for our understanding of the Pheidian achievement. A preliminary task, before we attempt to assess the material evidence, lies in the critical survey of 'the Pheidias legend'. What follows is an introduction to its extent – working backwards, from late antiquity, to sources more or less contemporary with the artist.

Pheidias: the legend

Anecdotes about the technical virtuosity of Pheidias are, in their way, as one would expect – for instance, the story that Pheidias, if shown just a lion's claw, could work out how the rest of the animal should appear, in shape and dimension (see e.g. Lucian, *Hermot.* 54). Our concern here is with the literary tradition that more particularly identifies Pheidias as gifted with a power of *phantasia* that amounts to transcendental imagination – the power to visualize the supernatural.

Plotinus This philosopher, writing in the third century AD, is usually classified as a 'Neoplatonist'. What he has to say about Pheidias, however, has little in common with Plato's own view of artistic *mimêsis* (*Rep.* 597b). Plotinus focuses

upon the statue which had become celebrated as one of the 'Seven Wonders' of antiquity – the colossal Zeus at Olympia. 'Pheidias did not make his Zeus from any model perceived by the senses,' argues Plotinus, 'but understood what Zeus would look like if he wanted to show himself visible [*phanenai*]' (*Enn.* 5.8.1).

Here is a statement of divine artistic insight – placing Pheidias on the same level as those poets and dramatists whose imaginations opened windows onto the heavenly. Pheidias has an inspiration (*enthousiasmos*) direct from Zeus; in his mind's eye, Pheidias sees through to the *will* of Zeus – how the god *would* appear, if he cared to appear. This is not an entirely new sentiment: Cicero (*Orat.* 2.8–9) had reasoned that Pheidias could not have replicated any model when making his Zeus, but conceived a mental image of perfected beauty independently (*in mente insidebat species pulchritudinis eximia*) which 'directed his hand' (*manum dirigebat*). Subsequently, Quintilian would deem Pheidias to be better at representing gods than mortals – to the extent that his Zeus, by its beauty, augments the awesomeness of Zeus the godhead and so enhances received religion (12.10.9). In a single sentence, Plotinus collects and systematizes these theological queries about Pheidias within a philosophy of 'intelligible beauty' that grants an artist ultimate power over his creation.

Dio Chrysostomus Dio's *Olympic Discourse* (*Or.* 12) of AD 97 comes from a rhetorician who approved of statues – but nevertheless a rhetorician who implicitly believes rhetoric to be more effective than sculpture. So Dio constructs an imaginary speech by Pheidias, defending his Zeus against the doubts of those sceptical that gods can be represented in human form. It runs like this: we need (says Pheidias) closer contact with the gods than simply gazing towards the skies; it is part of Greek tradition (from Homer onwards) to imagine gods in mortal guise; this statue is not trying to deceive anyone that Zeus is a man; Zeus is many-faceted – the best a sculptor can do is seek to reflect some of those anthropocentric epithets for Zeus, such as 'Father' (*Patêr*), 'King' (*Basileus*), and so on; *no* sculptor will ever capture the almighty thunder and lightning wielded by Zeus; and, finally, Zeus will not be displeased at this attempt at his representation – for Zeus himself is the supreme technician (*megasthenes aristotechna patêr*).

Artificial as it is, this piece by Dio indicates an important part of the definition of the 'genius' of Pheidias: the artist's supposed access to the supernatural – his extraordinary knowledge, gained by a superiority of vision that permits him to relay back to lesser creatures a notional image of Zeus.

Pliny By contrast, Pliny's assessment of the sculptor is more practical. Pheidias was 'rightly judged to be the first who opened up the art of chryselephantine sculpture and explored its possibilities' (*NH* 34.54: Pliny resorts to the Greek-

derived word *toreutike*, sometimes strictly understood as metal-chasing, for the working of gold and ivory). Elsewhere (36.15) Pliny mentions that Pheidias also 'worked in marble'. He gives a *floruit* of 448 BC without explaining why, but perhaps linking the fortunes of Pheidias with the political ascendancy of Perikles.

Plutarch Plutarch's *Life of Perikles* is, by far, our most informative source for what (little) we know about the life and times of Pheidias; but Plutarch, writing in the late first and early second centuries AD, can hardly be counted as a direct witness. He must have had a source: it is surmised to have been Euphorus, an Attic historian active in the fourth century BC. Plutarch's principal subject, of course, is the statesman; Pheidias belongs to the biography insofar as he is reported as the 'overseer' (*episkopos*) of the monumental development of the Periklean Akropolis – and more specifically the 'contractor' (*ergolabos*) of the Athena Parthenos statue. Many craftsmen (*technitai*) were involved in the project, Plutarch relates – but a special role must be assigned to Pheidias 'on account of his friendship with Perikles' (*dia philian Perikleous*). This amicable alliance then also explains, in Plutarch's narrative, the sculptor's downfall, for the political opponents of Perikles sought to use Pheidias as a means of discrediting Perikles. They first encouraged a stooge from the sculptor's own workshop, called Menon, to accuse Pheidias formally (at the Athenian Assembly) of peculation – that is, of reducing the gold content in the gold plates assigned for embellishment of the Parthenos statue and keeping some back for himself: a charge that Pheidias, apparently, was able to disprove. They then levelled another charge at him, one of impiety (*blasphêmia*), on the grounds that he had represented both himself and his sponsor Perikles on the shield of the Parthenos participating in an Amazonomachy (Perikles brandishing a spear, Pheidias – a nice self-image, if he ever made it – balding, yet still capable of lifting a boulder). This charge stuck, and Pheidias died in an Athenian prison: a sorry end which Plutarch caps by suggesting that he may have been poisoned.

Plutarch values entertainment in history and has no doubt embroidered whatever sources he had at his disposal. But both of these court cases seem plausible enough in the realm of democratic litigation. We know from inscriptions related to the Parthenos statue that it was regularly inspected to weigh and inventory the amount of gold on it, and discrepancies seem to have beset this procedure: for instance, the gold crown on the Nike-figure carried by Athena, when assessed in 428/427 BC, weighed both 50 and 70 drachms, implying either disagreement or skullduggery (or both). The statue – popularly referred to as *to chrysoun agalma*, 'the golden statue' – may have stood more or less intact at least until the early third century BC, when its gold was removed; but meanwhile various 'borrowings'

from the Parthenos are recorded (in times of civic need). It is all too easy to imagine financial scandal generated from the first conception of the piece. As for the crime of inserting portraits on a mythological scene, two figures approximating to the poses mentioned by Plutarch can be (arguably) identified on copies of the Parthenos shield. If alleged identities could be attributed to the Greeks shown battling with Amazons, again it is consonant with what we know of the Athenian courts that opponents of Perikles might have concocted a lawsuit.

The image on the shield may be judged too small to transmit a likeness, but that has not inhibited one optimist (Vagn Poulsen) from claiming the head of an evidently troubled old man as a portrait of Pheidias (Fig 7.2).

Plato Scholastic detectives might consider the following as implicit corroboration of the embezzlement part of Plutarch's story: for Plato, in *Meno* 91d, has Socrates measure the wealth of a philosopher (Protagoras) by reference to Pheidias. Protagoras, claims Socrates, made more from his teachings than Pheidias, 'who made such conspicuously fine works of art' (*kala erga*), and ten other sculptors

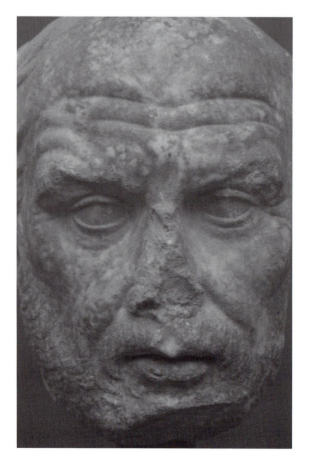

put together. In all of Plato's works, the only artists ever mentioned are Pheidias and Polykleitos – perhaps implying that those sculptors were 'household names' at least by the early fourth century.

Aristophanes Even a satirical mention of our elusive genius is valuable when it comes within a decade of his presumed death. In 421, Aristophanes presented his play *Peace* at Athens, and in lines 605–18 of that play – a protest against the Peloponnesian War between Athens and Sparta, which had begun in 431 and was to grind on another twenty years yet – Pheidias is nominated as the man who started the whole conflict with his 'misdemeanours' (*praxas kakos*). These crimes are not specified, but they implicate Perikles, who resorts to a war-mongering edict as a means of diverting public attention from his embarrassment.

Figure 7.2 *Proposed head of Pheidias. Roman version of an original made perhaps c. 400 BC. Ht 28 cm.*

The citation of Pheidias as a cause of the flight of 'Peace' from Attica is made by Hermes and is greeted with astonishment by the rustics whom the god is address-ing: good heavens, they respond – we would never have thought of that! And most historians of the Peloponnesian War, finding no corroboration of the story at all in Thucydides, dismiss it as 'pure invention' on the part of Aristophanes. As well it might be; yet we have to concede that Pheidias was at least a 'name' to be bandied on the Athenian stage – and that Plutarch's tale of anti-Periklean intrigue may have some substance to it.

How should we summarize all this? Prior to Plutarch, Diodorus (12.39.2), explicitly drawing upon Ephorus, gives an account of the legal arraigning of Pheidias that specifies *hierosylia* or 'theft of sacred materials' as cause of the indictment. Again Pheidias seems to be used as a scapegoat by the enemies of Perikles – but both Diodorus and Plutarch are probably telescoping events in their image of a politically beleaguered Perikles (they say that charges were brought not only against Pheidias as Perikles' friend, but also against Aspasia, Perikles' mistress, and Anaxagoras, his old mentor). True, as one of the guardians or 'assessors' (*epistatai*) of the Parthenos statue, Perikles would be vulnerable to any charge of embezzlement successfully brought against its sculptor; but there again, Perikles was only one of several assessors – five, to be precise, were appointed annually – and therefore he cannot have borne sole responsibility. We are bound to allow, however, that some sort of scandal, trumped up or otherwise, occurred – something that involved Pheidias in his capacity as maestro of the cult statue for the Parthenon. The question remains: when?

An ancient annotator of Aristophanes (commenting on *Peace*, lines 605ff.) alerts us to one further historical source, Philochoros. In one of his (now lost) accounts of Athenian history, compiled in the third century, Philochoros fixed a date for both the dedication of the Parthenos statue and the indictment of Pheidias around 438/437 (i.e. Olympiad 83). (This date cannot be regarded as entirely secure: one reading of the Parthenon accounts would move the completion date of the Parthenos to 435/434.) Philochoros also specifies the alleged theft as one of ivory, intended for the scales of the serpent coiled behind the shield. And he adds a different detail to the sculptor's life-story. Pheidias, according to Philochoros, was not imprisoned at Athens, but fled to Elis, where he undertook the commission to make the Olympic Zeus – and where, perhaps (the text is unclear), he ended his days: possibly condemned, again, for peculation.

We might be inclined to despair of establishing the truth amidst this partial and distant reportage. But here is a case where archaeology has directly affected the historical narrative. It came during the 1950s, when excavators at Olympia turned their attention to the remains of a building traditionally identified as the 'Workshop

of Pheidias' (Pausanias 5.15.1: a small Byzantine church was subsequently raised on the site) – yielding pottery datable to the 430s. (Among this pottery should be mentioned the find of a black-glazed cup with a base inscribed *PHEIDIO EIMI*, 'I belong to Pheidias'. The cup is authentic enough; but rumours subsist to the effect that the inscription was added by a mischievous modern hand.)

Readers keeping an eye on chronology may already have guessed where this is leading. The Parthenon, whose foundations seem to have been prepared *c.* 450–448, was most probably dedicated as a roofed structure in 438. Inscriptions, however, suggest that work on the building continued up till 432, and most scholars believe that the pedimental sculptures, and possibly the frieze, belong to this final phase of the project.

If we accept that the archaeological evidence from Olympia confirms the account Philochoros gives of the vicissitudes of Pheidias, then the consequence is clear: that Pheidias was at Olympia when the last stages of the sculptural decoration of the Parthenon were being executed. Pheidias, therefore, was not involved in carving the figures of the Parthenon pediments.

Who – we might now ask – ever said that he was? No ancient author, so far as we know; and even Plutarch's description of Pheidias as an *episkopos* has been queried, given the democratic antipathy to all singular appointments in fifth-century Athens. (Inscriptions related to the Akropolis monuments mention many official names, mostly of commissioners – *epistatai* – and accountants – *tamiai* – but make no reference to Pheidias, nor indeed to Perikles.) Admittedly, the homogeneity of style across all the sculptures of the Parthenon is questionable, with the metopes in particular seeming uneven in quality and demonstrably executed some years (perhaps two decades) before the pediments; and different 'hands' are relatively easy to distinguish on the frieze, when one has the advantage of seeing it close-up, and unpainted, at eye-level. But, as with the epics of Homer, our intuition seeks a controlling creator; and logistics may require the same. The pediments demanded fifty figures, all over-lifesize. If we read the accounts rightly, to get those fifty figures from quarried blocks into finished and painted forms *in situ* within the pediments took only six years. This means a total carving staff of literally hundreds. So surely there must have been some overall co-ordination of their work. But who discharged that role – if Pheidias himself was at Olympia?

The search for Pheidias 'the man' is haunted by such questions – probably unanswerable. So what shall we do with his name?

Rationalizing genius The reputation of Pheidias is moderately well attested by sources not completely removed from his own life and times: Plato at least implies that there was a sought-after, talked-about sculptor called Pheidias, even if he

might still be considered a *banausos*. Plato does not call Pheidias a genius as such, which would have been difficult to do, since ancient Greek has no word for 'genius' as we understand it – distinct from 'talent'. But that is not to say that the Greeks did not recognize something akin to our notion of genius. They knew about inspiration (*enthousiasmos*); and they knew about possession, divine or creative; or rather, divine *and* creative, since great art was the result of heavenly afflatus, the breeze of creativity blowing through select human channels. To onlookers this might seem a sort of madness (*mania*). In Plato's time, such inspiration (from the Muses) was considered the prerogative of poets and dramatists. But that attitude was about to change, with a proliferation of historical anecdotes about not only the lucrative careers of certain painters and sculptors, but also the public perception of how artistic 'marvels' (*thaumata*) came into being. Not only was the successful artist 'gifted' technically: his representations of the supernatural were made possible by supernatural experience (thus Praxiteles must have 'seen' Aphrodite in order to make the Aphrodite of Knidos: see p. 202).

Within the writings of Pliny we find some of the source material for caricature-vignettes of the artistic genius as later developed in Renaissance times by Condivi, Vasari and others. So Pheidias judging an entire lion by the size of one claw eventually becomes Albrecht Dürer, who from a fragmentary limb could reconstruct the figure of Christ Crucified. Even some of the psychotic tendencies of the 'great artist', as Romantically conceived, are prefigured in stories about Parrhasios and others. Solitary, single-minded, socially marginal, greedy, competitive, short-tempered, vain – the genius does not have to conform to each of these traits, but is unlikely to lack all of them. So it is fair to say that the Greeks launched a Western tradition in this respect – from the moment that Homer called upon the blessed Muses to assist his song.

What little we know of the life of Pheidias has all the potential for an epic of agony and ecstasy: grand projects, scheming opposition, court cases, gaol, exile, suspected poison, pederastic love-affairs – and Plutarch mentions 'loose' women, too (*Per.* 13.15). Here, at the risk of being dull, we shall attempt to rationalize the evidence. While such an analysis will not give graphic details of the death of Pheidias, it may at least save him from a worse theoretical fate – *la mort de l'auteur*, 'the death of the author/artist'.

The question of artistic status in antiquity surfaces throughout this book. To summarize, we witness a 'paradigm shift': from artists scorned in the seventh century, by Hesiod, as 'beggars' (*ptôchoi*: the Greek is onomatopoeic of a spat-out disparagement), to artists parading as wealthy 'celebrities' in the mid fourth century (Athenian property lists suggest that the family of Praxiteles was among the top 300 'rich list' of the city). Where to place Pheidias in this process of social

advancement is arguable. Certainly he would not have needed to earn very much (in absolute terms) to put himself ahead (relatively) of most jobbing stonemasons or sculptors. The Parthenon accounts record that in one year the wages bill for work on the pedimental sculptures totalled 16,392 drachmas. Assuming a work-force of 20 sculptors working 300 days in the year, this gives them a daily pay of just 2 or 3 drachmas a head. To put that into context, Plato reports (*Cra.* 384b) that a Sophist might charge 50 drachmas to give a single lecture.

We can only speculate how far the *design* of a huge statue like the Parthenos required, as it were, 'philosophical' erudition. (To judge from the recorded iconography of the Parthenos base, it was programmatic in a literary way, following, and possibly even reinterpreting, poetic legends of the Birth of Pandora.) Technically, however, there is no doubt that the commission for chryselephantine sculpture on the colossal scale posed extraordinary challenges. It was an unprecedented test of *technê*: new territory even for Pheidias, who at Plataea, early in his career, had set up an over-lifesize akrolithic image of Athena Areia ('Warlike Athena'), gilding the wood to create a 'pseudo-chryselephantine' effect. The premium for success may have been correspondingly pitched. And, of course, such a commission put the sculptor in contact with, if not in charge of, vast budgets. Forty-four talents of gold – over 1,000 kilos – are reckoned to have been 'deposited' in the Parthenos, not to mention many other precious materials. (The gold alone equates to the cash value of maintaining, for one year, a fleet of about 100 warships.)

According to Plutarch, the inordinate costs of monumentalizing the Akropolis caused protests in the Athenian Assembly, protests countered by Perikles threatening to pay for it himself and then have it named after himself too (presumably pure bluff – but it worked). But the inscribed Parthenon accounts, as we have noted, tend to reduce the entire project to logistics, obscuring by their democratic bureaucracy the lead roles we might wish to assign to Perikles and Pheidias as 'men of vision' here. So our rationalization of genius must rely on a comparative model.

Such a model is Michelangelo. Like Pheidias, his aura of genius is enough to confound any sensible account of how his works were accomplished. But like Pheidias, too, Michelangelo lived in a society which allowed upward mobility to those who worked with their hands so long as that work was highly skilled and engaged with the intellectual interests of 'the creative elite'. A study of Michelangelo's involvement in the shaping of the Florentine church of San Lorenzo is subtitled *The Genius as Entrepreneur* – which some might regard as a contradiction in terms (certainly Vasari, who defended Michelangelo stoutly against charges of greediness, and who preferred his sculptors to be like Donatello:

earning plenty, but so wrapped up in his work that he simply tipped any money into a basket and let people help themselves). Yet it is clear from the documentation from San Lorenzo that Michelangelo's role in the project was as much 'managerial' as artistic. That is, he was personally responsible for hiring and supervising an extensive workforce; he also selected all materials for the job, negotiating prices and organizing transport – even designing carts to that end; moreover, he specified cranes and scaffolding, as well as drawing templates for even the most minor architectural mouldings; on top of which, of course, he was both the architect commissioned for the San Lorenzo façade and sculptor of the tombs for the Medici Chapel inside. He was, in effect, his own foreman and his own clerk of works. Merely contemplating the range of responsibilities undertaken by a man in his late 40s is enough to make one feel vicariously exhausted. The documentary evidence for Michelangelo's activity, in fact, is every bit as intimidating as the legends of his 'superhuman genius'. But it is a way of rationalizing genius: and it probably makes sense to think of Pheidias just so.

The archival records for San Lorenzo, showing how Michelangelo supervised his many collaborators and subordinates – as many as 300, at full strength – cannot be matched by the epigraphic records of the Parthenon. It is instructive, however, to look at inscriptions relating to the Erechtheum. Among the accounts for the year 408/407, we find details of a 'sculpture summary' (*kephalaios agalmatopoiko*) totalling 3,312 drachmas. Here is an excerpt from the cash reconciliation columns:

To Phyromachos, for the youth beside the breastplate 60
To Praxias, for the horse and the man beside it 120
To Antiphanes, for the chariot, the youth and the horses being harnessed 240
To Phyromachos, for the man leading the horse 60
To Mynnion, for the horse, the man striking it and the stêlê *127*
To Sokles, for the man holding the bridle 60
To Phyromachos, for the man leaning on the staff 60
To Iasos, for the woman with little girl beside her 80

No ancient source tells us who, if anyone, was the overall designer of the Erechtheum frieze. (It was curiously constructed, with a base of blue Eleusinian limestone supporting attached marble figures.) One sculptor, Phyromachos, seems to have been busier than others; but evidently individual sculptors were paid per figure at a rate of 60 drachmas (not much, since it can hardly have taken less than six weeks to do such a figure). By comparison, the remuneration for fluting a column on the same temple was 100 drachmas, while making the wax model of an architectural detail was just 8 drachmas.

Some commentators prefer not to seek any top-down command in this democratic milieu. Long ago, Percy Gardner wrote: 'the Parthenon is less the work of individuals than the highest artistic bloom of a city and a period. Every worker on it seems to have partaken of a common inspiration, which worked rather in the unconscious than in the conscious strata of his mind.' Plutarch might have agreed: arguing that Perikles set about the embellishment of the Akropolis as a means of bringing full employment to Athens, he describes the consequent economic ripples in a memorable passage:

The raw materials were stone, bronze, ivory, gold, ebony, cypress-wood: to fashion and work them were the craftsmen – carpenters, moulders, coppersmiths, stone-workers, goldsmiths, ivory-workers, painters, pattern-weavers and workers in relief. Then there were the men engaged in transport and carriage – merchants, sailors, helmsmen by sea, cartwrights by land, and men who kept yokes of beasts, and drovers; rope-makers, flax-workers, shoemakers, roadmakers and miners. And each craft, like a general with his own army, had its own crowd of hired workmen and individual craftsmen organized like an instrument and body for the service to be performed; so, in short, the various needs to be met created and spread prosperity through every age and condition.

<div align="right">PER. 12</div>

And elsewhere, with an anecdote that relates to the shifting of stone up to the Akropolis – some 22,000 tons of marble were moved from the Pentelikon quarry to Athens – Plutarch cannot resist extending his vision of collective enterprise:

When Perikles was building the Hekatompedon [Parthenon] on the Akropolis, stones were naturally brought up by numerous teams of draught animals every day. And there was one mule who had assisted gallantly in the work, but had been put out to grass because of old age: this mule used to go down to the Kerameikos every day and meet the other animals carrying stones, and he would trot along with them, as if to encourage and cheer them on. The people of Athens, admiring the mule's spirit, gave orders for it to be looked after at public expense and voted it free meals, like an athlete receiving a pension.

<div align="right">MOR. 970; CF. CATO, 5</div>

Such was the civic participation in making the Parthenon that even mules – not known for their co-operative disposition – were keen to see the temple finished. And Plutarch is right to say that it was all done 'with miraculous speed'. The timescale points to an astonishing consonance of art, logistics and sheer hard labour.

How far Pheidias can be credited as mastermind here is, as we must conclude, impossible to judge. If he left Athens under a cloud of disgrace, it seems soon to have blown over. In the fourth century, various literary allusions to Pheidias (Xenophon, *Mem.* 1.4.3; Isocrates, *Antidosis* 15.2; Aristotle, *Eth. Nic.* 1141a10)

attest the respect and esteem attached to his name. Although there is no suggestion that Pheidias, like Iktinos and Kallikrates, the architects of the Parthenon, ever wrote a treatise about his work – and this became almost expected of artists, especially painters, in the fourth century – he was nevertheless famed for his 'wisdom' (*sophia*) and the sheer magnitude of his sculptural projects. All the more painful, then, that so little trace of them remains. But in our mind's eye, if we want to glimpse the 'genius of Pheidias', we shall have to attempt some reconstructions.

THE RIACE BRONZES: PHEIDIAN WORKS?

The technical quality of the two bronzes found in shallow waters off the southern coast of Italy in 1972 is well known, uncontested and referred to elsewhere in this book (see p. 36, and Plate IIa, b). The identity of the pair, however, is still debated among experts. Onatas, Myron, Polykleitos and Alkamenes have featured among proposed candidates; but in terms of probable provenance, Pheidias lays the strongest claim. The argument for this claim can be summarized as follows.

There is sufficient likeness between the two figures (Figure 7.3) to suggest that they belong together, and probably as part of a larger group. Stylistically, a date of *c*. 450 is the most plausible of the range suggested; and three groupings of lifesize bronzes are known to have existed at that time. One is the ensemble of ten Achaean heroes made by Onatas and displayed at Olympia, near the temple of Zeus (Pausanias 5.25.8); another is the line of Eponymous Heroes erected in the Agora (Pausanias 1.5); a third is the Athenian Marathon monument at Delphi (Pausanias 10.10.1). We have little idea about the appearance of the heroic group at Olympia, and what we know about the *Eponymoi* at Athens suggests they were draped, 'civic'-style figures. There are, by contrast, several positive reasons in favour of the Delphi location. The marble base of the Marathon monument survives – with cuttings for the feet of statues similar to the Riace figures. Two bronze shield bucklers, very similar to those on the arms of the Riace pair, have been found at Delphi (plus other likely armour parts). And if Pausanias is right in his naming of the group members assembled on this base, it was an unusual ensemble insofar as there was a single historical character included alongside a dozen divine or legendary types. Next to Apollo and Athena, says Pausanias, stood Miltiades – Miltiades, who of the ten Athenian generals at the battle of Marathon proved decisive and inspirational to victory (Herodotus 6.109ff.). How would a heroized *stratêgos* be represented? Nude, but armed, and with his helmet tipped back. That 'Statue B' was the figure of Miltiades, then, is a plausible hypothesis, and one that gains in plausibility when we learn that the Marathon monument was most probably dedicated at Delphi *c*. 450 under the sponsorship of Kimon – son of

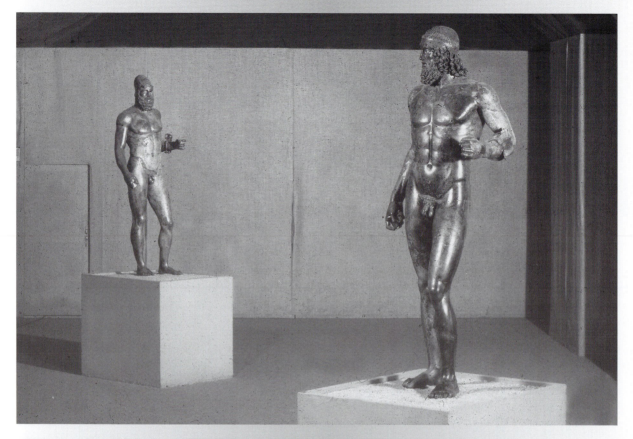

Figure 7.3 *The Riace Bronzes, probably made c. 450 BC, and perhaps sunk in transit from Greece to Italy during the first century AD. Ht of 'A' 1.98 m., 'B' 1.97. Both figures carried large hoplite shields on their left arms, with lowered right hands holding weapons. 'A' wore a wreath, or possibly a helmet. 'B' is recognized as senior in years.*

Miltiades. According to Pausanias (10.10.2) the sculptor of the monument was Pheidias.

Anyone in the presence of the Riace Bronzes – now 'rooted' to quake-proof bases in the museum at Reggio – is immediately aware of being in the vicinity of truly 'great' works of sculpture: technically, perhaps the most accomplished bronzes ever made. It is not proven that they come from the Marathon monument; and, since Pausanias is our only source for the attribution of the Marathon monument, it cannot be proven that Pheidias was their maker. But it is well within the range of his ancient reputation to accept that he was.

Athena Parthenos and Olympic Zeus

Pheidias began his career, according to Pliny (*NH* 35.54), as a painter. He worked successfully in bronze: not only at Delphi, for the Marathon monument, but also at Athens, with another Marathonian commemoration – the armed Athena on the Akropolis (eventually known as Athena Promachos), of colossal size – and a more delicate Athena, dedicated

on the Akropolis by Athenian émigrés on Lemnos and hence known as 'the Lemnia(n)'. Some scholars like to characterize a 'Kimonian' phase to the sculptor's commissions. Pheidias competed in the famous 'Amazon contest' at Ephesus; and he was apparently more than competent in marble (*NH* 36.15). But it was for his three major chryselephantine statues that Pheidias became most celebrated. One of these, possibly his artistic swansong, was a 'Heavenly Aphrodite' for Elis: though reportedly a sensuous piece, the swathes of drapery on this statue must have made it look distinctly conservative when Praxiteles made Aphrodite naked virtually *de rigueur*. But the statues at Athens and Olympia were never eclipsed. Pheidias, we are told, had associates, pupils and followers – prominently Alkamenes, Agorakritos and Kolotes – but none outdid the Athena that became known as Parthenos and the Zeus that we shall refer to as 'Olympic' (because of its location, though 'Olympian' is allowable, given the majesty of the work).

Sufficient testimonies survive for both statues to enable clear ideas about their effect. Of the Parthenos, a full-scale reconstruction has been completed within the replica Parthenon of Nashville, Tennessee; whether this improves upon a model created for Toronto in 1962 (Fig 7.4) must be a matter of taste.

The weight of gold attached to the statue – most of it as plates forming Athena's *peplos* – was reckoned between 40 and 50 talents; Philochoros specifies 44, equivalent to 1,137 kilos. The quantity, together with records of 'borrowings' from the statue, may suggest that the Parthenos served as a glorified treasury. Yet the principle of ornamenting a statue with a *kosmos* of precious trappings was long established – including the practice of adding an overlay of gold leaf (*agalmata epichrysa*); and as for size, it was also well-established that a deity could become manifest on a colossal scale (in the *Homeric Hymn to Aphrodite*, for example, after the goddess has made love with the shepherd Anchises, she suddenly magnifies herself so large that her head 'touches the well-hewn roof' of his house). Athena 'inhabits' the *naos* of this temple as befits its architectural dimensions – though that is a consideration seemingly overlooked at Olympia (see below).

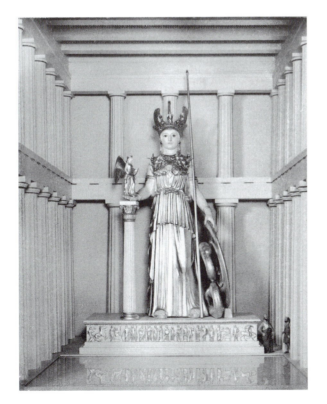

Figure 7.4 *Reconstruction of the Athena Parthenos by Pheidias, at a scale of approx. 1:10. The original was 26 cubits high, i.e. about 12 m. (probably including the base).*

Certainly Athena as imagined by Pheidias made a strong complement to the old olive-wood *agalma* known as Athena Polias ('of the city'), which would be housed in the eccentric temple known as the Erechtheum. Pausanias says that this statue 'fell from heaven' (1.26.6). Its scale was probably under-lifesize, and it may have been essentially aniconic, with a mask for a face; its principal decoration was almost 'homespun', for we suppose that this was the statue for which women of Athens annually produced a newly woven *peplos* (at a festival known as the Chalkeia, preceding by nine months the Panathenaic presentation of the garment).

Lines of Euripides' *Heracleidae* (770–2) hail Athena not only as 'Queen' (*Potnia*), but also as 'Mother, Mistress and Protectress' (*Mêtêr, Despoina, Phylax*). Looking at the Parthenos, we can see how she came to be known by that virginal title ('Maiden'), for, of those several epithets, the maternal aspect is not apparent. Traditionally central to Athena's protective, all-powerful aspect is her *aegis*, with *gorgoneion*-brooch. Here it is simply one element of a warrior status heightened by an elaborate helmet, with winged horses either side of its crest, a sphinx to the fore and gryphons on the cheek-guards; the great lance resting on her shoulder; and of course the shield, apparently propped by a coiled serpent (for Pausanias – 1.24.7 – this is the primal form of Erichthonios, an Athenian founder-hero, born out of the ground where semen fell after Hephaistos tried to breach Athena's virginity). Nike, herself flourishing a wreath, is held in the extended hand: so the statue as a whole implies that Athena is celebrating victory. Yet her body-language seems that of standing by for action. She is 'at home' – but not off guard.

Pheidias, as ancient commentators noted, explored every available space for extra figurative decoration. Just as an orator turned his speech around a series of topic-headings, so Pheidias used every 'juncture' of the Parthenos to build up its thematic swell (Pliny, *NH* 36.18). On the inside of the shield was a Gigantomachy: an obligatory aspect of Athena's iconography, here nicely twinned with an Amazonomachy on the shield exterior – while the Giants storm Mount Olympus, the Amazons attack the Akropolis, signifying a shared impiety. On the goddess's chunky sandals there were Lapiths against Centaurs – a combat whose allegorical message must have been clear enough by the mid fifth century. Pheidias saved for the base – the most conspicuous area of subsidiary relief – his most innovative contribution: scenes of the Birth of Pandora, attended by twenty deities.

What meaning this had remains subject to (much) speculation. The story of Pandora, at least as told by Hesiod (especially *Erg.* 42–105), does not seem particularly appropriate; scholars suppose, then, that there was some significance to the story quite different from Hesiod's morose misogyny. Recent theories draw

attention to mythological links and similarities between the stories of Pandora and Erichthonios; also to Pandora's original manifestation. Dressed (in a *peplos*) by Athena, she may be understood as matriarch of the *technê* of weaving. To anyone favouring the romance of Pheidias-as-genius, meanwhile, it is tempting to imagine that the sculptor found in the tale of Pandora a mirror of his own extraordinary power. As Hephaistos created Pandora, laden with *charis* ('grace'), for mortal delight, so Pheidias made images of the divine – for mortal *and* immortal delight.

Pausanias spent more time at Olympia than at Athens, and this shows in his description of Pheidias' Zeus (5.11.1–9). Perhaps he was fortunate to have found it still *in situ*, since the emperor Caligula, *c.* AD 40, reportedly made an attempt to transfer it to Rome – only desisting, seemingly, when lightning struck the ship intended to transport the statue, and workmen sent to dismantle it were terrified by a thunderous bellow from 'Zeus'. A series of coins minted between AD 98 and 198 vaguely substantiates Pausanias' account, which has guided a number of credible artistic reconstructions, all more or less befitting one of the 'Seven Wonders' (Plate VI).

The major games at Olympia were celebrated every fourth year: but that does not mean that the Zeus was relatively unvisited and out of sight. Olympia and the Olympics attracted pilgrims from all over the Mediterranean (and, under Roman control, from further afield), in a quantity perhaps only matched by Apollo's cult at Delphi. And Pausanias explicitly notes that there was an altar to Zeus *within* the temple structure at Olympia: so we must imagine worshippers regularly admitted inside, to see for themselves the magnitude of the image. Reaching just short of the temple ceiling, at about 14 m. high, the statue's size was made the more impressive by the addition of a shallow basin of dark limestone, filled with reflective olive oil. Pausanias tells us that a similar pool, though filled with water, was supplied for the Parthenos – in order to maintain moisture levels around the statue. We do not know whether humidity controls were the purpose of the oil basin at Olympia, but there is no doubt that it acted like a mirror. (The maintenance of both statues, incidentally, must have been a full-time occupation: at Olympia, there were hereditary retainers, the *phaidruntai* or 'shiners', who claimed that they were *apogonoi Pheidiou*, descendants of Pheidias himself.)

Olympia, unlike the Akropolis, was a Panhellenic sanctuary. The Zeus of Pheidias was accordingly designed to be of broad appeal to all Greeks, and later to Romans and others who held faith in an omnipotent divine father-figure. Strabo, the Greek geographer active around the time of Augustus, voiced a consensus when reminding his readers that the Olympic Zeus embodied an essentially Homeric image of Zeus – the moment of *Il.* 1.528, precisely: 'The son of Kronos spoke, nodding his dark brows; ambrosial locks streamed forward from the great god's immortal head, and all Olympus quaked' (8.3.30). (Pheidias himself was said to be the source of this tradition.) Strabo adds a practical note of concern about the scale:

'If Zeus arose, he would unroof the temple.' But perhaps this was to be too literalistic about visualizing the temple *naos* as the *oikos* of the deity.

Mention has already been made of the excavation of the workshop (*ergastêrion*) of Pheidias at Olympia. That this building replicated the *cella*-interior of the temple is clear enough; whether the original temple-builders had envisaged such a statue for their building, we do not know. In any case, debris from the workshop has added some technical information about the statue's lost splendour. Though it was larger than the Parthenos, it may not have carried so much gold. A number of terracotta moulds for the drapery of a subsidiary figure – probably the Nike held in Zeus's right hand – have been analysed: they indicate a technique of forming glass, perhaps with gold inclusions, or a gold-leaf backing. Traces of ivory and obsidian were also recovered, along with remains of tools, kilns and furnaces.

The Roman general Aemilius Paullus took time away from his business of extending Roman rule over Greece to visit Olympia, *c.* 167 BC. The historian Livy noted (45.27–8) that the sights of Greece were on the whole 'greater by reputation than by visual acquaintance' – but that the Zeus of Pheidias more than satisfied expectations. *Iovem velut praesentem intuens motus animo est*: the general's 'soul was stirred, gazing as if upon Zeus incarnate'. Olympia and the Olympic Games prospered under Roman control. But what became of the statue when the site was finally closed down, in the late fourth century AD? It seems that a Byzantine official called Lausus brought the Olympic Zeus to Constantinople, during the time of Theodosius II (408–50), where it joined a collection that also included the Aphrodite of Knidos. It was a brief sojourn, for *c.* AD 475 this collection went up in flames: but not before Christian artists had absorbed the 'beauty and magnitude' of Pheidias' vision and translated it into the image of Christ Pantocrator – Christ 'the Ruler of All', as shown in glittering mosaic at Haghia Sophia and elsewhere.

Sources and further reading

The epigraph to this chapter is in turn indebted to an observation by Pierre Vidal-Naquet: see *s.v.* 'Grèce', *Encyclopedia Universalis*, 1017. The quotation from Ruskin comes from *Aratra Pentelici* (using the London 1907 edition), 106. For ideas of genius generally, see P. Murray ed., *Genius* (Oxford 1989), esp. Ch. 1; and E. Kris and O. Kurz, *Legend, Myth, and Magic in the Image of the Artist* (Yale 1979). A. Burford, *Craftsmen in Greek and Roman Society* (London 1972), brings us down to earth with practical detail; I have also drawn upon her essay in G.T.W. Hooker ed., *Parthenos and Parthenon* (Oxford 1963), 23–34. Details regarding the Erechtheum accounts are taken from G.P. Stevens, J. M. Paton, L. D. Caskey *et al.*, *The Erechtheum* (Harvard 1927), 387ff., and R.H. Randall, 'The Erechtheum Workmen', *AJA* 57 (1953), 199–210.

Pheidias, life and works The triple-volume homage of C.C. Davison (with B. Lundgreen, ed. G. Waywell), *Pheidias: The Sculptures and Ancient Sources* (London 2009) provides an illustrated

compendium of attributions to Pheidias (including discussion of his involvement with the Parthenon) and pertinent ancient sources (up to late Byzantine times): see the present author's review in *JHS* 131 (2011), 259–60. There is a succinct summary of the sculptor's career by Evelyn Harrison in O. Palagia and J.J. Pollitt eds., *Personal Styles in Greek Sculpture* (Cambridge 1996), 16–65. It is not original to doubt Pheidias as an active influence on the Parthenon's marble sculpture: see N. Himmelmann, 'Phidias und die Parthenon-Skulpturen', in J. Straub, N. Himmelmann and A. Lippold eds., *Bonner Festgabe Johannes Straub* (Bonn 1977), 67–90. The literature on the 'Pheidias Process' is large, beginning with K.O. Müller's *De Phidiae vita et operibus* (Göttingen 1827); it is best summarized in P. Stadter, *A Commentary on Plutarch's* Perikles (North Carolina 1989), 284–97; to be supplemented with C. Höcker and L. Scheider, *Phidias* (Hamburg 1993). Comparanda with Michelangelo: W.E. Wallace, *Michelangelo at San Lorenzo: The Genius as Entrepreneur* (Cambridge 1994). I quote from Percy Gardner, *New Chapters in Greek Art* (Oxford 1926), 69. Various scholars, including Werner Fuchs and the late J.P. Barron, favour Pheidias as author of the **Riace Bronzes**: a curt account of the case is given by A. Giuliano in *Due Bronzi da Riace* (Rome 1985), vol. II, 297–306 (*au contraire*, C. Rolley in the same volume). An elaborate *restauro* programme of the Bronzes, begun in 2010, may force reconsiderations of their original creation. Alternative theories include the carefully argued proposal that the Bronzes formed part of a group on display at Argos showing heroes from the saga of the Seven Against Thebes: P. Moreno, *I Bronzi di Riace* (Milan 1998). On Pheidias as maker of chryselephantine masterpieces, see K. Lapatin, *Chryselephantine Statuary in the Ancient Mediterranean World* (Oxford 2001), 61–95.

Athena Parthenos G.P. Stevens, 'How the Parthenos was Made', *Hesperia* 26 (1957), 350–61; more thorough discussion in N. Leipen, *Athena Parthenos: A Reconstruction* (Toronto 1971). C.J. Herington's monograph *Athena Parthenos and Athena Polias* (Manchester 1955) is still valuable, and B.S. Ridgway's survey of 'Images of Athena on the Akropolis', in J. Neils, *Goddess and Polis* (Princeton 1992), 119–24, for discussion of the *peploi* woven in Athena's honour. On the imagery of the base, see J.M. Hurwit, 'Beautiful Evil: Pandora and the Athena Parthenos', *AJA* 99 (1995), 171–86. Hypotheses on the iconography of the statue (by B. Fehr) in *Hephaistos* 1–3 (1979–81: 71–91, 113–25, 55–93).

Olympic Zeus On the workshop, see A. Mallwitz and W. Schiering, *Die Werkstatt des Pheidias* (Berlin 1964) and W. Schiering, *Werkstattfunde* (Berlin 1991).

I would rather see her lovely walk and the shining sparkle of her face than the chariots of the Lydians and armed infantry fighting.

Sappho of Lesbos,
Greek Lyric I, 67

8

REVEALING APHRODITE

Predominant among the earliest three-dimensional images produced by human-kind are statuettes of the unclothed female form. There are variations within examples from around the world, but they share a basic selective emphasis of body-parts: breasts, hips and genitalia. Historically, (male) archaeologists have been unable to resist attributing a sexy function to these Stone Age figures – so the 'Venus of Willendorf', the 'Venus of Malta' and so on. The Latin name of the goddess has been preferred, but the Greek Aphrodite remains the conceptual source. And Aphrodite was not a 'fertility goddess'. To associate any image with Aphrodite is to place that image in the realm of the erotic.

What is 'erotic'? Pedantically, it should be whatever belongs in the realm of *eros*, which is Greek for 'love', and also Eros (Cupid), the winged boy, sometimes armed with bow and arrow, who is Aphrodite's son or messenger. In antiquity, as we shall see, there was scope for recognizing tension between what we would call 'love' and what we would call 'lust'; nonetheless, Greeks and Romans alike were relatively shameless in their acknowledgement of the force of erotic desire. The irresistible, carnal and generative power of Aphrodite/Venus was honoured glee-fully. 'You alone are the guiding power of the universe and without you nothing emerges into the shining sunlit world to grow in joy and loveliness.' Lucretius, the Latin poet-philosopher who made this unreserved salutation (*De Rerum Natura* 1.21–3), was writing in a time when his own head of state, the emperor Augustus, claimed descent from the goddess; yet it was not eccentric to recognize Aphro-dite's ultimate supremacy: supremacy over most of her fellow Olympians, and supremacy not only over humankind, but also 'birds that fly in the air and all the many creatures that the dry land rears, and all that the sea' (*Homeric Hymn* 5, '*To Aphrodite*', 1–6).

We do not know how far Stone Age communities shared this respect for the procreative impulse; we only assume, with the 'Venus of Willendorf' and others, that incomplete representation significantly isolates those female parts designed for intercourse, childbirth and lactation. But in any case, our view of past images of the female body is naturally conditioned by the experience of comparable imagery in our own world. Outside of art galleries, the generic term for this is 'pornog-raphy', formerly confined to an underworld of furtive outlets, now almost unavoidably ubiquitous across the internet.

How far we care to make a difference, in casual parlance, between 'erotic' and 'pornographic' may seem trivial – although one can think of certain cases in modern art and literature when it has been of great legal importance to make that distinction. But once again, etymology drags us back into the ancient world. *Pornê*, prostitute; *graphein*, to depict. The Greeks had a word for it, and Aphrodite was not excluded: at Ephesus

and Abydos, for example, she was worshipped as Aphrodite Pornê, while at Athens there was a cult to Aphrodite Hetaira, 'Aphrodite Courtesan'.

This somewhat fussy discussion of words is the necessary overture to our exploration of an area of Greek sculpture that directly affects high art and mass advertising in the modern world – and indeed pornography too, at least the 'soft' variety. For it was a consequence of the Greek cult of Aphrodite that the goddess was eventually represented as caught in a state of undress; and it was largely as a consequence of discovering these images during the early Renaissance period that the female nude became an accepted genre of Western art (Figure 8.1), which, with the invention of photography in the nineteenth century, effectively fostered the 'pin-up' that would serve not only as a source of titillation in its own right, but also a selling-point attached to all manner of consumer goods, from car tyres to newspapers.

So how did it all begin?

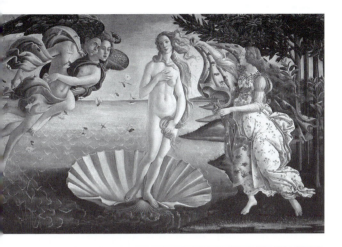

Figure 8.1 The Birth of Venus *by Sandro Botticelli, c. 1490 (detail). The title of this well-known painting – one of the earliest near-lifesize depictions of the female nude in European painting – is provisional: what is shown is Aphrodite's arrival on Cyprus, for which Botticelli used an eclectic range of Classical sources, probably mediated or supplied by the Medici court scholar-poet Angelo Poliziano. The central figure adapts the* Venus pudica *type of statue, examples of which were known in fifteenth-century Tuscany.*

Aphrodite's genesis and Aphrodite's cult

Greek mythology offers variant tales regarding the origins of Aphrodite, but the primary (and more memorable) account belongs to Hesiod's *Theogony* (154–206). The poet describes how trouble arose between Mother Earth – Gaia, or Ge – and her partner Ouranos (Heaven). Gaia bore many children by Ouranos – who proved an unloving father, yet was brutally persistent in his copulations. Eventually Gaia created a jagged flinty sickle and enlisted the help of her youngest son, Kronos, in punishing Ouranos. The punishment was drastic. Ouranos descended, as usual, to lie upon Gaia; then Kronos attacked him with the sickle, lopping off his genitals and scattering blood far around as they were cast into the sea. There the amazing birth took place. A white foam issued from the cut-off parts; and from that foam emerged Aphrodite. She drew near the island of Kythera, as Hesiod relates; but it was on Cyprus that she fully came ashore, causing grass to grow where she trod, and bringing her special gifts to gods and men alike – 'the whispering of maidens and smiles and deceits with sweet delight and love and graciousness'.

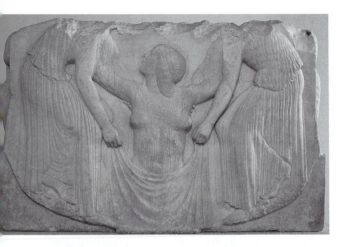

Figure 8.2 *The Ludovisi Throne: marble relief, c. 460 BC. Ht 1.04 m. Excavated in the Horti Sallustiani of Rome, this may have been made in the colony of Locri, where a number of small relief plaques (from a sanctuary to Aphrodite and Persephone, and now displayed in the Reggio Museum) show similar imagery. Aphrodite's arising from the sea, assisted by two handmaidens, seems the most likely interpretation.*

Hesiod offers an origin for her name: she is Aphrodite because she was born in *aphros*, 'foam'. (There are no graphic details of this: artists would have to use their imaginations – see Figure 8.2.) He calls her *Kyprogenes*, 'Cyprus-born', while being aware that Kythera claimed an early association with the goddess; and he says that Aphrodite is given the epithet Philommeidês, 'genital-loving', because of her bizarre, motherless birth.

All Greek deities carried a bundle of sobriquets with them, but Aphrodite carried more than most. She was Ambologêra, 'Postponer of Old Age'; she was Epistrophia, 'the Heart-twister'; she was Psithyros, 'the Whispering One'; she was Parakyptousa, 'the One who Peeps out of Windows' – to name but a few. Above all she was Charidôtês, 'the Joygiver'. Some images present her as armed, reflecting perhaps her dalliance with Ares (her regular Olympian mate was Hephaistos – but fidelity was not expected among the immortals, least of all from Aphrodite). Overall, however, the epithets and myths connected to Aphrodite consistently evoke a certain lightness of spirit and playful charm; and the 'below the navel' aspect of her birth serves to validate the often overtly carnal nature of her cult.

This characterization is not entirely unproblematic. Several centuries after Hesiod, Plato wondered whether it were not possible to recognize two Aphrodites (*Symp.* 180d): first, a primal goddess, descended from Ouranos, who was the 'Heavenly' Aphrodite; then a second type, the offspring of Zeus and Dione (as Homer knew her: *Il.* 5.370–1), who was the 'Popular' or 'Common' (Pandêmos) Aphrodite. Plato (or rather one of his characters) proceeds to argue from this that two kinds of love must therefore exist – with *hoi polloi*, the commoners, simply responding to mutual bodily attraction, while more refined people concentrate upon the affinity of mind or 'soul'. In the context of Plato's discussion, this 'higher' love, as represented by Heavenly Aphrodite, is the ideal of a relationship between men (specifically a pederastic relationship); but it has come to be known more widely as 'Platonic love', and arguably gives evidence for some ancient moral concern about the difference between *(a)* the sort of

erotic impulse that may lead to sexual violence and *(b)* the sort of erotic impulse that leads to a lifelong partnership.

Whether such philosophical scruples impinged upon the day-to-day conduct of Aphrodite's worship and the development of her 'cult' image is doubtful. The goddess was synonymous with making love – *ta aphrodisia*, the act; *aphrodisiazein*, the action – and the several narratives of her divine behaviour – most notoriously in the Judgement of Paris, cause of the Trojan War – nowhere suggest that Aphrodite favoured love without sex. The Greeks were aware, however, that worship of Aphrodite was not unique to them. Hesiod mentions Aphrodite's passing visit to Kythera, off the south coast of the Peloponnese; Herodotus knew that on Kythera a temple to Aphrodite Ourania had been established by the Phoenicians – adding that the cult came from Syria-Palestine (1.105); and Pausanias confirms that Kythera was claimed as the earliest site of the cult of Aphrodite, with an archaic wooden *xoanon* showing the goddess armed (3.23.1).

If the cult of Aphrodite was introduced to the Greeks by Phoenician traders, it is likely that the name 'Aphrodite' is a Hellenization of the Near Eastern deity Ashtoreth or Astarte. This probability is unwelcome in south-west Cyprus, where modern tourists are assured that the foamy surf of such-and-such a beach is the very bay where Aphrodite arose from the waves. But, as archaeologists have proved, the Phoenicians were active along the coast of Cyprus. At Kition, in the south-east, they set up a large temple to Astarte *c*. 850 BC; and dedications to Astarte have also been recovered from Paphos – where Herodotus believed the Phoenicians to have initiated Aphrodite's cult.

Astarte, or Ishtar as she was known in Mesopotamia, is usually understood as a 'Mother Goddess'. The Phoenicians, assiduous sea-farers, carried her cult not only to parts of Greece (such as Kythera, and probably Corinth too), but widely around the Mediterranean. They did so at Eryx (Erice), on the western tip of Sicily, which was indigenously a settlement of the Elymian people; likewise at the Etruscan *entrepôt* of Pyrgi, to the north of Rome. Corinth, Eryx, Pyrgi: at each of these places there is either literary or archaeological evidence for what we know as 'sacred prostitution'. The practice is attested for Ishtar's cult in Babylon, and Herodotus (1.199) mentions, disapprovingly, that such Babylonian customs were found on Cyprus; yet already by the early fifth century, as lines from Pindar indicate (see Ath. 574a), Aphrodite's 'attendants' (*amphipoloi*) were busy at Corinth – or rather, at the eminent sanctuary at Acrocorinth. By Roman times, these so-called 'priestesses' (*hierodouloi*) reputedly numbered a thousand or so.

What does this mean? The answer is that prayers and offerings to the goddess brought vicarious sexual favours. A man – stereotypically, someone involved in trans-Mediterranean trade – made a visit to such a sanctuary with the express purpose of paying a vow appropriate to Astarte or Aphrodite; the sanctuary staff obliged, making use of cubicles *in situ*.

Whether this was the nature of business sanctioned by an Athenian inscription of 333 BC, recording permission given to 'men of Kition' – probably Phoenicians – to establish a temple to Aphrodite in the Piraeus, we can only guess. The cult aspect of sacred prostitution, eventually demonized by Christian writers, remains problematic in both a moral and a religious sense – was it ideally a sort of *hieros gamos*, a 'holy union'? – but that is not our problem. We are concerned, after all, with the image of Aphrodite as developed by Greek sculptors: and whatever Phoenician elements infiltrate the Greek mythology of Aphrodite – the story of Adonis, for example, is one such; also the tale of Pygmalion – our priority will be to ask if *images* of Astarte/Ishtar had any impact upon how the Classical Aphrodite appeared.

We shall return to that question shortly. Meanwhile it remains just to observe that by the fifth century, Greeks were accustomed to refer to Cyprus as 'Aphrodite's island' (see e.g. Euripides, *Bacch.* 402–7), and accustomed also to recognize Paphos as a particular cult centre for the goddess. Paphos today offers an unremarkable archaeological experience, in an area of Cyprus more devastated than dignified by modern visitors; however, the sanctuary there flourished throughout antiquity, even after a shift of habitation to Nea Paphos in the fourth century. And it did so despite the fact that no great temple was created for the 'queen of Cyprus' (*Kyprou despoina*), nor any marvellous image. Sacrifices were mostly small-scale – no great herds of oxen, at least; worship was conducted in an open-air environment; and in lieu of any artificial image stood a conical betyl-stone. Relics of the cult have been recovered, and indeed the venerated stone (by J.L. Myres in 1913): at Paphos, we may conclude, it was the very depth of tradition – demonstrably extending to the early Bronze Age – that gave the site its special status.

Phoenician dedications from Paphos indicate that the goddess there was saluted, by Phoenician pilgrims, as Astarte. Conversely, within the sanctuary of Astarte at Kition, it seems that Astarte could double as Aphrodite for the Greeks. This syncretism or 'combining' of deities was conceivably a determining factor in the eventual revelation of Aphrodite, goddess of love, as the prototypical female nude.

Female nakedness, nudity and taboo

Respectable women in Greek society, by contrast with their male counterparts, were expected not only to spend most of their lives indoors, but also to be fully clothed: even their husbands may rarely have seen them undressed. A story in Herodotus (1.7–13), though set in Asia Minor, epitomizes the force of taboo here. Candaules, king of Lydia, is so proud of his wife's body that he compels his best friend, Gyges, to hide himself in her bedroom, for the sake of taking a surreptitious glance while she undresses. The queen, however, notices Gyges and gives him an ultimatum. Either he must face execution, for intruding on her privacy, or else he must kill the king and marry her – as he does. This historical tale has a clear structural association with the Old Testament episode of David and Uriah; for the Greeks, though, its resonance was with the myth of Actaeon, as told by Stesichoros and passed on by Ovid (*Met.* 3.138ff.). Actaeon was the hunter whose chase took him, quite by chance, to a pool where Artemis was bathing. Actaeon could not help espying the goddess naked – but that privilege hardly mitigated his punishment: his own dogs tore him apart. A metope from Temple E at Selinus shows this story (though not the version in which Actaeon is first turned into a stag).

In keeping with this taboo, images of female nudity in Greek art of the sixth and fifth centuries are rare, and largely confined to a certain category: that is, paintings

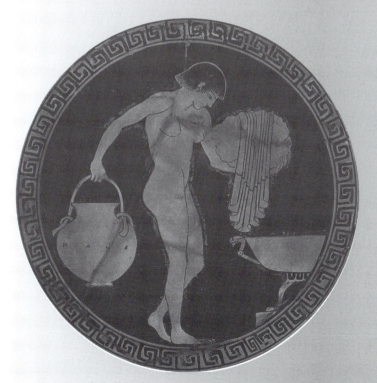

on vases used in the *symposium*. This was an occasion where 'female companions' (*hetairai*) might be hired for the sake of male entertainment and gratification. Such women would drink with the men, contributing music and conversation; if the images on the vases are not fantasy, sex was also on offer. A number of black-figure vases show *hetairai* (probably: this is a topic of debate) showering at fountain-houses; while for the interior scenes of some red-figure cups, an almost telescopic view of one or two women

Figure 8.3 *Interior of an Athenian red-figure kylix c. 500 BC by Onesimos. The boyish figure, approaching a basin, carries her robes in one hand and a water-jug in the other: the jug is inscribed KALE – 'beautiful [girl]'.*

'at toilette' is preferred (Figure 8.3). The element of voyeurism here is undeniable: as wine is drained from the vessel, this is the visual admittance to a scene of personal privacy. A male viewer becomes Gyges with impunity: he sees what he is not supposed to see – and that sense of the illicit may be enough for gratification.

Knidos: the shock of the nude?

So far as we know, images of Aphrodite in Archaic and Classical sculpture conventionally showed the goddess draped. She may, indeed, be represented by one of the luxuriantly reclining figures on the Parthenon (see Figure 12.10). Pheidias is known to have executed a freestanding image of Aphrodite fully clad, and it is to a pupil of Pheidias that some scholars like to attribute the so-called Venus of Morgantina, a late fifth-century work made notorious by a modern contest over ownership. (Although if this figure was holding a torch, a case could be made for her significance as Persephone rather than Aphrodite.)

Then came the celebrated divestment. Around 360 BC the sculptor Praxiteles made an image of Aphrodite that is commonly claimed to be the original 'female nude' in Western art. The statue itself is gone, but, with over 130 known ancient 'copies', it has arguably been one of the most influential artworks ever created (Figure 8.4). In the words of one scholar, 'the idea of representing the goddess of beauty and love as naked may have occurred quite naturally and spontaneously to the Greek artists of the fourth century'. This is possible; however, ancient sources persistently suggest that the *reality* of representing Aphrodite naked caused controversy at the time, with a mix of indignation and prurience still evident centuries later. Perhaps, as some argue, Praxiteles always intended to 'shock' the public – prefiguring the now routine artistic strategy of *épater la bourgeoisie*, to outrage the 'man in the street'. Or was it neither spontaneous nor so calculated?

There are several precedent factors to be considered here.

(i) *The naked Astarte.* As we have seen, the Semitic roots of the cult of Aphrodite allowed for a widespread association of Aphrodite with Astarte. And Astarte's image, so far as it can be fixed, does not shy from nudity. On the contrary, the goddess will usually be shown not only unclothed, but touching or cupping her breasts with both hands, or placing one hand towards her genitals, as if to emphasize her sexuality (Figure 8.5). If Greeks were accustomed to viewing images of Astarte at sites such as Cypriot Amathus, the call for an equivalent, as it were, might be expected.

Figure 8.4 *The Capitoline Venus. Second-century AD statue of Parian marble, found in Rome c. 1670. Deemed by Winckelmann to evoke Praxiteles' Knidian Aphrodite, this lifesize figure probably departs from the original in several respects; to judge from Knidian coin-images, the Colonna Venus (Vatican) seems a more faithful evocation.*

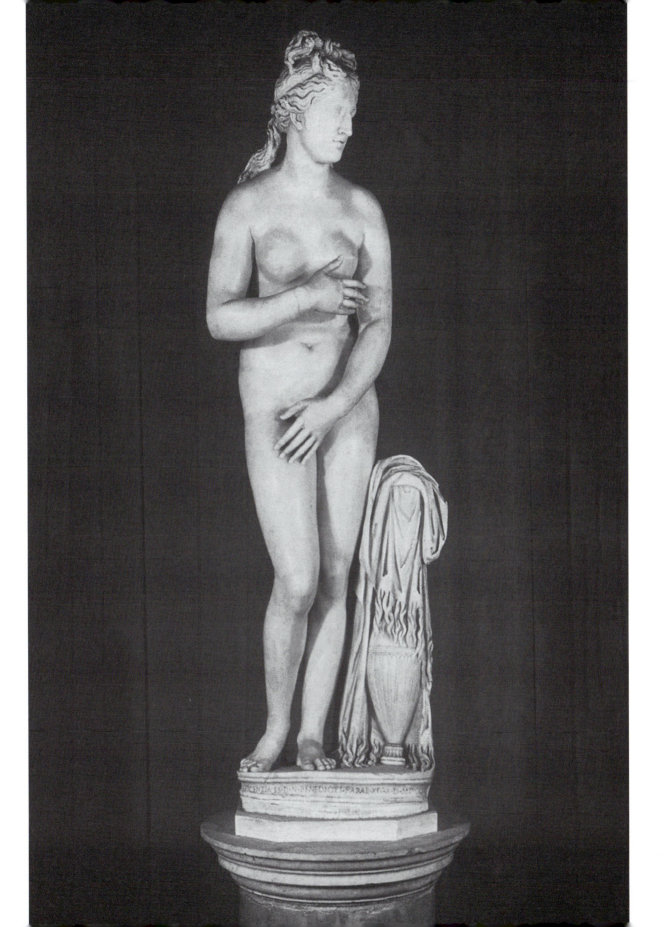

Figure 8.5 *Terracotta relief-figurine of Astarte (probably), from the necropolis of Tharros, sixth century BC. Ht 17 cm. Tharros, a Phoenician colony on the west coast of Sardinia, is believed to have been a site of 'sacred prostitution' – from votive evidence at a temple below the Torre S. Giovanni.*

(ii) *The naked Helen.* It was towards the last quarter of the fourth century when Zeuxis, the far-famed painter of the Classical age, undertook a picture of Helen for the city of Croton in south Italy. According to an anecdote repeated by several authors in Roman times, Zeuxis composed his image of the world's most beautiful woman by amalgamating different parts of the five most beautiful models he could find (Cicero *De inv.* 2.1.1). The picture became notorious, however, because Helen was shown naked, with a Homeric tag to the image (*Il.* 3.156–7) to the effect that to behold Helen's beauty is to understand why the Trojan War was fought. So Zeuxis glorified the female nude in epic style – and challenged sculptors to follow his lead.

(iii) *Praxiteles at Thespiai.* In Boeotia, at Thespiai in the foothills of Mount Helicon, there was a long-established cult of Eros; and here, according to Pausanias (9.27.4), there were three statues made by Praxiteles: one of Eros, one of Aphrodite and one of Phryne. Phryne is a (nick) name that resonates, apart from its literal meaning ('toad'): she is the Classical paradigm of the successful *hetaira*, the courtesan-celebrity whose power is epitomized by the story of how, when brought before a court on charges of impiety, she gained instant acquittal by revealing her breasts (the oldest source of this story, much elaborated by subsequent authors, seems to be Posidippus: see Ath. 591). Phryne was from Thespiai; more significantly, she was said to be both model and mistress to Praxiteles. Insofar as a chronology of the sculptor's career can be constructed, it seems that his work at Thespiai precedes the Knidian Aphrodite: and since part of the controversy caused by the Knidia relates to the allegation that Phryne posed as Aphrodite, we gain a further precedent.

Nonetheless the Aphrodite of Knidos was a *cause célèbre*. Writing several hundred years later, Pliny describes the circumstances of its creation:

The Aphrodite – which many have sailed to Knidos in order to see – is the finest statue not only by Praxiteles, but in the whole world. In fact he had made and was offering for sale two figures. One of these was draped, and because of this was preferred by the people of Kos, who had first choice of the statues (which were offered at the same price). They considered this the restrained and decent option. But the statue they rejected was bought by the people of Knidos, and it was this statue that became so much more renowned. King Nikomedes [of Bithynia] later sought to buy it from the Knidians, offering to discharge their state debt (which was enormous). But they preferred economic hardship, and rightly so: for by this statue Praxiteles made Knidos famous. The shrine containing it is quite open, so that the image – made, as they say, with direct inspiration from the goddess herself – can be viewed from all sides. And indeed it is admirable from every aspect.

NH 36.20

The opportunism of this 'art deal' may be placed in historical context. Knidos was a Doric colony located at the tip of the Datça peninsula, in the ancient region of Caria; in the decades after a Greek–Persian sea-battle (in 394) off the coast, the city settled to prosperity within the regime of the Hekatomnid dynasty (see p. 222). Terraced into ground that rises steeply from sea-level to a natural acropolis, the site retains to this day its characteristic of maritime accessibility – a pivotal position between the Aegean and Mediterranean, with two adjoining harbours. The island of Kos, visible on a clear day, makes an obvious rival. And what Pliny says about the statue conferring fame upon Knidos is evident enough from Hellenistic and Roman coin issues from the city's mint, which use it as a motif – and enable us to identify the so-called Venus Colonna, from among many adaptations of the Praxitelean piece, as most faithful to the original marble.

Excavations at Knidos began in the mid nineteenth century. One of the finds from those early campaigns provides a ready point of comparison and contrast with the Knidian Aphrodite. This is the Demeter of Knidos, a substantial statue from the sanctuary of Demeter occupying a high terrace in a north-east corner of the city (Figure 8.6).

The enthroned goddess was found at the far end of the sanctuary, where she probably occupied an *oikos* or shelter, accompanied perhaps by a standing figure of her daughter, Persephone. Finds from the sanctuary point to the regular observance of the Thesmophoria festival here, a rite confined to married women; and intuitively we must read the image of Demeter, with its distinctively demure drapery, as an emblem of maternity and matronly reassurance. As Marcel Detienne has argued, the cult of Demeter offers an antithesis to that of Aphrodite: one deity worshipped by wives and virgins, the other by courtesans; cult occasions of Demeter

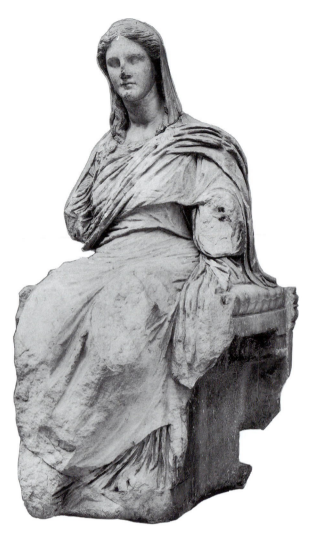

marked by fasting and abstinence, those of Aphrodite by feasting and licence; and while Demeter is governess of fertility and renewal – partly in terms of human procreation, but mainly in agriculture – Aphrodite's praise is couched in the language of sensual pleasure and passing joys. Aphrodite has her cherished boy, Adonis – eternally young, eternally to be adored; while Demeter's concern is for Persephone, half-saved from lustful abduction to bring about crops and abundance.

At Knidos, the contrast could hardly have been made more stark: Demeter – possibly carved by one great Athenian sculptor, Leochares – an awesome matriarch; Aphrodite – certainly carved by another great Athenian sculptor, Praxiteles – apparently caught in the intimate space of washing herself, and wearing nothing but a bracelet on her upper arm (an accessory favoured by *hetairai*).

That Aphrodite is represented as bathing is hard to deny: the robe she holds rests upon a *hydria*, and what we know of the work of Praxiteles indicates that he liked to show immortals engaged in 'everyday', even banal, activities. But is she shown as 'surprised' by some unexpected intrusion? The gesture of her right arm is often interpreted as one of modesty – quite counterproductive, of course – but this is not entirely persuasive; nor is the 'reading' of her head as if turned to meet a visitor.

The archaeology of her display at Knidos is a mixed story. It was in the late 1960s that excavations conducted by Iris Love revealed a circular structure on the western edge of the upper sacred terrace at Knidos (Figure 8.7). A stepped gray limestone podium, approached from the east, can clearly be seen at the site today. The excavator had no hesitation in announcing this as the temple in which the Aphrodite once stood; subsequent investigations, however, raise possibilities of other cults

Figure 8.7 View of the Round Temple at Knidos. The construction of what we now see appears to date to the second century BC. Diameter of tholos 17 m. The base of a statue remains in situ.

located here – of Athena, of Asklepios and of Apollo. Despite these possibilities, and the absence of a full publication, it remains an attractive proposal, reinforced by the apparent replication of the 'Knidos experience' at Hadrian's Villa (Figure 8.8).

What was the 'Knidos experience'? One source, albeit sensational, must be invoked: a dialogue entitled *Erotes* ('Loves', or 'Affairs of the Heart') and attached, with scholarly qualms, to the name of the Greek satirist and essayist Lucian, writing in the second century AD. Regardless of authorship, it seems to provide an authentic account of what it was like to visit the Knidian temple in Roman times. As Pliny says, people made the journey purportedly to see (*ut viderent*) the statue. Lucian sails to 'Aphrodite's city', as he calls it, with two male friends. One is Corinthian, and interested in women; the other Athenian, and interested in men.

Once disembarked, the travellers wander through the lower porticoes of Knidos – so much is plausible from the site's archaeology – before ascending to the higher levels. Here they find the precincts of Aphrodite's temple to be a little paradise of fruit-trees and myrtle-bushes, grown over with ivy and vines. Couches are provided in this garden for the use of devotees. Then they set eyes on the image of the goddess. Her beauty is 'uncovered' (*akalyptos*): save for a modest gesture with one hand, she is fully on view. The writer's heterosexual friend cries out with delight and immediately plants kisses on the statue.

The three men proceed to the back of the shrine. As described, it seems to be *not* a rotonda, with the statue visible all round – as Pliny's text implies – but rather an open-front *naiskos* with a back door. At any rate, in Lucian's narrative, a priestess unlocks this back door, to permit a viewing from behind; and now it is the turn of the Athenian to get excited, appreciating as he does 'those parts of the goddess which would befit a boy' – her flanks, which prompt a likeness with Ganymede. All three, however, are moved by the sight.

And at this point our attention is drawn to a mark or stain on Aphrodite's backside. Could this, they wonder, be some defect of the marble? The priestess is on hand to explain. She tells the visitors about an unfortunate lad who fell desperately in love with the statue and who one night contrived to have himself shut in the temple with it. The stain was no less than a relic of the boy's attempt to consummate his passion. When discovered, in his shame he hurled himself over a cliff (and there

is, indeed, a precipitous drop into the sea on the western limit of the sacred terraces of Knidos).

Various messages may be extracted from this text, among them a certain hermaphroditic appeal of 'the naked Paphian' as wrought by Praxiteles. Above all, however, is the direct aesthetic effect of the statue – its sheer carnal vitality. Some fragments of the Knidia-'copies' hint at this quality (Figure 8.9), but on the whole it is what inevitably tends to get 'lost in translation'.

Why did it shock? After all, despite taboos about female nudity, anyone can see that Greek sculptors were, from the late sixth century onwards, eminently capable of using close drapery and long hairstyles to bring out the contours of a woman's body – to palpably erotic effect (see Figure 4.19). An image of 'Aphrodite in the Gardens' created by Kallimachos at Athens towards the end of the fifth century, later favoured as a model for a late Republican statue of Venus Genetrix in the Roman Forum, seems essentially to have played the same trick as the 'pin-up' photography used in the Pirelli Calendars: if it is agreed that wet or breeze-blown clothes, or partial clothes, falling off the shoulder can be more exciting than full revelation.

The Three Graces

It was Hesiod (*Th.* 907) who defined the Graces (*Charites*) as daughters of Zeus by Ocean, and three in number. Conveyors of 'limb-loosening love' (*eros lysimelês*), they naturally became associated with Aphrodite and their iconography developed accordingly. Archaic images of the Graces show draped figures, holding hands as if part of a choral dance. Pausanias (9.35.2) was aware of this decorum and at a loss to say exactly when it became customary for the Graces to be shown naked (see Figure 11.15). We may guess that it was some time during the Hellenistic period, and possibly following the precedent set by a painting. In any case, Roman versions of the group proliferated, in turn providing sensuously powerful models for Neo-Classical sculptors. (An example of the close-knit type that evidently inspired Canova has lately been recovered from the late Imperial villa of Mediana at Niš, in Serbia.)

Figure 8.9 *Marble fragment of a Knidia statue from Tralles, second century BC. Ht 45 cm. It is a feature of the Knidia and all her 'successors' that pubic hair is absent – and details of the female genitalia are not carved.*

The sensuality of Aphrodite's cult, and indeed Aphrodite's image, was not in itself a cause for great shame among Greek writers. We have cited Herodotus as a voice of censure regarding the practice of sacred prostitution. Yet the *Homeric Hymn to Aphrodite* exults in the story of how the goddess takes a fancy to a Trojan shepherd, Anchises, and seduces him; and one of the most distinctive features of Archaic Greek poetry – the work of Anacreon, Sappho and others – is its celebration of sexual desire, as deified by Aphrodite and Eros.

Ultimately, then, it is not very clear why the Aphrodite of Knidos created, in Kenneth Clark's phrase, a 'sensual tremor' across the Mediterranean – unless we assume that custom expected an image of a goddess to be clothed. Possibly it was the allegation that Phryne had modelled for the statue that caused disquiet – *tên seautou hetairan idrusas en temenei*, 'you have set up a statue of your own mistress in the sanctuary' (Alciphron, *Letters* 4.1). But – Posidippus apart – these testimonies belong to a later period. (Pliny's allusion to a bid for the statue by King Nikomedes does not, unfortunately, help us to put a date on its notoriety – for there was a succession of kings by this name in Hellenistic Bithynia.) In any case, it was not until a century or so after Praxiteles that sculptors began to try variations upon the theme he had so adroitly exploited – 'the female form divine'.

Aphrodite at large

Aphrodite at Knidos was worshipped as Aphrodite Euploia – Aphrodite of 'fair voyage'. The increase of sea-borne trade in the Hellenistic Mediterranean naturally fostered the spread and prosperity of Aphrodite's cult. The Phoenicians faded, but the Romans arrived – and with them, eventually, fresh impetus for the worship of Aphrodite as Venus Genetrix, the

progenitor of all things (and in particular, divine mother of the *gens Iulia*). In Asia Minor, Aphrodite half-returns to her Near Eastern roots with the creation of her eponymous city, Aphrodisias – a site whose original cult associations lie with Astarte/Ishtar.

Of the sculptural variations wrought around the concept of a naked or semi-naked Aphrodite, the following is a selection of personal favourites:

(i) *The Crouching Aphrodite.* Traditionally attributed to a Bithynian sculptor called Doidalsos, and worked into a story whereby the same King Nikomedes who tried to buy the Knidia was consoled by this alternative view of Aphrodite bathing, the image of *Aphrodite accroupie* (Figure 8.10) is in fact difficult to assign to any particular place or time. (And, once again, it may be that painters took the lead: a fine red-figured vase from Kamiros, attributed to the Marsyas Painter – now in the British Museum – and dated *c.* 350 BC, shows the nymph Thetis naked in a similar pose.) One version of the type seems to have made a group of Aphrodite with a toddler-Eros, who has one hand on her back and with the other holds a mirror. But when all that remains of the piece is a body with legs (Figure 8.11), it may be that the goddess was alone, in the pose of washing her hair (a fine example of this variant is the so-called Marine Venus found on Rhodes). Either way, the sensuality of the piece is arresting.

(ii) *Aphrodite Kallipygos.* The same might be said of the Kallipygos type – 'Aphrodite of the Beautiful Bottom' – known from a series of statues and reliefs showing a figure who, as if while dancing, lifts her skirts to reveal her backside – and glances over her shoulder, as if to check its beauty for herself

(Figure 8.12). Athenaeus, predictably, relishes the opportunity to tell how the cult of Aphrodite Kallipygos grew up at Syracuse after two peasant sisters were bickering as to which of them possessed the fairer behind and asked a passing stranger to adjudicate. The passer-by not only fell immediately in love with one of the girls, but summoned his brother; double nuptials ensued, to the joy of the girls' father – who vowed gratitude to Aphrodite (*Ath.* 554c–e). The nexus between Aphrodite and the world of the *hetairai* is again evoked by a description, in Alciphron's (admittedly imaginary) *Letters of Courtesans* (14), of 'bottom competitions' among the ladies, conducted with Aphrodite's blessing. They take it in turns to reveal not only the form and hue of their bottoms, but also the shaking potential (*kinêmata tês pygês*) – and a 'surreptitious glance' (*hypoblepousa*) is duly made by one of the contestants.

(iii)　*Venus de Milo.* Recovered apparently *in situ* from a niche in the Hellenistic-Roman gymnasium on the island of Melos, this 'iconic' figure is not so bereft of arms as she seems: the left hand survives, and it is holding an apple – indicative, presumably, of Aphrodite's victory in the Judgement of Paris; plus there is the local pun (*mêlon* = 'apple'). The gesture of the right arm is open to speculation: other variants on the Aphrodite theme will show her in a pseudo-domestic role (for example, pulling a thread), but of course she could simply be trying to keep hold of her drapery, which looks to be on the way down, not up (Figure 8.13). The slippage is, of course, an element of titillation – as the impresarios of modern erotica are well aware, the human body half-revealed is generally more arousing than the sight of complete nakedness – but it has the further effect of 'genital mapping'. That is, the bunching of folds and creases, apparently so dishevelled, serves to accentuate where the *mons Veneris* lies.

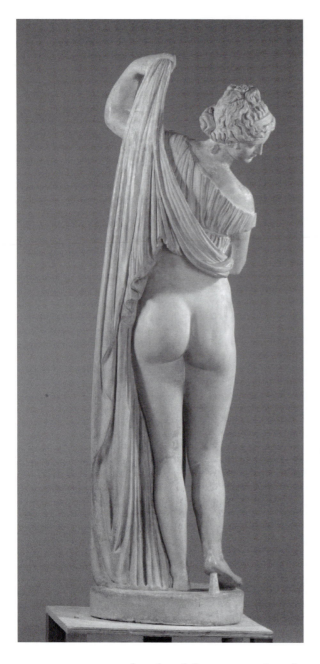

Figure 8.12 *Aphrodite Kallipygos: eighteenth-century cast of a type created in Hadrianic times, after a bronze original of Hellenistic date. Original in Naples (Farnese Collection). Ht 1.52 m.*

The 'afterlife' of the Knidia and her Hellenistic 'successors' is a long story, beyond the scope of this book to explore. We may content ourselves with just two observations. One concerns the way in which art came to supply a touchstone for reality. This is noticeable in Hellenistic and Roman erotic literature – for instance, the romance *Chaireas and Callirhoe*, attributed to Chariton and thought to belong to some time between 100 BC and AD 150. Callirhoe is introduced to us as 'a maiden of outstanding beauty, the ornament [*agalma*] of all Sicily'; and in Book 2 of the story we are given a lingering vignette of this beauty at her bath, through the eyes of female companions:

*When she undressed, they were awestruck … Her skin gleamed white, sparkling just like some shining substance [*marmarygei – implying marble*]; her flesh was so soft that you were afraid even the touch of a finger would cause a bad wound.*

CHAIREAS AND CALLIRHOE II.2.2,
TRANS. REARDON

Like Pygmalion's statue coming to life, there is the image of an object gleaming and unblemished as sculpted marble – yet at the same time wondrously gentle to feel. The image of Aphrodite *baigneuse* has become a shorthand literary mode of evoking the (male) fantasy of a beauty both ideal and attainable.

If the Romans had not admired, adopted and adapted the Knidia, of course, we should have nothing left of it: the statue did not survive for long after being transferred to Constantinople in the fourth century AD. But how did the Romans themselves make use of what Praxiteles created? Roman

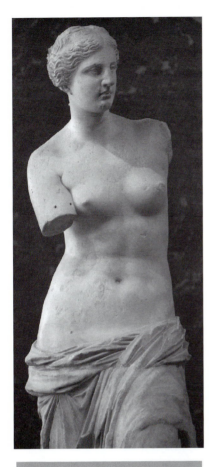

Figure 8.14 Marble statue of a Roman lady in the guise of the Capitoline Venus, c. AD 140 Ht 1.84 m.

matrons, like Greek housewives, did not customarily display their bodies in public. But such was the power of the nude Aphrodite that a number of Roman women, some with close Imperial connections, had themselves portrayed as *Venus pudica* – essentially based upon the Knidia or the Capitoline Venus, with hands making shielding gestures (Figure 8.14). They kept their own rather stern facial expressions, and sometimes highly elaborate hairstyles. The assimilation of mature *materfamilias* to the goddess of love is not an imposture: probably the specific reference was to Venus Genetrix, 'the mother' or 'bringer-forth', an ancestral goddess of the Roman people. But the bodily representation is due to Aphrodite – or rather, due to that Greek cultic and sculptural tradition which took delight in revealing Aphrodite.

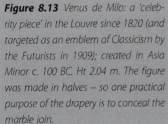

Figure 8.13 Venus de Milo: a 'celebrity piece' in the Louvre since 1820 (and targeted as an emblem of Classicism by the Futurists in 1909); created in Asia Minor c. 100 BC. Ht 2.04 m. The figure was made in halves – so one practical purpose of the drapery is to conceal the marble join.

Sources and further reading

Aphrodite's genesis On the 'primary' acount, see M.L. West ed., *Hesiod: Theogony* (Oxford 1966); note also citations of an archaic epic, the *Kypria*, in West's Loeb edition, *Greek Epic Fragments* (Harvard 2003). The location of Aphrodite's cult on Kythera is uncertain: Schliemann and Stais, investigating in 1887, thought it must be where the church of Ayios Kosmas stands, but other sites have been proposed – see J.N. Coldstream and G.L. Huxley eds., *Kythera* (London 1972), 34–6.

Aphrodite's cult To Farnell's synthesis (L.R. Farnell, *The Cults of the Greek States* (Oxford 1896) vol. II, 618ff.) add V. Pirenne-Delforge, *L'Aphrodite grecque: contribution à l'étude de ses cultes et de sa personnalité dans le panthéon archaïque et classique* (Athens 1994). Archaeological evidence from Cyprus is collected in J. Karageorghis, *Kypris: The Aphrodite of Cyprus* (Nicosia 2005); for Athenian practice, see R. Rosenzweig, *Worshipping Aphrodite* (Michigan 2004).

Female nudity and taboo For the images of women bathing, see S. Pfisterer-Haas, 'Mädchen und Frauen am Wasser', *JdI* 117 (2002), 1–79 – with the argument that these images do not necessarily represent *hetairai*.

Knidia C. Blinkenberg's monograph, *Knidia* (Copenhagen 1933) remains valuable – not least for its assessment of the iconographic influence of Astarte images from Cyprus. Also: J. Closuit, *L'Aphrodite de Cnide* (Paris 1978); M. Pfrommer, 'Zur Venus Colonna: Eine späthellenistische Redaktion der Knidische Aphrodite', *IstMitt* 35 (1985), 173–80; and C.M. Havelock, *The Aphrodite of Knidos and her Successors* (Michigan 1995). On the Helen by Zeuxis, F. de Angelis, 'L'Elena di Zeusi a Capo Lacinio', *RendLinc* 16 (2005), 151–200. In the context of the Praxitelean *oeuvre*, see A. Pasquier and J.-L. Martinez, *Praxitèle* (Paris 2007) and A. Corso, *The Art of Praxiteles*, vol. II: *The Mature Years* (Rome 2007) – the latter including a list of 335 copies of the Knidia. Apart from Iris Love's interim reports (*AJA* 74 (1970), 149ff.; 76 (1972), 61ff.; 77 (1973), 413ff.), there is a résumé of recent investigations at Knidos in C. Bruns-Özgan, *Knidos* (Konya 2004); on the Round Temple, see H. Bankel, 'Knidos: Der hellenistische Rundtempel', *AA* (1997), 51–71. On the poetic responses to the Knidia, see V. Platt, 'Evasive Epiphanies in Ekphrastic Epigram', *Ramus* 31 (2002), 33–50. Elevated discussion of the Pseudo-Lucian passage in M. Foucault, *The Care of the Self* (Harmondsworth 1990), 211ff.; many insights generally in G.L. Hersey, *The Evolution of Allure* (MIT 1996) and K. Clark, *The Nude* (London 1956). E.M. Forster's exclamation to Demeter comes from his 1904 essay 'Cnidus', to be found in *Abinger Harvest* (Harmondsworth 1967), 190–5.

Three Graces The standard monograph is E. Schwarzenberg, *Die Grazien* (Bonn 1966); on the extensive afterlife of the figures in later European art, see V. Mertens, *Die drei Grazien* (Wiesbaden 1994).

Crouching Aphrodite R. Lullies, *Die kauernde Aphrodite* (Munich 1954); A. Linfert, 'Die Meister der "Kauernden Aphrodite"', *AM* 84 (1969), 158–64. For the *pelike* by the Marsyas Painter, see R.M. Cook, *Greek Painted Pottery* (London 1960), pl. 51.

Kallipygos G. Säflund, *Aphrodite Kallipygos* (Stockholm 1963) locates an origin for the type at Locri. See also K. Parlasca, 'Aphrodite Kallipygos', in K. Schade, D. Rössler and A. Schäfer eds., *Zentren und Wirkungsräume der Antikenrezeption* (Münster 2007), 223–34.

Venus de Milo A. Pasquier, *La Vénus de Milo et les Aphrodites du Louvre* (Paris 1985); for the 'afterlife' of the figure, see E. Prettejohn's discussion in C. Martindale and R.F. Thomas eds., *Classics and the Uses of Reception* (Oxford 2006), 227–49.

All these and further Aphrodite-types discussed and documented in D.M. Brinkerhoff, *Hellenistic Statues of Aphrodite* (New York 1978).

Roman matrons as Venus H. Wrede, *Consecratio in formam deorum* (Mainz 1981); E. D'Ambra, 'The Calculus of Venus: Nude Portraits of Roman Matrons', in N.B. Kampen ed., *Sexuality in Ancient Art* (Cambridge 1996), 219–32; and *cf.* Kampen, 'The Cult of Virtues and the Funerary Relief of Ulpia Epigone', in E. D'Ambra ed., *Roman Art in Context* (Englewood Cliffs 1993), 104–14.

The king was … a political actor, power among powers as well as sign among signs. It was the king's cult that created him, raised him from lord to icon; for, without the dramas of the theatre state, the image of composed divinity could not even take form.

Clifford Geertz,
Negara (Princeton 1980), 131

9

ROYAL PATRONAGE

The lengths to which an artist may go in quest of a commission have never, perhaps, exceeded the effort of Dinocrates the Macedonian, who, 'confident of his own ideas and skill', sought to present himself to the attention of Alexander the Great. Having attempted all the usual formalities of gaining court access, Dinocrates decided to capitalize upon his own powerful physique. He anointed himself with oil, placed a wreath on his head and a lionskin over his shoulders; then, brandishing a knotty club, he walked prominently in front of a law tribunal where Alexander was giving judgement. Semi-naked, attired as a second Herakles, Dinocrates could hardly fail to be noticed. Alexander duly beckoned him over to explain himself:

I am Dinocrates, a Macedonian architect: I come with ideas and plans worthy of your majesty. Look, I have shaped Mount Athos itself into the statue of a man, whose left hand cradles the ramparts of a substantial city; in his right hand he holds a bowl, to catch all the waters of the rivers running down from the mountain.

According to our Latin source for this episode (Vitr. *De Arch.* 2.1–4), Alexander is delighted by this proposal, perhaps foreseeing that the statue could be made in his own image. But a practical objection strikes him. How will the city's corn supply be provided? There is no satisfactory answer to this problem, so the Mount Athos project is stalled. However, Dinocrates is taken into royal service – and eventually entrusted with the layout of Alexander's eponymous city in the Nile Delta.

As we shall see, Alexandria – especially as it flourished under Alexander's former general Ptolemy and his successors – became a model centre of royal patronage in the Graeco-Roman world (even if it was, strictly speaking, Macedonian-Egyptian). Meanwhile, the nature of the proposal gives us a useful index of what it takes to please a holder of absolute power. Vanity, megalomania, quasi-divine omnipotence and paternalism: all these are satisfied by the Mount Athos design. The contrast with the self-effacing decorum of Classical Greek democracies could hardly be greater.

As for the scale of the idea, it was, we may say, in keeping with the spirit of the age. Alexander's own court sculptor, Lysippos, constructed several famously colossal statues, including one of Herakles and one of Zeus for the Greek colony of Tarentum; but it was his pupil Chares who dared to double the dimensions, raising the Colossus of Rhodes in the early third century. This hollow-cast bronze stood 70 cubits high (about 40 m.; comparable to the Statue of Liberty in New York harbour); its dimensions are best understood by the ancient estimate that 'few men can get their arms around the statue's thumb'. Though efforts were made to stabilize the piece, apparently with a core of stone blocks, it was a doomed enterprise, standing for less than sixty years before an earthquake (in 226) caused the figure

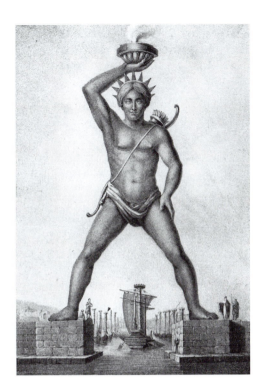

Figure 9.1 *The Colossus of Rhodes, as imagined in a nineteenth-century engraving. (It is, however, highly unlikely that the statue straddled a harbour entrance.)*

to collapse at the knees; but even in its ruined state it was reckoned as one of the 'Seven Wonders', until finally removed by Saracens. A bronze statuette in the Louvre probably indicates an original pose of salutation; needless to say, perhaps, reconstructions of the piece range from the debatable to the fantastic (Figure 9.1). Nevertheless: its genealogy is telling. The Rhodians commissioned the statue after surviving a protracted siege by Macedonian forces led by Demetrios Poliorketes. The allies of Rhodes were the Ptolemies of Egypt; and Egypt offered its own precedents for vast statues. Nor were Egyptians unaccustomed to images of the Sun-god (equated to the Greek Helios). So when Chares proposed to 'give the world a second sun to match the first', it may have been with Egyptian models in mind. The choice of medium was Greek; and presumably the style of the image was Greek too. Their conjunction with an Egyptianizing subject, executed on a scale reminiscent of Ramesses the Great, seems typical of what happens in the period we know as 'Hellenistic'.

As we have noted (p. 12), 'Hellenistic' is an entirely artificial denomination, often used to signify fusions of Greek and non-Greek elements in works of art from Egypt and Asia. Is it more useful to use monarchy as the key to Hellenistic art? We do not, it is true, possess the same richness of documentary evidence for royal patronage in antiquity as is available for historians of later centuries (supplying, for example, Norbert Elias' *The Court Society*). Yet certain testimonies of royal 'events' – such as the *pompê* staged by Ptolemy II Philadelphus, as described by Kallixeinos of Rhodes (Ath. 196a–203b), or the poetic pantomime of how a lock of hair belonging to Queen Berenike II became a constellation (Cat. 66) – eloquently evoke the delicacy and extravagance of art in a 'courtly' context such as Alexandria. And of course Alexander was himself a child of this culture – groomed by a Greek philosopher at the Macedonian court to become the paradigmatic 'Saviour-King'.

If kingship is the key to the Hellenistic period, however, then we must allow its chronology to be elastic: for our study of royal patronage begins prior to Alexander, with two case-studies from kingdoms on the Mediterranean coast of Asia Minor.

The Nereid monument

Bathe him in the streams of the river, and anoint him with ambrosia, and clothe him with immortal robes, and let him be swiftly carried away by the twin brothers, Sleep and Death, who shall convey him direct to the fertile realms of fair Lycia. There shall his family and kinsfolk give him burial, with mound and pillar, as the dead deserve.

These are the instructions given by Zeus for salvaging the body of Sarpedon from the Trojan battlefield (*Il.* 16.669–75): instructions prompted by paternal concern, but also echoing the sentiments voiced by Sarpedon himself, when urging his fellow-countryman Glaukos to join the fight (see p. 124). Homer does not specify where in Lycia the burial honours of Sarpedon were conducted; subsequent sources, however, leave us in no doubt that the site known as Xanthos, by the river of the same name in Lycia, became the hero's resting-place. A formal *hêrôon*, the Sarpedoneion, was still in existence during late Roman Republican times (Appian, *Bell. Civ.* 4.10.78–9) – and French excavations, ongoing since the 1950s, may well have located this hero-cult on the so-called Lycian acropolis of Xanthos ('Building G').

According to Herodotus (1.147), Sarpedon's friend Glaukos was claimed as an heroic ancestor by certain kings along the Ionian coast. It is highly likely that the cult of Sarpedon at Xanthos was likewise invested with genealogical significance by local rulers, who were conspicuously buried within or close to the city (and perhaps within sight of the Sarpedoneion). Historically these Lycian dynasts remain obscure: caught up successively in wider conflicts with Persians, Greeks, Macedonians and Romans, the definition of their own identity relied largely upon inscriptions in a language that we cannot yet understand. One king of Xanthos, however, included some lines of Greek verse on a grandly inscribed *stêlê* by the city's marketplace, reporting family prowess on the battlefield and at wrestling: we may guess that he competed successfully at a local festival known as the Sarpedoneia, which featured combat events.

A tradition of Lycian heroic pride is the context of the most remarkable sculpted tomb to be found at Xanthos, the Nereid monument (Figure 9.2). When first retrieved from the overgrown ruins of Xanthos in 1842 (by Sir Charles Fellows), close to the city's main entrance, this was described as an

Figure 9.2 *The Nereid monument (west façade) from Xanthos, as partially reconstructed. Original height c. 15 m. The seated figures in the pediment are thought to represent the dynast Erbinna (Arbinas) and his wife. Erbinna's reign, c. 390–380 BC, provides a date for the tomb.*

'Ionic trophy monument' – and indeed it does not at first sight look so much like a tomb as a small temple, in some respects recalling the Nike Bastion of the Athenian Akropolis. Raised on a podium-base, with no evidence of steps for access to the porch, the medium (marble) is typically Greek, the architecture carries elements of Greek design – the swelling of the Ionic columns, for instance, to make them appear straight when viewed from below – and the sculptural decoration, too, must have been done by Greek or Greek-trained craftsmen, whose experience with akroterial figures shows in the fluent energy of the Nereids placed in between the columns (Figure 9.3). They seem to be aloft, suggesting to some commentators that they represent Aurai (Breezes); however, albeit inconspicuously, each is borne by some form of marine life – dolphin, crab, cuttlefish and suchlike – hence the proposal that they be taken as Nereids: daughters of the primal sea-god Nereus, and best known in mythology as companions of Thetis, mother of Achilles.

Whether these sinuous female forms should be understood as Nereids or, as some scholars prefer, Nymphs belonging to local iconography, is relatively immaterial. More important to their significance in a funerary monument is the supposition that they serve here as an imaginative *cortège* for the deceased. Poetically the passage to the next world was often envisioned as a sea-journey; the Nereids, who will raise a threnody of lament for the dead Achilles, are also escorts of heroic immortality, speeding noble souls to the Islands of the Blessed – as evoked by Pindar (*Ol.* 2) and songs to the Tyrannicides (see p. 139).

That a Lycian royal tomb should constitute a *syngenikon*, amalgamating a celebration of the deeds of the deceased with a tribute to his dynastic forebears, is widely accepted. Here a series of relief friezes on the podium and architrave of the monument apparently collects various military exploits, and a number of

Figure 9.3 *Detail of Nereid from the Nereid monument. Each of the eleven figures would have appeared about lifesize; the surviving pieces indicate that each wore a close-clinging chiton, with mantle billowing about.*

banqueting and sacrificial scenes. Erbinna – whose name may be of Iranian origin – or some predecessor is shown in Persian mode, enthroned, and shaded by a parasol while receiving delegates; there are city sieges, hoplite battles and what seem to be heroic skirmishes. Overall, it is hard to resist the conclusion that this is the grave, and cult-chapel, of a ruler who thought of himself as a second Achilles, or even – despite his Persian connections – a descendant of the mighty Sarpedon.

The Mausoleum at Halicarnassos

The Nereid monument has in its way prefigured an essential quality of 'Hellenistic' art: the use of a Greek stylistic vocabulary – and Greek sculptors, probably – to express the wishes of non-Greek patrons. A similar phenomenon is evident at Halicarnassos, in neighbouring Caria, where a tomb was raised of such magnificence that it became not only an official 'Wonder', but the generic byword for subsequent monumental tombs.

The Mausoleum at Halicarnassos is named after its honorand Mausolus, satrap of Caria. To describe the title 'satrap' as 'governor on behalf of the Persians' is customary, but this should not imply that Mausolus was a Persian puppet. He was born of a local dynasty, the Hekatomnids. (Hekatomnos of Mylasa preceded Mausolus as satrap and may have initiated some of the 'proto-Hellenistic' policies with which Mausolus is credited.) His wife (and sister) Artemisia shared her name with an earlier queen who had assisted, with distinction, the Persian king Xerxes at the battle of Salamis. But although Caria as a region extends inland, its seaboard was its main route to prosperity; and Mausolus, whose rule began *c.* 377, seems to have determined that the cultural orientation of his country should point westwards to Greece, not eastwards to

Persia. He established a new capital at Halicarnassos, transforming a modest settlement into a large fortified city-port; and there he located his palace, and a resting-place so conspicuous that it could not be missed by anyone sailing past the city.

Some ancient writers, fascinated by the incestuous devotion of his wife, ascribe the tomb to Artemisia, who organized an epic *agôn* for Mausolus after his death in 353. But Artemisia only survived her brother by two years, scarcely time enough to complete such an ambitious undertaking. Other siblings may have helped; but the chances are that Mausolus, like those Roman emperors who coveted 'Mausolea' (notably Augustus and Hadrian), conceived his own colossal grave as an integral part of his city. As the founder or *oikist* of 'new' Halicarnassos, Mausolus would have known that Greek tradition allowed his commemoration, even cult, near its *agora*. And he was surely aware of other traditions, both local and extraneous, which would legitimize the scale and ostentation of this monument.

The Nereid monument, along with other dynastic tombs in Lycia, was one such. Then, of course, there was Persia. Whether Mausolus ever went there is not certain: as satrap, it might have been his occasional duty to do so. Had he visited Pasargadae, he would have seen the sixth-century tomb of Cyrus the Great – or what then remained of it. In absolute terms this was not a massive structure, yet it must have been striking in its solid simplicity. A substantial terraced podium was surmounted by a gabled tomb chamber: the height was sufficient to command the view for miles around. For Mausolus it would have been appropriate that his architects made some reference to this landmark. The stepped part of his tomb, however, was the roof rather than the podium; and in its dimensions it would recall not so much Persia as Egypt, and in particular the pyramids – the *erga* so wonderingly described by that famed son of old Halicarnassos, Herodotus.

The columns of the Mausoleum were of the Ionic order; and, like the lords of Lycia, and indeed like the great kings of Persia, Mausolus summoned Greek craftsmen to his service. For the sculptural decoration of the Mausoleum our sources mention a number of 'great masters' called in from Greece: the names of Skopas, Bryaxis, Leochares, Timotheos, Pytheos and Praxiteles are invoked, and there is supposed to have been some sort of competition between several of these *virtuosi*, each taking a different side of the monument (Pliny, *NH* 36.30). On stylistic grounds this has so far proved impossible to demonstrate, and attributing the various and numerous fragments of the Mausoleum's decoration is likewise a rather fruitless exercise. But even the more battered remains of these sculptures

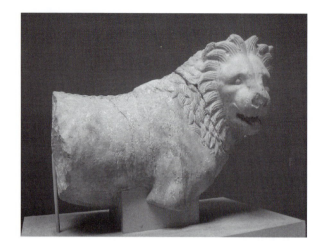

attest that whoever made them, the work is of the first order; and the sculptors pandered fully to their patron's Hellenizing inclination.

Today the Mausoleum keeps a very discreet presence in the back streets of Bodrum. From the scattered column-drums that remain one would hardly guess that the structure once towered some 50 m. high. The blame for dismantling the monument lies mainly with the Crusaders (whose castle still dominates the harbour) and gratitude for salvaging what remained with Charles Newton and his excavations of 1857–8, supplemented by more recent Danish investigations. Uncertainties persist about how the monument should be reconstructed: the summary below adheres to a proposal displayed at the site, but it is far from definitive. Descending from the top of the building, the sculptural programme may have been as follows:

(i) At the apex of the stepped pyramidal roof: a four-horse chariot. The rider (if there was only one) of this chariot may have been Mausolus himself; Helios is another candidate, or perhaps Herakles (from whom Mausolus claimed ultimate ancestry). Such quadrigas would become regular emblems of royal power (*cf.* Figure 12.2).

(ii) Around the base of the chariot-group: a Centauromachy frieze (of which little survives). By the mid fourth century this theme had become a standard token of 'the Classical'; if Mausolus had any notion of its potential symbolic value of Greeks against Persians, he chose to ignore it.

(iii) At the foot of the sloped roof: patrolling lions (Figure 9.4). Royal beasts, of course, are the preserve of royalty to chase; here they seem like guardians of the tomb.

(iv) Below the roof: an Ionic colonnade. On the inner wall of this colonnade there was a second frieze, showing chariot-racing: a reference, perhaps, to the Homeric-style games that would mark the funeral of Mausolus. Some freestanding figures, plausibly Hekatomnid ancestors, may have been placed between the columns.

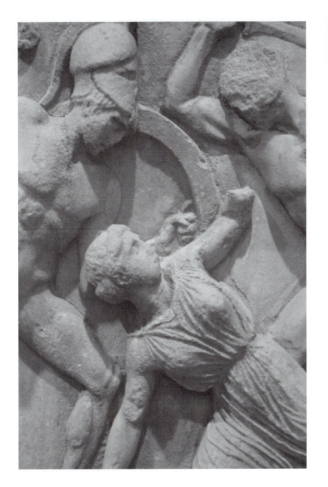

Figure 9.5 *Detail of the Amazon frieze from the Mausoleum: two Greeks beset a kneeling Amazon. Frieze ht 90 cm.*

(v) Immediately below the colonnade, on the upper part of the podium, a third frieze. The largest and best preserved, this was a vigorous Amazonomachy. Not so densely figured as some of its Classical predecessors (e.g. the frieze on the interior of the temple at Bassae), it was made readily comprehensible to the viewer below by lavish indulgence in what is sometimes called 'the heroic diagonal' – sharp postures of combat, strikingly outlined against a simple background of shields and flying cloaks (Figure 9.5). Beyond its Classical resonance, this theme may have carried direct family claims – for the Hekatomnids allegedly possessed, as a sacred relic (kept at their inland sanctuary of Labraunda), the double axe of the Amazonian queen Hippolyta, as seized by Herakles (Plutarch, *Mor.* 301f–302a). Slab no. 1008 in the British Museum shows 'Herakles destroying a principal Amazon lady': it may be that an epic was composed for Mausolus, linking his ancestors with this feat.

(vi) Finally, there were further sculptures in the round, on different scales, displayed on or around the podium. Finding secure places for these statues is particularly problematic; and unfortunately we cannot be sure that two colossal figures usually identified as 'Mausolus' and 'Artemisia' indeed represent the royal couple. 'Artemisia', faceless as she is, has been judged to strike an 'adoring' pose; 'Mausolus' (Figure 9.6) displays physiognomic features, and a splendid moustache, that relate closely to other images of Persian satraps (as evident, for example, from the numismatic portraits of Tissaphernes and Pharnabazus, who ruled in these parts in the late fifth century). However, it may be wiser to reserve the remains of one colossal enthroned figure as Mausolus; and as for the rest of the figures, the distance between immediate family and heroized ancestors may not have been easy to ascertain even when the monument was intact.

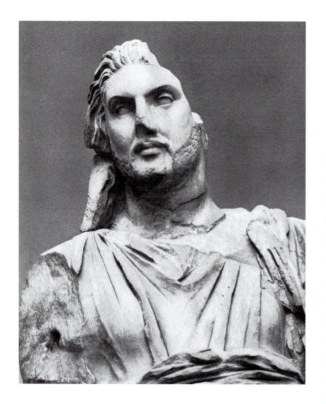

So the Mausoleum became a notoriously 'excessive' tomb, commemorating an equally 'excessive' rite of cremation. Few of the tomb treasures have been recovered, but excavators found remains of a great animal sacrifice. Participants at this funeral might have felt glad of the sustenance, for the story is that Artemisia staged a contest between prominent Greek rhetoricians, including Isocrates, as to who could deliver the most ample oration in honour of Mausolus (the winner was Theopompus, a pupil of Isocrates). The eulogies are all lost. The surviving sculptures of the Mausoleum, however, are solid indicators of a development characteristic of the Hellenistic period – the phenomenon of 'ruler-cult'.

Ruler-cult and 'propaganda'

'In the studio Alexander used to talk a great deal about many artistic matters without any real knowledge of them, and Apelles would politely advise him to be silent, saying that the boys engaged in grinding the colours were laughing at him.' Pliny's vignette (*NH* 35.36) anticipates Dr Johnson's barbed definition of a 'Patron': 'a wretch who supports with insolence, and is paid with flattery'. Apelles, supposedly the only painter to whom Alexander entrusted his portraiture, did not stint on the flattery: a picture at Ephesus showing Alexander Keraunophoros, 'Thunderbolt-wielder', implied powers on a level with Zeus. Alexander's sculptor, Lysippos, allegedly reprimanded Apelles for going too far (Plutarch, *Mor.* 360d). But who dictated the limits of decorum in royal representation?

Alexander's image will be discussed in the next chapter. Meanwhile, we may attempt some reconstruction of the workings of ruler-cult as developed not only by Alexander, but also his father and his successors.

Distantly, one of those successors may be reckoned to include 'the Sun King' – Louis XIV, who created Versailles and ruled France for most of the seventeenth century. Documentation can be assembled that charts the careful control of

messages projecting the king's power: not only paintings and sculpture, but also plays, poems, ballets and public spectacles. The bureaucrats, advisers and scholars involved in this close monitoring process have left us many of the clues we need to recreate its programmatic intentions, and it is perfectly possible to speak of 'the fabrication of Louis XIV'. As for the contemporary moulding of an image of power, often entrusted to an advertising agency or 'Public Relations' consultancy, it rarely defies analysis: the 'hidden persuaders' of today may have deeper insights into human psychology, but their methods are essentially similar to those of the offstage masterminds who controlled the 'theatre state' of Louis XIV.

One numismatist has denied that 'propaganda', understood as a highly co-ordinated and carefully monitored activity, really existed in Hellenistic courts. What we find instead, he argues, is 'the largely unsystematic attempt at irregular intervals to publicize a ruler's actual achievements or omens, legends, and prophecies concerning him in order to enhance his own personal prestige and to provide added reasons for continued loyalty to future members of the dynasty he hoped to establish'.

This was written prior to the discovery, in 1977, of a barrel-vaulted tomb beneath one of the tumuli near Vergina (thought to be the site of the Macedonian city of Aigai) – the tomb, as proposed by its excavator, Manolis Andronikos, of Alexander's father, Philip II.

Aigai, with ruins of a palace covering some 12,500 sq. m., promises more information for archaeologists. We know from historians that Philip was assassinated in the theatre at Aigai in 336; but if his funerary rites were hasty (as reported), it seems they were not lacking in handsome tribute. And among the rich circumstances of the deposition in this tomb were some twenty miniature ivory images, including what appear to be portraits of Philip and his family. According to this (perhaps optimistic) identification, Philip, bearded, and scarred by an arrow in the right eye (Figure 9.7), contrasts

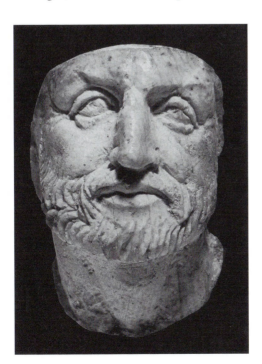

Figure 9.7 *Ivory head with the features of Philip II. Ht 3.2 cm. Part of a couch decorated with relief ivory figures.*

with a young man who looks very like Alexander – or at least, as portraits of Alexander will eventually appear (Figure 9.8). So we sense that a particular 'look' had already been created for the king's most favoured son.

A painting above the entrance to the tomb showed the climax of a royal hunt. Deer, a wild boar, a bear and a lion fall simultaneously victim to a party of huntsmen and dogs; in a mountainous wooded landscape, the figures of Philip and Alexander, each on a rearing horse, may be recognizable. There was a rich ancestry for such imagery in the Near East; but already in the first half of the fifth century, Alexander I of Macedon had introduced coinage with images of horsemanship and hunting, and set a stamp on this dynasty's iconic character. The heroic genealogy of Alexander I invokes a son or kinsman of Herakles, called Temenos, who in turn begets Perdiccas, a founding king of Macedonia. Hence the dynasty may be known as Temenid and given a broadly Greek or Dorian affiliation. The myths accompanying this genealogy, however, ascribe some Persian adventures to Perdiccas – reflecting the political balancing-act Alexander I maintained throughout the Persian Wars: on the one hand, offering either help or no resistance to the Persian invaders, while on the other extending his formal friendship (*xenia*) with the Greeks by qualifying (perhaps thanks to his Heraklean blood) for the Olympic Games and allegedly supplying Greek forces with information about Persian movements before the battle of Plataea (479). A later successor, Archelaus (who ruled *c.* 413–399), would adopt the Persian standard of coin weight, while using the image of Herakles on those coins. The same Archelaus brought the Athenian playwright Euripides to a palatial new court at Pella. But it was with the accession of Philip II in 360 that Macedonia, on the basis of Philip's professionalized army, began to dominate Greece – and beyond.

With strategic success – such as the battle of Chaeronea (338), which some historians regard as marking the end of the independent Greek *polis* – came

symbolic markers. At Olympia, Philip endowed a *tholos*-chapel, close to the temple of Zeus: this displayed a semi-circle of lifesize family portraits made by Leochares. The medium was chryselephantine – which, in the vicinity of Pheidias' Zeus, can hardly have failed to suggest that Macedonian royalty claimed divine honours – and originally the group seems to have featured images of Philip, his parents Amyntas and Eurydice, and both Alexander and his mother Olympias. If Isocrates reflects general sentiment after Chaeronea, then this monument was to be expected: the feeling being that if Philip and young Alexander were to bring down the Persian empire, they would indeed have earned divine status in Greek eyes (*Ep.* 3.5). Certainly the Philippeion at Olympia was a harbinger of what would happen within the Panhellenic sanctuaries under the rules of royal patronage. At Delphi, it was a federal ally of Philip, Daochus II of Thessaly, who in the 330s commissioned a marble assemblage of himself, his son, his father and five dynastic forebears. The inscribed base of this monument – which matched

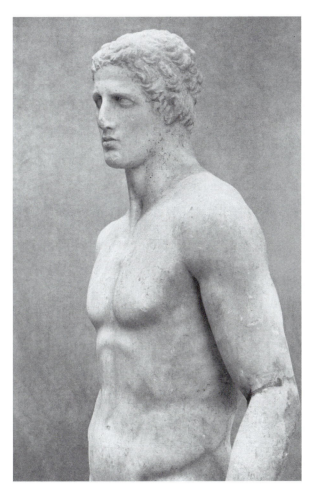

a Lysippan bronze group set up in the Thessalian town of Pharsalus – gives some reason for the commission: the great-grandfather of Daochus, for example, was a celebrated all-in fighter called Agias, who won a series of *pankration* victories at the Pythian Games, as well as Olympic, Isthmian and Nemean titles. His image endures (Figure 9.9) – and undeniably evokes the presence of a fearsome opponent.

Athletic ancestors, however, were not necessary to earn a place in the sanctuary. On the Marathon memorial of the Athenians, three monarchs – Antigonus the One-Eyed, his son Demetrios and, later, Ptolemy III – replaced the images of Athenian heroes with their own heroic nominees, doubtless in their own respective likenesses. Still at Delphi, one of Alexander's generals, Krateros, dedicated (with the help of his son) an ambitious bronze *tableau vivant* that captured a moment when Krateros came to the

Figure 9.9 *Marble figure of Agias, from the Daochus Group at Delphi, c. 330 BC. Ht 2 m. The influence of Lysippos is evident (cf. Figure 11.9), including the 'Sikyonian' principle of making the head proportionately one-eighth of the body.*

aid of Alexander, not in the thick of battle, but during a lion-hunt. Set in a substantial stone niche above the temple of Apollo, this group may have been landscaped to suggest its exotic location 'in faraway Syria'. Lysippos and Leochares are accredited with the work. An attached inscription salutes Krateros as *hyios Alexandrou*, 'Alexander's son': not, in fact, *the* Alexander, but perhaps intended to express a pseudo-filial claim upon the great leader, whose death in 323 caused a number of his generals hurriedly to make manifest their devotion and loyalty.

After Alexander

Krateros, killed in 320, was one general who did not survive the in-fighting between Alexander's 'successors'. Their fortunes were mixed; little united them except indebtedness to their late captain. One minor beneficiary was a King Abdalonymus (Abdalonim) of Sidon, whose Phoenician realm was 'liberated' from the Persians by Alexander in 333. When it came to his own funerary memorial, Abdalonymus chose to honour the debt by commissioning a sarcophagus that showed scenes of Macedonians and Persians fighting, but also Macedonians and Persians hunting together (Figure 9.10): cleverly encapsulating the territorial opposition and ideological affinity of the rival empires.

The prize possession was Egypt: self-sufficient, easily defended, and with an indigenous population already accustomed to saluting Alexander as son of Amun-Ra, or (at the oasis sanctuary of Siwah) Zeus-Ammon. Egypt fell to Ptolemy, son of Lagus: and Ptolemy soon claimed a second prize possession, which was Alexander's corpse. Intended for deposition at Vergina, the king's coffin was in a great funerary *cortège* travelling northwards when intercepted by Ptolemy in Syria and forcibly redirected to Egypt. Though the whereabouts of Alexander's ultimate resting-place yet elude archaeologists, no one doubts that Ptolemy held on to this prize. His own access to the field-accounts of Alexander's campaigns became a primary source for the hagiography of Alexander – and all the more so because Ptolemy was a friend to writers and the Greek 'intellectual

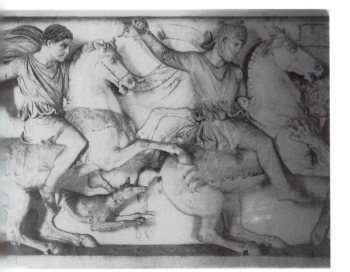

Figure 9.10 *Detail of the Alexander Sarcophagus, from Sidon, c. 320 BC: hunting scene, showing Macedonian and Persian riders closing in on a lion.*

community' at large. He invited Demetrius of Phaleron to establish in Alexandria a *Mouseion*, or 'home of the Muses': something like this had been created at Athens by Demetrius, next to Aristotle's Lyceum; predictably the Ptolemaic version was bigger and better, and arguably the prototype of the modern university. Ancient accounts describe only vaguely how works of art were 'curated' and displayed at this Museum, but it surely fostered a scholarly fashion for writing about images – and, with the adjacent Library, an historical, archival interest in Greek culture generally.

It was during the reign of Ptolemy's son by Berenike, Ptolemy II Philadelphus (285–246), that the first royal pageant was staged in Alexandria. Honouring his parents as *theoi sôtêres*, Philadelphus organized a procession that featured an image of Dionysos accompanied not only by worshippers dressed as satyrs, but also a fantastic train of animals from the East; it culminated with a statue-group headed by the talismanic image of Alexander. The event typified the *megalophrosynê* or 'magnanimity' of its sponsor – and reflected the status of Alexandria as the leading metropolis of the age, with some 500,000 inhabitants made up of diverse ethnic groups. Ptolemaic power beyond Egypt periodically encompassed parts of Africa, the Middle East and Asia Minor, as well as many Aegean islands. (In the rather nauseating panegyric to Ptolemy II that is the seventeenth *Idyll* of Theocritus, all nature is ultimately subject to *anassô Ptolemaiô*, 'Ptolemy's lordship'.) Alexandria absorbed its population from all these areas – and one effect of this, in the eyes of scholars seeking alloys for 'the Hellenistic period', was a certain 'cosmopolitanism', or at least a blurring of the distinction between Greeks and 'Others'.

THE DRUNKEN OLD HAG

We are not sure of the ancient title for this statue, well known in various versions (Figure 9.11). But if Pliny's allusion to an *anus ebria* (*NH* 36.32) by Myron is to the prototype, then at least 'Drunken Old Woman' will pass as a translation. The subject, more than the style, makes it unlikely that the original sculptor was the same Myron who created the Discobolus. (A third-century Myron from Thebes has been proposed.) But – to stay with the subject – we might well ask: who would want to see an image of an inebriated and apparently destitute 'hag'?

It seems likely that the piece was intended to be placed on the ground, as if the woman herself were collapsed ('legless'), perhaps raising her head to the viewer. Whether she is laughing, singing or possibly in more agony than ecstasy is debatable. But this is not the only ambivalence here. She may be old and missing most of her

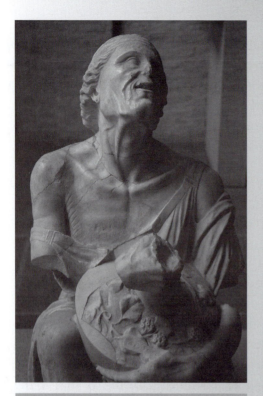

Figure 9.11 *The Drunken Old Hag: marble statue after a bronze original of c. 200 BC. Ht 92 cm.*

teeth, but she is not an habitual down-and-out. She wears jewellery and a headcloth; and her dress, whose deep folds and 'off the shoulder' arrangement recall the reclining voluptuous goddesses of the Parthenon pediments, is not a beggarly outfit. Some commentators take these as signs that she must be a senior *hetaira* – a type encountered in New Comedy. Others propose that she is dressed for a festival: in which case, a possible occasion is the *Lagynophoria* instituted at Alexandria by Ptolemy IV Philopator, himself notoriously bibulous.

Whether or not it is technically a *lagynos*, a wine-jar is certainly what the woman carries – tricked out with Dionysiac ivy-leaves. At this Alexandrian festival, it seems (Ath. 276a), participants quaffed directly from flagons which each of them carried. We do not know much more about the event – did the king provide the wine? – but if it entailed direct consumption of undiluted wine (a Macedonian custom), then drunkenness was presumably widespread, glorified in the name of Dionysos. A theatre, or sanctuary of Dionysos, might then be a fitting place for the statue – and the purpose of the statue then to celebrate, like Theocritus, royal *largesse*.

Back in Macedonia, Alexander's own family did not survive dynastic wrangling. Eventually the country became 'Antigonid' after its seizure by Antigonus the One-Eyed, a long-serving general on Alexander's staff, and the subsequent accession of his son Demetrios in 306. Demetrios inherited aggressive ambitions, signalled by his sobriquet Poliorketes, 'the Besieger'; yet he reserved a tender attitude towards Athens, which the Athenians repaid in sheer flattery. In a telling effusion of ruler-cult, they saluted him as a tutelary deity, brother of Athena and a second Dionysos; and, in a hymn preserved for us by Athenaeus (253d–f), went further than this, declaring Demetrios to be 'the only true god' (*monos theos alêthinos*), an active manifestation of divine favour, by contrast to the Olympians who 'either do not exist or pay no attention'. For his residence in the city they granted Demetrios the *opisthodomos* or rear chamber of the Parthenon, although, as Plutarch reports (*Dem.* 23), 'he was no very orderly guest and did not occupy his quarters with the decorum due to a virgin'.

As we have seen, Demetrios, despite his reputation, failed to take Rhodes by siege. Eventually Athens turned against him, and his reign was judged disastrous. However, his own flamboyance may conceivably be commemorated in one of the most exuberant sculptures to survive from antiquity, the Nike of Samothrace (Figure 9.12). Samothrace, an island in the north Aegean which the Macedonians considered theirs, offered a naturally spectacular site for architectural endowment, and it was in the *exedra* or portico of the elevated sanctuary of the Great Gods, facing towards Thrace, that this massive Victory-figure was displayed, shown as if she were alighting on the prow of a ship. The prow, of greyish marble, was set in a pool of water or fountain. Prevailing sea breezes would have stippled the water's surface; combined with the Nike's outstretched wings, and almost audibly flapping robes, this made for an effect that some describe as 'Baroque'. The date of the piece is much disputed: a coin issue of Demetrios, celebrating his victory over Ptolemy in the waters off Cypriot Salamis, shows a Nike in similar pose, though flourishing a trumpet rather than a fillet (as is believed to belong to an outstretched hand of the statue). What we do know is that either Demetrios or his son, Antigonus Gonatas, set up a comparably conspicuous naval victory monument on Delos: a colossal marble basin, supported by bull's head capitals, in which was placed an entire warship, dedicated *ex voto* to Apollo.

The cult of Fortune, *Tychê*, is discussed elsewhere in this book (p. 270). Here it may be invoked by way of incomplete explanation for the many apparently 'generic' pieces of Hellenistic sculpture that show anti-types of the Polykleitan ideal: that is, representations of the aged, the deformed, the malnourished and so on. Some of these, as already noted (p. 96), may be expressive of exemplary, if humble, piety. Others are thought to have carried apotropaic value – being embodiments of 'ugliness', with the power to ward off evil. A further factor may be purely that of an aesthetic challenge. An athlete's muscular contours were a well-practised commission and easily admired: but could sculptors evoke the presence of some bowed and doddery pedagogue – and how should viewers 'appreciate' such an image? (Looking at the various attempts made to represent Hermaphrodites, during and beyond the Hellenistic period, one is struck by awareness of pure technical endeavour – trying to elide, with plastic subtlety, the male and female form.)

It is hard to make a claim for 'social realism' here: there is no evidence from antiquity to match, say, the mid nineteenth-century humanitarian concerns of artists and writers for basing works of art on the lives of the poor and oppressed. An 1891 edition of the Alexandrian poet Herodas hailed him as a precursor of Dickens because of his apparent interest in 'low life'. But Herodas was a creature of the Ptolemaic Museum: his characters may be studiously 'simple' in person and in what they say – yet their vocabulary requires erudite attention. We do not know the original circumstances for the commission, perhaps in third-century Alexandria, for the

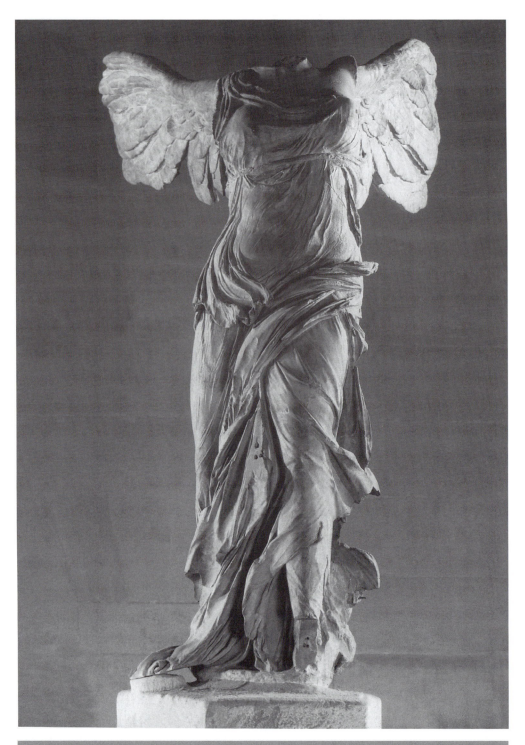

Figure 9.12 *The Winged Victory of Samothrace: marble ensemble mostly found in 1863. Ht of the Nike 2.45 m. Dates proposed for the piece range from late fourth to late first century BC.*

Figure 9.13 *Old Fisherman in black marble: Roman version of a type created perhaps c. 200 BC. Ht 1.22 m. The alabaster loincloth and marble basin were added while the statue belonged in the Borghese collection, and it was construed as an image of the Stoic Seneca committing suicide. ('De-restored' in the late nineteenth century, the Dying Seneca has since been reassembled.)*

prototype of the Old Fisherman statue (Figure 9.13). Cross-referencing the type to Alexandrian poetry, such as *Idyll* 21 of the Theocritean collection, with its stress upon poverty (*penia*) as a motive for work and creativity, may furnish a moralizing purpose to the piece. Perhaps it is enough, however, to remember the powerful sense of *Tychê* in the world of the Hellenistic monarchs. One person was raised to the virtual divinity of royal line, another condemned to eke an existence by casting the shallows for small fry: the gulf between them would only be emphasized if some vivid image of the latter unfortunate were placed in a suitable court area – by a pond, perhaps – visible, yet reassuringly unobtrusive to royal ears and (better still) nostrils.

Pergamon: the Athens of the East

Luck certainly played its part in the creation of Pergamon, whose remains, under excavation since the late 1870s, are substantially more evident than those of ancient Alexandria. Culturally, the two cities were direct rivals, with librarians at Pergamon developing the use of parchment as a text-storage medium to compete with Egyptian papyrus. Territorially, however, and in terms of populace, Pergamon was distinctly the smallest of the Hellenistic kingdoms – a reality one would hardly suppose from the magnitude of the ancient citadel above modern Bergama, about an hour's drive south of the site of Troy. Mysia was the ancient name of this region, known for its fertility, pine forests and mineral deposits. But Pergamon's success as a kingdom was due nonetheless to *Tychê* – or, at least, the nimble opportunism of certain Macedonian deputies who happened to be 'in the right place at the right time'.

Alexander famously amassed great quantities of bullion during his Persian campaigns. His immediate 'Successors' (*Diadochoi*) duly quarrelled over it. At the battle of Ipsus in 301, Lysimachus, a Macedonian ruling in Thrace, contested its possession with Antigonus, fighting in Phrygia for his dominions there. Supported by Seleukos, Lysimachus prevailed. Much of the treasure he took to Thrace. But a portion he left in Asia Minor, to be guarded by an administrator – one Philetairos, son of a Macedonian general called Attalos. This portion was 9,000 talents, the value of which may be impressionistically conveyed by reminding ourselves that all the gold on the Athena Parthenos amounted to a mere 44 talents; and the place chosen for its safekeeping was Pergamon – a natural stronghold, dramatically elevated above two tributaries of the River Kaikos.

Philetairos may have been primed from an early age to become a 'manager' (*diokêtês*) of court funds – depending on whether he became a eunuch by accident or design. His portrait shows a thickset, resolute individual. In any case, he proved

a shrewd custodian; and his lack of a son did not frustrate schemes of inheritance. The treasure was intact when Lysimachus died; and Philetairos kept hold of it when the erstwhile ally of Lysimachus, Seleukos, was assassinated in 281. Eventually there was dynastic confusion about the ownership of Pergamon and its precious contents. Since Philetairos had taken precautions to arrange suitable defences, he might claim that Alexander's bequest was safer with him than with anyone else. Pergamon was nominally under Seleucid supervision, but when Philetairos died in 263, his nephew Eumenes succeeded to his post. Over the following two decades, this Eumenes effectively made Pergamon independent; and though he never actually assumed kingly title, we know him as 'Eumenes I', the first of the Attalid dynasty.

It was the successor to Eumenes who styled himself *basileus*, thus 'King' Attalos I. We see from his presumed portrait that the principle of

Figure 9.14 *Posthumous marble portrait of a Pergamene ruler, probably Attalos I, from Pergamon. Ht 39.5 cm.*

imitating Alexander persisted (Figure 9.14). But Pergamon as a city chose Athens as its mimetic model. Cults of Athena Nikephoros and Athena Polias were instituted; a local version of the Panathenaic Festival was devised; and in the Library, stocked with such Athenian 'Classics' as the tirades of Demosthenes against Philip, a marble evocation of the Athena Parthenos presided. Schools of philosophy, in particular the Stoics, gathered at Pergamon; and so, too, did the sculptors.

So Attalid Pergamon, like Periklean Athens, considered itself the urban embodiment of civilized values; and, as with Athens, articulating what it meant to be civilized entailed some contrast with hostile outsiders. But the Attalids were, nonetheless, autocrats – and Athens, of course, enshrined eloquent suspicion of autocracy. How could the Attalids redeem themselves as despots? Almost providentially, it seems, hostile outsiders materialized. They came not from the East, as the Persians had done – but from Europe.

To refer to them as 'Gauls' may be misleading. *Galati* is, strictly, how we should style them – Celts who, around 300 BC, began to migrate down the course of the Danube and through the Balkan peninsula, crossing the Hellespont in 278. Eventually they would settle in the area that became known as Galatia. They are recorded as having attacked the sanctuary of Delphi in 280/279; and though their aggression might be harnessed by hiring them as mercenaries, these Gauls troubled several of the Hellenistic kingdoms throughout much of the third and second centuries. It was *c.* 230 when Attalos I met them in battle by the River Kaikos. Whether this was a full-scale engagement, or else a buy-off persuaded the Gauls to move on eastwards, we do not know. In any case it was commemorated as a great victory on the Pergamene Akropolis, specifically in the sanctuary of Athena Nikephoros, where a statue-group comprising at least three lifesize bronze figures was set up (probably on a circular base). The composition was pyramidal, with an apex formed by the figure of a broad-shouldered Gaul averting his head while plunging his own sword towards his heart via a point above his clavicle. Hanging limply from his other arm is the body of a woman, her life-blood oozing: she is taken to be the warrior's own wife, killed by him for the same reason he is now killing himself – so as not to be captured alive (Figure 9.15). Nearby is the stripped body of a battlefield victim, fatally

Figure 9.15 *Detail of the Suicidal Gaul Group: marble version after an original bronze by Epigonos, c. 230–220 BC.*

wounded in the chest: he is twisting himself into a position that might facilitate a few last intakes of breath (Figure 9.16).

Callimachus in Alexandria was aware of the Gallic incursions – they troubled Ptolemy too – and in his *Hymn to Delos* (171ff.) not only styles them as barbarians – a 'senseless tribe' – but 'latter-day Titans' (*opsigonoi Titênes*), launching crazed assaults upon divine order. Subsequently, Diodorus (5.28.1–3) relates the Gallic custom of washing their hair in liquid lime, making it dense and tousled, so that they looked like satyrs, or even Pan. The lifesize group created for Attalos I succeeds in capturing these stereotypical aspects of the Celtic marauders without demeaning them as an enemy. Here, after all, is a victory monument without the victors: what we see are the images of physically formidable opponents who have a certain pride in their own identity – and show the same reluctance to surrender, the same dignity in defeat, that Tacitus and other Roman writers would admire in the Celts of Germany. Of course, the achievement of Attalos in overcoming such spirited foes is thereby heightened: he can therefore claim the title *Sôtêr*, 'Saviour'. But the likeness of the Gauls to chaotic Titans also invites the Pergamene partisan to reflect on the divine

Figure 9.16 *The Dying Gaul: marble rendition after a bronze original by Epigonos, c. 230–220 BC. Ht 93 cm. The figure is circumscribed by a broken curved war-trumpet (cornu) and has not yet been robbed of his neck-bracelet (torc).*

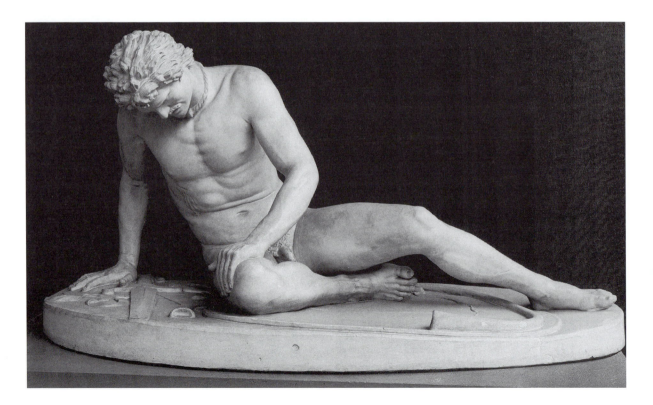

alliance between Attalos and the Olympian deities: a special relationship that would be fully publicized by the next Attalid, Eumenes II.

The rule of Eumenes II lasted from 197 to 160/159 (when his brother and eventual successor became co-regent): a period of extensive development within the citadel. (Careful stewardship of their funds did not inhibit the Attalids from grand projects.) Eumenes, a bibliophile, built the Library; he added the vertiginous theatre, which largely survives, and a gymnasium. And it was probably under his sponsorship, some time after 168 or 166, that the 'Great Altar of Zeus' was raised. On his death, Eumenes was deified, and it seems (from later epigraphic evidence) that the altar was consecrated, perhaps *c.* 150, in honour of all twelve Olympians, plus the divine Eumenes.

Altars were traditionally modest structures – pedestals placed to the fore of the temple entrance. Their elaboration under Hellenistic royal patronage was spectacular, in both size and decoration. At Syracuse, Hiero II sponsored a massive podium that could accommodate the slaughter of some 450 oxen at once, while architects in the East were developing elevated and colonnaded precincts, such as the altar for the Artemision at Magnesia. At Pergamon, the altar itself was inconspicuous; but the surrounds were quite literally palatial, perhaps even intended to evoke the fantastic grandeur of Homer's imagination (when describing the palace of Menelaus: *Od.* 4.40ff.).

The high quality of the marble reliefs decorating this monument was first recognized in the late 1860s by a German civil engineer, Carl Humann. Alarmed by the local practice of feeding marble fragments into lime kilns, Humann organized proper excavations. And as more and more pieces emerged from the site, it became clear to the excavators that they were uncovering nothing less than (in Humann's words) 'a whole new epoch of art'. Despite occasional detractors (see p. 13), we may agree. Confident, vigorous, sophisticated and innovative, the reliefs constitute the most ambitious project of Greek sculpture since the Parthenon. It is feasible to seek visual cross-references to the Parthenon in the Great Altar, and not whimsical to imagine that the sculptors of the Altar took some pride in making their work, by contrast with the Parthenon, highly visible.

The main frieze, over 100 m. in length (about three-quarters of which survive), was not only visible, on the exterior wall of the altar-podium, but immediately comprehensible. A glance is enough to recognize that it represents the battle between the gods and the Giants. Since this was mythically the establishment of supremacy by Zeus and his fellow Olympians over the earth's aboriginal inhabitants – of heavenly power over 'the earth-born ones' (*gêgenêis*) – it might be considered an eminently suitable subject to decorate a site where the Olympians were worshipped. And the elevation of the altar within a court is suggestive of

Zeus's own magnificent habitat at the top of Mount Olympus: as worshippers ascend the steps, indeed, they will see two eagles of Zeus beating back a winged Giant apparently on the verge of breaching the 'palace'. But above all it is the proximity of the Pergamene Library, plus the attested influence of certain philosophers at the Attalid court, that has encouraged scholars to speculate on literary sources and allegorical possibilities. The scant allusions to Giants in Hesiod's *Theogony* would not have helped the artists much, that is true; and the only detailed account surviving to us is the *Gigantomachia* of Claudian, composed in the late fourth century AD – so we can do little more than speculate. The likelihood that the frieze relayed metaphors of Stoic ideology, especially as articulated by Krates of Mallos (an advisor to Attalos II), remains strong, but not essential to the viewer's sense of a message about divine omnipotence.

Traces of inscribed and highly particular names for the Giants may imply that some textual agenda guided the master-design of the frieze. There are sculptors' signatures too: sixteen apparent, with the possibility that up to forty were originally engaged on the project. The Olympians and their allies, fighting in more or less intelligible groups based on family connections (e.g. Apollo, Artemis, Leto) or defined realms (e.g. the marine deities), were also once identified by inscription, but scarcely require it. Their attributes suffice – and, of course, the graphic explication that they are ubiquitously on the winning side (Figure 9.17).

Impressionistically the frieze represents a tumult, with action so violent that it spills onto the entrance steps (Figure 9.18). Yet this is a tumult in which the faces of the Olympians are invariably calm and those of the Giants all contorted, or paralysed by fear: a great battle, nonetheless a contest in which the superiority of one side over the other is absolute. How far the ancient viewer was supposed to read the images as emblematic of Attalid victory over the Gauls we can only guess. (Certainly there is no place here for any representation of the citizen-body of Pergamon.) There may, however, be a significant twist in the story as unfolded on the Altar, if it

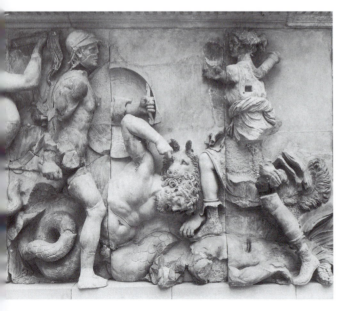

Figure 9.17 *Detail of the Great Altar Gigantomachy frieze from Pergamon: Artemis (with hunting dogs) confronts two Giants (one helmeted, carrying a shield, the other writhing under a mastiff's bite). As she strings an arrow, the goddess – in fur-trimmed boots – tramples over the body of a fallen Giant. Ht 2.3 m.*

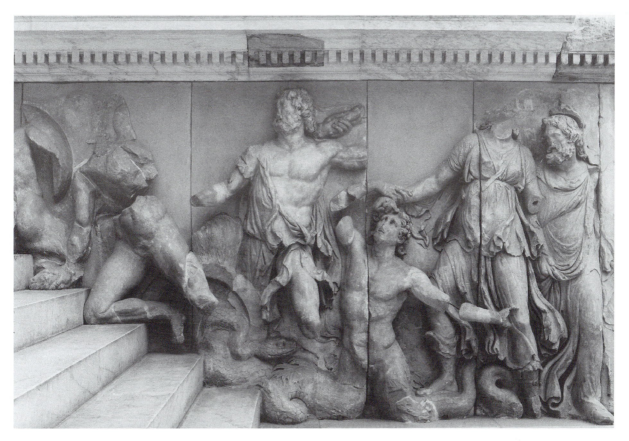

Figure 9.18 *Further detail of the same: marine deities (Nereus, Okeanos) in action on the north spur of the frieze.*

were made clear – in some part of the frieze now missing – that Herakles was involved. For one version of the Gigantomachy, alluded to by Apollodorus (*Bibl.* 1.6.1–2), specified that by oracular decree, the Gods could only prevail against the Giants if they enlisted mortal help – and so Zeus recruited Herakles. This would provide a nice link to the genealogy of the patrons.

The heroical and divine dynastic origins of the Attalids were outlined by the inner frieze located within the inner courtyard of the Altar. Sure enough, there we find Herakles: son of Zeus, father of Telephos (by Auge of Tegea) and therefore progenitor of the Attalids (Figure 9.19). The frieze is far from complete in its excavated state, and again we are without direct access to the epic that was surely concocted at royal behest. What we can glean from scattered literary sources indicates a rather eclectic and convoluted tale. For its part, the frieze takes Telephos from conception to deathbed in an episodic manner classified as 'continuous narrative': that is, with a fluent chronological sequence not interrupted by structural breaks. Though 'quieter' than the Gigantomachy, this frieze is no less adventurous artistically: the transitions of time and place are smoothly

Figure 9.19 *Panel of the Telephos frieze: Herakles finds his son, Telephos. Ht 1.1 m. The princess Auge ('Brightness'), exiled to Mysia, was forced to abandon the infant. Adopted by shepherds in the Parthenion mountains, he is suckled by a lioness – as Herakles discovers him.*

managed, with a controlled urgency that compresses the story while staying true to its heroic scope. Of the various narrative strands, perhaps the most significant is the involvement of Telephos in the Trojan saga, where he figures alternately as an opponent and then as an ally of the Greeks. Such mythical equivocation suited the Attalids very well, because their philhellene cultural affinities had to be increasingly balanced with a foreign policy oriented towards Rome. As the Romans were tracing their own origins from the Trojan side of the Trojan War, it was opportune for the Attalids to align themselves as Troad neighbours of old.

Pro-Roman *entente* was furthered by Attalos II (160–138) – but still the Athenian connection was maintained. It was Attalos II who endowed Athens with a new *stoa* along the east side of the Agora, *c.* 150 BC (reconstructed in 1956): a discreet token of eastern influence was signalled by the 'Pergamene' capitals of this colonnade, using Asiatic palm-leaf designs. To this generous bequest we should add mention of the remarkable Pergamene donation once to be seen on the south-west wall of the Akropolis. As Pausanias relates (1.25.2), this consisted of a multitude of statues, probably bronze, commemorating several distinct but symbolically connected battles: of the gods against the Giants; of the Athenians against the Amazons; of the Athenians against the Persians at Marathon; and of the Pergamenes against the Gauls in Mysia. Unfortunately, Pausanias only tells us that 'Attalos' made the donation, without specifying which king by that name. (Attalos II, who campaigned against the Gauls in 168–167 – during the reign of his brother Eumenes – is favoured by most scholars.) Each group seems to have included dead or dying figures; triumphant types, some on horseback; and others pathetically kneeling, cowering from blows. It was as if each victory was

sanctioned by the same universal moral justification. The Giants threatened proto-divine order in an excess of *hubris*: they were put down. The Amazons threatened prehistoric Athens: they were repulsed. The Persians threatened historic Athens: they too were beaten back. Finally, the Gauls threatened Pergamon, Athens of the East; and, thanks to the Attalids, they suffered the same fate as their evil predecessors. This 'Lesser Gaul Group' (as it is known, to distinguish it from the earlier monument of Attalos I) was patently programmed by someone who had studied patterns of symbolism in Classical Athenian iconography – the friezes of the temple of Athena Nike, for instance, and the paintings of the Stoa Poikile. That a Pergamene king could count upon second-century BC viewers to recognize an ideological linkage between these images may be of comfort to those students who worry about seeing anti-Persian symbolism in every Classical Gigantomachy or Amazonomachy.

From Pergamon to Rome

Pergamon, subject to raids by the nearby kingdom of Bithynia in the mid second century, was arguably an obvious target for Roman armies in Asia. Attalos III, succeeding to the throne in 138, may have been mindful of the fate of Corinth – razed by Lucius Mummius in 146 – when, during just five years in power, he drafted a will instructing that Pergamon, and all its possessions – including the nucleus of the treasures once entrusted to Philetairos – be bequeathed to Rome. Or was it sheer prescience on the part of a ruler allegedly more interested in zoology than politics? At any rate, he died childless; and the Roman Senate, after some consternation, accepted the bequest – which with hindsight seems to mark a 'paradigm shift' in Rome's perception of itself as a capital city (see p. 284).

One statue, conceivably commissioned as a bronze original by the last of the Attalids, may epitomize this transfer of power from east to west: 'the swansong of Pergamon', as it has been called (by Bernard Andreae) – the Laocoon Group (Figure 9.20).

Although it is no longer the must-see statue that it was during the eighteenth century (see p. 314), there is still much to say about the Laocoon – too much to comprehend here. We shall content ourselves with notice of how the piece served both a Hellenistic monarchy and the emperors of Rome. With that in mind, it is hard to reconcile the statue with the story of Laocoon as recounted in earlier Greek literature. Homer does not contain it; the summary of an *Iliou Persis* ('The Sack of Troy') epic ascribed to Arktinos of Miletus suggests that when the Wooden Horse was left as a 'gift' to Troy – by Greeks pretending to abandon hostilities – it was received with mixed suspicion and acceptance; acceptance

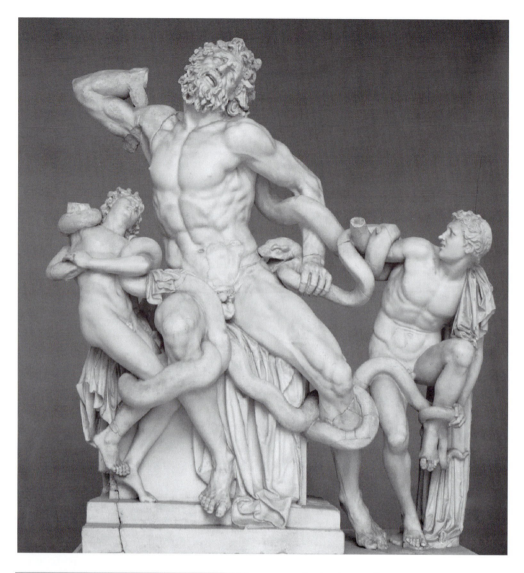

Figure 9.20 *The Laocoon Group: marble version after a bronze original perhaps c. 200–150 BC. Ht 1.84 m. Recovered in January 1506, the statue's exact findspot in Rome remains subject to some debate. One attractive proposal suggests an original installation in the Gardens of Maecenas on the Esquiline Hill, c. 30 BC (see p. 286).*

prevailed, but thereupon two great snakes appeared and destroyed the leading sceptic, a Trojan notable called Laocoon, and one of his two sons. Further allusions to the tale, by Bacchylides and Sophocles, specify Laocoon as a priest of Apollo: for Sophocles, Laocoon witnesses the death not only of both sons, but of wife too – just punishment for offences against priestly celibacy. It may be that the existent marble group shows one son disentangling himself from the serpent's coils, perhaps to escape. But a more plausible 'reading' of the statue is supplied by

Vergil's well-known description of how Laocoon – brother of Anchises, and therefore uncle to Aeneas – was the only Trojan to voice his distrust of 'Greeks bearing gifts' – and hurls a lance at the horse's flank. While Laocoon, serving his turn as priest of Neptune, is preparing a sacrifice by the shore, his suspicions are drastically punished. As Aeneas recalls, 'two giant arching snakes' suddenly reared out of the sea, 'with blazing, bloodshot eyes, and tongues which flickered and licked their hissing mouths'. First, they seized and crushed the bodies of his little sons; then, as Laocoon comes with weapons to rescue the boys, they turn upon him, binding him twice round 'in the giant spirals of their scaly length … His hands strove frantically to wrench the knots apart … His shrieks were horrible and filled the sky, like a bull's bellow when the axe has struck awry' (*Aen.* 2.201–27).

The villain of Sophocles has become a hero. The voice of defiance will, after all, be proven the voice of truth: the Wooden Horse indeed contains not only Greeks who will destroy Priam's Troy, but among them the peculiarly nasty Neoptolemos, avenging son of Achilles. So the Romans have sound patriotic reason to venerate the memory of Laocoon and could be proud that the ensemble created probably *c.* early first century AD by Hagesandros, Polydoros and Athenodoros incorporated Italian marble – though the sculptors hailed from Rhodes.

Pliny seems to have seen the same ensemble on display in the residence of his patron, the emperor Titus – which may be why the piece is saluted as 'a work to be preferred to all that the arts of painting and sculpture have produced' (*NH* 36.37). His report that it was made 'from a single stone' (*ex uno lapide*) seems to be part of his technical appreciation – though if he means that it was a single block, he is wrong; and what he intends by saying that the three sculptors worked *de consilii sententia*, 'from an agreed plan', continues to perplex us; yet we may accept that Pliny's comments show how far this statue, which stylistically translates the Great Altar into three dimensions, came to 'belong' in Rome. So Pergamon's 'swansong' became, for the Romans, something like a sculptural national anthem.

Sources and further reading

The Hellenistic period invites surveys that 'characterize' its coherence as a period. J.J. Pollitt's *Art in the Hellenistic Age* (Cambridge 1986) remains a standard *exemplum*, though for pictures to be supplemented with B. Andreae and A. Hirmer, *Skulptur der Hellenismus* (Munich 2001), and piece-by-piece discussions in the three volumes of B.S. Ridgway, *Hellenistic Sculpture* (vol. I: Bristol 1990; vol. II: Wisconsin 2000; vol. III: Wisconsin 2002). The rapport between art and literature in the period is astutely explored in G. Zanker, *Modes of Viewing in Hellenistic*

Poetry and Art (Wisconsin 2004). The quotation about Hellenistic numismatic propaganda comes from R.A. Hadley in *JHS* 94 (1974), 51. Comparative material in P. Burke, *The Fabrication of Louis XIV* (Yale 1992).

Colossus of Rhodes Critical and accessible survey, along with good technical discussion, in W. Hoepfner, *Der Koloss von Rhodos und die Bauten des Helios* (Mainz 2003).

Nereid monument Full publication of the sculptures in W.A.P. Childs and P. Demargne, *Fouilles de Xanthos* (Paris 1989), vol. VIII; see further discussions in J.M. Barringer, *Divine Escorts* (Michigan 1995), 59–66 and I. Jenkins, *Greek Architecture and its Sculpture* (London 2006), 186–202. For the reading of Lycian Nymphs instead of Nereids, see a note by T. Robinson in *OJA* 14 (1995), 355–9, and A.G. Keen, *Dynastic Lycia* (Leiden 1998), 204–6.

Mausoleum A crisp summary in I. Jenkins, *Greek Architecture*, 203–35, with further bibliography: of which one should single out S. Hornblower, *Mausolus* (Oxford 1982) as the best historical account, and (for the reconstruction of the Mausoleum more or less favoured here) K. Jeppesen's contribution to I. Jenkins and G.B. Waywell eds., *Sculptors and Sculpture of Caria and the Dodecanese* (London 1997), 42–8. On the principal statuary, see G.B. Waywell, *The Free-Standing Sculptures of the Mausoleum* (London 1978); on the friezes, B.F. Cook, *Relief Sculpture of the Mausoleum* (London 2005).

Vergina M. Andronicos, *Vergina: The Royal Tombs* (Athens 1987).

Nike of Samothrace A.F. Stewart in P. Holliday, *Narrative and Event in Ancient Art* (Cambridge 1994), 137–53.

Drunken Hag P. Zanker, *Die Trunkene Alte* (Frankfurt 1989); S. Sande, 'An Old Hag and Her Sisters', *Symbolae Osloenses* 70 (1995), 30–53. On Ptolemaic spectacles, see E.E. Rice, *The Grand Procession of Ptolemy Philadelphus* (Oxford 1983); on 'genre' pieces, H.P. Laubscher, *Fischer und Landleute* (Mainz 1982). See also N. Himmelmann, *Alexandria und der Realismus in der griechischen Kunst* (Tübingen 1983).

Pergamon E.V. Hansen, *The Attalids of Pergamum* (Ithaca 1971); E. Schmidt, *The Great Altar of Pergamon* (Leipzig 1962); R. Dreyfus and E. Schraudolph eds., *Pergamon: The Telephos Frieze from the Great Altar* (San Francisco 1996); A.F. Stewart, *Attalos, Athens, and the Akropolis* (Cambridge 2004); E. Polito, *I Galati vinti* (Milan 1999); N.T. de Grummond and B.S. Ridgway, *From Pergamon to Sperlonga* (California 2000); plus imaginative suggestions in F. Queyrel, *L'Autel de Pergame* (Paris 2005) and F.-H. Massa-Pairault, *Pergamo e la filosofia* (Rome 2010).

Laocoon B. Andreae, *Laokoon und die Kunst von Pergamon* (Frankfurt 1991), with review by R.R.R. Smith in *Gnomon* 63 (1991), 351–8; R. Brilliant, *My Laocoön* (California 2000), with review by B.S. Ridgway in *JRA* 14 (2001), 571ff.; S. Settis, *Laocoonte* (Rome 1999).

A portrait really is a portrait, and does not just become it through and for those who see in it the person portrayed … A portrait never tries to reproduce the individual it represents as he appears in the eyes of the people near him. Of necessity, what it shows is an idealisation.

H.-G. Gadamer,
Truth and Method (2nd edn, London 1979),
129–31

10

PORTRAITS AND PERSONIFICATIONS

'The mask of Socrates' By all reports, Socrates was an odd-looking man. Even those who loved and admired the philosopher had to admit that he was strikingly bereft of conventionally handsome features. He was short and stubby in stature, with a paunch and solid neck: an apparently ignoble physique was only accentuated by Socrates' habitual disregard for clothes and shoes. His head was large, topped by a balding dome. He had bulging eyes, a snub nose and thick lips. Half-seriously, he liked to claim some advantage from his physical nature – for instance, if his eyes protruded, was his range of vision not increased? (Xenophon, *Symp.* 5.3–7) – and his constitution was notoriously resilient, whether to heavy drinking or extreme cold. All the same, it made for a personal presence that his disciples described as *atopos* – 'weird', or 'out of place'.

Some went further. 'I say', declares Alcibiades, 'that he resembles nothing so much as those Silenus-figures you see in statue-shops' (Plato *Symp.* 215b). Alcibiades – stressing that he makes the analogy in the spirit of truthful candour, not mockery – then likens Socrates to Marsyas. Again this is not flattering: the story of Marsyas (see p. 287) is an unhappy tale of semi-bestial *hubris*, even if the satyr had a reputation as a music-teacher. But Alcibiades – himself acknowledged as winningly handsome, and athletically successful too – has a point to prove. With Socrates, what you see is *not* what you get. Ugly and graceless he may have appeared: but as soon as Socrates opened his mouth, it was a revelation of marvellous inner beauty. Or rather, on first hearing, the words of Socrates could seem absurd, the stuff of vulgar comedy; but when 'opened up' they proved utterly 'beautiful and good' (Plato *Symp.* 222a). This is a memorable contribution to the piece; and a particular portrait-type of the philosopher is traditionally associated with the Silen-image conjured by Alcibiades (Figure 10.1)

Socrates, as we have already noted (p. 35), was as guilty as anyone of making the twin assumption that good looks equated to good

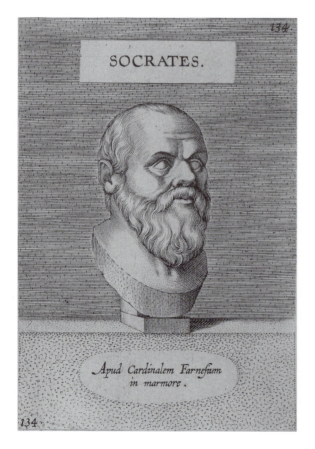

SOCRATES.

Apud Cardinalem Farnesium in marmore.

Figure 10.1 Engraving of a marble head of Socrates once in the Farnese Collection, likely to have been found in a Roman villa near Tivoli (possibly Hadrian's). An example of the 'Type A' image of Socrates: date of the original perhaps c. 380 BC. (Plato's Academy may have been the original location.)

character, while being 'ugly' (*aischros*) should guarantee a mean and shameful nature. When, for example, he alludes to one of his prosecutors, Meletus, as 'hook-nosed, lanky-haired and scant-bearded' (Plato, *Euthyphro* 2b), Socrates clearly wants to evoke a disagreeable type; yet his own physical formation – including the shape of his nose – could equally be used as prejudicial evidence against him. (A travelling physiognomist called Zopyrus notoriously gave Socrates a poor report: see Cicero, *De Fato* 5.10; *cf. Tusc. Disp.* 4.37.) The difference is, of course, that in the cult of Socrates, his very divergence from the norms of canonical beauty was converted to heroic effect: symbolic of his own refusal to meet general expectations of social, political and intellectual decorum, the outward appearance of Socrates became a prototype of individual integrity. Meletus prevailed in the court-room; but posthumous victory went to Socrates. As a later biographer records, *apropos* of Socrates' trial and enforced suicide:

So he was taken from the company of men. But not long afterwards the Athenians closed their wrestling-schools and gymnasia as a mark of regret. Meletus was put to death, and the other prosecutors exiled. Socrates they honoured with a bronze statue, made by Lysippos and placed in the Pompeion.

DIOG. LAERT. 2.43

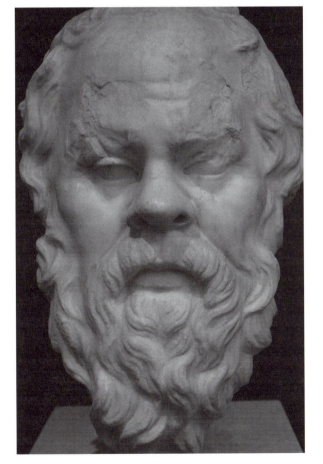

The Pompeion is a known structure in the Kerameikos area: located between the Dipylon and Sacred Gates, it provided a mustering-place for the Panathenaic procession. A base for a statue of Socrates has been tentatively identified there: theoretically it is possible that Lysippos – whom we have encountered as 'court-sculptor' to Alexander the Great – made a lifesize image of the philosopher seated on a bench, perhaps as if among those waiting to join the procession. The piece may be reflected in a painting of Socrates found on the walls of a Roman house in Ephesus; thirty-odd sculpted heads and herms have been grouped as possibly deriving from it (Figure 10.2).

Figure 10.2 *Marble head of Socrates, mid first century AD; found in Rome. Ht 35 cm. An example of the more nuanced, less satyric 'Type B' series of Socrates portraits, thought by some to derive from the bronze statue of Socrates created for Athens by Lysippos, perhaps c. 318–317 BC.*

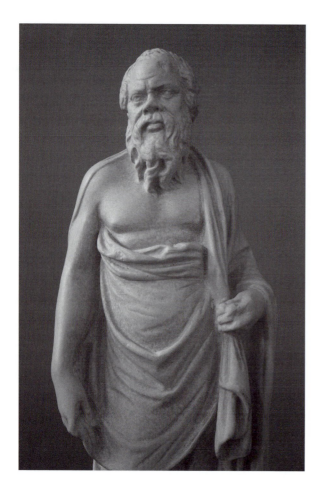

Figure 10.3 *Statuette of Socrates (cast): original in marble, perhaps of Hellenistic date, and reportedly from Alexandria. Ht 27.5 cm. This image – of a dignified, properly clad Socrates – seems to deny the analogy with Marsyas.*

Historically it is impossible for Lysippos to have carried out this commission soon after the death of Socrates (when the Pompeion itself was only recently built). But there is some further archaeological evidence for the posthumous cult of Socrates in the form of a statuette-fragment found in a building (by the south-west corner of the Agora) identified by American excavators as the 'State Prison' of Classical Athens. This looks similar to a type that showed Socrates standing, plausibly with his brow set in a defiant frown (Figure 10.3). Quite when such a figurine was produced is difficult to say, but it is tempting to suppose that some iconographic 'idolization' of Socrates took place not long after his followers – most notably Plato and Xenophon – produced their literary portraits, *c.* 380–370. (Conceivably, as has been suggested, it happened *vice versa*: those affectionate vignettes were shaped by some conspicuous image, if only a sketch on a wall.)

In written sources, Socrates is unusually well-served to posterity: for Plato, in particular, was not only a consummate prose stylist, but also prepared to create a 'rounded' image of his master, adding anecdotal detail to the supposed transcription of philosophical dialogue. But in any case, the peculiar lineaments of Socrates' appearance were a gift to artists. Alcibiades, making the comparison between Socrates and a satyr, risks making the great man 'laughable' (*geloios*); some translators render this as a 'caricature' by Alcibiades, an allowable anachronism – for although 'caricature' as an artistic genre was not recognized as such until centuries later, there is no doubt that it existed *de facto* in antiquity. Outright and 'obvious' caricatures of Socrates were indeed produced – an inscribed pottery lamp found at Knidos shows him as a monkey with a scroll – but sculptors were content, on the whole, to let a few key facial features stand for Socrates: snub nose, wide nostrils and full lips, set between a balding dome and thick beard twisting to a point below the chin.

This has been called 'the mask of Socrates': a stock visual epitome of the 'thinking man's thinking man', mediated to us largely by way of Roman 'copies'.

And as the language here suggests – a 'mask' commonly serving to disguise, not reveal – we shall meet insurmountable problems if we dare suppose that the image has a *direct relation* to the Socrates who lived and taught in Athens during the second half of the fifth century. (In other words, let us eradicate any idea that Socrates once 'sat' or posed while an artist studied his features.) The Silen-aspect offered, as one commentator suggests, a conventional visual pattern to portray the unconventionality of Socrates' 'otherness'. But how much does this matter?

The epigraph to this chapter, culled from the ontological concerns of Hans-Georg Gadamer, indicates an answer of 'not very much'. If Gadamer is right, every portrait, *per se*, takes on an independent existence. The portrait is not a means of recognition or identification, like a passport photograph: it is a work of art whose principal function is to confer 'an increase of being' upon its subject. This is just what gives rise to the trope that a good portrait looks more like its subject than the subject does in person.

There is no particular word in either Greek or Latin to translate 'portrait' as understood in this way. But a discussion by Aristotle of the portrayal of 'character' (*êthos*) in drama alludes to the skill of a successful portrait-painter (*eikonographos*) in creating images that are both 'true to life' and yet 'more beautiful' (*Poetics* 1454b9). Effectively, then, Aristotle understands the incremental value of portraiture. This is crucial for our application of the term 'portrait' to the assorted heads and bodies we possess of various Classical worthies, many of them anonymous. And it becomes even more germane to our comprehension of the aesthetics of portrait-making by Greek sculptors when we add, retrospectively, certain findings of modern neuro-science and cognitive psychology. These suggest that the human brain is actually 'hard-wired' for recognition by way of selective exaggeration. Numerous tests have demonstrated that we tend to remember another person's face primarily by recall not of a 'veridical' image, but a distorted likeness. The efficient level of distortion has been measured at between 4 and 16 per cent of 'loading' an individual's distinctive features – jutting ears, thin lips, heavy jowls, thick eyelashes, etc. Whether we preserve an image of someone's identity like this, or use selective exaggeration as a means of retrieving a 'face' from the many faces we have already stored, is not clear. But the process, all the same, amounts to caricature.

So far, art historians have been slow to apply this research to the study of portraiture; with regard to Greek sculpture, perhaps understandably so, since portraits were largely a posthumous process, and inclined towards the stereotyp-ical. But how do the stereotypes germinate in the first place? True, there are some fantasy-creations within the scope of what we classify as 'Greek portraits' – the obvious example being the image of Homer, acknowledged even in antiquity as an 'imaginary likeness' (Pliny, *NH* 35.2.9). But many others credibly

communicate a particular identity – thanks to the element of caricature. This being admitted, the next task is to match that identity with a name.

Putting names to faces

The first public portraits, according to Pliny (*NH* 34.16–17) were the images of Harmodius and Aristogeiton, the Tyrannicides (see p. 136). So Athens created an urban custom that was followed (in Pliny's words) 'all around the world'. For Pliny and his readers, the practice of displaying portrait-statues to perpetuate memories and provide *exempla* of individual virtues – an individual's virtues – might indeed seem ubiquitous: to the point, in some Roman cities, of forming a dense 'second population'. But the precedent of the Tyrannicides (dated by Pliny to a year equivalent to 510 BC) was not so straightforward. For one thing (as Pliny is aware), it seems that certain victors at the Olympic Games had already earned the right – by several victories – to have 'iconic' images of themselves erected in the precincts of Olympia: the redoubtable Milo of Croton, dominant in Olympic wrestling during the later sixth century, probably won this honour (his statue has not survived, but was reportedly like the *kouros*-type). And secondly, the democratic constitution of Athens ensured that the practice of commissioning portraits, whether public or private, was subject to debatable criteria. Various sources attest to precise protocols for granting the 'gift' of a civic portrait by the 'People' (*Dêmos*) or the city Council (*Boulê*); and while it was apparently possible for the descendants of a famous or cherished individual to extend commemoration beyond a gravestone, the practice was hedged by the obligation to prove that collective 'gratitude' (*charis*) had been earned. (During the pro-Macedonian governorship of Athens by Demetrios of Phaleron, between 317 and 307, even images on gravestones were curtailed.)

So Harmodius and Aristogeiton were not, as it were, 'an easy act to follow'. However, we can trace a cumulative accretion of portraits at Athens from around the mid fifth century onwards. By the time that Pausanias made his visit to the city (*c.* AD 150), it was a showcase of images of the great and the good. A quantity of inscribed bases survives. Most of the persons commemorated have no place in the grand narratives of ancient history: magistrates, priestesses, harbourmasters, senior treasurers – the people who, on a day-to-day basis, make a community work. Some were overtly fantasy portraits, such as a bronze image of the archaic poet Anacreon, shown singing with his lyre and wearing nothing but a short cloak over his shoulders. And in most cases we have little hope of matching what remains of a portrait-statue with what remains of its inscribed base. But by various means it is possible to arrange a virtual gallery of *imagines illustrium* from the Classical and early Hellenistic period: what follows is a selection, made with the *caveat* that this privileges male 'celebrities' favoured by the canons of the Second Sophistic (see p. 5).

Seven Athenian worthies

(N.b. All pieces here are so-called 'copies' from Roman times.)

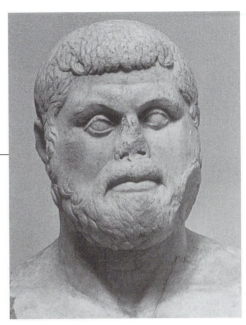

Figure 10.4 Themistokles: marble herm (found at Ostia in 1939). Stylistically this head evokes the Severe Style of sculpture on the temple of Zeus at Olympia – assimilating Themistokles (who died, in exile, c. 460) to Herakles (see Figure 6.8). The analogy fits with Themistokles' historical reputation as a dauntless, even reckless, man of action.

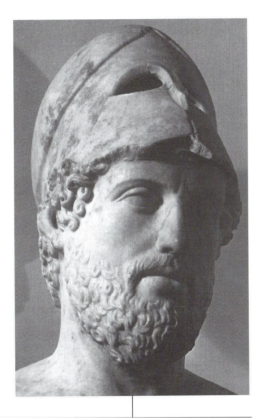

Figure 10.6 Marble bust of an Athenian general, possibly Konon. Like Themistokles and Perikles before him, Konon had a controversial career; but a naval victory over the Spartans at Knidos in 394 BC earned him – along with his Cypriot sponsor King Evagoras – the honour of a portrait in the Agora, prominently located in front of the Royal Stoa.

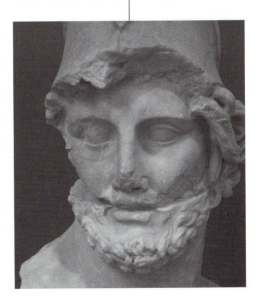

Figure 10.5 Perikles: marble herm (from the Villa of Cassius at Tivoli). Plutarch, in his Life of Perikles (3.2), reports that the statesman had an elongated head, which was why artists invariably showed him with a helmet. But the helmet also designates Perikles as military commander (stratêgos) – one of the modes of state service for which honorific portraits could be awarded (and not only to Athenians). A Cretan sculptor of the fifth century BC, Kresilas, is recorded as creating an 'Olympian' image of Perikles, which may have been that displayed in the Propylaia, at the entrance to the 'Periklean' Akropolis, not long after Perikles' death in 429.

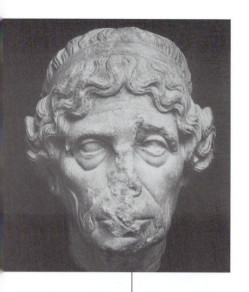

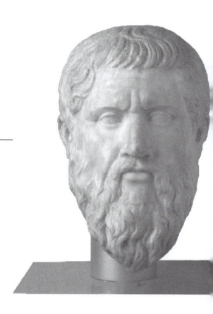

Figure 10.8 *Marble bust of Plato. Images of leading Greek philosophers were de rigueur within the libraries and courtyards of an educated Roman. The Stoics (whose figureheads included Chrysippos, Cleanthes and Zeno) were often represented; Epicurus was another recurrent choice. Plato's image – sufficient to evoke 'the groves of Academe' – seems to derive from an original portrait made by Silanion during the mid fourth century. The philosopher was reputed to have been an irritable type, 'hostile to everyone' (Ath. 506a) – which may be conveyed by the somewhat peevish expression worn by his portraits – but scowling became a facial trademark of the philosopher-type. Date of this example first century AD; ht 35.5 cm.*

Figure 10.7 *Head of 'Lysimache'. Pausanias records seeing the image of a long-serving priestess, Lysimache, on the Akropolis (1.27.4). A corresponding base has been found, attesting the image of a woman perhaps in her 80s: the sculptor is surmised as Demetrios of Alopeke, active in the early fourth century BC, and famed for preferring 'likeness over beauty' (Quintilian 12.10.9).*

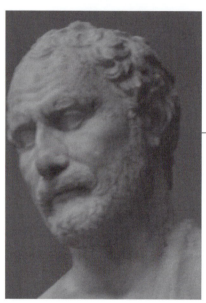

Figure 10.9 *Portrait-statue of Demosthenes (ht 1.92 m., without plinth). This well-known image of the anti-Macedonian orator aggrandizes an old man as civic hero and political martyr: based on the honorific bronze statue made by Polyeuktos c. 280 (Demosthenes died in 322), its body-language captures the concentration of someone about to make an important speech, perhaps, or listening hard – or the anguished 'senior citizen' lamenting his city's lost autonomy.*

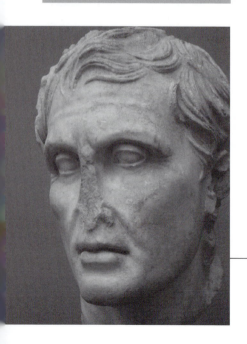

Figure 10.10 *Head of Menander. Author of over a hundred comedies, Menander (c. 342–292 BC) was highly esteemed by the Romans – which explains why over fifty images of his likeness have been found. An original (probably bronze) statue made by Kephisodotus and Timarchos, the sons of Praxiteles, was erected in the Theatre of Dionysos in the early third century and seems to have shown the dramatist seated in a padded chair, slightly leaning forward – as if in the front row at one of his plays.*

The physiognomic factor Physiognomy is a discredited pursuit. Practised seriously in early modern Europe, it has long since joined astrology as a pseudo-science – though at a popular level we indulge it occasionally ('Would you buy a car from someone who looks like *that*?'). Its influence in antiquity, however, is not to be underestimated. Medicine, oratory, education, theatre and art: it would be hard to say which of these was most affected by the belief that someone's 'character', 'nature' or 'personality' could be deduced by their physical appearance. That, essentially, is what physiognomy amounts to: acccepting the philosophical belief that 'body' and 'soul' are interdependent in humans, and, recognizing that connoisseurs of animals will judge the disposition of a dog or a horse from exterior signs, a number of Classical authors attempted to compile guidebooks for reading the exterior signs in humans. How could you tell, at first sight, if a man was courageous or cowardly? Was it possible, just by scanning someone's face, to know if that person could be trusted?

In a sense we have already encountered this system of visual prejudice: it is, after all, implicit from the doctrine of *kalokagathia* (see p. 34). How far it was considered a 'science' in antiquity is open to debate: though a short treatise on *Physiognomonics* is traditionally included in the *Corpus Aristotelicum*, no one supposes that it was actually written by Aristotle. (He would decline in our estimation if it were – containing as it does a number of frankly ridiculous observations, e.g. 'Men addicted to *Gaming* have short arms, like weasels, and are dancers'). Aristotle's pupil and successor Theophrastus, in his *Characters* – a collection of thirty Athenian 'types', composed at the end of the fourth century – exploited the droll potential of such people-watching. But there is no doubt that Aristotle *et al.* seriously believed in some demonstrable connections between a person's physical appearance and his or her *êthos* – 'character', or 'disposition'. Moreover, the sharing of certain 'characteristics' between humans and animals was readily countenanced. The author of the *Physiognomonics* admits that lions are not the only courageous animals, and that timidity is not confined to hares. But the traits of animals are on the whole more polarized, and more consistent, than those of humans; and so, when transferred, they assist and simplify the analysis of human nature.

In the Aristotelian view (*Hist. An.* 488b) there can be no such thing as a cowardly lion. The lion is by nature 'noble' (*eugenês*) and will always exhibit courage. Tellingly, the Greek for 'courage', *andreia*, literally entails 'manliness'; so, by reverse logic, a courageous man is recognizably leonine: not only in possession of a 'mane' of hair (preferably tawny in colour), but also a powerful gait, lean haunches and muscular shoulders. Achilles, whose childhood nutrition was the

marrow of lions' bones, legendarily displayed a nature that was the fusion of man and lion: this is repeatedly stressed by epic simile (see e.g. *Il.* 20.164–73). For the visual and historical version of such assimilation, we have the outstanding example of Aristotle's own pupil Alexander – who, notoriously, considered himself Achilles born again.

Alexander – 'the Great'

'Alexander the Great' is one way of distinguishing Alexander, son of Philip II and Olympias, from other Alexanders in the Macedonian royal line. It is also posterity's recognition of his military achievement. It reflects his megalomania (*ho megas* is Greek for 'the Great') and allows for his assumption of regal supremacy in Persian style. And, as we observed in the previous chapter, there is some evidence that this Alexander was 'programmed' in his youth to become 'the Great'. Whether Aristotle had any influence in shaping his pupil's authoritative 'look' is open to speculation. But it is hard to deny that a fourth-century fascination with physiognomics affected the image of Alexander as we find it in statues (of various size), on coins, and in paintings and mosaics.

It is conceivable that one day the tomb of Alexander – presumed to be somewhere in Egypt – will be found, and found to contain the mummified remains of the man, in which case we may have some chance of measuring the distance between art and 'reality'. This is not a crucial *desideratum* for any discussion of his portrait, since we have allowed any portrait to have a life of its own. It is more a matter of pure curiosity – because so many literary sources record the 'charismatic' effect of Alexander in person. A number of anecdotes relate to the potency of Alexander's image: for example, the report about his fellow Macedonian, Cassander. Cassander, eldest son of Alexander's appointed regent in Macedonia, went (on his father's behalf) to Babylon to meet Alexander – and was not well received; a victim of Alexander's sudden and violent temper, he was beaten up, in public. Years later, after he had become king of Macedon (and exacted some revenge on Alexander's family), Cassander happened to be walking through Delphi when he caught sight of a statue of Alexander. It 'smote him suddenly, with a shuddering and trembling of the body from which he could scarcely recover' (Plutarch, *Alex.* 74.6). Psychologically, this is a highly credible episode; incidentally, it says something about the power of a portrait to create a virtual presence. But all the same we are obliged to analyse the several components that underpin the power of Alexander's image. How far did artists – and sculptors in particular – make Alexander 'the Great'?

A repeated assertion in ancient literature is that one sculptor – Lysippos of Sikyon – won Alexander's trust. Only Lysippos, it was said, could capture the

man's essential *êthos*. Other sculptors, fixing too selectively upon Alexander's habitually tilted neck and 'melting, liquid eyes', were liable to lose the leonine, 'manly' aspect. This was a commission that called for great technical finesse (*akribeia*). But – as Cicero wondered – if Lysippos did make a hundred images of Alexander, how would we tell them apart? The reality is that even a brief survey of the range of Alexander portraits is enough to suggest that no 'master-type' was imposed. Since many of these portraits are demonstrably posthumous, this is perhaps to be expected: Alexander could not then control the use (or abuse) of his image. Nonetheless it is possible to isolate some recurrent iconographic strategies here – and whether or not these are owed to Lysippos, they add up to a coherent set.

Forever young Alexander died before he grew old. That is a well-known fact, but calls for some comment. He was in his early 30s when in 323 he succumbed to a fever (possibly compounded by alcoholism); so, like his heroic model Achilles, he was spared the degenerative transformation from 'Young Man' to 'Old Man'. However, as one later writer observed (Apuleius, *Flor.* 7), all images of Alexander conveyed 'the same look of youthful freshness'. True, it is possible to distinguish an Alexander whose status is 'Crown Prince' – that is, while still a teenager, before taking his father's place, aged 20, in 336: a mesmerizing head in Athens has good claim to be one such image (Figure 10.11). Roman writers report that portraits of Alexander were undertaken during his boyhood; and, as we have seen (p. 228), finds from the Macedonian royal tombs at Vergina may be interpreted as 'fixing' a dynastic likeness. But among the differences between the images of Philip II and his foremost son Alexander one feature is worth emphasizing: Alexander chooses not to grow a beard.

Long before the invention of the safety razor, this was not an easy option; ideologically, it might have been deterred by an association (among Greeks) of effeminacy with smooth-faced men. But Alexander's choice was no doubt followed by his immediate Macedonian 'Companions' and thence diffused through the numerous ranks of his army. So it is that the Stoic philosopher, Chrysippos – himself sprouting, of course, a mature Greek citizen's customary foliage of facial hair – sourly remarked that 'the fashion for shaving came about with Alexander, though the foremost men refrained from it' (Ath. 565a). No one tells us why Alexander made this stylistic decision; speculatively we may presume that in company with the dedicants of *kouroi* statues, and of course the athletic victors as commemorated by Polykleitos, heroism was bathed in the glow of youth – compounded by Apolline beauty.

The warrior irresistible Alexander may have convinced himself that he was, like Achilles, invulnerable; alternatively, if he wore no helmet into battle then it was part of his military genius: making himself conspicuous, a point of morale-raising focus for

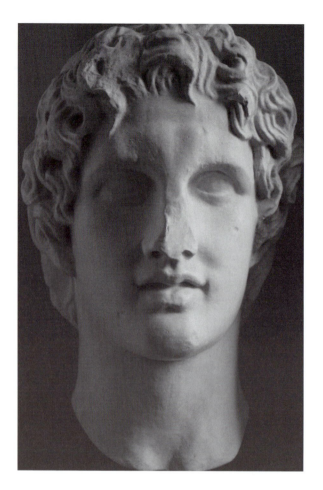

Figure 10.11 *Head of the 'ephebic' Alexander, c. 338–330 BC (cast). Ht 35 cm. Original of local (Pentelic) marble. This portrait may have been commissioned immediately after Alexander's debut as cavalry commander at the battle of Chaeronea (338); Leochares has been credited with the work (though some believe it a copy). Found near the Erechtheum.*

his own officers and troops and a source of panic to the enemy. This is the image of him given in the so-called 'Alexander Mosaic', which is apparently based upon a large-scale painting of the battle of Issus, where in 333 Alexander routed the Persians under Darius III. The painting, in turn, probably 'quotes' a sculptural vision of Alexander on horseback, wielding a lance, created by Lysippos. 'Who can blame the Persians?' quipped the Macedonian-born poet, Posidippus of Pella, epigrammatically evoking this bronze – 'Oxen are forgiven for fleeing a lion' (*A-B* 65). The 'Alexander sarcophagus' (see Figure 9.10) presents Alexander in similar mode, while a bronze piece in Naples, though heavily restored, shows a variant on the theme, with Alexander wielding a sword – and again without helmet.

The numinous gaze The sources tell us that Alexander, though well-proportioned, was not a physically large man. When he tried to sit upon the throne of the Persian kings, his legs swung well short of the ground, and minions hurriedly fetched a stool. His friend Hephaisteion was of more impressive stature; the ladies of the defeated Persian king's harem instinctively threw themselves for mercy at the feet of Hephaisteion, not Alexander. Yet Alexander had a superbly commanding presence – radiating from his eyes. These were the source of much comment – regarding their size, colour and glistening quality, but above all their contribution to a 'heavenwards gaze'. Now it is not easy, with any surviving ancient visage, to determine where exactly a line of sight may once have travelled. Nonetheless, many images of Alexander – albeit lacking bodily stance, original base and inner markings of the eye – seem to show him transfixed by some distant prospect (Figure 10.12). Admirers took this as a symptom of Alexander's 'divine inspiration' (*enthousiasmos*). He appeared superhuman.

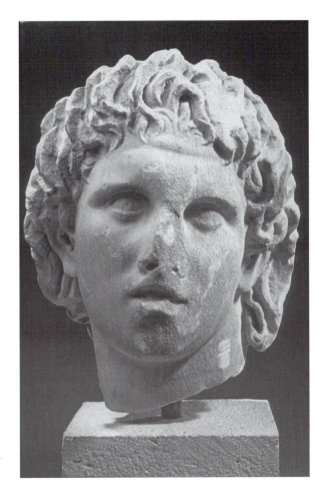

The sun of righteousness The parts of the world unvisited by Alexander stayed sunless – so it was said. Not only was Alexander Apolline in appearance, but he assimilated also to Helios the Sun-god. This facilitated his progress in the East – where the cult of the Sun (*Sol Invictus* to the Romans) was so entrenched by the third and fourth centuries AD that Christian bishops decided, as a matter of compromise, to fix the birthday of Jesus around the time of the winter solstice. Helios was the subject of an influential chariot-group created by Lysippos; the 'Colossus of Rhodes' represented Helios too (see Figure 9.1); and Macedonian kings used a gleaming sun as one of their prime symbols. It was inevitable that when Alexander conquered Egypt, he adopted the honours traditionally due to pharaoh as son of Ammon-Ra, the Egyptian deity uniting supreme divine power with cosmic solar control.

'Big hair' Naturally the leonine man must have a thick and tousled head of hair framing his wide, and typically bulging, corrugated brows. In Alexander's case the mane-like effect may have been heightened by his (alleged) practice of sprinkling his hair with gold dust. A distinctive forelock – the *anastolê*, or 'putting back' that some translate as 'quiff' or 'cowlick' – marks many of his portraits. But what is most important is the mass of the hair. Its power is primal. The strength of mighty Samson derived from his hair (Judges 16); Spartan warriors used to grow theirs long (Plutarch, *Mor.* 228f); and eventually the Latin word for 'mane' or 'luxuriant hair', *caesaries*, would enter (via Julius Caesar) the title of Roman imperial power – which is one reason why a Roman *imperator* (beginning, ironically, with Caesar himself) might be sensitive on the topic of his baldness. Long hair, again, recalled the Homeric hero as traditionally represented. Alexander's proven bravado in front-line fighting simply reasserted an archaic association of shoulder-length coiffure with abundant virility.

After Alexander Alexander's image was in itself a powerful legacy to his successors. Some of them, as we have seen (Figure 9.14), openly imitated his appearance; others – beginning with the Egypt-based Ptolemy, *c.* 318 – liked to include Alexander's head on their coin issues, as if a talismanic reminder of their right to rule. The fact is that many, if not most, of the images of Alexander that survive were produced in the centuries after his death. Truly 'a legend in his own lifetime', Alexander's posthumous reputation only burgeoned – to the point at which, eventually, not only Christian hagiography, but also Judaic and Islamic traditions accommodated him. But it is no accident that the main testimonies to Alexander's greatness belong to Roman times: for it was only under the Romans that the unity of Alexander's 'spear-won land' was restored.

This is not the place for recounting how the various kingdoms of Alexander's empire became subject to Rome. But Alexander's iconographic legacy concerns us, so too the undisputed presumption that portraits made of eminent Romans were as a rule produced by Greeks. It is easy enough to demonstrate, visually or else from literary sources, that diverse powerful Romans attempted their own *imitatio* of Alexander – Pompey, Augustus, Caracalla are notable examples. But the broader question is: how far should Roman portraits generally be considered within the category of 'Greek sculpture'?

Since it might be pointed out, pedantically, that we have put portraits of the Macedonian Alexander under our conspectus, this may seem a false dilemma. Certainly the Greek *technical* involvement in shaping Roman portraits contributes significantly to the so-called 'veristic' style often perceived as a hallmark of *Romanitas* in images of the later Republic. (It has even been suggested that a Greek antipathy towards the subjects of these portraits is manifest in the 'ugliness' of the results.) That the Classical ideals of youthful beauty were spurned (perhaps consciously) by Roman patrons seems undeniable when surveying, for instance, the range of portraits recovered from Delos, prime among the Greek sites 'colonized' by Roman traders in the second century BC. By then, however, the aesthetics of respect were transformed, as also at Athens. We do not know the identity of one middle-aged man honoured with a portrait in the Agora during the late Republic (Figure 10.13): it is a supposition that he officiated for a cult of Egyptian origin, though that does not mean he was ethnically non-Greek. In any case, although his excavators were not endeared to him – 'the man has the appearance of an ascetic priest of disagreeable character' – this is a highly accomplished *memorandum* of personal identity: the grooves and jowls of age have been carved with great physiological sensitivity.

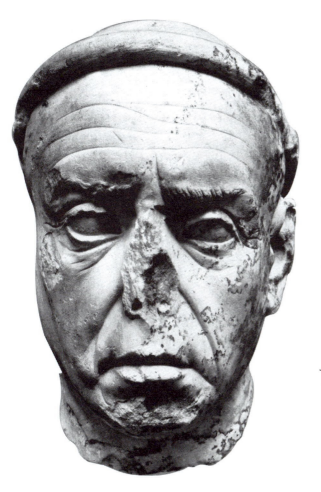

Figure 10.13 *Marble head from the Agora, mid first century BC. Ht 29 cm. (Whether the portrait was originally full-length is not clear.) The man wears a rolled cloth on his shaven head – indicative of his priestly status.*

The phenomenon of the 'portrait-bust' is Roman. There is no doubt that Greek habits of nakedness (in gymnasia) and nudity (in art) caused some cultural unease among the Romans. Though this does not imply that bodies, whether draped or undressed, were necessarily of secondary importance in a portrait-piece, a Latin predilection for locating character in facial features is evident enough. *Vultus indicat mores*: 'countenance shows worth', as the rule might be summarized. Voters were advised to judge a political candidate *vultu ac fronte, quae est animi ianua* – 'by face and brow, the gateway to the spirit'; and while orators might worry whether a *vultus bonus* were sufficient witness of a good man, they also counselled aspiring barristers to exploit fully whatever signs of moral turpitude seemed apparent from a defendant's visage. Sculptors working within this Roman adaptation of the physiognomic rulebook had to respond to expectations of representing such virtues as *gravitas, auctoritas, severitas*: these were among the key concepts used by Romans to differentiate themselves from Greeks (and others).

This sense of cultural difference gives us some reason to fix our parameter of where 'Greek sculpture' ends. We know that *imagines maiorum*, 'images of the ancestors', were an important part of family identity among Roman patricians, especially at funeral occasions (Polybius 6.53); if these were derived from the practice of taking wax-casts from a face in death, all the more reason to overlook the delegation of 'carving live faces from marble' to the Greeks (*Aen.* 6.848).

We shall draw the line accordingly and allow the (anonymously) Greek-made portraits of Romans to be objects of Roman art. Yet one example should be put forward to show what we are missing. It is a head now on display in the museum at Delphi (Figure 10.14), where it naturally attracts a fair degree of visitor attention – despite its disembodied state, and despite being surrounded by a wealth

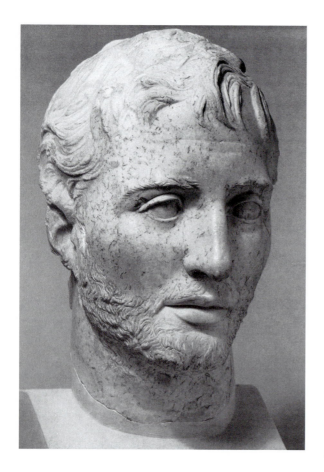

of high-quality sculpture of all sorts. A generic title has been granted to it – 'The Melancholic Roman' – although a proposed identification is also given, as the Roman general Titus Quinctius Flamininus. If so, then the impression of melancholy is at odds with the man's historical reputation. Triumphant over the Macedonian king Philip V at the battle of Cynoscephalae in 197, Flamininus was more than a successful soldier: he was adroitly diplomatic, too, which enabled him to put Greece under Roman control while apparently liberating the Greeks from Macedonian domination. At Delphi he was honoured as *proxenos* ('foreign friend'); salutations as *sôtêr* and *theios* were also forthcoming. 'Fairness' (*epieikeia*) and 'humanity' (*philanthrô-pia*) are the twin outstanding characteristics of Flamininus signalled by Plutarch; but one does not have to have read Plutarch's *Life* of Flamininus to recognize these traits in the face displayed at Delphi. If the lineaments of the young man's features – Flamininus was only 33 at the time of his triumph – show any sadness, it is not chronic melancholia, but rather an expression of empathy. *Clementia*, the capacity for mercy, would become one of the ideal virtues of a Roman emperor. Is it fanciful to see such virtue emanating from this portrait?

The identification of this head with Flamininus, proposed on the grounds of similarity with an eponymous coin issue, is not definitive: by the same numismatic mode of argument, Flamininus has also been mooted as the subject of a rather different portrait, the bronze nude well known as the 'Hellenistic Ruler' (now in the Palazzo Massimo, Rome). But suppose we put aside that problem of identity and focus instead upon the symbolic potential of the portrait. Granted that it conveys a certain distinct virtue – the quality of mercy, 'mightiest in the mightiest' – we should ask: how can images do this? What enables an abstract concept to be rendered visible?

This question applies generally beyond portraits: but a discussion of Graeco-Roman portraits seems like the natural place to seek an answer, because the literary and iconographic evidence from Classical antiquity points in a direction that seems like a branch of portraiture. This is the practice of personification.

Personifications: a selective survey

What the Greeks personified makes a heterogenous list. It would include states of being, such as 'Health' (*Hygieia*); emotions, such as 'Envy' (*Phthonos*); principles, such as 'Justice' (*Themis*); creative inspiration (the Muses); old age (*Geras*); and topographical entities – not to mention various phenomena we have already encountered, such as 'Victory' (*Nikê*). No satisfactory system of categories seems to hold here; but the practice was sanctioned by its early poetic application – notably Hesiod's *Theogony* – and has an obvious religious logic. If the Olympian deities could be personified – which is what happens in Homeric epic, and in the anthropomorphic development of 'cult images' alike – then it was natural enough to personify the attendant 'gifts' or attributes of those deities. So we find Aphrodite in company not only with *Eros*, but also *Himeros* ('Desire'), *Pothos* ('Yearning') and *Peitho* ('Winning Over', or 'Persuasion'). Many personifications became objects of cult worship; some take up abode with the Olympians (and one of the twelve Olympians, Hestia, 'the goddess of the hearth', is virtually a personification already).

THE MUSES

One may visit the 'Valley of the Muses', below Mount Helicon in Boeotia; even ascend to the Spring of Hippokrene, metaphorical source of poetic inspiration: and it is still a site suggestive of bucolic tranquillity. Scattered relics and inscriptions, however, are all that remain of what was once a sacred ancient 'theme park' dedicated to the local poet, Hesiod, and all who heeded the rhapsode's vocation (including Orpheus). Pausanias (9.28–31) found shrines and statues here, a *Mouseion* largely financed by Hellenistic monarchs (beginning with Philetairos, first of the Attalids) and Roman emperors. The nine named Muses themselves were envisaged by Kephisodotos and other sculptors; though eventually carried off to Constantinople, and destroyed there, these figures gave enduring shape to the Classical value invested in 'the arts' and intellectual curiosity at large.

Outside of cult activity, personifications had various uses. They were a gift to dramatists – appropriately so, when we call to mind the etymological fact that our word 'person' comes from the Latin *persona*, which originally meant a theatrical mask or stage identity. (It was a device developed in the so-called 'Middle' and 'New Comedy' of the fourth and third centuries that stock characters – the crafty slave, the raddled courtesan *et al.* – were made easily recognizable by a range of masks and stereotypical roles in a plot.) And we sense the histrionic utility of personification when Hellenistic philosophers, striving to make their metaphysical inquiries 'accessible' to a wider audience, resorted to theatrical metaphors. A renowned example of this is recorded of the Platonist Crantor in his contribution to the debate about what should be the prime 'good' for mortals to pursue: Wealth, Pleasure, Health or Courage? Crantor asked listeners to imagine a stage, upon which each of the four desirable possessions would appear and make a claim for pre-eminence (Sextus Empiricus, *Against the Ethicists* 51–9). All four are imagined as female figures, each winning applause and votes from the crowd in the theatre (in Crantor's view, Courage prevails – but the debate was not settled at that).

We know that one of the personified 'goods' here was already established as a cult image in Athens during the second half of the fifth century – this was Hygieia, worshipped on the Akropolis after one of the craftsmen at work on the Propylaea, having suffered a very serious fall, recovered his health (Plutarch, *Per.* 13.7–8; the base of the statue has been found). In this instance, Hygieia was represented in the guise of Athena. But in due time Hygieia would have an independent iconography (see p. 106). As the cults of personified entities proliferated, from the late fifth century onwards, sculptors were naturally required to provide suitable images.

The commissions were not easy. At Rhamnous, located where the territory of Attica looks over to the island of Euboea, a sanctuary to Nemesis, 'Retribution', had probably existed for a century or more when victory happened at nearby Marathon. The popularity of the cult was then boosted by an attribution of Persian defeat to the far-reaching power of Nemesis. The results of divine vengeance could be spectacular. But what did 'Retribution' look like? Artists might extract some idea from narratives attached to Nemesis: Hesiod made her a daughter of Night; other poets and dramatists emphasized her implacable nature; while by a tradition probably local to Rhamnous, Nemesis was claimed as the mother of Helen. This latter tradition gave something for sculptors to work with when, *c.* 425, a new cult statue of Nemesis was created as part of a rebuilding programme at Rhamnous: relief scenes on three sides of the rectangular base of the statue evidently explained how Nemesis related to Helen, Leda, Menelaos and others involved in the story (Pausanias 1.33.7–8; fragments of this relief survive).

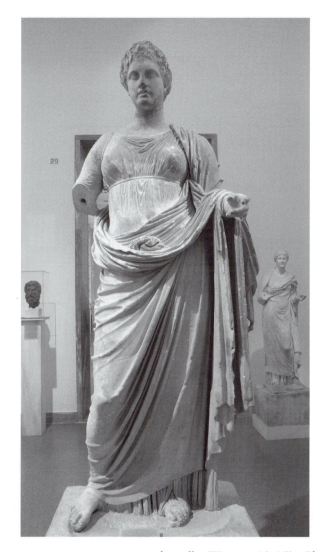

Figure 10.15 *Marble statue of Themis from Rhamnous, c. 300 BC. Ht 2.22 m. Found at Rhamnous in 1890, more or less in situ, an accompanying base attests Chairestratos as sculptor. The left hand will have held a pair of metal scales; the right, an offering bowl.*

But the figure of Nemesis herself remained a challenge. Pausanias was told it had been carved by Pheidias; a variant (and more credible) attribution is to a Pheidian pupil, Agorakritos of Paros. Either way, ancient visual references to the statue can do no better than show us a rather lumpen matron wearing a figured crown and extending a bowl or *phialê* with one arm. Disparate excavated remains show that the carving of the drapery was of high quality – all the same, a heavily draped matron, merely relaxing her right leg, seems not to evoke the quick and furious indignation associated with the Nemesis of poetry.

An honest assessment of personifications in Greek sculpture would conclude that the recourse to stolid, fully draped female figures became conventional, *ad nauseam* (to modern eyes, at least). At Rhamnous, the cult of Nemesis became joined with that of Themis, whose image was found, not badly damaged, in the temple *cella* (Figure 10.15). She is of course an archetypal precedent for every post-Classical figure of 'Justice' holding out a set of scales. But that does not detract from the conclusion that between Themis, Nemesis, Hygieia and others the differences of basic personification were not very conspicuous. And it is hard to resist seeing the same blandness in copies of the celebrated ensemble of Eirene ('Peace') cradling the infant Ploutos ('Wealth'), set up in the Agora following the cessation of hostilities between Athens and Sparta *c.* 375. The motif ought to be one of close nurturing, but Eirene's expression seems impassive and her gaze introspective.

But we must remind ourselves of the problems posed by representing personifications – and conclude this survey with mention of three valiant efforts to resolve them.

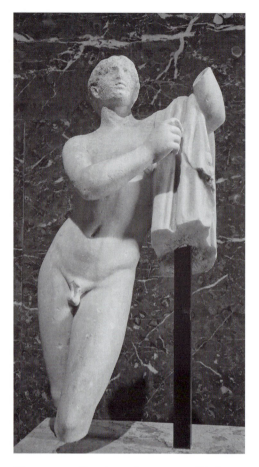

Figure 10.16 *Marble statuette of Pothos – one of forty-odd presumed versions made after an original by Skopas, c. 340–330 BC. Ht 85 cm. (Former restorations of this figure as Apollo have been dismantled.)*

Pothos Most of us know – all too painfully, it may be – the feeling known to the Greeks as *pothos*: the acute 'yearning' or 'longing' for someone or something, perhaps absent, perhaps unattainable. Deeply felt, however, does not equate to readily visualized. Who could *impersonate* the aching intensity of 'longing'? And yet Pothos was recognized, in cult terms, as a companion of Aphrodite, and a sculptor duly tasked with producing a statue of the emotion. Skopas of Paros rose to the occasion, for a group at Megara (seen by Pausanias: 1.43.6), and possibly also on Samothrace (Pliny, *NH* 36.25). From Roman adaptations of the piece, we cannot be sure if the Pothos of Skopas was leaning, almost at a 45-degree angle, against a central image of Aphrodite, or else some other prop. But the figure's very attitude is suggestive of a reaching-out for higher things. Its form is not hermaphroditic, but certainly androgynous, and 'soft'; the head, marked by an arching brow, is lifted as if to the heavens (Figure 10.16). Plato had signalled *megistos pothos*, 'the greatest longing', as symptomatic of the soul's wish to 'grow wings' and take flight from bodily imprisonment towards realms of immortality (*Phdr.* 252b); so it relates to what we loosely know as 'Platonic love'. How far Skopas may have been influenced by such metaphysics we can only guess. But as for the influence of his interpretation, it is not unlikely that the far-seeking gaze and tilted head of Skopas' Pothos should contribute something to the image of Alexander; Alexander's *pothos* for heroic conquests and accomplishments is repeatedly mentioned by his biographers.

Kairos 'Know the right moment' (*kairon gnôthi*) was one of the wise nuggets associated with Pittakos, ruler of Lesbos *c.* 600 BC. If the Greek *chronos* corresponds to our 'time', a fair rendition of *kairos* would be 'timing'. 'Occasion' and

Figure 10.17 *Fragmentary marble relief of Kairos from the Roman colony of Tragurium, on the Dalmatian coast (now Croatia), first century AD. Ht 45 cm. The figure balances a set of scales on the curved edge of a razor. The curious tonsure mentioned by Posidippus is clearly visible.*

'opportunity' are also possible – the concept, therefore, has many potential uses. The fact that an altar to Kairos existed by the entrance to the stadium at Olympia (Pausanias 5.14.9) may reflect a basic sense still familiar to us in sporting commentary – the sense of 'good timing' that a boxer or racing driver might possess. Ideologically it was an ideal adaptable to diverse philosophical purposes – Platonic, Stoic, Epicurean – and naturally there were political and military leaders who distinguished themselves by the ability to take a spontaneous decision. Themistokles was one; and it will not surprise readers to be told that Alexander showed, in Arrian's words, 'the most wonderful power of grasping the right course when the situation was still in obscurity'.

It may have been for Alexander's palace at Pella that Lysippos created a personification of Kairos, in bronze. At some point, the statue seems to have been transferred to Constantinople; but whether it stood in Pella, or at Olympia, or in the agora of Sikyon, is not established (and conceivably Lysippos made two versions). Needless to add, the original has vanished. But it is evoked in several later reliefs (Figure 10.17), suggestive of ingenuity on the part of Lysippos; and fortunately we have, once more, the poetic witness of Posidippus – who, as a younger contemporary, and mixing in court circles, possibly encountered Lysippos in person. Acquaintance with the artist is at least plausible from the tone and substance of the following poem by Posidippus – in which the poet takes on the role of exposition, as if standing by the statue and responding to a viewer's curiosity:

Whence the sculptor? – Sikyonian. – His name? – Lysippos. – And who are you? – Kairos, lord over everything. – Why do you stand on tip-toe? – I am always running. – And why do you have a pair of wings on your feet? – I fly like the wind. – And why do you hold a razor

in your right hand? – A sign to mortals that I'm sharper than any blade. – And why that hair over your brow? – To be seized by whoever meets me – by Zeus! – So why the baldness on the back of your head? – So that no one can catch me from behind, however much he desires to, once I have run past on my winged feet. – So to what end did the artist make you? – For your sake, stranger, he placed me in the entrance-hall, as a lesson.

A–B 142

The final sentiment of this unusual poem is crucial. Lysippos, it reports, intended the work as 'a lesson' (*didaskalia*). Yet the very fact that Posidippus feels obliged to supply an exegesis implies that the medium was not sufficient to carry the message: further explanation was necessary. If this was the case within the artist's lifetime, how much more would such intellectual intervention be required in later centuries? In due time, therefore, the fourth-century AD rhetorician Callistratus felt obliged to describe (imaginarily, perhaps) how he stood in wonder at the sight of the 'lifelike' statue – before some expert 'in artistic matters' (*peri tas technas*) stepped forward to expound the allegorical meaning of the piece (Callistratus 6.4).

Tychê In the Graeco-Roman world there was, as today, a widespread belief in the activity of 'Chance', which is one mode of translating the Greek *Tychê* or Latin *Fortuna*. The lexicon also offers 'what man obtains from the gods' – which leads naturally enough to the deification of Tyche Soteira, 'Saviour Luck'. Participants in a modern lottery may mutter prayers or fiddle with a rosary when they buy a ticket; however, we do not raise altars and temples to this goddess. In the Hellenistic world, most cities did just that. And for an apposite image, many followed the iconographic lead set for Antioch on the Orontes (now Turkish Antakya) *c.* 300 BC.

Alexander's death was fortuitous for some: that is one way of saying that his general Seleukos could count it as a piece of fortune to be in charge of Alexander's Babylonian territories in 323. This gave Seleukos a base from which to establish his own kingdom across Mesopotamia and central Asia. The city of Antioch – named in honour of Antiochus, son, co-regent and successor to Seleukos – marked the western extent of this kingdom. It was a 'new town', therefore with no ancient protective goddess to match (say) the role of Athena at Athens. So when the commission came to a pupil of Lysippos to create *ex novo* a talismanic image of Antioch's success, the opportunity for something new presented itself. The sculptor's name was, appropriately, Eutychides ('Lucky One') – and although his original bronze statue is gone, coin-issues of Antioch point to a recognizable type, much imitated and adapted by others (Fig 10.18).

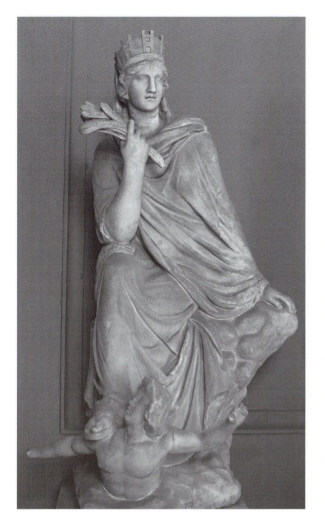

Figure 10.18 *The Tyche of Antioch: scaled-down marble version of a colossal bronze created for Antioch by Eutychides c. 300 BC. Ht 89 cm. The apparent likeness of the personified River Orontes to Alexander may be unintentional – or else an allusion to the fact that the Seleucid kingdom was built on the back of Alexander's conquests.*

Tyche was not a new concept: known to Hesiod, she was saluted as a 'saviour' by Pindar (*Ol.* 12.1–2) – and Pindar is credited, by Pausanias (4.30.6), as giving Tyche the role of 'City-carrying' (Pherepolis). A sixth-century sculptor, Boupalos, had fashioned an image of Tyche for Smyrna, reportedly showing a female figure carrying a 'horn of plenty' (*cornucopia*, or 'horn of Amaltheia' as it was also known). But it was Eutychides who elaborated the form into a sedate yet dynamic composition. Antioch's Tyche as reproduced in the Vatican carries a sheaf of grain, symbolic of prosperity; on coins it looks more like a palm branch, symbolic of victory; either way, it is a gift that the goddess chooses to bestow. Her headdress looks like the sort of pill-box crown that the Greeks might describe as a *polos* – yet it is clearly turreted, evoking city-walls, and in this respect assimilates to royal headgear known from the Assyrian and Hittite images. Such a combination of Greek and Near Eastern elements was entirely fitting for the Seleucid capital. And long after the Seleucids themselves had been displaced from power (by Pompey, in 64 BC), the icon of their tutelary spirit at Antioch continued to influence civic personifications – and transfer its pose not only to suit powerful women at Rome (such as Livia), but also the empresses of Byzantium.

Sources and further reading

The study of ancient portraits has received fresh attention since G.M.A. Richter's three-volume survey, *The Portraits of the Greeks* (London 1965) and its critical abridgement (by R.R.R. Smith, Oxford 1984): among recent contributions, S. Dillon, *Ancient Greek Portrait Sculpture* (Cambridge 2006); P. Schultz and R. von den Hoff eds., *Early Hellenistic Portraiture*

(Cambridge 2007); O. Jaeggi, *Die griechischen Porträts* (Berlin 2008); and S. Dillon, *The Female Portrait Statue in the Greek World* (Cambridge 2010).

'The mask of Socrates' This subtitle echoes (in homage) the title of Paul Zanker's extensive study, *The Mask of Socrates: The Image of the Intellectual in Antiquity* (Michigan 1995). For the Agora statuette (championed by Eugene Vanderpool), see J.M. Camp, *The Athenian Agora* (London 1986), 114–15. That a visual image of Socrates was generated prior to literary sketches is suggested in the course of L. Giuliani, 'Il ritratto', in S. Settis ed., *I Greci* (Turin 1997), vol. II, 983–1011; see also L. Giuliani, 'Das älteste Sokrates-Bildnis', in C. Schmölders ed., *Der excentrische Blick* (Berlin 1996), 19–42. J. Henderson (to whom we are indebted for describing Socrates' image as 'a thinking man's thinking man') leads a Puckish dance around ancient sources and modern scholarship in 'Seeing through Socrates', *Art History* 19.3 (1996), 327–53. Socrates as monkey: *AJA* 78 (1974), 427.

Selective exaggeration V. Bruce ed., *Face Recognition* (Hove 1991 = *European Journal of Cognitive Psychology* 3.1); G. Rhodes, *Superportraits: Caricatures and Recognition* (Hove 1996); with further comment in V. Bruce and A. Young, *In the Eye of the Beholder: The Science of Face Perception* (Oxford 1998).

Public portraits Much material relating to the protocols of claiming and being awarded a portrait-statue is collected in P. Gauthier, *Les cités grecques et leur bienfaiteurs* (Paris 1985); see also J. Tanner, *The Invention of Art History in Ancient Greece* (Cambridge 2006), 97–140 and G.J. Oliver, 'Space and the Visualization of Power in the Greek Polis', in P. Schultz and R. von den Hoff eds., *Early Hellenistic Portraiture*, 181–204.

Athenian worthies: Themistokles Martin Robertson's salutation of this head as 'the first true portrait of an individual European' (*A History of Greek Art*, Cambridge 1975, 187) indicates the willingness of scholars to accept an early fifth-century date for the original statue. **Perikles** Evidently the statue placed in the Propylaia was paired with an image of Perikles' father, Xanthippos – Pausanias 1.25.1. *cf.* K. Fittschen ed., *Griechische Porträts* (Darmstadt 1988), 377–91. **'Konon'** It is notoriously difficult to assign names of historical *stratêgoi* among the various disembodied heads that survive of the 'Athenian general type': a valiant attempt is made by G. Dontas, 'Bemerkungen über einige attische Strategenbildnisse der klassischen Zeit', in U. Höckmann and A. Knig eds., *Festschrift für Frank Brommer* (Mainz 1977), 79–92. **'Lysimache'** The case for associating the British Museum head (which is not unique) with the bronze statue seen by Pausanias (whose text is not perfect at this point) was made by Jan Six: *RM* 27 (1912), 83–5. The Akropolis base is not clear, but may support the claim that Lysimache served for sixty-four years. Doubts are raised about the decorum of showing a priestess so advanced in years – see J. Connelly, *Portrait of a Priestess* (Princeton 2007), 131 – and a mythical subject (Aithra?) for this head is possible. Yet if any piece warrants association with the reputation of Demetrios of Alopeke, this is it. See S. Pfisterer-Haas, *Darstellungen alter Frauen in der griechischen Kunst* (Frankfurt 1989), 101–5; and for Ernst Berger's conjecture about an accompanying body, 'Die Hauptwerke der Basler Antikenmuseums zwischen 460 und 430 v. Chr.', *AntK* 11 (1968), 67–70.

The case of **Menander** is instructive of (i) the methods for identification of ancient portraits and (ii) the history of a portrait-type in antiquity. See K. Fittschen, 'Zur Rekonstruktion grie-chischer Dichterstatuen. 1 Teil: Die Statue des Menander', *AM* 106 (1991), 243–79; O. Palagia, 'A New Interpretation of Menander's Image by Kephisodotos II and Timarchos', *ASAtene* 83 (2005), 287–96; and S.E. Bassett, 'The Late Antique Image of Menander', *GRBS* 48 (2008), 201–25.

The physiognomic factor The standard survey of ancient physiognomics is E.C. Evans, *Physiognomics in the Ancient World* (Philadelphia 1969); to which add M.M. Sassi, *The Science of Man in Ancient Greece* (Chicago 2001), 34–81; S. Vogt, *Aristoteles Physiognomonica* (Berlin 1999), esp. 45–107; and, for a fresh translation of the Pseudo-Aristotelian text, see S. Swain ed., *Seeing the Face, Seeing the Soul* (Oxford 2007), 637–61.

Alexander 'the Great' A huge literature exists – most of it collected, along with a useful compendium of ancient texts, in Andrew Stewart's *Faces of Power* (California 1993). B. Kiilerich, 'Physiognomics and the Iconography of Alexander', *Symbolae Osloenses* 65 (1988), 51–66, is pertinent to the discussion here. The problems of fixing iconographical consistency on the portraits of Alexander are well highlighted by Hans Lauter in W. Will and J. Heinrichs eds., *Zu Alexander d. Gr., Festschrift G. Wirth* (Amsterdam 1988), 717–43; for further ruminations, see the various contributions to J.O. Carlsen ed., *Alexander the Great: Myth and Reality* (Rome 1993); T. Hölscher, *Herrschaft und Lebensalter. Alexander der Grosse: Politisches Image und anthropologisches Modell* (Basle 2009); and A. Kottaridi *et al.*, *Herakles to Alexander the Great* (Oxford 2011).

After Alexander R.R.R. Smith, *Hellenistic Royal Portraits* (Oxford 1988); F. Queyrel, *Les portraits des Attalides*; P. Stanwick, *Portraits of the Ptolemies* (Texas 2003). On the Agora priest, see E.B. Harrison, *The Athenian Agora 1: Portrait Sculpture* (Princeton 1953), 12–14; I have quoted from T. Leslie Shear's earlier publication of the piece in *Hesperia* 4 (1935), 402–7. Roman discussions of *vultus* include Cicero, *De leg.* 1.19.27 and Quintus Cicero, *Comm.Pet.* 44; for the notion that a Roman wish for 'realism' licensed Greek sculptors to create portraits of 'heightened ugliness', see R.R.R. Smith, 'Greeks, Foreigners, and Roman Republican Portraits', *JRS* 71 (1981), 24–38. On Quinctius Flamininus, I have concurred with Fr. Chamoux, 'Un portrait de Flamininus à Delphes', *BCH* 89 (1965), 214–24, while remaining more sceptical of J.C. Balty's allocation of the 'Hellenistic Ruler' – in *MEFR* 90 (1978), 669–86.

Personifications Although chiefly concerned with vase-painting, Alan Shapiro's *Personifications in Greek Art* (Zurich 1993) is a useful introduction to the topic. See also B. Borg, *Der Logos des Mythos* (Munich 2002); E. Stafford, *Worshipping Virtues* (Swansea 2000); and E. Stafford and J. Herrin eds., *Personification in the Greek World* (London 2005). Literary, epigraphic and topographical evidence for the Muses is collected in A. Hurst and A. Schachter eds., *La montagne des Muses* (Geneva 1996). On the Pothos of Skopas, see A.F. Stewart, *Scopas of Paros* (New Ridge 1977), 107–10; fresh assessment of the sculptor by G. Calcani, *Skopas di Paros* (Rome 2009). On the Kairos of Lysippos, see P. Moreno, *Lisippo* (Monza 1995), 395–7; G. Schwartz, 'Der lysippische Kairos', *Graz.Beitr.* 4 (1975), 243–67; also L. Prauscello, 'Sculpted Meanings, Talking Statues', *AJP* 127 (2006),

511–23; and on Posidippus as poetic commentator on statues, see K. Gutzwiller ed., *The New Posidippus* (Oxford 2005), 183–205; E. Prioux, *Petits musées en vers* (Paris 2008), 159–252. On the Tyche of Eutychides, and similar figures, see S.B. Matheson ed., *An Obsession with Fortune: Tyche in Greek and Roman Art* (Yale 1994); E. Christof, *Das Glück der Stadt* (Frankfurt 2001) and M. Meyer, *Die Personifikation der Stadt Antiocheia* (Berlin 2006).

The early Roman poets had a word to describe their activity: it was vortere *– in English, 'to turn, or translate'. This was the technique which they applied to Greek plays; but it would give a very misguided conception of their activity to describe it as 'translation'. It was a peculiarly complicated form of adaptation, which accepted all the Greek conventions … but felt free to add elements of Roman custom and practice so that the end-product was neither Greek nor Roman but belonged to an imaginary half-way world, an amalgam of both civilizations.*

Gordon Williams,
Tradition and Originality in Roman Poetry
(Oxford 1968), 37

11

GRAECIA CAPTA

To plunder was an ancient right of war. Modern instances are not unknown – the British in Africa and China during the nineteenth century, Germans and Soviets during the Second World War – but these have been more in the nature of targeted reprisals. The original logic lay rather in the consequence of martial success. Taking an enemy's most cherished objects of self-definition and collective esteem was a symbolic act of incorporation, or – to put it more strongly – digestion. As victors of certain tribal disputes are said to make cannibalistic meals of the defeated, so the carrying-home of prize possessions may be thought of as a sort of predatory feast. Ceremoniously, the enemy is 'eaten up'.

This makes a rather crude overture to a chapter about the Roman assimilation of Greek sculpture, which – as already intimated – was a complex historical process, subject to increasingly sympathetic modern study. There was a 'cultural revolution' that accompanied Rome's dynamic growth from a pastoral settlement on the banks of the Tiber in the seventh century BC to domination of the Mediterranean and beyond when Hannibal's Carthage was destroyed in 146 BC: as we shall see, Greek sculptors were at work in Italy since the very beginnings of Rome as a city. Yet the narrative of plunder was how the original writers of Roman history chose to describe the 'reception' of Greek sculpture in Rome – as the rightful spoils (*spolia*, or *praeda*) of conquest. So let us start with that tradition.

A passage in Livy dramatizes the turning-point as the aftermath of the capture of Syracuse by the Romans in 211 BC, when the victorious general, Claudius Marcellus, as Livy is careful to record, 'came to a settlement, throughout Sicily, with such good faith and integrity that he increased not only his own glory, but also the respect for the Roman people'. Livy proceeds more sternly: 'But as for the ornaments of the city [*ornamenta urbis*] – the statues and paintings with which Syracuse was loaded – these he took off to Rome, as spoils of the enemy, rightfully gained by conquest. *That was the origin of our admiration for Greek works of art*' (25.40; italics added). Plutarch, in his *Life of Marcellus* (21), elaborates the point by claiming that Rome had been a rough and unlovely place, to which Marcellus brought Hellenic 'grace' (*charis*) with these 'beautiful dedications' (*kallista anathêmata*) from Syracuse.

Accounts remain rather indistinct about precisely what booty was seized from Syracuse: it seems to have included a certain amount of 'intellectual property', such as a pair of globes belonging to the scientist Archimedes (who had lent his expertise in the Syracusan resistance to a siege lasting three years); otherwise Livy (26.21) mentions only a quantity of military hardware and the 'trappings of regal opulence', including 'many distinguished statues' (*multa nobilia signa*).

This was, in a sense, a matter of course. For Syracuse was itself stocked with booty from aggressive raids on other cities. Under its tyrant Dionysios I, in the late fifth and early fourth centuries, Syracuse sacked not only sanctuaries belonging to Sicilian neighbours, but those of further Greek states, and of the Etruscans. And which state, throughout the ancient Mediterranean, could claim innocence in this respect? The treasuries at Olympia and Delphi were showcases of trophies gained by war. The Persians carried off works of art precious to the Athenians (notably the original Tyrannicides: see p. 26); the Athenians for their part made a conspicuous display of 'fine things' (*aristeia*) seized from the Persians. When the Carthaginians attacked the Greek colonial city of Akragas (Agrigento, southern Sicily) in 406, they, too, are recorded as having carried off 'all kinds of works of art' (*kataskeuasmata*). And as for Alexander, he is reckoned, during his Persian campaigns of 333–331, to have accumulated 180,000 talents of booty – equivalent to many billions in today's terms.

Polybius, the Greek historian who himself was something of a Roman prize – taken prisoner after the battle of Pydna (167 BC) – registered the elegiac effect of seeing once-treasured objects in foreign hands (9.10.7–10). But the melancholy of a Greek observer may be balanced by the indignation of a Roman traditionalist who took no glee in the arrival of these same objects. Livy (34.4.4) reports the arch-Republican Cato's response to the *nobilia signa* carried off by Marcellus: 'Mark my words, those statues brought from Syracuse to this city are dangerous. Altogether too many people I now hear praising and admiring the ornaments of Corinth and the Athenians, and laughing at the terracotta antefixes of the Roman gods.'

There is probably an element of retrospective moralizing on Livy's part. The Elder Cato (234–149) embodied a parcel of values that had made Rome 'great': hard work, thrift, simplicity and, of course, a pride in the sort of collective discipline that sustained Roman triumphs over opponents on the battlefield. 'Art' was made by wily Greeks with nothing better to do – and collected by effeminate monarchs with more money than sense. Echoes of similar inverted snobbery may be heard in many and various Roman sources: we may content ourselves with just two examples. Julius Caesar, addressing his troops on the eve of battle with the forces mustered by Pompey, draws attention to the ethnic origin of the enemy – Greeks, 'recruited from the gymnasia, scarcely able to carry their weapons' (Luc. 7.270–2): the implication being that Greek athletic narcissism was no match for Roman hardness in the field. Then there is the declaration of faith from Julius Frontinus, a man with military experience, but also a hydraulic engineer, *curator aquarum* to Nerva and Trajan. In the course of his practical treatise

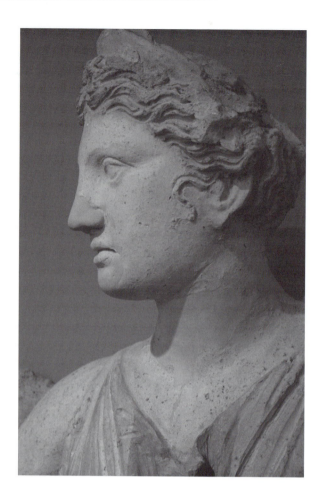

Figure 11.1 *Detail of a female deity from the terracotta pediment found near Via di San Gregorio; probably from a temple to Fortuna, located on the triumphal route between the Caelian and Palatine hills. Mid second century BC.*

about the Roman water-supply, *De aquis* (1.16), Frontinus takes a gibe at the Egyptians, with their magnificent, redundant pyramids – and all the useless 'yet widely celebrated works of the Greeks' (*cetera sed fama celebrata opera Graecorum*). How did a statue, for all its 'beauty', assist in the provision of reliable ablutions and clean drinking-water to an urban populace?

Such sentiments make a context for the well-known verses of Vergil – whose hero Aeneas, when shown the course of future Roman greatness by his father Anchises, is warned that it would be a mistake for the Romans even to attempt the art of sculpture. 'Others shall beat more delicately the breathing bronze, coax living faces out of marble' (*vivos ducent de marmore voltus*: *Aen.* 6.847–8); the Romans' destiny lay with the creation of empire (*imperium*). But what was the indigenous *status quo* for diehards such as Cato?

As it happens, archaeologists routinely attribute the making of terracotta sculpture in Archaic Latium and Etruria to émigré Greeks (*cf.* p. 80); but, putting that nicety of scholarship apart, we can point to examples of the sort of 'home-grown' fictile revetments and statuary Cato may have had in mind when expressing his *caveat* about the influx of bronzes and marbles from Syracuse, Corinth and Athens. Pieces of a polychrome pediment of the second century now reassembled in the Capitoline Museums (Figure 11.1) show what would become a typically 'Roman' subject: a scene of sacrifice, in honour of Mars, featuring muscular *victimarii* (stewards); above this, an *akrôtêrion* of Hercules wrestling with a sea-monster. The workmanship is perfectly competent and attuned to Hellenistic style – only the medium, and possibly the subject, might have seemed a little strange to some visitor from the eastern Mediterranean. The same might be said of the volcanic stone figures surviving from a second-century 'triumphal' shrine or funerary monument on the Via Tiburtina, where the

Figure 11.2 *Head of a figure carved in volcanic stone ('peperino'), from a shrine or funerary monument on the Via Tiburtina, second century BC. Ht 35 cm.*

sculptors were clearly at home with the style of Skopas – only eccentric in their choice of stone (Figure 11.2).

The testimony of these and similar finds suggests that it may not be easy to define an ideological schism between those Romans who shared Cato's suspicions of Greek art ('Catonians') and those who, like Cicero, became fascinated enthusiasts and collectors of Greek art ('Connoisseurs'). This chapter carries a selective survey of the ways in which the conquerors were – to borrow an over-used, still irresistible Horatian apophthegm – themselves 'conquered'. But if we now turn to the most celebrated legal case regarding Greek sculpture in a Roman context, we may notice that the *principle* of admiring – indeed coveting – Greek art is not at stake – only the practice.

The Verrine controversy It is recorded somewhat mordantly (Vell. Pat. 1.13.4) that when Lucius Mummius, the general who oversaw the destruction of Corinth in 146, was organizing transport of booty back to Rome, he cautioned his troops that if any item were damaged, it would have to be replaced. So far as such anecdotes are credible, the concept of an absolute masterpiece was not yet established – at least in the mind of this uncouth commander. A subsequent Roman general, Sulla, campaigning in Greece against Mithridates VI in the early first century BC, was more cynical. Plutarch (*Sulla* 12.3) reports that Sulla, to fund his army, stole treasures from Epidauros, Olympia and Delphi. When priests at Delphi protested, claiming that Apollo's lyre had been heard in the sanctuary, a sign of divine distress, Sulla flippantly retorted that this was proof of the god's contentment, not anger; he would accordingly carry off more. Sulla's actions, and his sack of Athens in 86 BC, have been hypothesized as the reason why statues were aboard a ship that went down off the island of Antikythera (the wreck located by

sponge-divers in 1900); also for the so-called 'Piraeus Apollo' (see Figure 2.18), which may have been already crated for deportation when evidently caught in a fire at the port of Athens *c.* 86 BC.

No charges were brought against Sulla, the first self-proclaimed Roman *dictator*. It was one of Sulla's favourites, Gaius Verres, who later incurred legal proceedings on account of plunder and appropriation: first while a legate in Cilicia, then during a term of governorship in Sicily (73–70). Up till then, Verres might have counted himself a lucky, if crafty, man. And he might still have thought himself lucky when learning that his prosecutor was a relatively inexperienced young barrister called Marcus Tullius Cicero. In the event, the trial had hardly begun before Verres absented himself – presumably because the weight of testimony against him was so incriminating that even a partial judge would be obliged to pronounce him guilty. So Verres took exile in Marseilles, while Cicero – who as part-time detective in Sicily had assiduously collected such irrefutable evidence – found himself, after a mere nine days in the courtroom, with a number of carefully crafted tirades still to deliver. Veterans of classroom Latin lessons may not be grateful for it, but Cicero chose to publish these speeches. In doing so, he bequeathed to the world the first moral discussion about 'cultural property'.

The principal charge against Verres was one of extortion – to the tune of 40 million sesterces from his time in Sicily. Here was a man who lost no opportunity to enrich himself while in a position of power, whether controlling the corn supply or ordering columns for a temple in the Forum Romanum. But Cicero's most sardonic attacks are reserved for the misbehaviour of Verres as an art-collector. We learn that when Verres descended upon Aspendos in Pamphylia, not a single statue escaped his greedy trawl. He plundered the Samos Heraion; in addition, Chios, Erythrai and Halicarnassos. As for his Sicilian governorship, it left many cities and private individuals short of their cherished possessions. Regional dignitaries were obliged to be hospitable. But the great danger of inviting Verres to dinner was that if he himself did not walk away with the relief-decorated silverware, his henchmen would call round the next day to carry it off – and anything else that had caught the governor's eye.

How far Verres differed from other provincial rulers in this respect is hard to say. What Cicero charges against Verres is that beyond the flagrant theft of art, he acted against Roman interests – by including Rome's allies, such as Antiochus of Syria, among his victims, and by keeping his thefts to himself – instead of making proper inventories of that he had taken and passing a proportion to the public chest. (For military spoils, the expectation was that a certain number, the *manubiae*, were reserved for public benefit.)

Verres' collection of artworks – which he appears to have taken with him to Marseilles, for, several decades later, he was asked to yield up some Corinthian bronzes to Mark Antony and then was put to death for refusing to do so (Pliny, *NH* 34.6) – included statues by Myron, Polykleitos and Praxiteles. These belonged to one Gaius Heius of Messina, who (it seems) had been a *negotiator* based on the island of Delos – centre of the Mediterranean slave-trade during the late Republic. Had the trial continued, Cicero was poised with some withering denunciations of Verres' predatory greed for these sculptural prizes. But would a jury have been entirely convinced? Cicero admits that Verres acquired these masterpieces by purchase, only at a ridiculously low price, and adds that Heius had inherited the statues. With long-range hindsight, though, we may wonder how such pieces came into Roman possession at all. The bronze by Myron was an image of Herakles; the statues by Polykleitos were a pair of *kanephoroi*, maidens carrying baskets; and the Praxitelean piece was a marble Eros, comparable to his Eros at Thespiai (p. 204). All were presumably once dedicated in some Greek sanctuary or other. The fact that Heius exhibited them in a *sacrarium* open to visitors may attest to the owner's *pietas* and *humanitas* – but his rights of ownership are not questioned. It is tempting to suspect that Cicero was irked by Verres' brazen success in building up a collection of a quality to which Cicero himself aspired.

Letters from Cicero to Atticus – a close Roman friend who had moved to Athens – testify to the particular *desiderata* of a Roman 'Connoisseur' in the mid first century BC. Moderately prosperous, and with a number of properties to furnish, Cicero requested Atticus to procure for him the right statues for particular parts of a house and its grounds: library, portico, gymnasium and so on. Decorum was the paramount consideration (Cicero resorts to the Greek word *oikeios*, 'in the house', in its sense of 'proper to place': *Att.* 6.3). While Cicero, who had spent time in Athens as a student, seems to have possessed a good working knowledge of the 'Classic' Greek sculptors and their styles (he only pretends not to, for the sake of courtroom drama, in *Verr.* 4.2.4), his instructions to Atticus rely upon a soulmate's intuition in choosing artworks that would befit an owner aware of their significance. A figure of Athena, or portrait of Plato, is suitable for Cicero's studious retreat; some scene of a Dionysiac *thiasos* is not.

Collectors were of course constrained by what was available. The considerable quantity of bronze and marble statues recovered from the Villa dei Papiri at Herculaneum – which may well have belonged to L. Calpurnius Piso, another victim of Cicero's invective – indicates little more than a philhellene owner: it is hard to reconstruct any specific interest or 'programme' from the assemblage

(though ingenious attempts have been made). Nonetheless, Cicero's insistence upon acquiring the right subject for a particular place of display warns us not to think of Romans as 'collectors' in the modern sense. For Cicero and his contemporaries, Athena may be known as Minerva, but she is still a divine force; Apollo presides at Delphi; and Troy at last belongs to its rightful inhabitants – the descendants of Aeneas. The Verres case brought into sharp relief the problems of codifying the practice of transferring 'cultural capital' between Greece and Rome, yet it also underlined the essential continuity of symbolic value. So the very worst crime committed by Verres is, in Cicero's eyes, the abduction of an ancient cult statue of Ceres from her sanctuary at Henna (*Verr* 2.4.105–8). Demeter as was, Ceres as is: for Cicero, the statue may be *antiquissima*, but the cult was alive as ever.

'Captive Greece made captive her wild conqueror'

Graecia capta ferum victorem cepit et artis intulit agresti Latio: Horace, summarizing the process of how Greece culturally colonized Rome, 'and brought the arts to rustic Latium' (*Ep.* 2.1.156–7), plays nicely on the nuances of the verb *capio* – entailing seizure by military force, and to 'take hold of, delight, charm, captivate' – and also echoes a trope known to Cicero. Referring to the art of eloquence generally, Cicero had declared, 'we were conquered by conquered Greece' (*vincebamur a victa Graecia*: *Brut.* 254). Horace too makes his comment with an eye to literary culture; and it may be worth noting that Cato had no more time for 'fancy' foreign rhetoric than he did for Greek works of art. But the sentiment is borrowable, and its metaphor is equally significant whether applied to poetry or sculpture. There was a struggle: and Rome conceded to Greek superiority.

For Horace and his contemporaries this could be pronounced a gracious surrender. Less than a century after Sulla's impudent raid on Athens, Augustus was following the lead of his adoptive father Julius Caesar and embellishing the same city – including restoration of the Erechtheum and the endowment of a neat Ionic circular temple close to the Parthenon, dedicated to the cult of Rome and Augustus; the city authorities hailed him *Sebastos Sôtêr*, 'Augustus Saviour'. Athens, then, was 'Romanized' – but not half so thoroughly as Rome was Atticized.

By way of epigram Augustus declared that he found Rome built of brick and left it made of marble. This was an exaggeration: the general Metellus Macedonicus, who (as his name indicates) was victorious over Macedonian forces, in the mid second century, had created a marble temple within a squared

colonnade, the Porticus Metelli, by the Circus Flaminius – which was the work of a Greek architect, with Greek sculptors also involved. So marble was not unprecedented; it was, we may say, part of the triumphal process. From his Macedonian campaigns, Metellus had seized a substantial bronze ensemble by Lysippos, showing Alexander and his cavalry 'Companions' in action: once a commemoration of high-level casualties at the battle of the Granikos (334), this had been ordered by Alexander for the prime Macedonian sanctuary at Dion, below Mount Olympus. Now it was installed in a colonnade between the Campus Martius and the Tiber, where it became a symbol of Rome's assumption of Macedonian power. Still, it was typical of Augustus that he rebuilt the portico, in honour of his sister Octavia – and retained the statues, with the insinuation that he was a second Alexander.

As a city, Rome might now claim to rank with the likes of Alexandria. Ideologically, perhaps, the vaunted transformation from brick to marble served to persuade Romans that they were living in the intellectually elevated atmosphere, even the democratic style, of Periklean Athens. If that was mere illusion, the integrity of the Augustan project remains impressive. And Greek sculpture formed a conspicuous part of the whole design.

On stylistic grounds it is clear that prominent Augustan monuments, such as the *Ara Pacis*, were assigned to Greek or Greek-trained sculptors. The names of sculptors mentioned in Latin sources are invariably Greek; from the mid first century BC, for example, we are told of Arkesilaos, Pasiteles, Stephanos and the sons of Polykles; and where works are signed, the signatures are Greek – with further information directed at viewers literate in the language (so a certain Menophantos, inscribing the base of an image of Aphrodite, specifies that it is 'after the Aphrodite in the Troad' – perhaps indicating, if inaccurately, the Knidia).

Pasiteles, who came from Magna Graecia, was evidently an active practitioner of the ideal of faithfulness to nature. It almost cost him his life: for down in the docks of Rome, where African beasts were being unloaded for the circus, he was making studies of a lion at close quarters when a panther got loose from a cage and mauled him (*NH* 36.40). Pliny's praise of him as 'the most conscientious [*diligentissimus*] of artists' sounds slightly damning, at least if *diligentia* is reckoned as not equivalent to the Greek *akribeia* – but may be explicable by the reputation Pasiteles earned for compiling a five-volume tome on 'the World's Great Masterpieces'. Pasiteles himself was said to be highly versatile: yet could he match the *nobilia opera* of the past? Would he deserve mention in the same breath with Praxiteles and Polykleitos?

Magistra Graecitas, 'authoritative Greekness', could be an onerous presence. But our habit of referring to 'Roman copies' of 'Greek originals' misleadingly implies a mechanical dependence. Admittedly, the tell-tale signs of a marble statue following

a bronze prototype can be distracting: for extra supports have to be introduced to stabilize the piece, and some of these – such as the palm tree growing into the side of an athlete's thigh – can look (to us) preposterous. At the same time, the conspicuous struts on nude portrait statues of eminent Romans help to emphasize that these are *statues*. There is evidence, as noted (p. 137), that plaster casts of Greek statues were available to sculptors' workshops during the Roman period, perhaps for occasions when exact replicas were indeed wanted – such as the Tyrannicides, of which a group was set up on the Capitol in the first century. But it is not clear that absolutely accurate copying techniques were often deployed, or desired, in Roman times. So it is that while Latin sources speak of the canonical Polykleitan Doryphoros (p. 39) as an ideal model for sculptors – using words such as *lex, magister, exemplum* – no amount of measuring from the many Roman 'copies' of this statue-type will restore to us the precise dimensions of the original.

A heightened sensitivity – on the part of modern scholars – to the 'power of images' in the age of Augustus can only increase our reluctance to disparage Roman 'captivity' to Greek art. *Nobilia opera* indeed played their part: but they were not simply exhibited as trophies of antiquarian interest and 'good taste'. Close to the Porticus Octaviae, for example, stood a temple of Apollo, with fifth-century origins, which under Augustus was thoroughly reconstructed (the expense seems to have been met by one Sosius, an erstwhile supporter of Mark Antony perhaps anxious to ingratiate himself with the *princeps*). Sculptures on the pediment, showing Herakles and Theseus against Amazons, were original Greek work of the same period as the temple's foundation – furthering the impression that Augustus had 'twinned' Rome with Athens; while inside the temple were choice allusions to Apollo's power and patronage. These included a group of the nine Muses by Philiskos of Rhodes; Apollo Kitharoedus by Timarchides; and Niobids by Praxiteles or Skopas. Augustus himself occupied a *domus* on the Palatine adjacent to another temple of Apollo; and few Romans could be unaware that it was within sight of Apollo's temple near Actium that victory had been achieved in 31 BC.

So we can begin to comprehend the force of Cicero's *desideratum* for statuary that was 'fitting' for Roman display. And although the archaeology of Greek sculpture in Rome has an uneven history, there is scope for reconstructing some fractional notion of how statues were distributed in 'the urban landscape' – which is not, for Rome, a contradiction in terms.

Sculptures in the *horti*

The Augustan poets may have spent many hours in a building discovered on the Esquiline in 1874 and known as the 'Auditorium of Maecenas'. So much is idle speculation – brought on by

the delicate paintings on the walls of this apsidal structure, complete with learned graffiti (a citation of Callimachus, on the effects of wine and love – *AP* 12.118). But no one doubts that it belongs to the estate known as the Horti Maecenatis, 'the gardens of Maecenas'; and although Maecenas remains a shadowy, powerful figure in the Augustan regime, the refinement of his 'taste' is not only apparent from the poetry he coaxed from his *protégés* – Horace, Vergil, Propertius – and the peacocks painted on his walls, but also the pieces of sculpture recovered from the grounds of his estate.

With the obligatory caution that the estate was passed on to others, including M. Cornelius Fronto in Hadrianic times, and beyond the obvious 'ambience' portraits of poets and philosophers, some sympathetic guesswork about motives and meanings can be attempted. Take, for example, the figure of the 'Hanging Marsyas' found not far from the 'Auditorium' (Figure 11.3). The basic story of Marsyas was articulated in the fifth century: Athena picked up a set of pipes and tried to play them; on seeing how they puffed out her angular cheeks, the goddess threw them down in disgust; whereupon the Phrygian satyr Marsyas picked them up and taught himself to play well – so well that he was emboldened to challenge Apollo to a musical contest. Myron choreographed a group enacting the first part of the story. The sequel was left to some Hellenistic, perhaps Pergamene, sculptor: to show how Marsyas, losing to Apollo, paid the price of defeat by being flayed alive. Later representations of this unpleasant event (Figure 11.4) indicate that an ensemble included Marsyas, suspended for punishment; a crouching Scythian, sharpening his knife to peel away the satyr's skin; and perhaps a seated Apollo, exacting the pain.

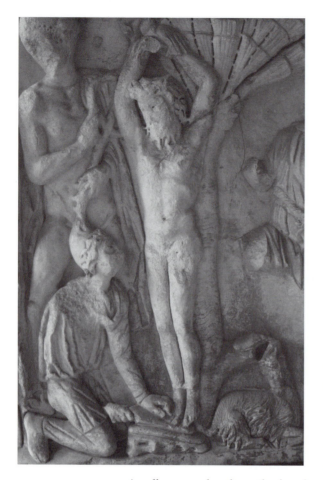

Figure 11.4 *Detail of a late antique sarcophagus showing the Punishment of Marsyas.*

Did Maecenas once link arms with Horace and the two of them meditate on the lessons of the myth? This version of 'Hanging Marsyas' was surely never painted, for it makes such adroit use of a violet-stained marble (*pavonazzetto*) – sourced from Phrygia, appropriately enough – and regardless of whether other figures were part of the group, the viewer's attention is drawn towards the corrugated features of the suspended satyr. Presuming to compete with Apollo, his insolence made valid his horrific end. And yet, as tradition maintained (Pausanias 10.30.9), Marsyas was a local hero in Phrygia, having used his flutes to help repel the Gauls. His flayed hide was a relic exhibited at Kelainai (Herodotus 7.26), as if testament to some great deed. So it may be that his image furnished a lesson about the risks of artistic genius. (Ovid, whose offence against Augustus/ Apollo earned only exile, but lamentable nonetheless, would have understood; and the agonies of Marsyas were graphically evoked by him – *Met.* 6.387–91.)

The customizing of Greek art to Roman taste is likely to have been a pragmatic process. We do not know, for instance, which Greek temple yielded figures pertaining to another story of Phrygian *hubris*, the Niobids – children of Niobe, daughter of Tantalus – shot down because their mother boasted that her maternal fecundity was superior to that of Leto (whose own offspring, Apollo and Artemis, carried out the massacre). One suggestion is that the pediments of Bassae once hosted such an ensemble; another that the temple of Apollo Daphnephoros at Eretria carried the theme. Niobids may also have formed a pendant pediment to the Amazonomachy adopted for the temple of Apollo Sosianus. In any case, images of dying Niobids found their way into the gardens of Sallust, where again they offered an *exemplum* of Apollo's wrath (Figure 11.5). This estate, like others, has an interesting history: laid out by the historian Sallust and passed on to his

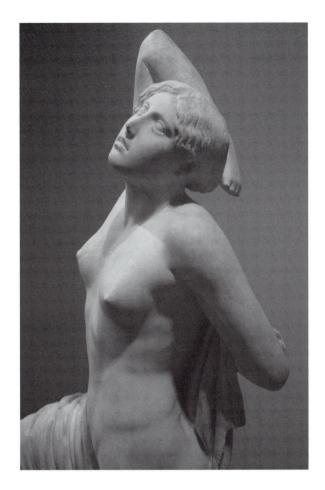

adoptive nephew C. Sallustius Priscus, it eventually came into imperial ownership (Tiberius) – but not before Sallustius Priscus had made amends, it seems, for his affiliation with Mark Antony by commissioning a monument celebrating victory at Actium, featuring a colossal robed Apollo, and a frieze of acanthus volutes and sphinxes. A Dying Niobid would complement this pro-Augustan intention very nicely – wherever it came from.

The term *horti* will be translated as 'gardens' – but that is understated. True, an aristocratic *hortus* could be productive of flowers, fruit and vegetables; above all, however, it was a retreat from urban hustle – typically, an area of greenery landscaped with terraces, porticoes, fountains, grottoes and nymphaea. All of these features were hospitable to statuary; and even bushes and trees could become the settings for more or less important *objets d'art*. The fashion for creating such sculpture parks was already developed in the late Republic – as we have noted in respect of Cicero's collecting habit – and it persisted through until the third century AD, despite risks to both private individuals (of incurring imperial envy) and emperors themselves (of incurring public resentment). No one has yet done the calculus of how much that we know about Greek art is due to this Roman practice. But if we consider that Pliny, when compiling his *Historia Naturalis* (*c.* AD 70), was in large part writing for those Romans who were proprietors of or regular visitors to such open-air museums, the tallies will be significant.

To what extent the aristocratic *horti* were open to general viewing is debatable. Some proprietorial pride in making a memorable 'museum' is indicated by various literary and historical allusions: from Pliny, for instance (*NH* 32.33), we learn that Asinius Pollio, better known as a late Republican patron of books and writers, sought to create a show at his home by installing a dramatic, complex group that represented the fatal punishment of Dirke by the two founders of Thebes (Figure 11.8). Powerful

ORNAMENTA GYMNASII

Whether the Romans practised athletics in quite the same way as the Greeks is debatable; at least the Panhellenic Crown Games continued, with some emperors (Nero was one) promoting Roman participation. Regardless of their commitment to athletic disciplines, however, there is no doubting the Romans' penchant for statues of Greek athletes as *ornamenta gymnasii* – decorative of baths, swimming-pools and exercise areas, and setting the tone for strenuous endeavour (Figures 11.6 and 11.7; Plate VII).

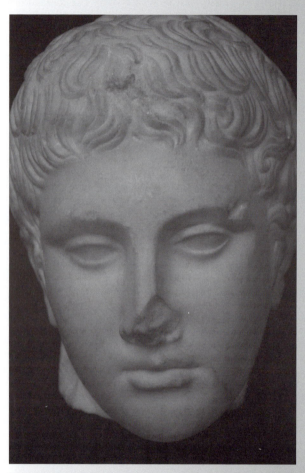

Figure 11.6 *Head of an athlete (found in excavations for the Via dei Fori Imperiali), first century AD. Ht 22.5 cm. After the so-called 'Westmacott' type created by Polykleitos.*

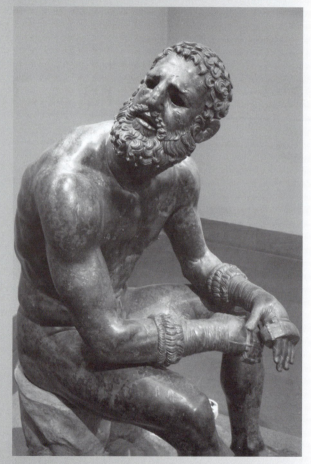

Figure 11.7 *The Terme Boxer: bronze original (with copper inlays for face wounds) from the Hellenistic period (c. 200 BC), found in the ruins of the Baths of Constantine in 1885. Ht 1.2 m. Among the excavators was Rodolfo Lanciani: 'I have never felt such an extraordinary impression as the one created by the sight of this magnificent specimen of a semi-barbarian athlete, coming slowly out of the ground, as if awakening from a long repose after his gallant fights' (R. Lanciani,* Ancient Rome in the Light of Recent Discoveries *(London 1888), 305–6).*

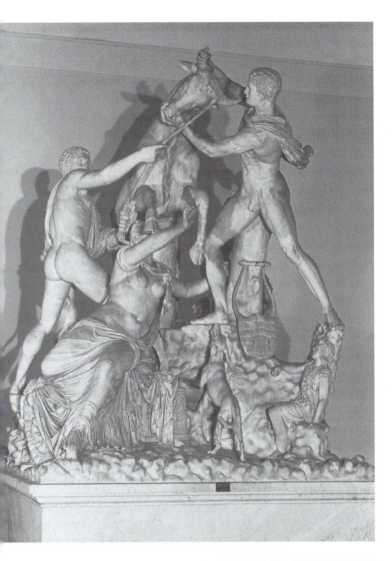

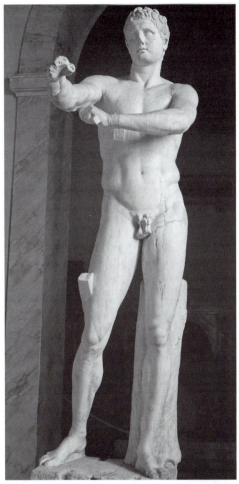

Figure 11.9 *Marble version of the Apoxyomenos ('the Scraper') by Lysippos, from Trastevere. After an original of the late fourth century BC. Ht 2.05 m. This must be related to the image of an athlete using a strigil (destringens se) mentioned by Pliny (NH 34.19).*

Figure 11.8 *The Farnese Bull: marble ensemble representing the punishment of Dirke by Amphion and Zethus, the sons of Antiope (for the story, subject of a tragedy by Euripides, see Apollodorus 3.5.5). Ht 3.7 m. Whether Pollio owned a Pergamene version or this very piece (probably of Rhodian origin, subsequently elaborated) is debated. It was found in the palestra of the Baths of Caracalla in 1545.*

individuals may have imposed their own taste very directly: it is not fanciful, for example, to wonder if the Laocoon Group (see p. 244) might have been commissioned by Nero, whose personal interest in the subject of the fall of Troy remains notorious.

An *opus nobile* could become public property: so much is evident from the story about the bronze original of the so-called Apoxyomenos by Lysippos, which was placed by Agrippa in front of his eponymous *Thermae* – the first of the large public

bathing establishments in Rome. That the image of an athlete scraping himself after a 'workout' was suitable for such a building is clear enough; that (at least after Agrippa's death in 12 BC) the Roman people considered the statue theirs is indicated by Pliny's report (*NH* 34.62) that when Tiberius took a fancy to the statue, and had it removed to his own bedroom, a collective protest forced the emperor to restore the statue to its former situation (Figure 11.9).

Tiberius, however, had further opportunities to indulge his own taste in Greek sculpture – if the finds from Sperlonga are, as widely supposed, part of his villa there.

The Sperlonga sculptures

It was in September 1957 that roadbuilding along a stretch of coast between Rome and Naples led to the discovery of a hoard of ancient artefacts within a large cave. This cave was very close to the shoreline, and sea water was channelled into it, as part of an architectural complex suspected to be the villa-retreat of Tiberius described (by Roman sources) as located *ad speluncas* – near today's resort of Sperlonga. The site has been associated with a dramatic episode in the life of Tiberius: rocks began to fall while the emperor was at dinner, and his henchman Sejanus heroically intervened (Tiberius subsequently created his more notorious villa on the island of Capri). A more serious collapse did not occur until the eighth century AD, sealing the entrance. Among the thousands of fragments of marble statuary recovered from the cave are several marble *tableaux* that seem to have decorated the interior of an imaginative dining-area plausibly attributed to Tiberian sponsorship *c.* AD 20 – and including an inscription naming Hagesandros, Athenodoros (or Athanodorus) and Polydoros – apparently the same trio as credited by Pliny with the Laocoon.

The inscription is attached to a group, once set in water, showing the prow of a ship beset by a marine monster answering to the

Figure 11.10 *Fragments of the Rape of the Palladium Group from Sperlonga. The face of Diomedes, though poorly preserved, is a mask of fearful apprehension, while his hand powerfully grips around the breasts of the xoanon of armed Athena.*

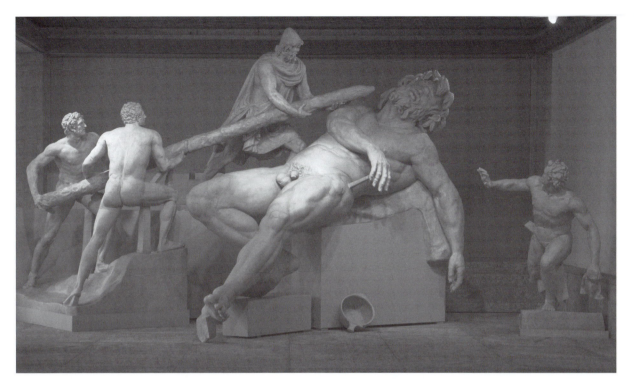

description of Scylla, the monstrous scourge of sailors trying to avoid the whirlpool of Charybdis (*Od.* 12.85–101). As the ensemble has been reconstructed, Scylla, flourishing the ship's rudder with her left hand, grips and twists the cranium of one mariner (the steersman, perhaps) with her right, while her six extensions, ending in the shape of ravening dogs, tear at others of the crew.

Odysseus, whose figure is conjectured to belong above this *mêlée*, appears to have been armed, but there is nothing he can do to help, and the Homeric text specifies that Scylla is fated to take her half-dozen toll.

Further groups seem to represent other adventures of Odysseus: his daring seizure, with Diomedes, of the Palladium – Troy's archaic image of Athena, eventually retrieved, via Aeneas, to become a Roman keepsake (Figure 11.10); his rescue of the body of Achilles – at least in the version of the story retailed by Ovid (*Met.* 13.279–88); and, as the most ambitious and most apposite piece within the grotto, a sculptural enactment of the ruse whereby Odysseus and his followers escaped confinement in the cave of a one-eyed, man-eating monster – the Cyclops Polyphemus (Figure 11.11).

For all that this group relies heavily upon 'Pergamene' style and borrows flagrantly from other statues (Polyphemus, with conspicuously hairy toes, and

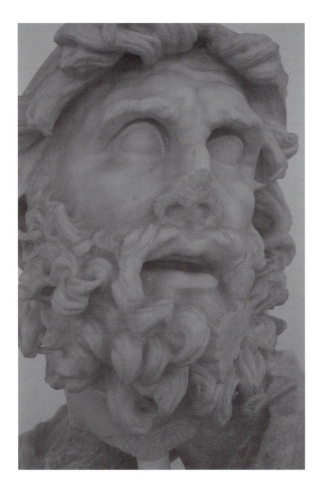

caught in the troubled sleep of drunkenness, is nicely described as a 'big brother of the Barberini Faun' – see Figure 12.8); for all that an element 'worthy of Disneyland' (as one scholar puts it) pervades this, and the entire project – one could claim that the aims of Greek sculpture since the Archaic period have been fully realized here. It is a fantastic story, but (in keeping with the spirit of Homer and *Odyssey* 9) is realized in a thoroughly naturalistic way. The location is already provided; Polyphemus, sprawled out on goatskins, his wine-cup knocked away by a flailing left arm, is appropriately brutish and col-ossal; and the viewer instinctively identifies with the lifesize figures of Odysseus and his companions – especially with the figure in the foreground, who, clutching a leather wine flask, recoils in terror. Odysseus, his pointed shep-herd's cap emphasizing his position at the apex of the composition, must guide the heated point of the stake into the giant's single eye: his proximity to the Cyclops therefore signals his courage. Fortunately, the head of Odysseus survives relatively undam-aged – and has justly become a defining image of the hero (Figure 11.12).

That these four groups devised by the three Rhodians share a thematic unity with other sculptures at this site is highly probable. A smaller-scale marble group appears to show the enchantress Circe, dressed like a *hetaira*, with several of Odysseus' companions transformed into pigs. That Tiberius – whose personality, marked by *calliditas* ('cunning'), tended to find in Odysseus/Ulysses a 'parallel life' – personally commissioned the theme is very possible. It is also tempting to believe that Tiberius, by reputation an active pederast, had something to do with the placement, above the entrance of the cave, of the figure of Ganymede, caught just at the moment of 'take-off' with an eagle perched on his back. And if, as a number of scholars suppose, the theme was guided more by the writings of Ovid than by any Greek epic, then we have at Sperlonga an outstanding case of sculpture that deserves to be meaningfully classified as *Graeco-Roman*.

Hadrian's Antinous

A similarly significant hybrid is implied by the fame of a Roman emperor so transparent in his predilection for Hellenic culture that he earned the nickname *Graeculus*, 'Greekling'. Hadrian's rule (AD 117–38) leaves us more 'archaeology' than that of any other emperor – though the man himself remains an enigmatic identity – among which is a sculptural phenomenon that calls for notice here, since it combines subject, style and sexual ethics in such a studiously Greek manner. The portraiture of Hadrian's boyfriend Antinous has been described as 'the last enchantment of *kalos k'agathos*': it is certainly one of the reasons for characterizing Hadrianic patronage as 'a chapter in the history of Greek art'.

Statues of Antinous – around a hundred have been found so far – were once set up in many parts of the Roman empire: Spain, North Africa, Egypt, Asia Minor, the Black Sea, Greece and of course Italy. The reasons for such ubiquity are various. Antinous, as is well known, died prematurely on the Nile in October 130, and Hadrian's grief was extravagant. By imperial order, cult status was immediately awarded to the memory of the boy. We duly comprehend that his image, obviously 'Classical' yet also idiosyncratic in its beauty, became a prime symbol of Hadrian's ideal of the civilized *oikoumenê* that defined the Roman empire against barbarism (Figure 11.13). No matter that Antinous was even then the equivalent of a 'gay icon': who was going to criticize the pederastic habit of a man in command of thirty legions – at least while he was alive? Anyway, the youth (ethnically Greek, though from Bithynia) had an aura exceeding his sexual appeal.

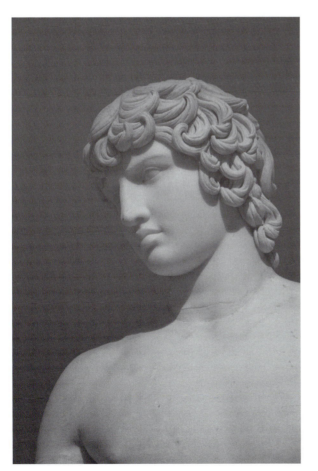

The sculpted Antinous shares with Alexander the quality of more or less instant recognizability. Allowing for a few post-Renaissance misattributions, one can say that Antinous should be identifiable by an educated viewer at a distance of about 25 m. He carries, of course, an air of doomed youth about him, so is often shown

Figure 11.13 *Detail of a marble figure of Antinous (the head and body are not an ancient match) from the Farnese Collection. Second century AD. Ht of head 26 cm.*

Figure 11.14 Examples of apprentices' trial pieces recovered from the sculpture workshop by the Bouleuterion of Aphrodisias. (Representing the human foot in either two or three dimensions requires practice: even great artists – Rembrandt for one – confess its difficulty.)

looking downwards, if not downcast, in a manner recalling the pensive modesty of a Polykleitan athlete. In full-length portraits it is made evident, however, that while comely, he was no formulaically muscular victor: somewhat 'pigeon-breasted', and tenderly fleshed. His lips, customarily pursed in an expression just short of a pout, are arguably the most sensuous feature of his face. But overwhelmingly there is the imprint of a gene-pool from fifth-century BC Athens.

The cohesion and consistency of the image implies not only a centrally produced model or *Haupttypus* – an *'Urantinoos'* presumably created for the sake of the youth's apotheosis – but also the mechanisms for its empire-wide diffusion, presumably during the eight years before Hadrian's death. Anecdotally it is known that Hadrian cultivated artists at his court; epigraphically we can identify a number of sculptors who probably worked for him – including Aristeas and Papias, who created the two grey marble centaurs found at Hadrian's Villa in the eighteenth century. We do not know which particular 'court artist' shaped the image of Antinous, but there is little doubt that it will have been a Greek sculptor, recruited by Hadrian to work at Tivoli (where the Antinous-tally runs into double figures).

Aphrodisias in Caria probably supplied such a sculptor; as it did for projects undertaken by Hadrian's Antonine successors. In fact a 'school' of sculptors flourished throughout the late empire at Aphrodisias – with marble quarries nearby – leaving a detritus of 'trial pieces' that eloquently testifies to the rigours of technical proficiency demanded by the Classical tradition (Figure 11.14).

Coda: mutilated statues

Though the Romans built a special type of ship (the *navis lapidaria*) for the freight of heavy marbles, there was of course accidental damage in the course of cross-Mediterranean traffic (a relief from Ostia shows the salvage of a statue of Hercules). We close our survey of the Roman reception of Greek sculpture, however, with notice of some deliberate disfiguring

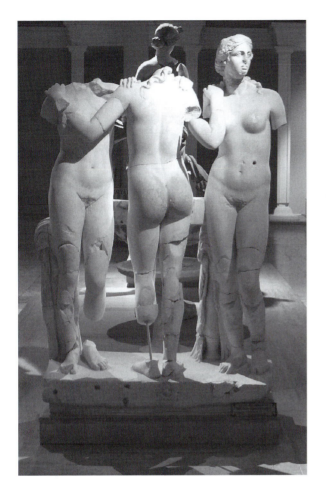

Figure 11.15 *Mutilated marble group of the Three Graces, from the Southern Baths at Perge. Male figures from the same location, including a Marsyas, suffered similar damage.*

of statues. The evidence comes mostly from the eastern Mediterranean, and it falls far short of a consistent pattern of iconoclasm; nonetheless, it is the subject of increasing scholarly attention. Excavators of the Baths of Faustina at Miletos were among the first to register the phenomenon: statues found in this ambience, endowed by the wife of Marcus Aurelius in the later second century AD, were of a sort to be expected in a bathing and *palestra* area, that is, male and female nudes – but some of them had evidently been attacked in antiquity by zealots intent on removing certain parts – male genitalia, and exposed breasts and *pudenda* of female figures. Statues found by the baths at Perge (Figure 11.15), and from a number of other sites, show similar signs of disapproval. The cause is ultimately traced to Christian adoption of the Hebraic 'Ten Commandments', in particular Exodus 20.4 ('Thou shalt not make unto thee any graven image'), with a further passage in the same book (34.13) licensing attacks upon the sacred images of other cultures. But in these cases the motive for partial iconoclasm must derive from ideals of sexual renunciation originating in the evangelism of St Paul. And that is another story.

Sources and further reading

The extent to which our knowledge of Greek art is refracted through a Roman screen is robustly measured in M. Beard and J. Henderson, *Classical Art: From Greece to Rome* (Oxford 2001). Breaking down the old dichotomy between 'Greek originals' and 'Roman copies' is a current scholarly preoccupation, exemplified by a plethora of recent monographs, seminar proceedings and exhibitions, including: F. Coarelli, *Revixit ars* (Rome 1996); M. Fuchs, *In hoc etiam genere Graeciae nihil cedamus* (Mainz 1999); E.K. Gazda ed., *The Ancient Art of Emulation* (Michigan 2002); M.L. Catoni ed., *La forza del bello: l'arte greca conquista l'Italia* (Milan 2008); M. Marvin, *The Language of the Muses* (Los Angeles 2008); K. Junker and A. Stähli eds., *Original und Kopie* (Wiesbaden 2008); E. La Rocca and Claudio

Parisi Presicce eds., *L'età della conquista* (Milan 2010); and S. H. Rutledge, *Ancient Rome as a Museum* (Oxford 2012). See also E.E. Perry, 'Notes on *Diligentia* as a Term of Roman Art Criticism', *CP* 95 (2000), 445–58; and M. Borda, *La scuola di Pasiteles* (Bari 1953). For a broader historical synthesis, see A. Wallace-Hadrill, *Rome's Cultural Revolution* (Cambridge 2008).

Roman booty The 'Catonian'/Connoisseur's attitude is argued in J.J. Pollitt, 'The Impact of Greek Art on Rome', in *TAPhA* 108 (1978), 155–74; see also E. Gruen, *Culture and National Identity in Republican Rome* (Cornell 1992), 83–140. Of late this topic has received further attention: L. Yarrow, 'Lucius Mummius and the Spoils of Corinth', *Scripta Classica Israelica* 25 (2006), 57–70; K.E. Welch, '*Domi militiaeque*: Roman Domestic Aesthetics and War Booty in the Republic', in S. Dillon and K.E. Welch eds., *Representations of War in Ancient Rome* (Cambridge 2006), 91–161; P.A. Rosenmeyer, 'From Syracuse to Rome: The Travails of Silanion's Sappho', *TAPhA* 137 (2007), 277–303; and M. Beard, *The Roman Triumph* (Harvard 2007), 143–86. On Sulla in Greece, see K.W. Arafat, *Pausanias' Greece* (Cambridge 1996), 97–105.

Roman Athens M. Hoff and S. Rotroff, *The Romanization of Athens* (Oxford 1997).

Verrines M. Miles, *Art as Plunder* (Cambridge 2008).

Villa dei Papiri P.G. Warden and D.G. Romano, 'The Course of Glory: Greek Art in a Roman Context at the Villa of the Papyri at Herculaneum', *Art History* 17.2 (1994), 228–54; for more exhaustive study, see C.C. Mattusch, *The Villa dei Papiri at Herculaneum: Life and Afterlife of a Sculpture Collection* (Los Angeles 2005).

Granikos monument G. Calcani, *Cavalieri di bronzo: la torma di Alessandro opera di Lisippo* (Rome 1989).

Horti K.J. Hartswick, *The Gardens of Sallust* (Texas 2004).

Marsyas A. Weis, *The Hanging Marsyas and its Copies* (Rome 1992).

Ornamenta gymnasii The topic of Roman nudity, or Roman attitudes towards nudity – actual or 'artistic' – has obvious ramifications for the Roman patronage and collecting of Greek sculpture, and perhaps deserved more attention here. It is, however, carefully explored in C.H. Hallett, *The Roman Nude* (Oxford 2005). A good case-study: A. Anguissola, 'Roman Copies of Myron's "Discobolus"', *JRA* 18 (2005), 317–35.

Sperlonga G. Säflund, *The Polyphemus and Scylla Groups at Sperlonga* (Stockholm 1972); A.F. Stewart, 'To Entertain an Emperor: Sperlonga, Laokoon and Tiberius at the Dinner-Table', *JRS* 67 (1977), 76–90; favouring a Homeric source, N. Himmelmann, *Sperlonga: Die homerischen Gruppen und ihre Bildquellen* (Opladen 1996); preferring Ovid, B. Andreae and C.P. Presicce, *Ulisse: il mito e la memoria* (Rome 1996); on Vergilian echoes (invoked by a fifth-century AD poetic inscription from the site), M. Squire, *Image and Text in Graeco-Roman Antiquity* (Cambridge 2009), 202–38.

Antinous The spirited reclamation of Hadrian – not a 'dilettante', still less a *poseur* – is owed to Jocelyn Toynbee – see J.M.C. Toynbee, *The Hadrianic School* (Cambridge 1934). Excavations at Tivoli and elsewhere reveal more of Hadrian almost annually, but the measured inventory of Antinous-images that is H. Meyer, *Antinoos* (Munich 1991) remains valid

(see pp. 17–23 for the *Haupttypus*); complemented by C. Vout, 'Antinous, Archaeology, and History', *JRS* 95 (2005), 80–96, also C. Vout, *Antinous: The Face of the Antique* (Leeds 2006), and *Power and Eroticism in Imperial Rome* (Cambridge 2007).

Sculpture workshop at Aphrodisias Pending a full publication, J. Van Voorhis, 'Apprentices' Pieces and the Training of Sculptors at Aphrodisias', *JRA* 11 (1998), 175–92.

Damage to statues N. Hannestad, 'Castration in the Baths', in N. Birkle *et al.* eds., *Macellum: Festschrift Robert Fleischer* (Mainz 2001), 66–77; P. Stewart, 'The Destruction of Statues in Late Antiquity', in R. Miles ed., *Constructing Identities in Late Antiquity* (London 1999), 159–89.

*Le jour où une statue est terminée, sa vie, en un
sens, commence. La première étape est franchie,
qui, par les soins du sculpteur, l'a menée du bloc
à la forme humaine; une seconde étape, au cours des
siècles, à travers des alternatives d'adoration, d'ad-
miration, d'amour, de mépris ou d'indifférence, par
degrés successifs d'érosion et d'usure, le ramènera
peu à peu à l'état de minéral informe auquel l'avait
soustrait son sculpteur.*

Marguerite Yourcenar,
Le Temps, ce grand sculpteur
(Paris 1983), 61

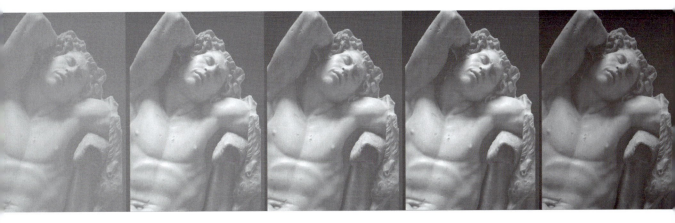

12

AFTERLIFE

Activity at the sculpture workshop at Aphrodisias seems to have continued up until the early fifth century AD. But it is conventional to establish a terminus for Greek sculpture about a century earlier. Setting aside the geopolitical changes signalled by Constantine's decision to locate (in AD 324) his administration on the site of an old Greek colony called Byzantium, the stylistic evidence from the last major pagan monument erected at Rome – the triumphal arch voted by the Senate in Constantine's honour (AD 312–15) – is enough, in the eyes of many modern observers, to mark the end of 'Classical antiquity'. Further to describe it as a definitive 'decline of form' is tendentious; yet by this time, it seems (to judge by an edict attributed to Constantine), the traditional craft skills of Greek sculptors were in short supply. Materially, there is only sparse and scattered evidence for their practice.

To draw a line with the Arch of Constantine is to say that whatever happens to Greek sculpture thereafter must be counted as part of its 'afterlife'. The term *afterlife* may, however, raise expectations that this chapter fails to meet. In German it would be *Nachleben*: and that word brings with it a specialized discipline within academic art history, which is the study of how the *forms* of images in the Classical repertoire were utilized by artists from the early Middle Ages onwards. Aby Warburg (1886–1929) was the pioneer of this discipline and is honoured by an institute to his name. The sort of *Nachleben* that fascinated Warburg may be typified by one of his first case-studies, following the visual trail of a Classical motif usually referred to as the Dancing Maenad (Figure 12.1). The prototype of this motif remains obscure: an Athenian monument of the late fifth century seems likely, possibly a representation of the Chorus from Euripides' *The Bacchae* by an artist called Kallimachos, famed for his 'fussy' drapery. There may have been eight or nine of these figures, all in various postures of Dionysiac ecstasy, on the original monument; numerous copies and derivations from them were made, in many media, in Roman times. For Warburg, the power of the motif consisted in its encapsulation of an extreme emotional state: an artist had only to 'quote' the figure of a frenzied Maenad to evoke that psychological state. So a visual 'emotive formula' (*Pathosformel*) was made available to artists down the ages. Classical sculpture served as a 'mint' (*Prägewerk*) that had put these epitomes into circulation, with both authority and versatility. (As one commentator observes, the typical Maenad 'is merely walking rhythmically, yet her garments flutter as if she were moving in a wild orgiastic dance'.) Whoever 'borrowed' the Maenad as a figure could use her as required, without a necessary connection to the 'band' (*thiasos*) of Dionysos: she could perform just as well in a Biblical or saintly tale.

To embark upon such subtle iconographic explorations is beyond the scope of this book – and would certainly breach the hermeneutic restrictions

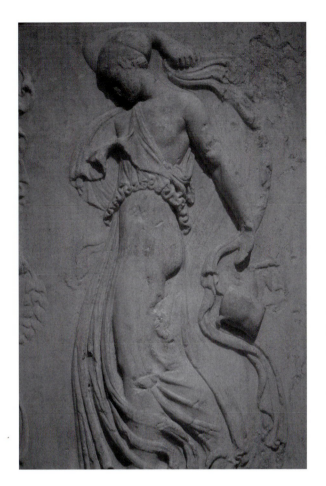

Figure 12.1 *Dancing Maenad on a marble relief from Rome, first century BC, after a late fifth-century Attic original by Kallimachos. Ht 1.15 m.*

we have imposed upon our task of understanding Greek sculpture within its period of production. The same applies to other modern 'readings' of ancient art. There is nothing intellectually criminal about investigating (for example) the significance to Sigmund Freud of a statue of a sphinx, or attempting (for another example) to give a Feminist interpretation of an Amazonomachy relief. But to preserve the integrity of this book as a monograph, what follows is simply a brisk historical survey of how Greek sculpture has endured the passage of time since its creation. The major part of it – at a moderately gloomy guess, about 95 per cent – has gone, mostly destroyed by human action. How the rest was preserved, recovered and esteemed is the story we are now poised to pursue, in four chronological stages.

Byzantium and the Middle Ages

'*Take care when you look at old statues, especially Greek ones.*' The author of this *caveat* has witnessed a distressing event. He has been wandering around Constantinople with a local scholar, looking at the many statues (*eikones*) still to be seen in the Byzantine capital in the early eighth century AD. As they gaze up at one of these, a portrait of some civic benefactor, and the guide begins to deliver his commentary, the statue – 'small and squat, but very heavy' – drops down from its pedestal. The guide is killed instantly. The visitor panics; after unsuccessfully trying to drag the statue into a river, he seeks refuge in a church. Relatives of the felled scholar gather round; a philosophical bystander blames divine providence. The emperor Philippicus (AD 711–13) then orders that the statue be buried, before it causes any more trouble.

This anecdote says something about both the respect and the suspicion harboured towards Classical statuary in the theocratic ambit of the Byzantine empire. And there was some quantity of visible 'survivors' from Classical sites. As is well

known, Constantine the Great was the first Roman emperor to grant freedom of worship to Christians (in AD 312). It is not quite so well known that Constantine stocked his centre of power conspicuously with overtly 'pagan' images: in the censorious observation of St Jerome, 'Constantinople was dedicated with the nudity of almost every other city' (*dedicatur Constantinopolis omnium paene urbium nuditate*: whether Jerome, writing *c*. AD 400, intended 'nudity' as a description of the statues, or the process of stripping other cities, is not clear). The Hippodrome – one of the few parts of the ancient city to survive, at least in basic structure, in modern Istanbul – once presented an array of Classical figures, all since vanished, though the inoffensive stump of a monumental bronze tripod from Delphi, originally celebrating Greek victory over the Persians in 479 BC, can still be seen in the area. An array of eighty-odd bronzes is recorded as grouped in the nearby public gymnasium known as the Baths of Zeuxippos – before it perished in a fire of 532; and, as we have noted (p. 192), the palatial home of an official named Lausus also became something of a museum of Classical masterpieces, including the colossal chryselephantine Zeus from Olympia.

How much of this statuary was destroyed by accident, by clerical hostility or (after 1453) by Ottoman disregard is hard to estimate. Constantine's bishop, Eusebius, from Caesarea, deplored the policy of displaying images from pagan sanctuaries but supposed that the emperor's intention must have been to expose such idolatry for the foolishness that it was and so release his people from 'the dotage of mythology'. We do not have Constantine's own reasons for why – to cite one possible example – an ancient emerald *xoanon* of Athena, accredited to Dipoinis and Skyllis, was transferred from Rhodes to Constantinople. Perhaps he imagined that if Christians were tolerated, they would in turn be tolerant of those with other faiths. (It is worth recalling that while Constantine effectively seized control of Christianity at Nicaea in AD 325, he never renounced the imperial cult and all that went with it.) Or perhaps it was merely a question of emphasizing the status of Constantinople as the 'New Rome' (*Nea Roma*). As it had been incumbent on Imperial Rome to assume the urban grandeur of Pergamon and Athens, so Constantinople needed 'accessories' of impressive embellishment – notably, trophy-artworks from the old world. Some sense of that grandeur may be gained from the four steeds known as The Horses of San Marco, probably looted from Constantinople during the wayward Fourth Crusade of 1204 (Figure 12.2).

On the margins of the Byzantine empire, it might be possible to claim that all idolatry had been damned on the morning of Christ's nativity. This was the message of a powerful tirade, *On the Fall of the Idols*, composed by a Syriac preacher, Jacob of Saroug (AD 451–521). But the principle of iconoclasm was hardly consistent within doctrinal Christianity itself, and episcopal blessing for

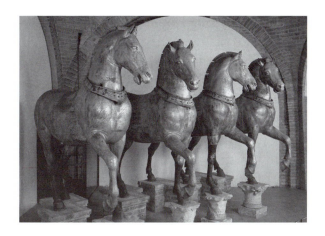

Figure 12.2 *The Horses of San Marco: gilded bronze quadriga (formerly displayed in the loggia of San Marco, Venice). Technical considerations suggest the workmanship to be Roman, but the style recalls Lysippos.*

attacks upon pagan images could not be guaranteed. A letter attributed to St Augustine of Hippo tells of the trouble caused in the city of Sufes (Tunisian Sbiba) when, possibly after an iconoclastic edict issued by the emperor Honorius in AD 399, a statue of Herakles was broken. A tumult ensued, in which some sixty people died. We find Augustine hastening to reassure the local councillors that the statue shall be restored, complete with paintwork. The tradition of attributing good luck to a particular image was evidently not bound to disappear when the original cult function or mythical significance of that image had gone. By the same token, presumably, a ninth-century empress called Euphrosyne – 'Good Sense' – reportedly had the colossal Herakles by Lysippos flogged. One chronicler of the early thirteenth century tells how a large bronze statue of Athena, in the Forum of Constantine, was deemed to be beckoning Frankish marauders into the city, and consequently smashed up by a drunken mob: such may have been the end of the Athena Promachos by Pheidias (Niketas, *De Isaac.* 738B).

Lingering traces of Classical style in Byzantine sculpture are there for those who seek them. And some very direct iconographic translations from pagan to Christian can be claimed. However, if the image of Hermes Kriophoros ('Ram-carrier') made a visual prototype of Christ the Good Shepherd, and if the Olympic Zeus did indeed provide a model for Christ Pantocrator, then such Classical precedents went unremarked by Christian commentators. Whether this was due to ignorance or deliberate oversight is hard to say. Photios, the learned ninth-century Patriarch of Constantinople, could measure the technical accomplishment of a new church mosaic by claiming it as superior to anything made by several named Classical artists, including Pheidias and Praxiteles. Later on, by contrast, the emperor Theodore II Lascaris (AD 1254–8) observed how magnificent the old monuments of Pergamon appeared, when compared with the squalor of his own period. Eventually, however, the forces of superstition or conservatism were insufficient against the predatory opportunities offered by gradual neglect. Suppose that the site of Olympia became somewhat overgrown and deserted after the official closure of the Games – or more specifically, the prohibition of animal sacrifice at the Games – in the late fourth century AD. Suppose local inhabitants

experienced shortages of metals; or they needed slaked lime for cement, or ready-trimmed stone. The 'rich pickings' of such a site must have become irresistible. And Rome, where so many Greek statues had (so to speak) been granted sanctuary, was no exception. A prominent family, the Symmachi, 'last of the pagans', are known to have tried to conceal statues in their house on the Caelian, in order to save them from destruction. A number of statues found in Rome seem to have been deliberately buried, as if for the sake of preservation.

Sacked by Alaric's Visigoths in AD 410, then struck by earthquakes, and further raids by Goths and Vandals, the city was a sorry sight by the time – towards the end of the sixth century – that St Gregory the Great established the Papacy as a political force in Europe. Even then, beyond the Vatican walls (begun in 847), Rome presented a lesson in mighty decay. And little was done to halt the process – especially when building materials were needed. During the Carolingian period – the ninth century – so much fiery reduction of ancient marble into lime was going on that it became a recognized profession (*calcararius*), with an area of the city (once known as Calcarario; by the old Crypta Balbi) given over to the activity. The processing of ancient statuary into powdered lime is recorded in Rome as late as 1443.

The Renaissance

One beacon of enlightenment is offered by the person of Cyriac (1391–1452), whose identity as 'a merchant from Ancona' does scant justice to his multifarious activities and tireless travelling. Self-taught in Greek and Latin, and evidently *au fait* with Arabic customs, Cyriac combined his business and diplomatic affairs with a keen interest in Mediterranean antiquities, and a curious credence in the Classical pantheon (he would give thanks to Jove and Mercury for any non-disastrous voyage). Cyriac was not a skilled draughtsman, nor a gifted writer, but that did not inhibit him from making sketches of memorabilia and keeping a full account of his journeys – not only to cities such as Athens and Constantinople, but also many other sites of mainland Greece and the islands, including the Argolid, Eretria, Thasos and Delos. It is typical of Cyriac's enthusiasm that he will come across the battered marble head of a bearded old man amid ruins on Samothrace and label his drawing of it as 'Aristotle' – knowing Aristotle to have been tutor to Alexander and Samothrace the island where Alexander's parents had met. Cyriac may seldom be right in his antiquarian deductions – but at least he cared.

The story of changing attitudes can be traced at Rome too. Petrarch visited in 1337 and found it ruined yet wonderful; it is a harbinger of serious antiquarianism when the poet notes the attribution to Pheidias and Praxiteles of the two large

nude male figures with horses on the Quirinal (following inscriptions added perhaps in the fifth century AD). However, it was not until 1417, when an internal crisis of Papal rule was settled in favour of Rome, that circumstances began to nurture an exploratory interest in Classical antiquities. Pope Nicholas V founded the Vatican library in the mid fifteenth century; Pius II (1458–64) was also a distinguished scholar of Greek and Latin (*qua* Enea Silvio Piccolomini); and of course the discovery and exegesis of Classical texts by 'Humanist' intellectuals encouraged an interest in finding pertinent sites and remains. Florence may have been the cradle of intellectual antiquarianism, but principal exponents, such as Poggio Bracciolini, knew that Rome especially had been adorned with numerous works of ancient sculpture. *Roma quanta fuit ipsa ruina docet* was a motto of the times – 'Rome teaches how great she was by her ruination'. But much of that greatness – despite the pounding of the lime-workers – still lay concealed.

The science of archaeology was yet to be invented. But as early as *c.* 1435, Leon Battista Alberti had recommended to artists that they seek out and study ancient *exempla* of design and stories, to gain a sense of decorum – what was 'fitting', in subject and style, for a particular genre. Roman sarcophagi, rich with mythological scenes, were the models he had in mind – and they had been available to sculptors such as Nicola Pisano in the thirteenth century. Mantegna, *c.* 1500, showed how a painter could achieve sculptural *rilievo* in two dimensions by depicting Classical relics in the monochrome technique known as *grisaille*. But more was soon to come. Giorgio Vasari, in his *Lives of the Artists*, tells us that a painter from Friuli, one Giovanni da Udine (1494–1564), went digging in the ruins of the presumed 'palace of Titus' at Rome, intentionally 'to find statues' (*per trovar figure*). (It was in these same environs that the Laocoon Group was recovered in 1506, allegedly with some assistance from Michelangelo.) Giovanni was in the circle of Raphael, who in 1515 was appointed by Pope Leo X as 'Superintendent' of antiquities in Rome; and it is a sign of increasing avidity in the acquisition of Classical statuary that one of Raphael's recorded activities during his official stint (cut short by the artist's death in 1520) was an acrimonious attempt to sequestrate, for the Papal collection, certain sculptures in the possession of the Roman de' Rossi family.

The Laocoon, as we know, was absorbed within the Vatican Borgo, where a dedicated space – commissioned by Pope Julius II – was being created for the display of ancient art and other curiosities. Galleries designed by Bramante to link several summer retreats in the Vatican gardens made a courtyard, the so-called Cortile Belvedere, where Julius installed sculptures of his own collection, including the Apollo Belvedere (Figure 12.3). So at last the Church was reconciled with images of profane deities and suchlike. Or up to a point: with Counter-Reformation strictures established, sensitivity over exposed bodily parts demanded

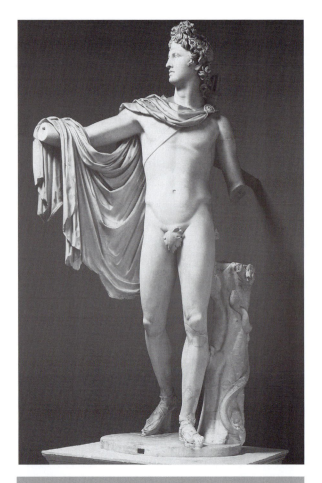

Figure 12.3 *Apollo Belvedere: probably derived from a bronze image of Apollo Pythios created by Leochares in the late fourth century BC. The god once held a bow in his outstretched arm. Ht 2.24 m.*

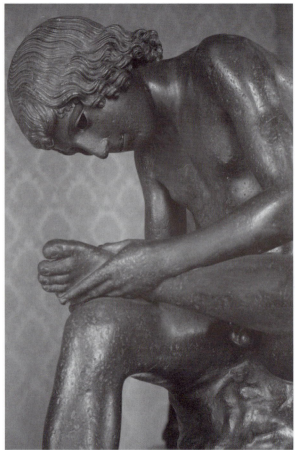

Figure 12.4 *The Spinario: Hellenistic bronze (c. 100 BC) found in Rome. Ht 73 cm. The motif is known in various media and may have been a metaphor for the crippling power of Eros (cf. Theocritus, Id. 4.55).*

the addition of fig leaves and draperies – and it was with the sense of righteous expurgation that Pius V transferred a quantity of 'pagan idols' from the Vatican to the Capitoline in 1566.

Such a transfer was possible because the principle of making certain antiquities available for general appreciation had already been confirmed. In 1471, Sixtus IV moved diverse 'survivors' of ancient sculpture from the Lateran church and palace – which since Constantine's time had been the Holy See, or administrative centre of the bishops of Rome – to premises on the Capitoline, where an inscription marks the 'restoration' (*sc.* to public view) of 'monuments of the excellence and virtue of the ancestors of the Roman people'. The pieces assigned to a recently built municipal 'Conservators' palace' (Palazzo dei Conservatori) included massive fragments of an

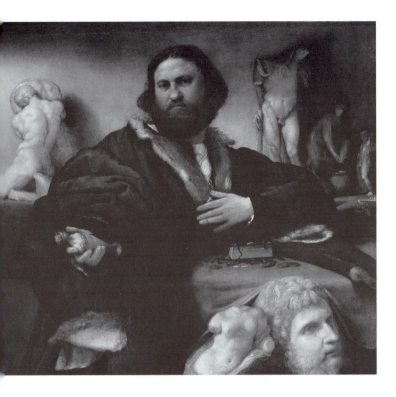

akrolithic image of Constantine; also the unfailingly popular Hellenistic bronze known as *lo Spinario*, or more verbosely as 'The Boy Pulling a Thorn from his Foot' (Figure 12.4). In 1538 they were joined by the great bronze equestrian statue of emperor Marcus Aurelius – seemingly spared destruction because it was once taken to represent Constantine.

That the acquisition and possession of Classical statuary became a part of both aristocratic 'high culture' and the early modern equivalent of 'big business' requires no explanation: the body language of certain portraits featuring such prize possessions is plain enough (Figure 12.5). In due time, the parasitic expertise of connoisseurship would be nurtured by the attendant need to know how much a particular piece was worth – or whether it was genuine (the issue of forgeries surfaces, for example, in the writings of the sixteenth-century polymath Pirro Ligorio – who was an early excavator at Hadrian's Villa). Meanwhile, however, artists set about formalizing the advice that had been given by Alberti. Michelangelo was at the fore but was only one of many Renaissance *maestri* who stressed the importance of drawing (*disegno*) as the basis of artistic ambition – in painting, sculpture or indeed architecture. The Accademia del Disegno founded in Florence in 1563 arose out of a number of artists' 'clubs', such as one presided over by Baccio Bandinelli (who made the marble copy of the Laocoon to be seen in the Uffizi); and while *disegno* also implies a range of intellectual activities, elevating artists to the level of scholars, the practice of 'studying' ancient sculpture by careful draughtsmanship was a core activity. The 'life class' did not yet exist; relics of Classical statuary (or plaster casts of the same) offered object-lessons to any artist who aspired to Michelangelo's genius. As for Michelangelo himself, the notorious *ignudi* of the Sistine Chapel contain some direct references to the figure of Laocoon; and

Figure 12.6 *The Belvedere Torso, as drawn by P.P. Rubens c. 1601–2. The statue, known since c. 1432, was much admired by Michelangelo – and later deemed by Winckelmann to represent Herakles in repose after his Labours.*

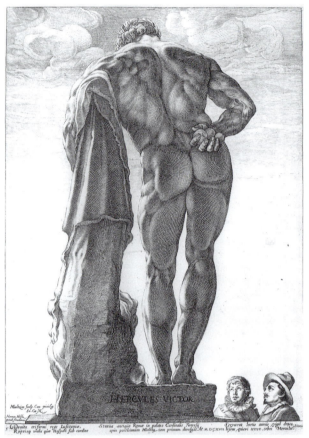

Figure 12.7 *The Hercules Farnese, as engraved by Hendrik Goltzius c. 1592. The unusual choice of a rear view shows the weary hero holding the prize from the last of his Labours – the Apples of the Hesperides. Made c. AD 200 by an Athenian sculptor called Glykon, the marble derives from a bronze by Lysippos; it was evidently displayed within Caracalla's gigantic bath-complex in tandem with another colossal statue of Herakles (now in Reggio di Caserta). The piece (ht 2.92 m.) was moved from Rome to Naples in 1787.*

Michelangelo's vision of the Creation entailed an Adam whose body seems to have been honed in a Greek gymnasium.

Artists around Europe took note. Crossing the Alps to pay homage to the Classical models displayed in Rome became almost obligatory, with the young Rubens, in Rome from 1601 to 1602, and 1605 to 1608, serving his antique apprenticeship by studies of the Laocoon, the Belvedere Torso (Figure 12.6) and various other pieces, mostly done in red chalk, and with a view to utilizing these models in grandiose commissions from European potentates. Even Rembrandt, who doggedly resisted Classical style even when depicting Classical subjects (e.g. the Rape of Ganymede), and who never went south, acquired a number of marble busts (including portraits of Homer and Socrates) and plaster casts (including one of the Laocoon, if only in part or on reduced scale) for his personal museum.

Familial connection with the Papal court was not necessary when gathering a collection of antiquities – but it certainly helped. The pontificate of Paul III (1534–49) favoured the Classical enthusiasms of several of his relatives in the Farnese dynasty, in particular his grandson (*sic*) Alessandro, who became *il Gran Cardinale* more on account of his wealth and generous patronage than his piety. Farnese property included the remains of the Baths of Caracalla, which in 1545–6 yielded a series of

proportionately enormous statues and statue-groups (Figure 12.7; *cf.* Figure 11.8). Nor was it a disadvantage to the Bolognese Ludovico Ludovisi that he was a nephew of Gregory XV when appointed cardinal in 1621–2. Ludovisi naturally needed a Roman residence; and he found a suitable site on the Quirinal, where the Horti Sallustiani had lain in ruins since Alaric's invasion. This area, once a landscaped summer retreat for Julius Caesar before passing to Sallust, proved fruitful of statuary; and, in keeping with the practice of the day, Ludovico added to his own finds with purchases from assorted local nobility.

THE 'BARBERINI FAUN'

It represents a sleeping satyr, not a faun; and it no longer belongs to the Barberini. The name, however, stays with a remarkable sculpture (Figures 12.8 and 12.9) that seems once to have been part of a Roman fountain. Found *c.* 1625 near Hadrian's Mausoleum (Castel Sant'Angelo), it was declared by Pope Urban VIII to be the property of his family for all time. But towards the end of the eighteenth century the Barberini needed cash, and of course in any inheritance crisis a statue is not feasibly divided. There was no shortage of willing buyers. The tale of bargaining and treachery between a Roman antiquities dealer, the Barberini family, Papal authorities and various European powers, ongoing between 1799 and 1819, would be worth a substantial novel. By dint of sheer persistence, and limitless *pazienza*, King Ludwig of Bavaria prevailed; and the satyr, apparently shown in the troubled sleep of a drunken stupor, was brought to rest in what may be judged perhaps the world's most congenial museum of Greek sculpture, the Munich Glyptothek.

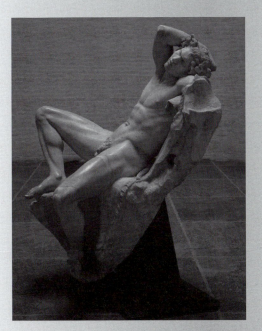

Figure *12.8* The Barberini Faun: an original (considerably reworked) of perhaps c. 220 BC. Ht 2.15 m.

311

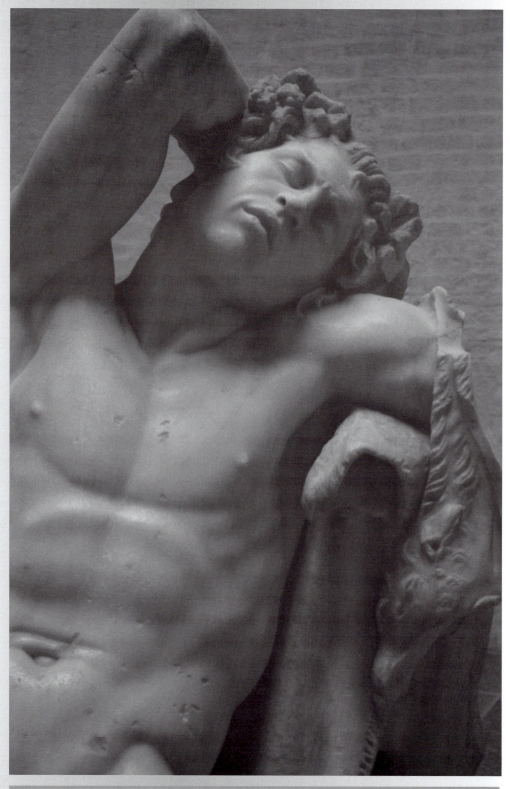

Figure 12.9 *Detail of same. The piece may evoke the fable of King Midas, who captured a satyr by mixing wine in the water of a source where the creature came to drink.*

For those without the resources to acquire their own collection of antiquities, or excluded from the collectors' social milieu, glimpses of Classical sculpture could be gained indirectly by a burgeoning industry of supplying engraved reproductions. Already by the late sixteenth century, a succession of illustrated catalogues – such as Lorenzo Vaccaro's *Antiquarum Statuarum Urbis Romae quae in publicis privatisque locis visuntur icones* (Rome 1584) – had appeared. The project of creating a comprehensive 'museum on paper' found its sponsor in Cassiano dal Pozzo (d. 1657) and is useful to this day – if only to check what has since gone missing.

Thanks in part to the printing press, then, knowledge of Classical statuary could travel beyond Classical lands. In northern Europe, antiquarians were beginning to take a scholarly interest in the relics of their own countries – prehistoric megaliths and flint tools, Bronze Age *tumuli* and so on. Advances in understanding these relics within the span of centuries did something to satisfy local and regional pride – though the 'rudimentary' appearance of such objects only served to heighten the grace and 'perfection' of the art of Greece and Rome. In France, signs of an encyclopaedic approach towards all monuments and curiosities of the past are evident in the activities and publications of Bernard de Montfaucon and the Comte de Caylus. But the most influential spokesman of 'the science of antiquity', *Altertumswissenschaft*, was J.J. Winckelmann, whom it is usual to introduce as the son of a poor Prussian cobbler.

Enlightenment and Romanticism

Winckelmann, as we know (p. 3), rose above his origins. It was in 1759 that he entered the service of Cardinal Albani, as a consultant on ancient art. Albani had instigated a campaign of excavations at Hadrian's Villa, a site that yielded an abundance of objects for the expert's blessing. Winckelmann went on to become 'Prefect of Antiquities' at the Papal Court in 1763. The following year saw the publication of his *magnum opus* – his *History of the Art of Antiquity*, a book whose effect was not only to canonize the absolute quality of Classical sculpture, as we have seen, but also to convey an almost erotic sense of excitement in the viewing of such masterpieces. (Some scholars would remove the 'almost' from that sentence.) 'The Medicean Venus, at Florence, resembles a rose which, after a lovely dawn, unfolds its leaves to the rising sun … The attitude brings before my imagination that Laïs who instructed Apelles in love. Methinks I see her, as when, for the first time, she stood naked before the artist's eyes.' Readers enchanted by Winckelmann's gushing *enthousiasmos* when gazing upon the Apollo Belvedere – 'Before this miracle of art I forget the entire universe … From admiration I pass to ecstasy; I feel my breast dilate and expand as if at the height of prophetic frenzy; I am transported to Delos and the groves of

Lycia' – naturally wanted to know if it might do the same for them, too. So Winckelmann contributed to the phenomenon of the 'Grand Tour' – the ritual passage of European aristocracy southwards in search of High Culture. Ottoman-controlled Greece was then considered rather dangerous, especially for women; Classical sites along the Turkish coast were as yet largely unknown; so Italy, and Rome in particular, was the most congenial destination for this educational pilgrimage – an early version of the 'gap year'.

Well-heeled Americans would be lured too: latecomers, however, to the practice of gathering souvenirs. The gentry of northern Europe rapidly became competitors in acquiring their own trophies of the Grand Tour. After all, it was an Enlightenment principle that one should have not only ideas, but empirical *proof*; and with more or less indiscriminate foraging among the estates of ancient Rome, the antiquities market was steadily supplied. Fragments became undesirable, so the art of restoration thrived. Specialists during the eighteenth century included Bartolomeo Cavaceppi, whose notion of where restoration ended and fabrication began was shamelessly loose. Since many pieces required substantial repairs, done to a high standard, it is not surprising that among the local restorers were several Neo-Classical sculptors distinguished in their own right. The Dane Bertel Thorvaldsen ('Pheidias of the North') was one; another was Antonio Canova, whose *atelier* on the Via del Babuino now makes an unusual backdrop for a café-bar. An example of what could be gathered by an enthused aristocrat in Rome *c.* 1770 is shown by the collection of Sir Charles Townley: once the pride of London, now mostly relegated to a ground-floor recess of the British Museum as a curiosity in the history of taste.

Perhaps the most significant testimony to Winckelmann's influence came from Napoleon Bonaparte, towards the end of the eighteenth century. Ideologues in post-Revolutionary France wished to make Paris 'the school of the universe' and the Palais du Louvre in particular a cultural centre of gravity to all right-minded people. Napoleon, leading the country's army on a victorious course through the principalities of Italy during 1796–7, was therefore given licence to make systematic confiscations of works of art *en route*. He took the four horses from St Mark's in Venice and made demands in Florence; but the main prizes lay in Rome. By the Treaty of Tolentino (1797), Papal authorities were required to give up 100 works of art – 83 of which were Classical statues. *Nous aurons tout ce qu'il y a de beau en Italie*, crowed one of the general's officials. As if Napoleon had a copy of Winckelmann to hand, he headed his wish-list with the Apollo Belvedere; the Laocoon Group and other celebrities of the Vatican collection were included in the requisition. It was a true case of *force majeure*: if the owners demurred, Napoleon was not above deporting to France the Pope in person. His perspective

was (presumably) that these *objets d'art* were now 'liberated' from the grip of the *ancien régime*.

The statues were laboriously transported to Paris overland, lest the English navy pounce on them. When triumphantly deposited in the Louvre, in 1798, a banner proclaimed:

Monuments of Ancient Sculpture. Greece gave them up;
Rome lost them;
Their fate has twice changed:
It will not change again!

That was a rash boast: in 1816, after Waterloo, and the Congress of Vienna – where, as a matter of interest, the Duke of Wellington aired the precept of making it internationally illegal to take art as war booty – the sculptor Canova was charged with escorting the greater part of the looted material back to Italy.

A change in taste was imminent, catalysed, ironically, by Napoleon's occupation of Italy. Earlier in the century, two British draughtsmen, James Stuart and Nicholas Revett, sponsored by the London-based 'Society of Dilettanti', had ventured to Greece and Asia Minor; they published, in 1762, the first folio volume of their handsome account of *Athenian Antiquities*. Apart from detailing, meticulously, the architectural remains of Classical Athens, they showed that the logistical and cultural difficulties of working in Ottoman territory might be regarded as more of an adventure than a series of inconveniences; and the footloose British gentleman, since Bonaparte had taken Italy, needed somewhere else to finish his schooling. So Greece became available. Lord Byron would glamorize the destination, espousing – in a spirit Winckelmann would have approved – the cause of Greek independence. But before Byron there was another British 'Milord' who descended: Thomas Bruce, the Seventh Earl of Elgin.

The saga of how Lord Elgin exploited a diplomatic posting to Constantinople to persuade Turkish authorities that he might remove *qualche pezzo di pietra* – 'a piece or two of stone': the deal was done by Elgin's Italian *factotum* in Athens, Giovanni Lusieri – has been well documented and can be uncontroversially summarized. Elgin inherited a rather gloomy ancestral home at Broomhall in Fifeshire: he liked the 'Grecian gusto' then gaining favour, and had seen how Stuart and Revett were able to access direct inspiration from the unkempt original relics of ancient Greece. It was natural enough that Elgin devised a project to commission further studies of Athens – and a measure of his ambition that his first artist of choice was J.M.W. Turner. (Perhaps deterred by the attendant obligation to give drawing lessons to Lady Elgin, Turner declined.)

There was a vested interest – with the aid of sketches and plaster casts from Athens, architects back in Scotland might 'make over' the Elgin residence – but what ensued seems more a case of opportunism than grand design. Nor can the motive of rescue be wholly discounted: after all, serious damage to the Parthenon had occurred in 1687, when the Venetian admiral Morosini, bombarding the Turkish mosque and garrison on the Akropolis, scored a direct hit on the enemy's powder-store – the Parthenon; in the aftermath, there was a botched attempt to take down some pedimental figures. (A Danish naval officer passing by Athens that year was able to purchase the heads of a Lapith and Centaur.) Later – in 1831, when a broken and bankrupted man – Elgin would declare that he had taken the Parthenon marbles 'wholly for the purpose of securing to Great Britain, and through it to Europe in general, the most effectual possible knowledge, and means of improving, by the excellence of Grecian art in sculpture and architecture'. This was disingenuous; yet it is clear to impartial historians of the affair that Elgin acted from

Figure 12.10 Female figures from the east pediment of the Parthenon, c. 435 BC. Previous interpretations include Three Fates, or the daughters of Kekrops; now surmised as Hestia (seated left), and perhaps Aphrodite reclining in the lap of her mother, Dione. (Two of the figures seem still to have had their heads intact when the pediment was sketched in situ by Jacques Carrey in 1674.)

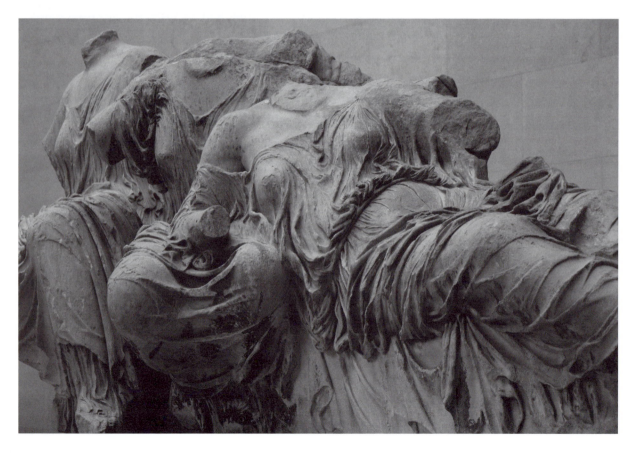

basically honourable motives. Of course there was an element of nationalistic rivalry – especially with France; and the appropriation of 'the Elgin Marbles' could not have happened if Nelson had not prevailed over the French fleet at the battle of the Nile in 1798. And the operation of removing the Parthenon sculptures – substantially promoted by the 'petticoat power' of Lady Elgin – was not without its mishaps. Nonetheless, the sculptures have probably survived better than they would have done without Elgin's action and the subsequent acquisition by the British government. (Logically that is not a reason why they should still be kept in London.)

With hindsight it is possible to polarize the Elgin episode as a collision of values at the turn of the eighteenth century. Elgin became an unquestioning apostle of the Enlightenment, convinced of the didactic virtue in stripping the Parthenon of its decoration before it suffered further damage *in situ*. His detractors (including Lord Byron) tended to be Romantics who preferred their ruins to be in a perpetual (yet fixed) state of picturesque decay. The two sides came together, however, on the issue of restoration. As Elgin lost control of the sculptures, and they passed into display at the evolving British Museum, the consensus was to leave them as they were, albeit lacking limbs, heads and so on (Figure 12.10). Voices of protest, from some senior dilettanti such as Richard Payne Knight, faded away as a minor revolution in taste took place. Authenticity became paramount; and fragments cast their own spell of partial mystery (Plate VIII).

In view of this shift in taste, it seems strange that when the agents of King Ludwig of Bavaria, outwitting the British, gained possession of the pedimental sculptures from Aegina in 1812–13 (see p. 127), Thorvaldsen was called upon to add complex restorations – and fig leaves – that were only dismantled after the Second World War. However, the Aegina finds stimulated a general appetite for more of the same: Greek originals, from Greek sites.

The rise of archaeology

Greeks declared for independence in 1821. Almost a decade of struggle ensued with the Ottoman rulers and their allies before the autonomous existence of a country called 'Greece' could be announced; and in the course of pro-Greek (or anti-Turkish) intervention by several foreign powers (Britain, France and Russia), a pair of Gallic explorers, Blouet and Dubois, made their way to the site of Olympia. They were part of a grand *mission scientifique* to the Morea – as the Peloponnese was then known – and they applied themselves to locating the temple of Zeus in the same spirit of scrupulous survey as shown by geologists and topographers also attached to the mission. True, several metopes from the temple were

excavated and removed to Paris. But treasure-hunting was not the uppermost aim. A concern to locate objects in a stratified position was manifest and so heralded the arrival of archaeology as a discipline derived more from geology than from the activities of collectors and connoisseurs.

Or so many archaeologists would like to think. As it happened, archaeology in general became caught in eventual academic tension between the 'Arts' and the 'Sciences'; and 'Classical archaeology' in particular has struggled to shake off its association with antiquarianism. All the same, and despite some signally unscientific forays at certain Bronze Age sites by Heinrich Schliemann, the nineteenth century witnessed the advent of method in digging ancient sites – basically adapting the stratigraphical techniques of geologists. Pausanias above all provided the ancient textual compass that pointed where to dig.

Despite the fact that it was a Frenchman, Pierre de Coubertin, who eventually rekindled the Olympic Games – in 1896 – the prize of excavating Olympia went to the Germans. (Otho I, the first king of Greece, enthroned in 1832, was of the princely line of Wittelsbach: this only compounded the already entrenched philhellenic legacy of Winckelmann and Goethe.) Ernst Curtius, a tutor to Prussian royalty, cleverly enlisted high-level support for his conviction that Olympia was key to understanding quintessential 'humanity' (*Menschheit*); and this support was needed, since Bismarck (Germany's first Chancellor) was appalled by the notion of using public funds for such a project. After years of lobbying, excavations began at Olympia in 1875. The mass of statues dreamed of by Winckelmann did not emerge – or at least, precious few of the *Meisterwerke* that had been on show when Pausanias visited the site. But among the compensations was a huge cache of Geometric bronze figurines. The young scholar assigned to study these figurines, Adolf Furtwängler, went on to produce a vigorous testament to the power of detecting artistic identity by close stylistic analysis, even if working without original pieces (see p. 6), and his *Meisterwerke der griechischen Plastik* (1893) made a handsome appeal to readers beyond academic enclaves. Another veteran of Olympia was Wilhelm Dörpfeld, graduating to the highly fruitful excavations on the Athenian Akropolis in the latter decades of the nineteenth century (one of King Otho's first acts, in 1834, was to declare the entire Akropolis an archaeological site). For their part, the French – who had established L'École française d'Athènes beneath the slopes of Mount Lycabettus in 1846 – chose two sites sacred to Apollo, Delphi and Delos, as their prime *grands projets*. The British, already suffering from Greek indignation at the Elgin affair, were rather marginalized (at Sparta); while the turn of the Americans did not really come until the

1930s, when Rockefeller funding underwrote the enormous costs of expropriating the neighbourhood of Athens that covered the ancient Agora.

As we have seen (p. 82), excavators during the nineteenth century were increasingly sensitive towards the evidence for the colouring of ancient statues and buildings, with Hittorff and Semper among the European enthusiasts, and Owen Jones a leading evangelist in Britain. The persistence of a preference for unadorned statuary, however, was reinforced by rapid growth in the production of plaster-cast replicas. This practice, dating back to the Hellenistic period, had been revived during the Renaissance, with Mantegna's master, the Paduan Francesco Squarcione, one of several attested exponents. The technique is not complicated: applying a separating agent over the original sculpture – a film of wax or suchlike – wet plaster is pressed on, in pieces; when it dries, the pieces are joined, and a mould is thereby created from which subsequent casts may be produced. Firms of specialists, such as Brucciani in London, developed to meet the demand from museums, art schools, interior designers and so on. The fashion may be traced to the celebration of an *Antikensaal* at Mannheim by the German Romantics, Goethe and Schiller. (Young Goethe first saw the Laocoon as a replica here in 1769.) With the patronage of the Bavarian royal Karl Theodor, this gallery of plaster casts (originating in Düsseldorf and eventually moved to Munich) set an example for offering the experience of entering among a 'second population' of pale, mostly unclothed figures. Neo-Classical sculptors naturally furthered the fashion: Thorvaldsen's collection, more or less intact in the museum he endowed to Copenhagen on his death in 1844, shows what could be obtained in Rome by the early nineteenth century.

University museums and Classics departments were in the market for casts as teaching aids. Schools of fine art, however, were equally keen customers – for as long as the Renaissance ideal persisted of serving an apprenticeship in representing the human figure by starting with studies 'from the antique'. Apart from obvious advantages – casts do not get cold or cramped while 'posing' and are faultless in holding an attitude – there was the repeated benediction of this practice from such eminent authorities as Leonardo da Vinci in Italy and Karel van Mander in the Netherlands. So we find Vincent van Gogh, so earnest in his aim to be a decent draughtsman, spending days in front of a Discobolus at the Antwerp Royal Academy (Figure 12.11).

Originals, naturally, were cherished too: over the course of one year (1879), the British Museum issued drawing permits to 15,626 students. Throughout the Western world, in fact, it became axiomatic that Classical sculpture provided exemplary models for the aspiring artist. A reaction duly followed from rebellious students. Among the angry propositions of the 'Futurist Manifesto' published on

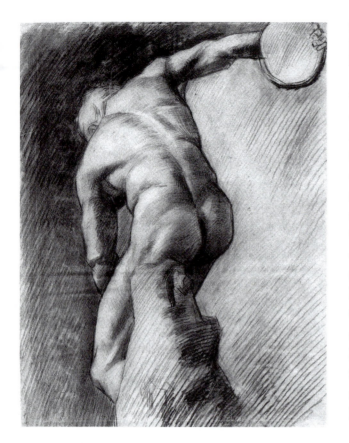

Figure 12.11 *Drawing of a Discobolus-cast by Van Gogh, 1886.*

the front page of *Le Figaro* in early 1909 was the claim that 'a roaring motorcar which seems to run on machine-gun fire is more beautiful than the Victory of Samothrace'. Museums, archaeologists and antiquarians were judged *en masse* as a disease, suppressing the embrace of technology: artists should have nothing to do with what was *passé*. Less melodramatically, other 'Modernist' artists simply turned their backs on Classical models. Picasso is the best known of those leading a 'preference for the Primitive'. Henri Gaudier-Brzeska ('There are few things so detestable as the Venus of Milo') and Henry Moore were typical of twentieth-century sculptors determined to reinvent the medium after so much sterile output from the heirs of Canova, Flaxman, Thorvaldsen *et al.*

'YOU MUST CHANGE YOUR LIFE'

Of modern responses to ancient Greek statuary, perhaps none is more empathetic than Rainer Maria Rilke's musings upon *An Archaic Torso of Apollo*, published in his *New Poems* of 1908. The collection was dedicated to the sculptor Rodin, whom Rilke had lately assisted: Rodin it was who encouraged his secretary to go to the Louvre and focus his poetic powers upon certain artefacts there. Rilke, who had already used Classical sculpture as a cue for poetry – his *Orpheus, Eurydice, Hermes* relies upon a late fifth-century relief known in several copies – was then developing a mode of concentrated description characterized as *Dinggedicht* or 'Object-Poem'. He appears to have chosen the fragmentary torso of a colossal *kouros* discovered in the theatre at Miletos and subsequently passed to the Louvre by a Rothschild donation in 1873 (see Figure 5.8).

'We cannot know his extraordinary head, in which the apple-eyes ripened. But still his torso glows like candlelight; and his gaze, though dimmed, gives off a steady gleam.' These verses, dense and couched in the subjunctive mood, resist translation; the sense of vibrant aliveness within a piece of carved marble has never been more urgently evoked. But the final sentiment is simple and imperative. Fragmentary as it is, the piece yet seems to issue an Apolline command. *Du musst dein Leben ändern*: 'You must change your life.'

The cause of Classicism was hardly helped by its implicit blessing in the aesthetic diktats of the National Socialists, despising 'degenerate art' that affiliated itself to prehistoric or tribal forms (and it is worth knowing that Hitler paid a great deal of money for the Lancellotti Discobolus, mistakenly repatriated to the Italian state in 1948). Witnessing the rise of Abstract Expressionism in the 1940s and after, Bernard Berenson, arch-connoisseur of Italian Renaissance painting, deplored a 'slacking of every kind of vigour' and 'disinclination for the long hard discipline of draughtsmanship' that paralleled the late antique descent into technical ineptitude he analysed on the Arch of Constantine. Berenson was powerless, however, to prevent the art schools from casting out their plaster casts. For example, Vassar College in New York State, which had eagerly assembled a respectable cast assemblage soon after its foundation in 1861, began disposing of the collection in the 1930s. European institutes were no more careful: casts in the Hague Academy, to name just one, were mostly pulverized in the early 1960s. Readers may judge for themselves whether this policy of emancipation from the discipline of drawing has given us a glorious new era of art.

'We do not want either Greek or Roman Models if we are but just & true to our own Imaginations.' That plea was made by William Blake, in 1804: with hindsight it seems like a *cri de cœur* for anyone who finds the presence of Greek sculpture an aesthetic burden. As we observed at the outset of this book, these fractured remains of shaped stone and bronze can seem like lords over time, adamant in their continued demand for attention. But so it is. They are permanent lodgers in the collective consciousness, and virtually familiar.

One purpose of this book has been to show how strange they really are.

Sources and further reading

Still fundamental to the study of Greek sculpture's 'afterlife' is F. Haskell and N. Penny, *Taste and the Antique* (Yale 1981). Further synthesis in S. Settis, 'Des ruines au musée: la destinée de la sculpture classique', *Annales, Economies, Sociétés, Civilisations* 6 (1993), 1347–80. On Warburg: E.H. Gombrich, *Aby Warburg: An Intellectual Biography* (Oxford 1970); A. Warburg, *The Renewal of Pagan Antiquity* (Los Angeles 1999). Dancing Maenads: L-A. Touchette, *The Dancing Maenad Reliefs* (London 1995).

Byzantium and the Middle Ages See generally S. Bassett, *The Urban Image of Late Antique Constantinople* (Cambridge 2004); for more specific details of sites and incidents mentioned in this section, see A. Cameron and J. Herrin eds., *Constantinople in the Early Eighth Century: the Parastaseis Syntomia Chronikai* (Leiden 1984), 88–91; C. Mango, 'Antique Statuary and the

Byzantine Beholder', *DOP* 17 (1963), 55–75 (reprinted, with the same pagination, in C. Mango, *Byzantium and its Image* (London 1984); C. Mango, 'The Palace of Lausus at Constantinople and its Collection of Ancient Statues', *JHC* 4 (1992), 89–98; and T.G.C. Thornton, 'The Destruction of Idols – Sinful or Meritorious?', *JTS* 37 (1986), 121–4. See P. Schaff and H. Wace eds., *A Select Library of Nicene and Post-Nicene Fathers*, vol. I – for Eusebius and the *Vita Constantinius* section 3.54 is particularly relevant; for St Augustine's intervention, the Loeb edition of his *Select Letters*, no. 16. The epigrams of Christodorus regarding statues in the Baths of Zeuxippos are translated in vol. I of W.R. Paton's Loeb edition of *The Greek Anthology*: for exegesis and commentary, see R. Stupperich, 'Das Statuenprogramm in der Zeuxippos-Thermen', *Ist.Mitt.* 32 (1982), 210–35 and A. Kaldellis, 'Christodorus on the Statues of the Zeuxippos Baths: A New Reading of the *Ekphrasis*', *GRBS* 47 (2007), 361–83. For Jacob of Saroug (or Serug), see P. Martin, 'Discours de Jacques de Saroug sur la chute des idoles', *Zeitschrift der Deutschen Morgenländischen Gesellschaft* 29 (1875), 107–47 (Syriac text with French translation). For the situation in Rome, J. Curran, *Pagan City and Christian Capital* (Oxford 2000).

The Renaissance For Cyriac of Ancona: B. Ashmole and E.W. Bodnar, *Cyriacus of Ancona and Athens* (Brussels 1960); P.W. Lehmann and K. Lehmann, *Samothracian Reflections* (Princeton 1973), 3–56; E.W. Bodnar and C. Foss, *Cyriac of Ancona: Later Travels* (Harvard 2003).

A huge literature exists on the discovery of Classical antiquities during the Renaissance: a standard reference is P.P. Bober and R. Rubinstein, *Renaissance Artists and Antique Sculpture* (2nd edn, London 2010). See also L. Barkan, *Unearthing the Past* (Yale 1999); M. Cristofani, 'Vasari e le antichità', in G. Garfagnini ed., *Giorgio Vasari* (Florence 1985), 16–25; H.H. Brummer, *The Statue Court in the Vatican Belvedere* (Stockholm 1972). Belvedere Torso: G. Hafner, 'Der Torso von Belvedere', *Öjh* 68 (1999), 41–57; R. Wünsche, *Der Torso: Ruhm und Rätsel* (Munich 1998).

Barberini Faun H. Walter, 'Der schlafende Satyr in der Glyptothek in München', in K. Braun and A. Furtwängler eds., *Studien zur klassischen Archäologie* (Saarbrucken 1986); C. Kunze, 'Die Konstruktion einer realen Begegnung: zur Statue des Barberinischen Fauns in München', in G. Zimmer ed., *Neue Forschungen zur hellenistischen Plastik* (Eichstätt 2004), 9–47; J. Sorabella, 'A Satyr for Midas', *CA* 26 (2007), 219–48.

Enlightenment and Romanticism Townley collection: B.F. Cook, *The Townley Marbles* (London 1985). On the phenomenon of British collecting it is still worth reading Adolf Michaelis' *Ancient Marbles in Great Britain* (Cambridge 1882), complete with an outsider's waspish observations on the habits of the gentry; updated by V. Coltman, *Classical Sculpture and the Culture of Collecting in Britain since 1760* (Oxford 2009).

Elgin Marbles W. St Clair, *Lord Elgin and the Marbles* (3rd edn, Oxford 1998); D. Williams, 'Lord Elgin's *firman*', *JHC* 2009, 1–28. More generally within the development of the British Museum: I. Jenkins, *Archaeologists and Aesthetes* (London 1992).

The Rise of Archaeology A. Schnapp, *The Discovery of the Past* (London 1996), 275ff. On the German experience, R. Baumstark ed., *Das neue Hellas* (Munich 1999). For a caustic view of Modern anti-Classicism, E.H. Gombrich, *The Preference for the Primitive* (London 2002). The quotation from Gaudier-Brzeska comes from a letter of 1911, full of loathing for the 'great names' of Classical sculpture: see H.S. Ede, *Savage Messiah* (London 1931), 53–4. The citation of Blake is from his *Complete Writings*, ed. G. Keynes (Oxford 1966), 480.

INDEX

Numbers in *italic* refer to illustrations

Only selective entries are given for certain authors quoted frequently throughout the book (Herodotus, Hesiod, Homer, Pausanias and Pliny)

A

Abdalonymus 230
Aegina, temple of Aphaia 9, *127*, *128*
Aeschylus 59
Agias 229, *229*
Agora, clay mould from *79*
Agorakritos 187, 267
Aigai (Aegae, Vergina) 227
Ajax, suicide of 165, *166*; supposed bones of 124
Akropolis, Athens 11, 26, 184, 186; *see also* Athena Nike, Erechtheum, Parthenon frieze
Alcibiades 250
Alexander I of Macedon 228
Alexander III of Macedon ('the Great') 12, 218, 219, 226, 258–62
Alexander Sarcophagus *230*
Alexandria, Egypt 218, 231
Alkamenes 187
Alma-Tadema, L. 176
Amazons 170, 225
Anavysos, relief from *108*
Antenor 136
anthropomorphism 42–4
Antinous 295–6, *295*
Apelles 226
Aphrodisias 296
Aphrodite 195–213; Crouching 210, *210*, *211*; Kallipygos 210, *212*. *see also* Knidos; Venus

Apollo 42, 45, *46*, 130, 170; Apollo Belvedere *308*; Apollo of Tenea *8*; Piraeus Apollo *47*
Apoxyomenos ('Scraper') *291*
Arion 107
Aristophanes 132, 180
Aristotle 152, 253
armour 75
Artemis 47, 90, *90*, *153*, *154*
Artemisia (Carian queen) 222, 225, 226
Asinius Pollio 289
Asklepios 106
Astarte (Ishtar) 202
Athanadorus (Athenodorus) 245, 292
Athena 114; 'Lemnia' 187; Parthenos 44, 189–91, *189*; Polias 44, 114, 157, 190; Promachos 44, 187, 305
Athena Nike, temple balustrade *11*
Athens *see individual topographical entries*
Attalids of Pergamon 236
Attalos I 237
Atticus 283
Augustus (Octavian) 12, 284
Auxerre Goddess (Louvre) 63
Ayia Irini, Cyprus 94
Ayia Irini, Keos 95

B

Bacchiads 156
Barberini Faun 311, *311*
Bassae, temple of Apollo Epikourios 98, *99*, *170*, *171*, *172*
beauty contests (*euandria* etc.) 33–4
Berenson, B. 321
Berger, J. 133
Blake, W. 321
Blond Boy (Athens) *9*
Boeotia, Mt Ptoion sanctuary 140
bronze-working 74–9

Brunn, H. 6
Buschor, E. 18

C

Callimachus 92, 96, 238
Callistratus 81, 270
Canova, A. 314
Cassander 258
Cassandra 48
Cavaceppi, B. 314
Cerveteri, Etruria 80
Chares 218
Chariton 212
Chrysapha, Laconia 144
Cicero 178, 282–4
Clark, K. 23, 36, 122, 209
Clarke, E.D. 93
Colossi of Memnon, Thebes (Egypt) 48
Colossus of Rhodes 218, *219*, 261
Constantine 302, 304; Arch of (Rome) 302
Constantinople 302, 303
Conze, A. 8
Corfu, temple of Artemis 153–6
Curtius, E. 318
Cycladic figurines 66
Cyprus 94
Cyriac of Ancona 168, 306

D

Daedalic, Daedalus 8, 44
Dancing Maenad type *303*
Darius I ('the Great') 26
Delos, portraits from 262
Delphi; Aegospotamoi monument 99; Daochus
 Group 229; Krateros Group 229; Marathon
 monument 187; Siphnian Treasury 97
Delphi charioteer 101, *102*
Demaratus 80

Demeter 97, 115; of Knidos 205
Demetrius Poliorketes 232
Demophon (Damaphon) 130
Dêmosion Sêma ('People's Grave', Athens) 141
Demosthenes, portrait of *256*
Dermys and Kittylos 140, *140*
Dexileos, *stêlê* of 142, *143*
Diadoumenos *see* Polykleitos
Dinocrates 218
Dio Chrysostom[us] 178
Diodorus Siculus 69, 181, 238
Dionysos, unfinished figure on Naxos *67*
Discobolus (by Myron) *103*, *320*
Dodwell, E. 93
Doidalsos 210
Dörpfeld, W. 318
Doryphoros *see* Polykleitos
Droysen, J.G. 12
Drunken Old Hag 231, *232*
Dying Gaul *238*

E

Eileithyia 96, 108
Eirene and Ploutos Group 267
Eleusis 97
Elgin, Lord 315–17
Ephesus (Artemision) 89–91
Epidauros 106
Eponymous Heroes (Athens) 167
Erechtheum 185
Erechtheus 169
Euripides 169, 190
Eusebius 304

F

Flamininus 264
Foce del Sele, Heraion, 108, 165
 see also Paestum

Furtwängler, A. 6, 318
Futurists 319

G

Galen 38
Gardner, P. 186
Gauls (*Galati*) 237
Gela, plaque from *115*
gilding 83
Goethe, J.W. 18–19
Gombrich, E.H. 21, 27

H

Hadrian 295–6
Hagesander (Hagesandros) 245, 292
Halicarnassos *see* Mausoleum
Hekate 58
Hephaistos 74
Hera 101
Herakles (Hercules) 156–60, 241; Farnese *310*;
 Labours of (Olympia) 160–5
Herder, J.G. 56, 82
Hermes of Praxiteles 109, *110*
Herodas (Herondas) 233
Herodotus 108, 117, 201; on Persian and
 Egyptian religion 43; story of Kleobis and
 Biton 127–9
'heroic nudity' 133–6
Hesiod 25, 101, 154, 183, 190, 197
Hestia *316*
Hipparchus 136
Hippias 136
Hippocrates 93
Homer 28, 124; Sarpedon and concept of
 thanatos kalos 124, 220; Thersites described
 by 34; Zeus described by 191
Homer, portraits of 253
Humann, C. 239
Hunt, P. 18

I

Illissos relief *144*

J

Jacob of Saroug 304
Jenkins, R.J.H. 64
Julius Caesar 261, 279

K

Kairos ('Opportunity') 268
kalokagathia ('beautiful goodness') 35
Kephisodotus 267
Kerameikos, Athens 142
Kimon 187
Kleobis and Biton 127–9, *130*
Knidos (Cnidus) 202–9
Knossos 62
Konon *255*
korai ('maidens') 72, 111–13
kouroi ('youths') 68, 130–2
Kritian Boy (Kritios Boy) 21, *23*
Kroisos 126

L

Laocoon Group 243, *244*, 291, 307
Lausus ('Palace' of) 304
Leochares 206, 223, 229
Livy 192, 278
Loewy, E. 21
'lost wax' 78
Lucian 60, 207
Ludovisi Throne *198*
Luxor (Egyptian Thebes) *68*
Lysander 99
Lysimache, supposed portrait of
 256
Lysimachides, votive relief 106
Lysippos 218, 251, 258, 269

M

Marathon 132, 169, 187
Marcellus, Roman general 278
Marsyas 287–8, *288*
Mausoleum (Halicarnassos) 222–6
Mausolus *see* Mausoleum
Maximus of Tyre 43
Medusa 154, 156
Meletus 251
Menander, portrait of *256*
Michelangelo 67, 184, 309
Miltiades 187
Moschophoros ('Calf-bearer') 114, *114*
Motya 'Charioteer'/*kouros* 101, *102*
Muses 265, 286
mutilated statues 296–7
Myron 49, 58, 103

N

Napoleon Bonaparte 314
Naukratis, Egypt 117; figures from *118, 119*
Naxos, unfinished statues on *68, 72*
Nereid monument 220–2
Newton, C. 224
Nikandre's *korê 64*
Nike of Paionios 100, *100*
Nike of Samothrace ('Winged Victory') *234*
Nikopolis (Actium) 13
Niobid Group *289*, 291
nomenclature of statues 45
nudity 133–6

O

Odysseus 293, *294*
Olympia, cult image of Zeus at 101, 178, 191; temple of Zeus, metopes 160–5; temple of Zeus, pediments 28–32, *29, 31, 32*; workshop of Pheidias 181

Overbeck, J. 6
Ovid 154

P

Paestum (Poseidonia) 71
Paionios 100
Palaikastro, Crete 61
Pandora myth 190
Panofsky, E. 41
Paphos, Cyprus 199, 200
Parthenon frieze *22, 27, 88, 88, 167, 168;* pediments *316, Pl. VIII*
Pasargadae 223
Pasiteles 5, 285
Pausanias 5, 27: at Athens, 242; on Daedalic statues 58; at Delphi 98; at Olympia 99, 160, 191; at Sparta 47
Pegasus 156
Peisistratos 136, 157
Pelops 30
Penelope *146*
Peplos Kore 82
Pergamon 235–43; Great Altar 239–42
Perikles 169; portrait of *255*
Perithoos 29
Persepolis 27
Perseus 156
Petrarch 306
Petrie, W.F. 117
Pheidias 176–92, 202
Pherekydes 31
Philetairos 77
Philip II of Macedon 227, 228
Philochorus 181
Phrasikleia 109
Phryne 204
physiognomy 257
Pindar 101, 161, 271
plaster casts 286, 319

Plato 37, 96, 135, 180, 182, 198, 252; on appearance of gods 48; on Egyptian art 25; on *mimêsis* 28

Plato, portrait of *256*

Pliny the Elder, *Natural History* 4–5, 178; on Aphrodite 204; on bronze-working 13; on Daedalus 59; on 'first sculpture' 60; on Laocoon 245

Plotinus 177

Plutarch 179, 186

Polemon 89

Pollis, *stêlê* of 126, *126*

Pompeion, Athens 251

polychromy 81–3

Polydorus 245, 292

Polykleitos 37–42

Posidippus 81, 260, 269

Pothos ('Longing') 268

Praxiteles 202, 223

Psamtik (Psammetichus, pharaoh) 75

Pseudo-Lucian 46

Ptolemy I (Sôtêr) 230

Ptolemy II (Philadelphus) 219, 231

Ptolemy IV (Philopator) 232

Pygmalion 50

Pyrrhic dance 105, 132

Pythagoras (sculptor) 103

Q

quarrying 66

Quatremère de Quincy 82

Quintilian 178

R

Raphael 307

Revett, N. 168, 315

Rhamnous, cult of Nemesis 266

Rhodes 95, 219

Riace Bronzes 36, 187–8, *188*, Pl. II

Rilke, R.M. 320

Rome 285; Horti Maecenatis 287; sack of 306; temple of Apollo Sosianus 286

Rubens *310*

S

St Augustine (of Hippo) 305

St Jerome 304

St Paul 90–1

Samos 68–70, 76–7; *kouros* from Heraion *70*

Samothrace 233; Winged Victory *234*

Sandow, E. 36

Sappho 194

Sarpedon 124–5, 220

Seleukos 236, 270

Selinus, Temple E *65*

'Seven Wonders' of the ancient world 89

Shaftesbury, Third Earl of 24

Siphnos 97 *see also* Delphi

Skopas 223, 268

Socrates 101; portraits of 250–3, *250, 251, 252*

Sounion, Sounion Apollo 131, *131*

Sperlonga 292–4

sphyrelata 75

Spinario *308*

Spon, J. 92

status of artists 183

stone-carving process 64–72

Strabo 191

Stuart, J. 168, 315

Sufes (Sbiba) 305

Sulla 281

Syracuse, sack of 278

T

Tanagra 79

Terme Boxer *290*, *Pl. VII*

terracotta 79–80

thanatos kalos ('beautiful death') 124–5
Themistokles 116; portrait of *255*
Theocritus 231
Theodore II Lascaris 305
Theophrastus 95, 257
Thersites 34
Theseus 29
Thespiai 204
Thorvaldsen, B. 314, 319
Three Graces Group 208, *297*
Thucydides 133, 136, 157
Tiberius 292–4
Tychê 233, 270; of Antioch *271*
Tyrannicides (Harmodius and Aristogeiton) 26, 136–9, *137*, 254

V

Varro 5
Vatican, Belvedere court 307
Venice, Horses of San Marco *305*
Venus: Capitoline *202*; *Genetrix* 209; *Pudica* 213; Venus de Milo 211
Vergil 245, 280
Vergina *see* Aigai

Verres 281–4

W

Warburg, A. 302
Wheler, G. 92
Winckelmann, J.J. 3–4, *4*, 24, 313–14, *Pl. I*

X

Xanthos 220
Xenokrates 4
Xenophanes 43
Xenophon 34, 112, 135
xoana 61

Y

Yeats, W.B. 54

Y

Zeus *35*; 'cult statue', Olympia 178, 191, 304, *Pl. VI*; Great Altar, Pergamon 239–42; *Zanes* statues 116
Zeuxippos, Gymnasium/Baths of (Constantinople) 304
Zeuxis 204